THE HISTORY OF

British Art

David Bindman (*General Editor*)

And this the form of mighty Hand sitting on Albions cliffs
Before the face of Albion, a mighty threatning Form.

His bosom wide & shoulders huge overspreading wondrous
Bear Three strong sinewy Necks & three awful & terrible Heads
Three Brains in contradictory council brooding incessantly.
Neither daring to put in act its councils, fearing each other,
Therefore rejecting Ideas as nothing & holding all Wisdom
To consist. in the agreements & disagreements of Ideas.
Plotting to devour Albions Body of Humanity & Love.

Such Form the aggregate of the Twelve Sons of Albion took; & such
Their appearance when combind: but often by birth-pangs & loud groans
They divide to Twelve: the key-bones & the chest dividing in pain
Disclose a hideous orifice; thence issuing the Giant-brood
Arise as the smoke of the furnace, shaking the rocks from sea to sea.
And there they combine into Three Forms, named Bacon & Newton & Locke,
In the Oak Groves of Albion which overspread all the Earth.

Imputing Sin & Righteousness to Individuals; Rahab
Sat deep within him hid: his Feminine Power unreveald
Brooding Abstract Philosophy, to destroy Imagination, the Divine-
Humanity A Three-fold Wonder: feminine: most beautiful: Three-fold
Each within other. On her white marble & even Neck, her Heart
Inorb'd and bonified: with locks of shadowing modesty, shining
Over her beautiful Female features, soft flourishing in beauty
Beams mild, all love and all perfection, that when the lips
Recieve a kiss from Gods or Men, a threefold kiss returns
From the pressd loveliness: so her whole immortal form three-fold
Three-fold embrace returns: consuming lives of Gods & Men
In fires of beauty melting them as gold & silver in the furnace
Her Brain enlabyrinths the whole heaven of her bosom & loins
To put in act what her Heart wills; O who can withstand her power
Her name is Vala in Eternity: in Time her name is Rahab

The Starry Heavens all were fled from the mighty limbs of Albion His

THE HISTORY OF

British Art

1600–1870

Edited by David Bindman

Yale Center for British Art
Tate Britain

Distributed by Yale University Press

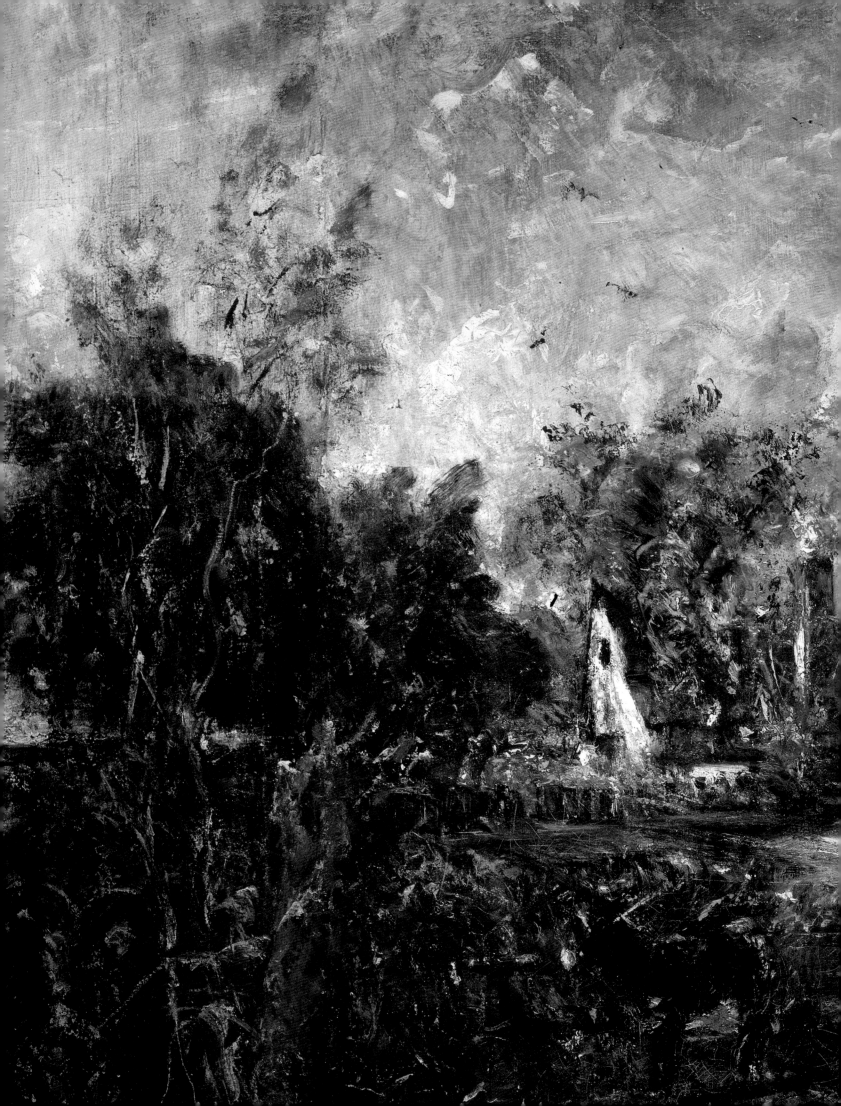

Contents

Contributors

Malcolm Baker is Distinguished Professor of the History of Art, University of California, Riverside.

Elizabeth E. Barker is Director and Chief Curator of the Mead Art Museum at Amherst College, Massachusetts.

Heather Birchall is Curator of Historic Fine Art at the Whitworth Art Gallery, University of Manchester.

David Bindman is Emeritus Professor of the History of Art at University College London.

David Blayney Brown is a Curator at Tate, London.

Stephen Calloway is Curator of Prints at the Victoria and Albert Museum, London.

Diana Dethloff is Academic Registrar in the History of Art Department, University College London.

Stephen Deuchar is Director of Tate Britain.

Natasha Eaton is Lecturer in History of Art at University College London.

Tom Gretton is Senior Lecturer and Head of the History of Art Department at University College London.

Nicholas Grindle works at the Open University and Imperial College London.

Karen Hearn is Curator at Tate, London.

Michael Liversidge is Emeritus Dean of Arts at the University of Bristol.

Julia Marciari Alexander is Deputy Director of Curatorial Affairs at the San Diego Museum of Art, California.

Martin Myrone is a Curator at Tate Britain, London.

Frédéric Ogée is Professor of English at Université Paris Diderot.

Morton D. Paley is Professor Emeritus in the Department of English at the University of California, Berkeley.

Christiana Payne is Senior Lecturer in History of Art at Oxford Brookes University.

Martin Postle is Assistant Director for Academic Activities at the Paul Mellon Centre for Studies in British Art, London.

Elizabeth Prettejohn is Professor of History of Art at the University of Bristol.

Geoff Quilley is Senior Lecturer in Art History at the University of Sussex, Brighton.

Romita Ray is Assistant Professor in Art History in the Department of Fine Arts at Syracuse University, New York.

Angela Rosenthal is Associate Professor of Art History at Dartmouth College, New Hampshire.

Kim Sloan is the Francis Finlay Curator of the Enlightenment Gallery and Curator of British Drawings and Watercolours before 1880 at the British Museum.

William Vaughan is Professor Emeritus in History of Art at Birkbeck College, University of London.

Peter Wagner is Professor of English and American Literature at the Landau Campus of Universität Koblenz-Landau, Germany.

Shearer West is Professor of Art History at Birmingham University and Director of Research at the Arts and Humanities Research Council.

Scott Wilcox is Senior Curator of Prints and Drawings and Chief Curator of Art Collections at the Yale Center for British Art.

Alison Yarrington is Richmond Professor of Fine Art and Head of the History of Art Department at the University of Glasgow.

Acknowledgements

My thanks are due to the contributors, who took time out from busy lives as academics and museum curators to write essays long and short for the volume. It has been a great honour and pleasure to work with old friends (including some former students) on what has been a genuine transatlantic collaboration between Tate Britain and the Yale Center for British Art. I would like to thank in particular Stephen Deuchar, Amy Meyers, Julia Marciari Alexander and Martin Myrone, all of whom contributed to the shaping of the volume, and the series of which it is part, as did the editors of the other two volumes, Tim Ayres and Chris Stephens. I also enjoyed working with Tate Publishing, especially with Roger Thorp, Rebecca Fortey, Katherine Rose and Tim Holton, and with Philip Lewis at LewisHallam Design, who all brought skill and enthusiasm to make a beautiful as well as (I hope) a useful volume.

DAVID BINDMAN

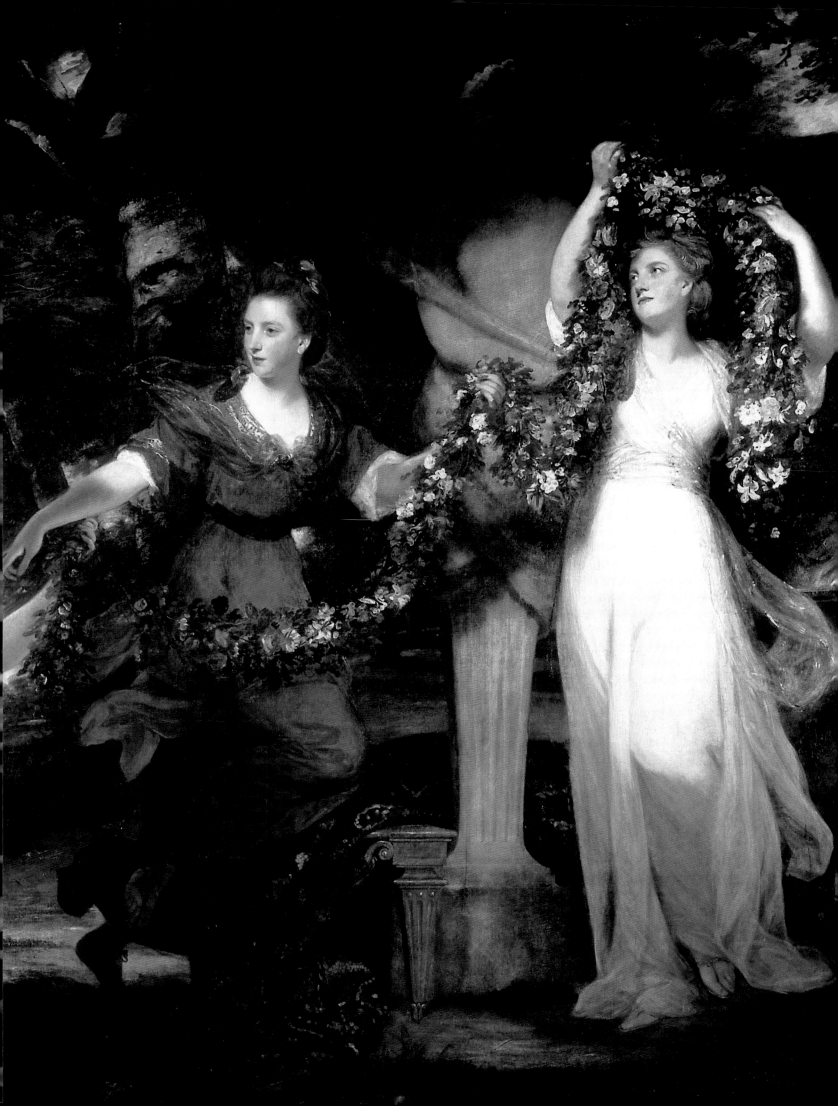

Foreword

Tate Britain in London and the Yale Center for British Art in New Haven, Connecticut, are the only major public museums in the world solely devoted to the collection, display, preservation and interpretation of British art. Together our resources and our programmes constitute an extraordinary gateway to a rich field, serving the needs of both scholars and the general public in our respective countries. As institutions we collaborate regularly – on exhibitions and on the loan of works of art, for example – and this three-volume History of British Art series reflects our ongoing wish to promote the cause of British art together, to as wide an audience as possible.

There have been exciting advances in art history over the past several decades. Whereas the appreciation of art was once conceived only in terms of taste and connoisseurship, confined implicitly to the privileged few, it is now viewed in natural relation to its historical and cultural contexts. Since this has begun to be properly reflected and articulated in exhibitions and displays worldwide, we thought it was time for some of these relatively new ways of thinking to be applied to a general overview of British art's history from its beginnings to the present day. The resulting volumes lay no claim to be comprehensive in their coverage; they aim rather to pose some current questions about British art and to shed fresh light on sometimes familiar ground.

David Bindman kindly took on the task of setting the criteria for the books, organizing the volume editors and authors, as well as editing the text. To him, to the many distinguished contributors, and to all those who have worked on seeing the books through to publication, we extend our grateful thanks.

STEPHEN DEUCHAR
Director, Tate Britain

AMY MEYERS
Director, Yale Center for British Art

Opposite:
JOSHUA REYNOLDS
Three Ladies Adorning a Term of Hymen 1773
(detail of fig.88, p.144)

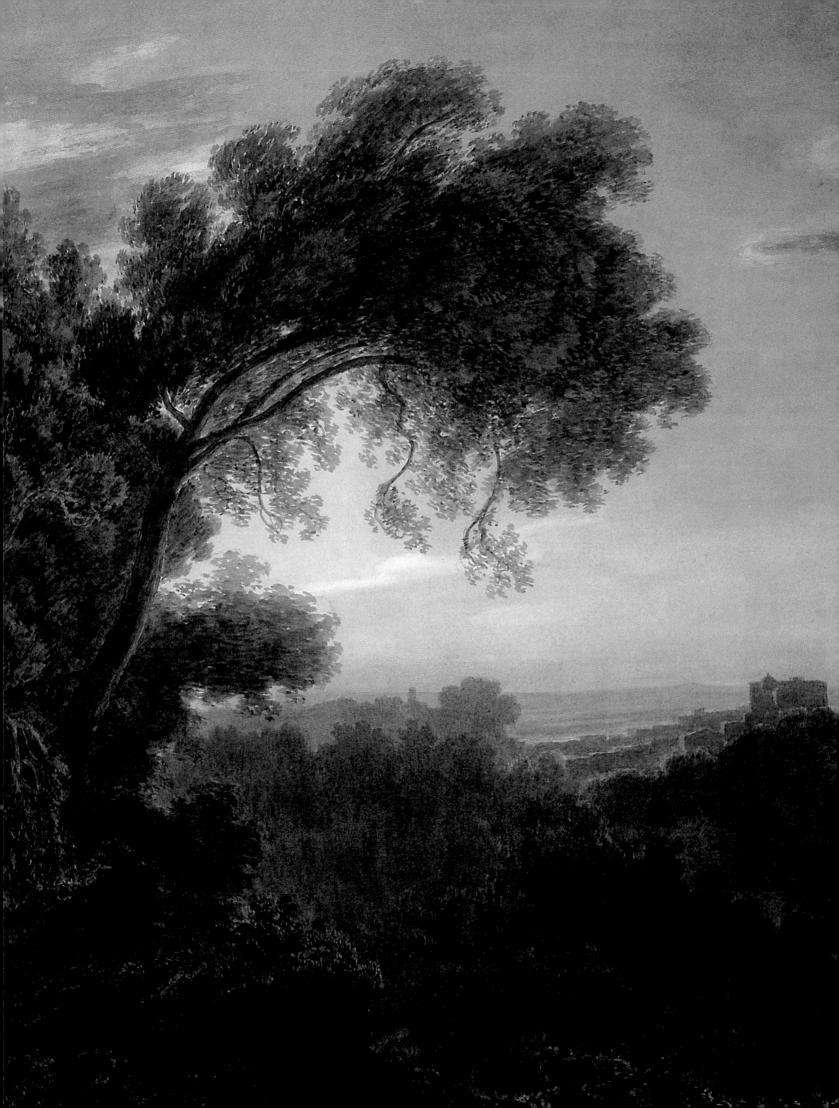

Introduction to *The History of British Art* Series

DAVID BINDMAN

This volume is one of a series of three, covering British art from around AD600 until the present day. The series is best seen not as a linear history of British art but as a number of separate though interconnected histories of art's ever-changing relationships with the idea of Britain, and of Europe, and of the world beyond Europe. The series also encompasses art's relationship with political, intellectual and social histories and, where possible, with the lives of artists themselves. These histories reveal a British art that is not inward looking, but open to the world beyond and to external events and social pressures. One of the chief aims of these volumes is to reinterpret British art in the light of Britain's inherent instabilities of identity, which still define it in a global world. British art is not, therefore, limited to artists born in Britain, but encompasses art made in Britain or made abroad by artists resident in Britain or its colonies.

The limits of what constitutes art are inevitably contentious and vary from volume to volume. In the medieval volume architecture and what we would now call the applied arts play an important part, while for the other two volumes they only appear as part of the background to painting and sculpture. This was essentially a practical rather than an intellectual decision, based on the amount of space available. The divisions between periods also led to much discussion because of the political implications of choosing a particular date. The beginning date of the

series, now c.600, was particularly thoroughly argued over, as were the beginning and end dates of the second volume. In the end it was agreed to leave them fluid, and though volume two technically runs from 1600 to 1870, some essays begin and end both before and after those dates for reasons that should be clear in each case.

The long essays in each volume run parallel to each other chronologically, each following its theme broadly from the beginning to the end of the period. In addition, there are short essays that pick up aspects of that theme for more detailed consideration, and allow for a particular focus on works of art and key episodes.

Though the volumes have been initiated by Tate Britain and the Yale Center for British Art, they are in no sense an 'official' version of British art; the editors of each volume and I have been given complete freedom to choose the topics and the authors, most of whom come from the academic world, though museums are well represented. The volumes do not claim to be encyclopaedic – you are bound to find that some important artists or issues have barely been considered – but they do show the broader concerns of scholars working in the field, the gains in knowledge over the last few years, and indications of future directions for research. Above all, they should convey some of the excitement that scholars feel in pushing back the intellectual boundaries of the study of British art.

Opposite:
JOHN ROBERT COZENS
*The Lake of Albano and
Castle Gandolfo* c.1779
(detail of fig.143, p.219)

Overleaf:
JOHANN ZOFFANY
Colonel Mordaunt's Cock Match
c.1784–6
(detail of fig.72, p.119)

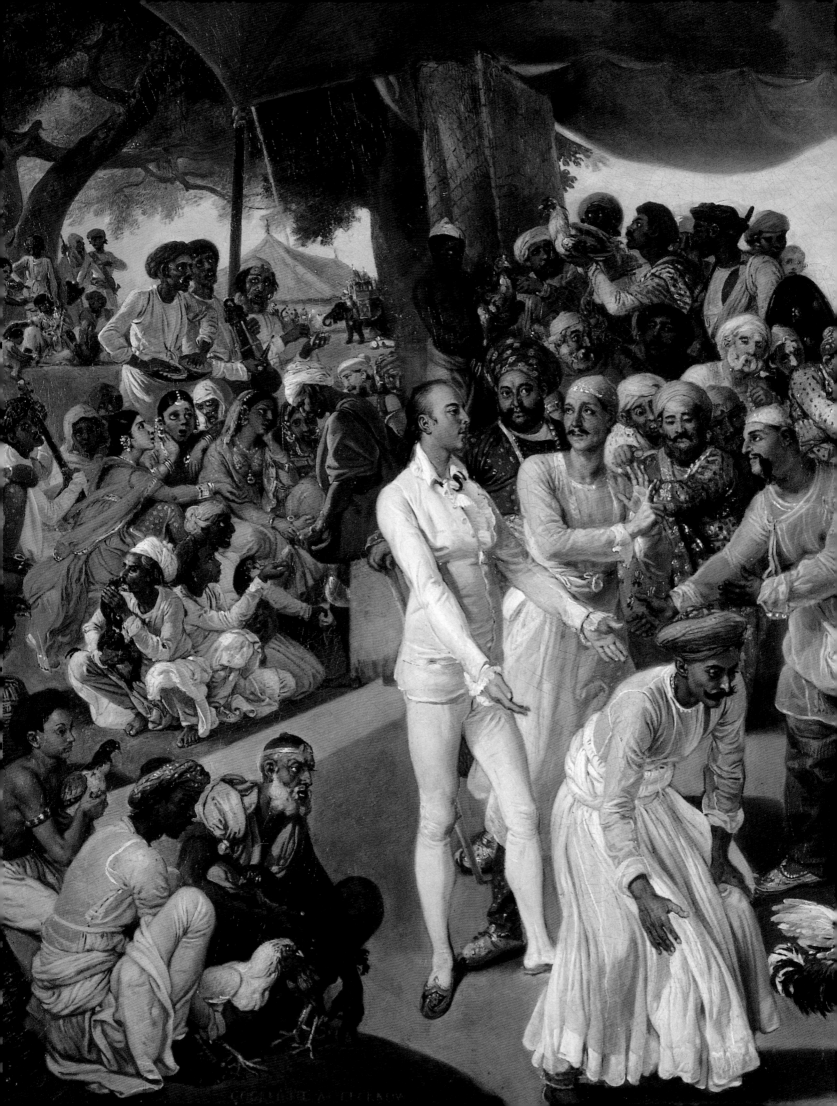

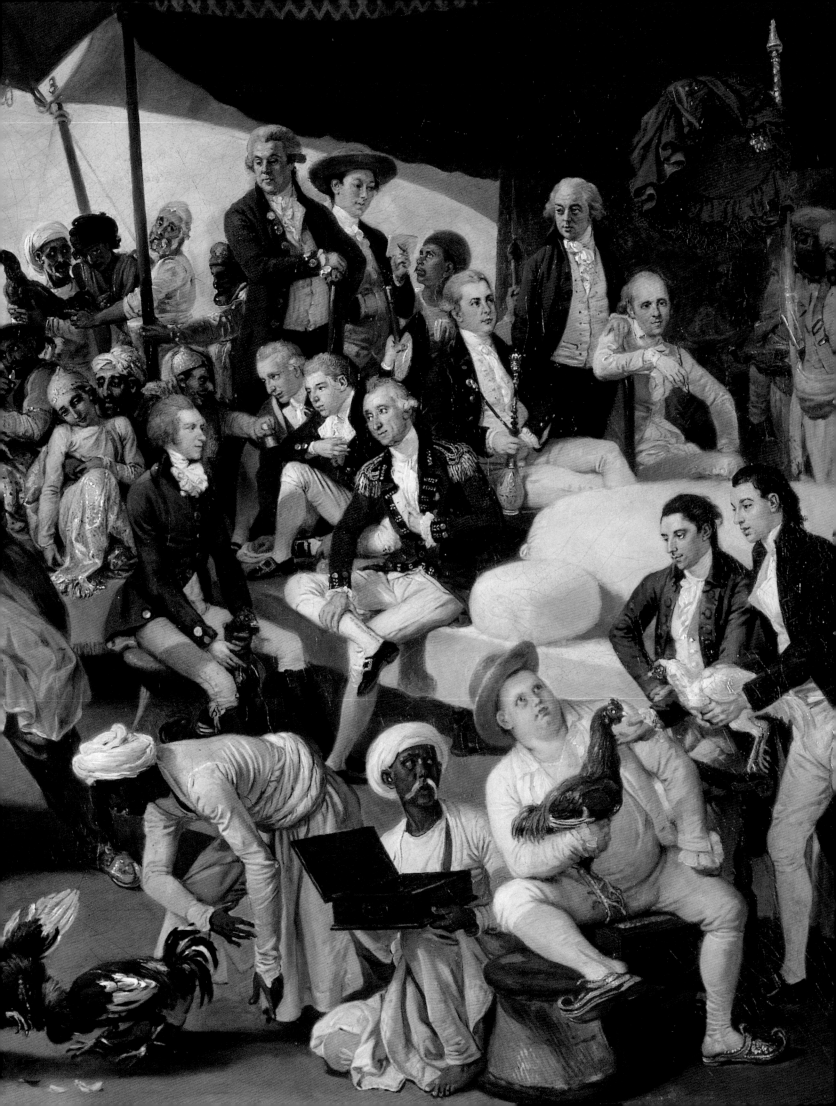

Introduction to *The History of British Art 1600 to 1870*

DAVID BINDMAN

The nearly 300 years covered by this volume saw immense change in the geographical boundaries, political structure and position in the world of what we have since the eighteenth century, called Great Britain or the United Kingdom. In the year 1600 the island of Britain was divided into the separate monarchies of England and Scotland, with Wales under nominal English rule and Ireland as a lightly occupied English offshore colony. A unified Britain existed only as one of the legendary claims of the English Crown, based on a distant memory of the Roman idea (and it was only an idea) of Britannia, until England and Scotland were brought together under a single King, James I, in 1603. Even then, it took a further century for the two kingdoms to be uneasily united by the Act of Union of 1707.

Towards the end of the nineteenth century, after Ireland was brought into the union in 1802, all four countries formed a United Kingdom under rule from London, and Britain was the centre of a worldwide empire of proverbial wealth, though one about to begin a precipitate decline. The idea of Great Britain as a single nation had been invented by the eighteenth-century English elite to counter the fissiparous tendency of its four constituent countries, expressed in the Scottish rebellions in 1715 and 1745, the Irish rebellion of 1798, and those of the North American colonies, who proclaimed themselves to be a separate nation in 1776. Subsequently, in the early twentieth century Southern Ireland split away from Great Britain to form an independent nation, and as I write the Scottish National Party has recently won a majority in the Scottish Parliament with a central agenda of creating a Scottish nation independent of Britain.

The idea of Great Britain has always been, and still remains, contested and unstable, but in the process of achieving a relatively short period of unity immense social changes took place. By the end of the seventeenth century, after a bloody civil war that ended in the execution of King Charles I, Britain became a constitutional monarchy, though one that seemed dangerously impermanent to contemporaries. This was followed by the dramatic growth of a mercantile society that made London a great city and the centre of a trading empire based on the import and export of goods, which in turn depended on the establishment of colonies built largely on slave labour. This wealth allowed the growth of a pleasure-driven economy in

London, which enabled the avid pursuit of luxury goods like paintings and sculpture; it also prompted an investment in the development of industrialization that transformed the physical structure of the kingdom, providing an example that led other countries in Europe and America to rival and eventually surpass Britain's productivity.

The creation and consumption of art in the period sometimes followed the pattern of other luxury goods; at other times it followed earlier traditions of patrician display. As they entered the marketplace, artists developed as a separate interest in society, creating associations for their own protection and advancement. Out of this there grew in London, and to a lesser degree in some provincial cities, a metropolitan 'art world' with public galleries and institutions, auctioneers and dealers, that would not be wholly unrecognizable today.

Visual art, like the other arts, had a prominent and contentious role in giving form to the national identity of the four constituent countries, and of Great Britain itself as it gradually emerged as an imagined community. At the same time, the London art world was open to immigration from the rest of Europe and from America; it was made up not only of English, Scottish, Irish and Welsh but also of French, Flemish, German, Italian and American artists, many of whom achieved a dominant position.

If the most fruitful and stimulating directions in the study of British art in recent years have tended to come under the rubric of 'the social history of art', with the influential writings of John Barrell, Marcia Pointon and David Solkin, it has arguably tended to reinforce the separation of British art from its international context and to a degree from the broader world of ideas. These scholars have tended to focus with some intensity on the London art world and its social circumstances, under the influence of historians like John Pocock, and their approach is represented in this volume by Martin Myrone's profound examination of the social existence of artists in the period. The concern in this volume with issues of national identity and the wider world is partly a response to persistent debates in the press, fired by political problems within Britain and the need to deal with the imperial past in the light of an increasingly global culture; it is also a reclamation of an earlier phase of British art history, when scholars like John Gage and William Vaughan actively

sought to bring a European perspective to the study of British art.

For younger scholars, like Romita Ray and Angela Rosenthal, neither of whom were brought up in Britain, the interest of British art lies in the complexities of the relationship between a shared imperial past and present day multiculturalism in Britain (chapter 3). For William Vaughan, on the other hand, British art has an equally rich relationship with Europe, involving both import and export from the Continent (chapter 2). In terms of such geography there is another story of British art *within* Britain: how art has played a part in the endless dialectic between the unifying idea of Britain, and the self-assertion of its constituent countries (chapter 1).

There is also the matter of British art's relationship to other fields of study and a broader cultural history. Nicholas Grindle's study of British art in relation to visual perception, from Francis Bacon onwards, brings British art into conjunction with the immense changes in ideas about the natural world in the period, demonstrating why landscape painting emerged so strongly in Britain (chapter 4). Where Martin Myrone elucidates the place of artists themselves, and the actual circumstances of what it meant to be an artist in the period (chapter 6), Frédéric Ogée's account of the social world of British art focuses more on reception than production, placing art in a context that is illuminated by the literature and philosophy of the period (chapter 5).

If these essays constitute lengthy meditations on broad themes, the short essays not only deal succinctly with works, categories or individual artists valuable in their own right or otherwise not dealt with, but they also comment on and extend the reach of the long essays into specific areas. They enable areas of art like sculpture and printmaking to be brought forward, and artists who had an equivocal role in relation to the mainstream, like George Stubbs, Joseph Wright of Derby and William Blake, to be given a definable place. Having said that, there has been no attempt to be fair to the reputations of individual artists; their 'importance' emerges not in the number of words allotted to them but in the fact that certain artists, like William Hogarth and Joshua Reynolds, and certain institutions or groups, such as the Royal Academy and the Pre-Raphaelite Brotherhood, appear in more than one essay.

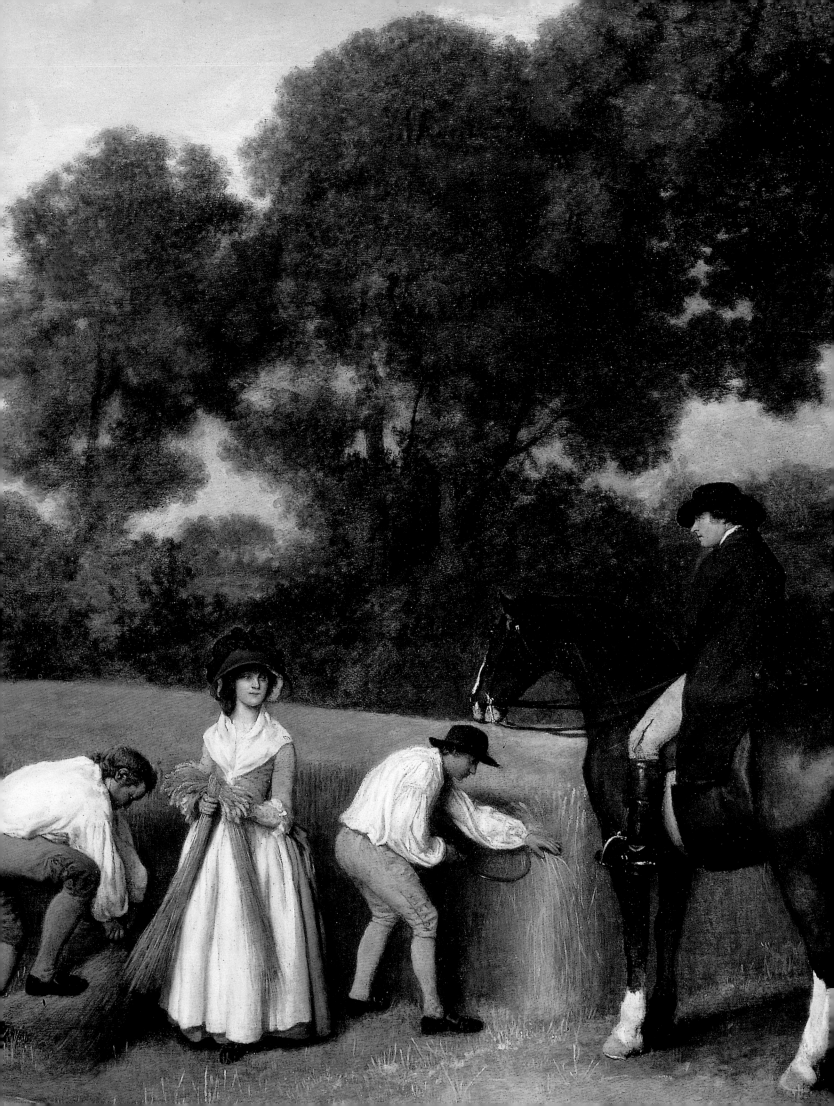

1 Ideas and Images of Britain c.1570 – c.1870

DAVID BINDMAN

Introduction

The urgency and complexity of issues of national identity and historical memory have in recent years challenged the concerns with 'national schools' and 'national character' that characterized older books on British art, like Nikolaus Pevsner's *The Englishness of English Art* (1956).[1] In this chapter I have assumed that national identity is not a fixed category or discrete entity but historically contingent and subject to widely varying perspectives. What follows is not an attempt to distinguish the Britishness of British art, but to survey the way in which questions of national identity and what constituted Britain at any particular time have affected its art and visual culture from the reign of Elizabeth I (1558–1603) to that of Queen Victoria (1837–1901).

Pevsner sought to define an English 'national character as it expresses itself in art', though he already felt the need to justify his enterprise against those who argued that internationalism had made the concept of national character obsolete. Pevsner claimed, along with many in the first half of the twentieth century, that there was an *English* national character rather than a British one, and few now would accept his contention that the principal features of English art, from Anglo-Saxon times to the present, have been 'a descriptive interest in earthy realism and a formal obsession with linearity', combined with a general distrust of ideas.[2] The idea of a *British* national character was less often argued for, though as a political entity Britain was a dominant European power for most of the period under consideration.

Histories of British art and culture have tended to perpetuate what Timothy Garton Ash has called the 'English-British blur', calling something 'British' when 'English' is meant and vice versa, but always assuming that England is centre and Ireland, Scotland, Wales and the colonies are on the periphery.[3] In compensation there have been histories of the national schools of art and visual culture within Britain, like David and Francina Irwin and Duncan Macmillan on Scottish art, Fintan Cullen's volumes on Irish art, and Peter Lord's on Wales; only Pevsner and Dagobert Frey have attempted in modern times to define a separate Englishness in art.[4]

A number of studies in recent years have, however, looked at artistic relations between the countries of Britain, their relation to the idea of Britain, or the role of art in ideas of British nationality. The most comprehensive has been Sam Smiles, *The Image of Antiquity: Ancient Britain and the Romantic Imagination* (1994), which is concerned with British antiquity and its revival, and the implications for all the countries of Britain. Fintan Cullen has followed his enquiries into Irish art by looking at Scotland in his 1993 article, 'The Art of Assimilation: Scotland and its Heroes', which examines the role of painting in the ongoing question of the reconciliation of 'Scottish national identity . . . with the pervasive force of the English centre'.[5] An exceptional group of scholars have meditated on landscape and the production of 'Englishness' in the early nineteenth century, especially Andrew Hemingway and Stephen Daniels.[6] In 1989 William Vaughan noted the shift towards a concern with an 'English' school in the period of the Napoleonic wars in his article 'The Englishness of British Art' in the *Oxford Art Journal.*[7] Dian Kriz's *The Idea of the English Landscape Painter* (1997) contains illuminating reflections on the ambiguities of the English/British relationship, noting that 'This study of English landscape painting demonstrates just what a complex and conflicted process this was by showing how certain notions of Englishness sometimes reinforced the idea of Britishness and at other times promoted regional differences'.[8]

Linda Colley has pointed out that Britain as a state did not exist before the eighteenth century; as Norman Davies put it pungently, '"the British people" were a product of modern times not a tribe from the Garden of Eden'.[9] Though royal claims to a unitary Britain are at least medieval, until well into the second half of the eighteenth century the inhabitants of Britain and its colonies would have thought of themselves primarily as English, Irish, Scottish or Welsh. They would also have made distinctions that were more real to them than country or nation: between Lowlands and Highlands in Scotland; North and South in England, Ireland and Wales; city and countryside, and between mother country and colony. The divisions also worked hierarchically; wealthy landowners were more

likely to think of themselves as English or British because they would have had connections with London or other English cities, while the poor were, at least until nineteenth-century industrialization, usually rooted in one place.

The British Island: Britannia from Elizabeth to George I

'Great Britain' since the late sixteenth century has usually signified a union under the Crown of England, Scotland, Wales and Ireland, but there is a tendency in English literature, painting and popular imagery to picture Britain as an island, and therefore made up figuratively only of England, Scotland and Wales. 'Britannia' was the name given to the Roman province under Hadrian that encompassed England and Wales but Scotland remained a separate and hostile country even beyond the 'Union of the Crowns' of 1604. The idea of Britain as an 'island-nation', the heart of a maritime empire, allowed for poetic conceits ('a jewel set in a silver sea'), but this island was often called just England; the 'English-British blur' has a long history.

Britain's lack of a common government or religion after the Reformation, and the absence of universally accepted borders, led English rulers to encourage historical narratives that bolstered their claim to power over all the constituent countries, in the face of often fierce resistance by those outside England. In the Tudor and Stuart periods architecture, painting, poetry and sculpture, and schemes combining some or all of these, were at the heart of government. Visual narratives of Britain were painted on ceilings and walls, or on large panels, and sometimes in the form of engravings, but they were in almost every case devised by authorities and carried out by artists. Art and literature were in every sense constitutive of politics, in a seamless continuum between image and political action. The real and allegorical figures in the Banqueting House ceiling by Peter Paul Rubens (1577–1640) hovered directly over the heads of foreign ambassadors, and over the masques played out by the king, queen and the court under Charles I (1625–49). The ceiling provided an appropriate setting for the last moments of the king before his execution on a scaffold erected on the outside of the same room.

Most allegorical literary constructions of Britain, before seventeenth-century historians began to undermine them,

rested on a myth of continuity put together from old tales from the twelfth century by Geoffrey of Monmouth.[10] He imagined a Britain and British monarchy that could be traced back into the mythical past, beyond the Norman usurpation, Arthurian Camelot and the Roman invasions, and beyond even the 'Ancient Britons' and their Druid priesthood, to 'Brutus of Troy', a descendant of Virgil's Aeneas, the mythical founder of Rome. In the late sixteenth century this myth, already attracting the scepticism of rational antiquarians like William Camden, spawned one in which Island Britain was married to the sea, that acted both as a defence and an opportunity to create what John Dee in 1577 called an 'Imperiall Brytish Monarchy'. This was rooted in King Arthur's mythical 'twenty Kingdomes', which included a large part of America and the northern islands all the way to Russia.[11]

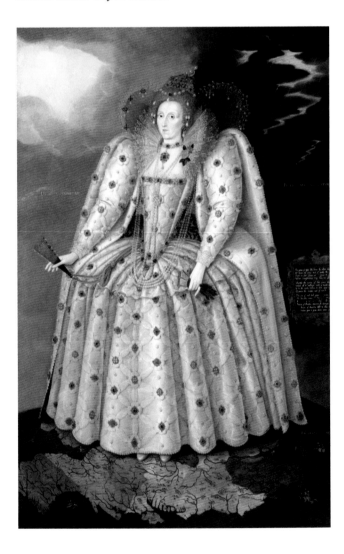

2 PETER PAUL RUBENS
The Union of the Crowns
(central ceiling panel) 1632–4
Oil on canvas
745 × 528 (293¼ × 207⅞)
Total ceiling 3350 × 1690 (1318⅞ × 665⅜)
Banqueting House, Whitehall, London

Towards the end of the same century Queen Elizabeth I (1558–1603) is portrayed frequently as embodying Britain itself and its divine mission of empire. In the 'Ditchley portrait' of c.1592 (fig.1) attributed to Marcus Gheeraerts the Younger (1561/2–1636), the Queen stands on a map of the southern part of England, whose contours seem to merge into her voluminous skirts, and her whole body broadly follows the shape of the island of Britain, so that the Queen *is* 'this yle of such both grace [and] power' mentioned in the sonnet inscribed on the panel itself.[12] The British island is embedded in a sea filled with ships, and in the background the sea is curved round like the top of the globe, suggesting the whole world is centred on the island of Britain. The woman-island is thus the world's arbiter, able to transform the storms on her right into the sun's domination on the left. Elizabeth is Queen of the World, as her fellow virgin, Mary, is Queen of Heaven.

After Elizabeth's death the island of Britain can be seen in the frontispiece to *Poly-Olbion* (1612), Michael Drayton's retelling of 'the British history' or myth of Britain, in the guise of the maternal goddess 'Britannia', one breast bare, carrying a cornucopia and seated on a rock inscribed 'Great Britain'.[13] She is the archetype of the Britannia who appears time and again in the eighteenth century, seated on the seashore with attributes of power, prosperity and liberty, but often forced into low company in print shops, where in caricatures she was frequently abused and physically mutilated by those, within and without Britain, who wished to destroy her. She was obliged to cohabit not only with her 'daughters' Scotia, Hibernia and Gallia, but with new types of personification like the plain-speaking John Bull, representing England.[14] She was invoked by caricaturists in threatening times as a maternal figure, whose children's rebelliousness was not enmity but the inevitable – and hopefully temporary – adolescent rejection of a loving parent.[15]

Scotland did not become part of Britain politically until 1603, when James VI of Scotland was also crowned James I of England (d.1625). Ireland, though officially part of the union since 1541, was treated more often as a troublesome colony than a constituent part of Britain itself. Even the 'Union of Crowns' under James was only nominal; almost all institutions in the two countries remained independent of and occasionally at war with each other until the Act of Union in 1707. James, though a fervent royal absolutist and ideologue of Divine Right, was not as susceptible to the lure of romance and chivalry as Elizabeth and her

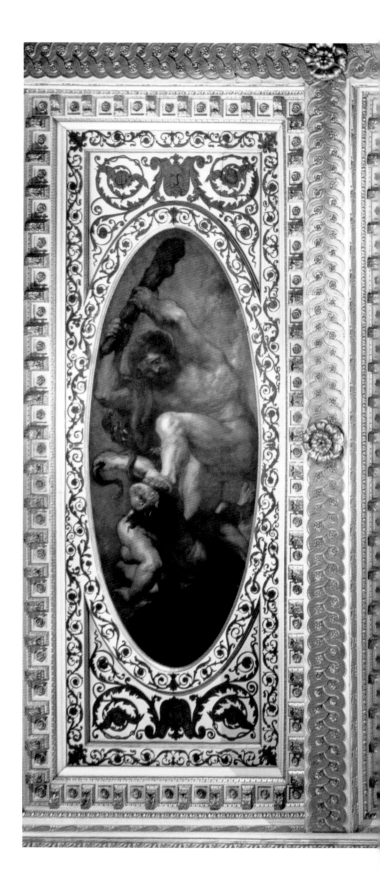

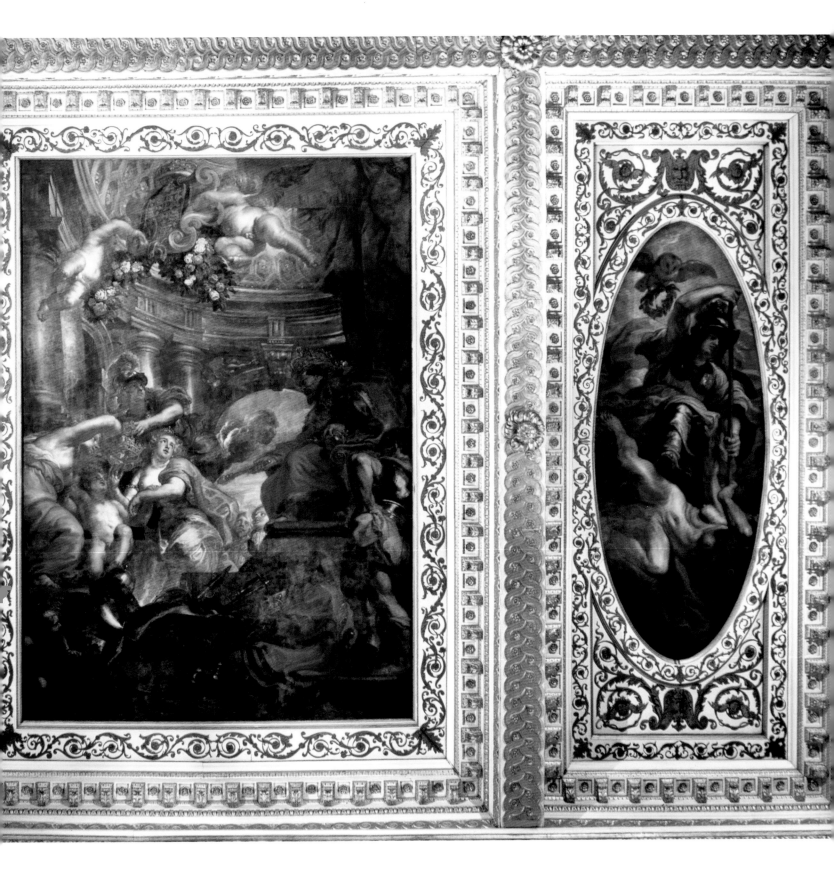

champions had been. Indeed, the cult of Elizabeth and the idea of empire were promoted by the opposition, particularly by his eldest son and heir Henry, Prince of Wales. The arcane and mystical symbolism that surrounded Elizabeth in her later years now attached itself to the Prince in the brief period before his death in 1612. This is evident in the remarkable portrait of Henry on horseback (Parham House, West Sussex) by his painter Robert Peake the Elder (c.1551–1619), where he is represented as an Arthurian knight as if on his way to a joust, his lance and helmet carried by an accompanying figure of Time with prominent forelock.[16]

The neo-Elizabethan vision of Great Britain implicit in the Parham painting was given little place in the greatest work of art to be produced in Britain in the seventeenth century, Rubens's ceiling painting for the Banqueting House in Whitehall, installed 1635–6 (fig.2).[17] It is now known that it was originally commissioned to celebrate the reign of James I, probably by James himself, for the first negotiation with Rubens took place in 1621. In the first undated plan 'The great Oual', the large space in the centre already installed by the architect Inigo Jones, was to contain a celebration of the defining achievement of James's reign, the union of England and Scotland: 'The King on a Throne raysed wth degrees, the two Kingdomes of England & Scotland in figures of women kneeling, holding the two Crownes bound together wth a Wreath of olive & myrtle; the King in action of ioyning them together; on both sydes are some of the nobility of England & Scottland & belowe some halfe figures of Sergeants at Armes for State.'[18]

This iconography corresponds to James's vision of a true union of the two nations based on the active consent of the nobility, but mutual suspicion and long-standing prejudices in both countries prevented anything more than a union in James's own mind. Nor was his affection for Scotland shared by his son and heir Charles I, whose advisers, when the project was revived under his reign, placed *The Apotheosis of James I* in the central oval and relegated *The Union of the Crowns* to one of the smaller square panels. The effect was to convert a scheme intended to proclaim to the world that England and Scotland were as one into a personal memorial to the late king.

The scheme for the Banqueting House ceiling completed under Charles did not change the imagery of the Union of the Crowns, which is clearly based on a learned programme produced at James's court by someone like John Thornborough, Bishop of Bristol.[19] *The Union of the Crowns* is an allegorical depiction of James's proclamation of the union of England and Scotland under the name of 'Great Britain', 'the true and ancient name which God and time have imposed upon this Isle'.[20] It is a complex enactment of the biblical *judgement of solomon,* with James as Solomon, assisted by Minerva in joining together the two crowns held by female personifications of England and Scotland. It is also possibly an allegory of the birth of an infant Hercules as the emergent nation of Great Britain, and there are references to the ancient 'Empire' of Britain, especially in the standing warrior to the left of the throne, who is probably Brutus of Troy.[21] The effect of this allegory was to give the Union a myth of origin in the ancient harmony, prosperity and peace of the island of Britain.

The absolutist nature of *The Union of the Crowns,* along with the central *Apotheosis of James I* and *The Peaceful Reign of James I,* is redolent of James's prosaic view of the world. Charles himself, though just as much an absolutist as his Scottish-born father, was nonetheless attracted, like his elder brother, to a more chivalric and Anglocentric view of the nation, and to the Renaissance symbolic language of the emblem, *impresa* and masque. Charles's conception of Britain was expressed most clearly in the masques performed at regular intervals throughout his reign from 1631 to 1640, usually in the Banqueting House.[22] A masque was neither a play nor an opera, but a court ceremony. Charles, Queen Henrietta Maria and courtiers themselves usually took the main parts. The plots were all based on the effect of monarchical power upon disorder, the latter represented by a comic 'anti-masque' that usually began the proceedings.[23]

In the genre of the masque political differences were swept up into a Platonic vision of the triumph of ideal virtue over discord and vice. Under Charles I it is love that triumphs, represented by his own union with Henrietta Maria.[24] However, some of the masques of the late 1630s, when Charles was losing control of the nation, are devoted to a complex vision of an ideal Britain that would come into being if only faction would cease. *Coelum Britannicum* of 18 February 1634 is also notable for the astonishing visual effects orchestrated by Inigo Jones (1573–1652), which can only be glimpsed now in our mind's eye by piecing together the surviving contemporary descriptions, the text itself and the few surviving drawings.[25] The masque begins with the

'more grave anti-masque of Picts, the natural inhabitants of this isle, ancient Scots and Irish', who here represent the disorder that precedes the unifying advent of Britain. Jones was responsible for the construction in the Banqueting House of a huge mountain made of cloth and wood, able to transform itself by a hidden mechanism at certain points in the drama: 'About the middle part of this mountain were seated the three kingdoms of England, Scotland and Ireland, all richly attired in regal habits appropriated to the several nations, with crowns on their heads, and each of them bearing the ancient arms of the kingdoms they represented.'[26] A young man in a white robe with a cornucopia is an image of the wealth of these countries united, and by implication of the poverty if they were divided. This unity is created by ancient 'British worthies' who rise from their tombs at the behest of a 'mighty British Hercules'. In the first transformation of the mountain, masquers dressed as ancient heroes emerge from a cave that opens in the rock and perform a dance. In the most spectacular effect the 'genius of the three kingdoms' is borne up by a cloud while the huge rocks that make up the mountain sink back into earth. The 'genius' who creates what is now a pleasant prospect of unity, the triumph of order, virtue and natural beauty, is, needless to say, a descendant of King Arthur. He is played by the king himself, heir to the ancient British heroes who are resurrected to live again in his kingdom.

Charles's fate on the scaffold effectively destroyed the association of royalty with chivalry and a vision of a Britain older than Rome itself, which had in any case been eroded by the historians of the day. Yet in proclaiming himself 'Lord Protector', even Cromwell evinced a need to take on an allegorical role in relation to Great Britain (see Dethloff, pp.48–9). He and his supporters used visual allegory in the form of engravings, the most spectacular of which is *Oliver Cromwell between Two Pillars* by William Faithorne after a drawing by Francis Barlow (British Museum, London), produced in 1658, the last year of Cromwell's life.[27] The programmatic richness and range of allusion are comparable to the Banqueting House ceiling, but in the mid-seventeenth century it was the engraved print, with its portability and relative speed of production, that took on the representation of power in troubled times. The figure of Cromwell as the Christian conqueror in the presence of God alone, trampling on the Whore of Babylon, is, like the Ditchley portrait of Elizabeth, an emblem of Britain, though the title

refers to 'England's Distractions As also of her attained, and further expected Freedome, & Happines[s]'. The constituent countries of Britain (omitting Wales) are represented on a column to Cromwell's left as crowned and gowned females – Anglia, Scotia and Hibernia – offering laurel wreathes (not a crown as he had refused it the previous year), with each of their flags flying from the column. As Lord Protector and in the name of Parliament, Cromwell has attributed to him the traditional theological powers of monarchy: to rule justly under God's direct sanction, and to guarantee Christian virtue and prosperity from the threat of Catholic enemies. For this reason it is not surprising that the original plate was resuscitated in 1690 with the head of William III (1689–1702) replacing Cromwell's.[28]

This account of some seventeenth-century allegorical schemes highlights the wishful thinking behind the harmonious and historically grounded vision of unity under a benevolent ruler that they present. Ireland remained an unruly and religiously divided colony, and Scotland resisted English rule on nationalistic and religious grounds throughout the century. Even the Act of Union of 1707, which abolished the Scottish Parliament, did not prevent two military uprisings with international support in 1715 and 1745, and there were revolts later in the century in Ireland and, of course, in the American colonies.

The Eclipse of 'the British History' and its Return

The immense Painted Hall in Greenwich of 1707–27 (fig.3) by James Thornhill (1675/6–1734), the largest allegorical painting scheme in eighteenth-century Britain, makes no reference to the legendary history of Britain, nor does it make much reference to Britain outside England, or indeed outside London.[29] The central oval, which virtually fills the whole ceiling of the Lower Hall, is an apotheosis of William and Mary who preside in the heavens above the triumph of Peace and Liberty over Tyranny. Their achievements are expressed as the freeing of Europe from the Catholic tyranny of Louis XIV, which allowed the growth in England of great institutions of learning and religion, the cornerstone of which was the rebuilding of St Paul's Cathedral, seen in a huge picture beneath the royal couple, held up by cherubs. The vast edifice of this royal heaven is supported

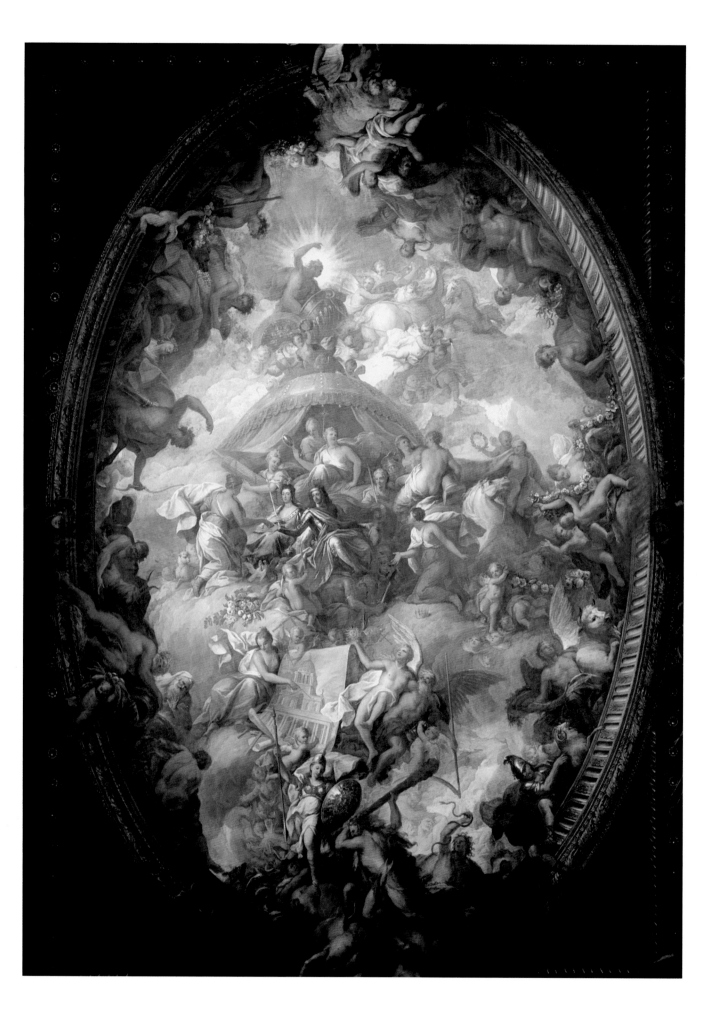

by naval power in the form of cannon, rope and the like; a fighting ship with union flag ready for battle outside the heavenly canopy; and a captured ship at the other end. The union flag establishes that the victorious navy is *British,* and the Upper Hall ceiling, celebrating Queen Anne (1702–14) and her husband Prince George of Denmark, alludes to the navy's role in empire by showing the four continents in adoration. The corners of the ceiling contain four armorial shields that in effect support the ceiling, but these are of England, Scotland, Ireland and France, the last commemorating the British Crown's ancient claim to France, which was not withdrawn until 1783. In the grisaille painting on the north wall of the Upper Hall, George I (1714–27) lands at Greenwich on his way to take up the throne, flanked by Justice and Peace. As St George attacks the dragon of Roman Catholicism, the discordant figure of Rebellion, representing the Scottish Jacobites defeated in the 1715 Rebellion, falls back in terror.

The idea of Britain is thus subsumed within the idea of a monarchy based on sea power and on the triumph of the Protestant religion symbolized by St Paul's. The mythical history of Britain has returned to the Elizabethan idea of the island Britannia married to the sea but now laying claim to virtually the whole world. In the marble chimney piece for the East India Company (London, Foreign Office) by John Michael Rysbrack (1694–1770), the continents bring gifts to a majestic Britannia, who, in absorbing invisibly her constituent countries into a seamless entity, reinforces the identification of England with Britain; thus in allegorical terms Britain in the eighteenth century tends to become ever more England 'writ large'.[30]

Even so, the idea of Britannia can seem like a crust of lava over a volcano of competing national myths. The legends of a pre-medieval Britain ultimately acquired more resonance for the individual countries of Britain than for Britain as a whole. In the later eighteenth century 'the British history' was taken up by poets as the expression of a deeper national identity that could only be retrieved by the imagination, while for British rulers it presented a tenuous historical justification for territorial claims. The Irish painter James Barry (1741–1806) painted for John Boydell's *Shakespeare Gallery* a version of *Lear and Cordelia* 1786 (fig.4) that sets Shakespeare's story deliberately in 'the British history', for Lear was one of the first British kings in the succession from Brutus of Troy.[31] The elaborate Stonehenge-like temple in the background, not mentioned in the play, establishes a pagan religious setting in the remote antiquity of the British island. For the most imaginative artist of the eighteenth century, William Blake (1757–1827), ancient Britain was 'the Primitive seat of Patriarchal Religion', the seat of the deeds recorded in the Bible.[32] For Blake the Druid priests of the ancient Britons were not, as they were for antiquarians like William Stukeley, benign forebears of Anglicanism[33] but bishops of a cruel religion that covered 'Albion's Ancient Druid rocky shore', practising human sacrifice and worshipping reason. In Blake's great epic, *Jerusalem,* plate 70 shows a gigantic ancient British trilithon set in a mysterious landscape, created by a strange 'Giant-brood' (fig.5). The 'Three Forms' who stand beneath the structure are 'Bacon & Newton & Locke',[34] for the legendary history and religion of the Ancient Britons live on in the materialist thinkers whom Blake saw as dominating the intellectual life of his own time; for him this history of Britain was more 'real' than the dry scholarship of the antiquarians.

Blake and Barry were drawn together not only by mythology but by a vision of the present corruption of Britain and the suppression of liberty that had now migrated to newly independent America. In Barry's etching *The Phoenix or the Resurrection of Freedom* of 1776, a group of modern advocates of liberty – Algernon Sidney, John Milton, Andrew Marvell, John Locke and Barry himself – lament over the tomb of Britannia as they look across the Atlantic to America, where peace, prosperity and the arts live in harmony without kings or priests.[35] In Blake's *Visions of the Daughters of Albion*, written in 1793 at the height of the French Revolution, Oothoon, the heroine who is trapped in a loveless marriage (a consequence of a priest-ridden society), runs in her thoughts across the ocean to America, Britain's redemptive 'other'.[36]

This notion of myth as a kind of national unconscious was a clear rejection of the dominant rationalist account of British history, and it opened the way for the revival of the Arthurian legends in Victorian poetry and painting, based on the rediscovery of the Elizabethan Thomas Malory's *Le Morte d'Arthur* and the poems based on it by Alfred Tennyson.[37] The discovery of a copy of Malory by William Morris (1834–96) and Edward Burne-Jones (1833–98) had a dramatic impact on what was to become the 'second wave' of the Pre-Raphaelite movement; as Burne-Jones wrote to Morris: 'Learn Sir Galahad by heart. He is to be the patron of our Order.'[38]

The Pre-Raphaelite revival of the Arthurian legends had more to do with male fellowship, sexuality and imagination than with the nature of Britain, but the legends of Arthur were already established as 'official' models of human conduct and sometimes of racial purity. The idea of chivalry appealed to landowners disturbed at the rise of the manufacturing interest. Arthur was to return to life in the ideal of the English gentleman, chaste, honorable and sexually pure, a representative of the English 'race' uncorrupted by foreign pollution, or the vulgarity of factory owners or labourers. In Tennyson's *Morte d'Arthur* (1842), the source of innumerable paintings, the narrator dreams that Arthur returns from death on a barge from 'the island-valley of Avilion', or Avalon, to live again in the present (lines 294–8):

> There came a bark that, blowing forward, bore
> King Arthur, like a modern gentleman
> Of stateliest port; and all the people cried,
> 'Arthur is come again: he cannot die'

The founding project of the 'national' Arthurian revival was the official commission for the Royal Robing Room of the Houses of Parliament, in which the monarch 'travels from the realm of history into that of mythology' as the incarnation of sovereign rule. It was Prince Albert's idea under the influence of Tennyson that it should be painted with Arthurian legends, with the overt intention of defining an ideal British character. As with the Elizabethan revival of the legend, Arthur was once again the model for the monarch (also female) of a great empire. The commission was given to William Dyce, a Scottish follower of the group of devout and idealistic German painters called the Nazarenes, who organized the wall paintings around the chivalric Companions of Arthur's Round Table. They were to personify the moral and courtly qualities of Religion, Generosity, Courtesy, Mercy and Hospitality; Courage and Fidelity were part of the original plan but were not executed.

The emphasis on virtue and moral goodness rather than dynasty, religion in the narrow sense, territorial expansion, or military or political achievements, separates the Victorian Arthurian Revival from earlier ages. King Arthur is not so much an ancestor of British monarchs as an ideal to live up to. The fact that Arthur's existence was uncertain made

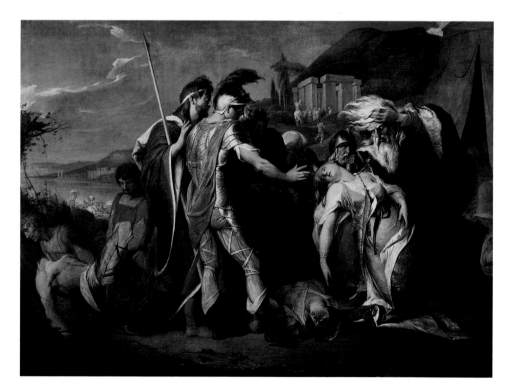

4 JAMES BARRY
King Lear Weeping over the Dead Body of Cordelia 1786–8
Oil on canvas 269.2 × 367 (106 × 144½)
Tate. Purchased 1962

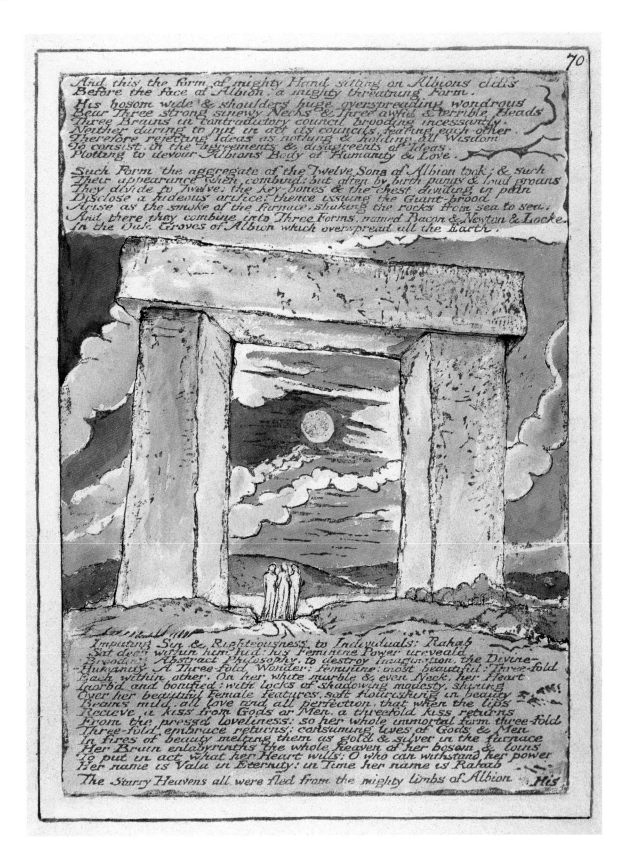

him immune from the corrosive effect of rational history; he could represent a lost Golden Age when Britain was a kingdom of virtue, united, chivalrous and triumphantly in possession of an empire. And yet he also represented, particularly for the later nineteenth century, an *English* ideal of natural, aristocratic and racial solidarity (see Calloway, pp.52–3).[39]

Resistance and Compliance: Myths of England, Ireland, Scotland and Wales

Each of the countries of Britain – England, Ireland, Scotland and Wales – claimed their own mythical histories, but these were intertwined with each other and with the history of Britain. The 'Ancient Britons' as putative ancestors of the Welsh could support a Welsh claim to a 'Celtic' ancestry quite different from the 'Saxon' roots of the English, or an English claim to be both Saxon and Celtic.[40] Ossian, the 'author' of the myth of ancient Scotland, was thought to have been an Irish bard, but the Irish-Scottish connections, so important before the eighteenth century, rarely impacted upon the world of painting. There are, however, two striking full-length portraits by John Michael Wright (1617–94), one of which shows the Irish chieftain, Sir Neil O'Neill of Killeleagh (1680, fig.6), a fervent Catholic and Irish patriot.[41] His costume is a traditional one, though highly elaborated, and is clearly intended to assert his independence from English customs, as perhaps does his possession of an Irish wolfhound. The presence of a piece of Japanese armour in the foreground is unexplained. The other portrait is of a Highland laird, *Sir Mungo Murray* of c.1683 (Scottish National Portrait Gallery, Edinburgh), and shows him wearing an equally distinctive Scottish garment, a tartan plaid belted round his waist to form a kilt, an aristocratic form of the plaid worn by even the poorest Highlanders. He represents a distinctly un-English ideal of the gallant laird that was never completely surrendered by landowning Scots despite its associations with Jacobitism.[42]

The two paintings by Wright hint at a resistance to an English or British idea of the gentleman, but there was also a radical English history that invoked a 'Saxon' liberty imperfectly repressed over the centuries by the usurping Normans of 1066, and their royal and landowning descendants.[43] To call up the rights of 'the Free-Born Englishman',

as Tom Paine and Thomas Jefferson did in resisting the taxation of the American Colonies, was to reduce the idea of Britain to a courtly fabrication built on ancient wrongs. The idea of an immemorial English liberty, rooted in the old German forests where sturdy warriors had annihilated Roman legions, had an influential following in the seventeenth century, and an appeal to radicals and to opposition Whigs in the following century.[44] The Saxon King Alfred (King of Wessex 871–99) became the model of a king who was both defender of his people and upholder of parliamentary government.

Many landowners had busts of Alfred by John Michael Rysbrack and others, but the most substantial 'Saxon' sculptural scheme of the eighteenth century is the same sculptor's circular group of seven full-size statues of Saxon gods, formerly at Stowe and now dispersed, which were commissioned by Sir Richard Temple, Viscount Cobham, a dedicated Whig disaffected with the Prime Minister Robert Walpole.[45] The iconography of the seven statues, representing the days of the week, is based on Richard Verstegan's *Restitution of Decayed Intelligence*, first published in 1605 and dedicated to James I of England as 'the chiefest Blood-Royal of our ancient English-Saxon Kings'. It claims that the German nation is 'the Tree from which English men, as a most stately and flourishing branch, are issued and sprung forth'.[46] Hugh MacDougall has argued that Verstegan's book 'represents the first comprehensive presentation in English of a theory of national origin based on a belief in the racial superiority of the Germanic people',[47] but at Stowe the Saxon gods represent a Whig appropriation in the name of Britannia of an ancient English liberty suppressed by the present tyranny of politicians. According to Gilbert West in 1731, they were

Gods of a Nation, valiant, wise and free,
Who conquer'd to establish Liberty!
To whose auspicious Care Britannia owes
Those Laws, on which she stands, by which she rose.[48]

The association of England with liberty was also expressed in the construction by Lord Bolingbroke and his 'Patriot' supporters of a prelapsarian England that preceded the devastating disruption of the Civil War. This England can be observed most clearly in the large panel paintings by Francis Hayman (1708–76) for the private boxes of the pleasure gardens at Vauxhall, like *The Milkmaid's Garland, or Humours of May Day* 1741–2 (Victoria and Albert Museum,

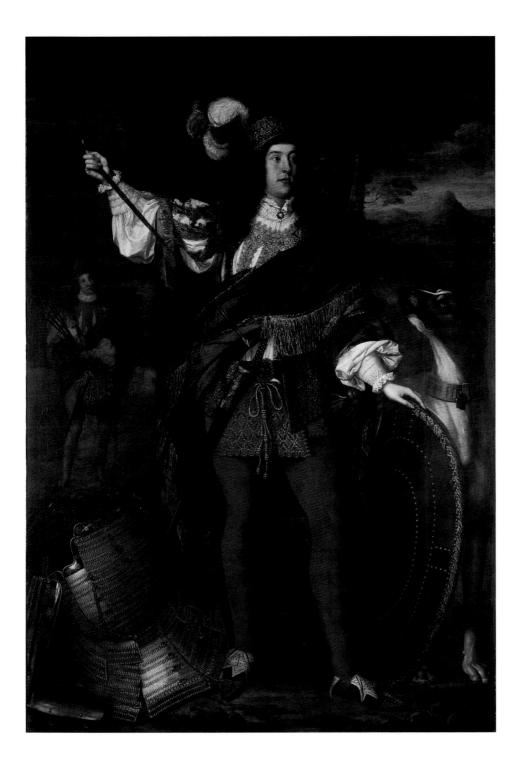

6 JOHN MICHAEL WRIGHT
Sir Neil O'Neill 1680
Oil on canvas
232.7 × 163.2 (91⅝ × 64¼)
Tate. Purchased with assistance
from The Art Fund 1957

London) or *See-Saw* c.1742 (fig.109), in which ancient and seasonal English pastimes are depicted.[49] One painting, however, *The King and the Miller of Mansfield* (known only in an engraving) tells of a medieval king of England, Henry II (1154–89), whose generous treatment by a miller who does not recognize him alerts him to the virtue of his subjects and the corruption of his courtiers, a clear reference to contemporary politics.[50]

In the great portrait by William Hogarth (1697–1764) of *Miss Mary Edwards* of 1742 (Frick Collection, New York), the sitter's Englishness is expressed both in the busts of Alfred and Elizabeth I in the background and in her identification with the latter, a manuscript of whose Armada speech (in a version by Joseph Addison) she holds, bearing the words: 'Remember Englishmen the Laws the Rights The generous plan of power deliver'd down from age to age by your renown'd Forefathers.'[51]

In the second half of the eighteenth century artists and poets began to return to national myths precisely because they represented an imaginative truth about each nation that transcended history. This revival originated in Rome in the 1760s and 1770s among an international group of

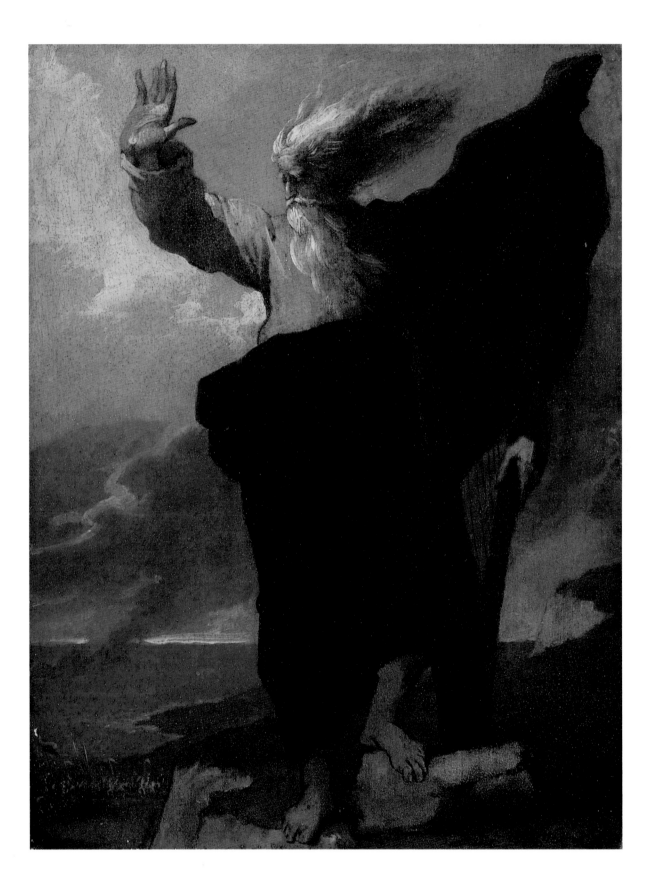

painters, who hoped on their return to their countries to reconstruct myths of national heroism in public schemes.[52] Only one British painter was to approach the dream. The Scottish painter Alexander Runciman (1736–85) was commissioned in 1768 by Sir James Clerk to paint on a ceiling in the latter's house in Penycuik, near Edinburgh, scenes from the mythical history of Scotland enshrined in the Ossian legends that were based on the Homeric fantasies of their 'translator' James Macpherson.[53] The ceiling, completed by 1772, was destroyed in a fire in 1899, but impressions of it can be pieced together from old photographs, drawings, etchings and descriptions. In the ceiling of 'Ossian's Hall' Runciman visualized a bardic Scotland of ancient heroes and tragic passions and conflicts, largely through forms learned from the Italian Renaissance and classical art. The central oval, of *Ossian Singing,* known from an oil sketch (National Gallery of Scotland, Edinburgh) and a photograph, could be a representation of Homer were it not for the background with clouds forming ghostly shapes of the dead heroes evoked by the bard, as if the landscape were irrevocably haunted by the country's legendary past.

There were no real Scottish successors to the Penycuik ceiling, and myths of Celtic Ireland do not appear in Irish painting before the next century. In the eighteenth century the ancient Irish past was essentially limited in subject matter to St Patrick, who, as a pre-Reformation saint, was distant enough in time to be common property for both Catholic and Anglican churches. He could be absorbed into the 'official' imagery of British ascendancy, as in the Italian Vincent Waldré's ceiling in Dublin Castle, where a scene of Patrick's benevolent triumph over the pagan Druids is partnered by a scene of *King Henry Meeting the Irish Leaders,* both flanking the central painting of *George III, Supported by Liberty and Justice.*[54] As early as 1763 James Barry had exhibited in Dublin a painting of *The Baptism of the King of Cashel by St Patrick* (Terenure College, Dublin), and he later sketched out another version (National Gallery of Ireland, Dublin) probably in connection with the Act of Union of 1801.[55] Barry's take on St Patrick was rather different as an Irish Catholic and supporter of the cause of Ireland. In his later sketch the saint is accompanied by a monk carrying a crucifix, which emphasized his priestly role in baptising the Irish king.

The ancient myth of Wales was based on the descent of the Welsh from the Ancient Britons who retreated with Caractacus to Anglesey after their defeat by the Roman Emperor Claudius. As Sam Smiles has noted, eighteenth-century representations of Caractacus usually show the British hero in captivity before Claudius, demonstrating nobility in defeat and a 'primitive' bearing that astonishes his sophisticated Roman captors.[56] This, of course, emphasizes his generic Britishness, and in a relief sculpture of 1777 (Stowe School, Buckinghamshire) made in Rome by Thomas Banks (1735–1805), Caractacus is a Celtic chieftain with a moustache and an animal-skin cloth that scarcely covers his body. English writers like William Mason and Thomas Gray were drawn to the Ancient Britons and their Welsh descendants, as exemplars of a primitive nobility alien to over-sophisticated Romans and modern Britons.

Despite the fact that most of its inhabitants still spoke Welsh in the eighteenth century, Wales had been politically part of England since the early sixteenth century. Medieval Wales was defined in Thomas Gray's *The Bard* (1757) as still holding on to a 'Celtic' tradition of bardic power and resistance to the Romans. Gray picked up the story of Edward I, who, after conquering Wales in the late thirteenth century, determined to kill all the bards, for fear of their power to inspire the defeated people of Wales.[57] The eponymous bard is the last to survive and hurls defiance at the advancing troops from a rock overlooking 'old Conway's foaming flood', cursing the king while striking 'the deep sorrows of his lyre'. It is an assertion of the power of poetry in the face of armies and its diminished role in materialistic societies like England.

The Welsh painter Thomas Jones (1742–1803) made a notable painting of *The Bard* (National Gallery of Wales) as early as 1774, which emphasizes the 'Ancient British' tradition by setting it in a wild landscape with a Stonehenge-like configuration of Druidic stones in the background. By the end of the century the subject became part of the standard repertoire of Royal Academy painters whatever their origins, the American Benjamin West's *The Bard* 1778 (fig.7) being one example. For the radical William Blake, in his painting of *The Bard* of 1809 (Tate, London) it was an example of the prophet's necessary defiance of worldly authority.[58] John Martin (1789–1854) revelled in the sublimity of the lonely figure high on the mountain top, creating a painting (c.1817) that is more a landscape than a history painting; the emotions called up by the tragic bard are expressed strongly in the confrontation between impregnable

castle and jagged mountaintop. In such paintings, as in some of Runciman's Ossian scenes, British mythology migrates from history and figure painting into landscapes inhabited by eloquent traces of ancient buildings and ghosts of the long dead.

An allegorical view of national differences within Britain lived on, however, in the form of visual satire, which reached its height of popularity and influence in the late eighteenth century. England was represented by the ambiguous figure of John Bull, who was also the common people of England, in need of the guidance of his social superiors. In pro-government prints by James Gillray (1756–1815) of the 1790s he is a man contented, provided he has enough roast beef, porter and plumb pudding, though without them he can become ungrateful. In *The French Invasion – or – John Bull, Bombarding the Bum-Boats* of November 1793 he is transformed into a map of England that explicitly excludes Scotland, shitting from a point on the Sussex coast to scatter the French invading fleet (fig.8).[59] In a curious echo of the Ditchley portrait (see pp.21,22) he is also George III (1760–1820), uniting king, people and country not as imperial Britain but as embattled England.

In Richard Newton's *The Progress of a Scotsman* 1794 the primitive poverty-stricken Scottish Highlander wearing only a plaid, who succeeds by cunning, servility and opportunism in achieving a peerage, stands for all Scotsmen, including the highly educated and those powerful in London and the colonies.[60] In caricature the Scots are defined by poverty and the Irish by Catholicism, though, of course, the Irish ascendancy was Protestant in the eighteenth century. In *The Progress of an Irishman* 1794, also by Newton, Catholicism is somehow responsible for the Irishman's drunken temperament and impulsiveness, which lead to his unnecessary death in a duel.[61] A darker note appears, however, in the characterization of the Irish in response to the unrest in Ireland in 1798. In Gillray's *United Irishmen on Duty* 1798 Irish 'sans-culottes' loot and terrorize a John Bull-like farmer and his family. Gillray's Irish rebels exhibit a total lack of all human and moral feelings which allows them to massacre all those who stand in the way of their rapacity.[62]

'Wide glows her land': Britannia's Prosperity

If the idea of Great Britain that arose in the eighteenth century was to succeed in unifying the diverse and warlike nations that constituted it, it had to develop narratives not of an English but a British nation. The role of art in the creation of a mercantile ideology in eighteenth-century Britain is dealt with in David Solkin's *Painting for Money* (1992), but I want to indicate some ways in which an ideology of the new Britain affected landscape painting. In the Scottish poet James Thomson's highly influential *The Seasons* of 1730 the fecund countryside of Britain (not only England) is presented as the foundation of prosperity, sea power and empire:

> A simple scene! Yet hence Britannia sees
> Her solid grandeur rise: hence she commands
> Th'exalted stores of every brighter clime,
> The treasures of the Sun without his rage:
> Hence, fervent all, with culture, toil, and arts,
> Wide glows her land: her dreadful thunder hence
> Rides o'er the waves sublime, and now, even now,
> Impending hangs o'er Gallia's humbled coast;
> Hence rules the circling deep, and awes the world.[63]

This passage moves from the simple contemplation of an everyday scene of agricultural labour to Britain's prosperity in country and town, then to her naval power and finally to her ability to humble the French enemy. Nature is cultivated efficiently to feed and give contentment to those who own and those who labour on the land, but this cultivation also creates enough surplus through trade and commerce to bring prosperity and civility to the nation as a whole. We are exhorted to see the humble ploughman and sheepshearer as key operatives in a wholly benevolent, divinely sanctioned national system, which ensures not only the contentment of the countryside but wealth sufficient to support the country's protection and expansion, the manufacture of goods and the promotion of the liberal arts. The ploughman's 'well-used plough [that] lies in the regular furrow' is part of an orderly Anglican and Newtonian universe in which God's 'all-perfect hand! / . . . impels, and rules the steady whole'. The universe is a benign mechanism directed by an unseen God who provides for the physical and moral sustenance of humanity through the cultivation of nature. Nature, of

8 JAMES GILLRAY
The French Invasion – or – John Bull,
Bombarding the Bum-Boats 1793
Published by Hannah Humphrey, Nov. 1793
Hand-coloured etching
24.8 × 25 (9¾ × 9⅞) plate
36.5 × 26.1 (14⅜ × 10¼) paper
National Portrait Gallery, London

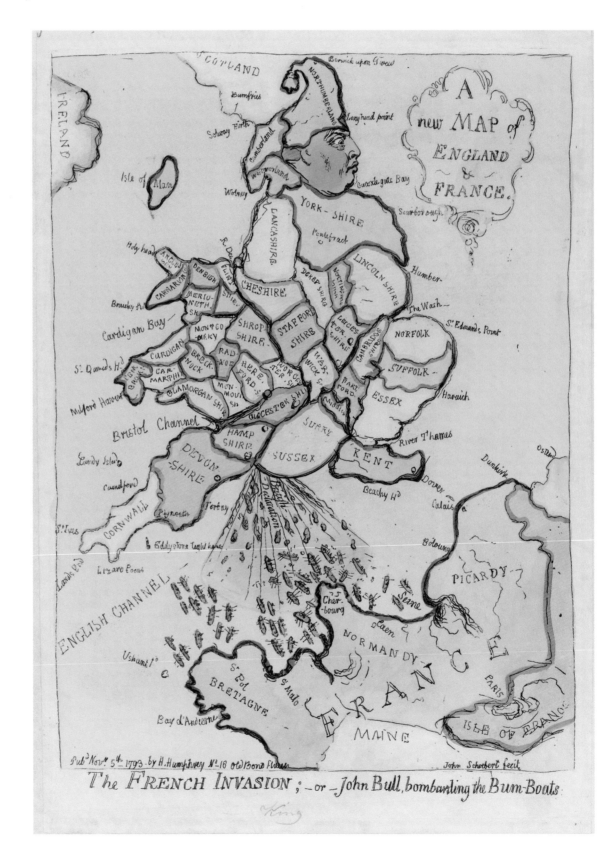

course, requires hard labour to make it productive, but it also offers in return to those who work it well-earned rest, a decent cottage and enough food and drink. It also makes possible elegant houses for landowners, and ceaseless communication between countryside, cities, ports and the world beyond.

This harmonious view of the countryside bears little relationship to the real countryside where hardship and exploitation were rife, but it pervades paintings by Thomas Gainsborough (1727–88), innumerable popular prints of the century, and such works as *Reapers* 1785 by George Stubbs (1724–1806), where well-dressed harvesters work in the benevolent presence of the overseer or landowner, while a church steeple in the distant hints at the divine compact between God, man, his social superiors and inferiors, and nature (fig.9). Stubbs's painting, elegantly painted though

it is, uses a vocabulary that had become commonplace by the 1780s.

A less overt but nonetheless Thomsonian vision also pervades the early paintings of John Constable (1776–1837), like *Stour Valley and Dedham Church* of 1814–15 (fig.10), which depicts the cyclical rhythm of cultivated nature. The landscape is the very model of a prosperous and contented countryside, with the winding river Stour leading to the church-dominated village of Dedham. But the clump of earth that the labourers are working on is a large dunghill left to mature over several months in order to manure the fields. The recycling of cows' waste makes the crops grow and thus feeds the cows again, but this process nationwide, as we have seen, not only feeds the population but also underwrites the civility represented by the cities, towns, fine villages, country houses and churches that fill the

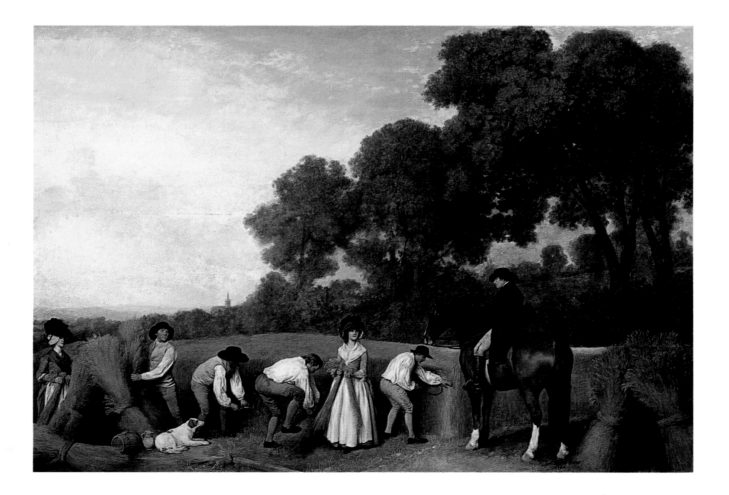

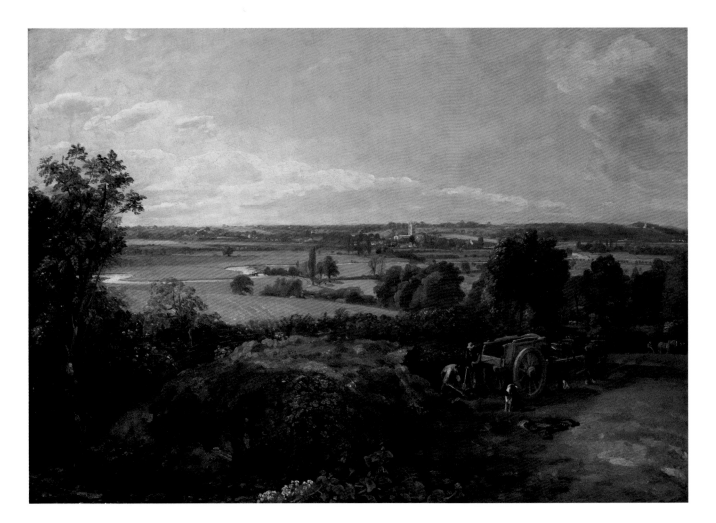

landscape at short intervals. Thomson's vision brings city and country into an organic relationship; but it also encompasses an idea of an empire rooted in the soil of Britain, for the same rural surplus allows the building of a navy, which both defends trade and returns a further surplus. Thomson's vision thus celebrates the life of the countryside but is entirely in harmony with a mercantile ideal.

There was, however, a problem for painters in the idea of a 'British landscape', for not all of nature, particularly in mountainous areas, was productive, nor did it take account of the variety of types of landscape. The late eighteenth-century idea of the picturesque responded to a greater sense of particular places represented in landscape paintings not only of Scotland and Wales but of the different regions of England. Thomas Girtin (1775–1802) was one of the first to use watercolour to represent the different qualities of

light and topography in Yorkshire and the northern counties, while his contemporary J.M.W. Turner (1775–1851) revealed a larger sense of Britishness in his constant return to the theme of empire, and his sensitivity to the mythical history of Britain, particularly of Scotland and Wales.

Turner's large-scale paintings of Carthage, Rome and Venice are based on his reading of eighteenth-century poetic epics that reflect with melancholy on the inevitable decline of even the mightiest empires, as of all earthly things.[64] To paint Carthage in its fall, Rome in its grandeur, and Venice in its faded splendour was to invite the thought that Britain's wealth and power also would not last forever. Turner's reflections on national identity guided his choice of rivers, castles, ports, towns, battlefields and seas from one end of the island to the other. He was always aware, as were many of the poets to whom he alluded, of physical

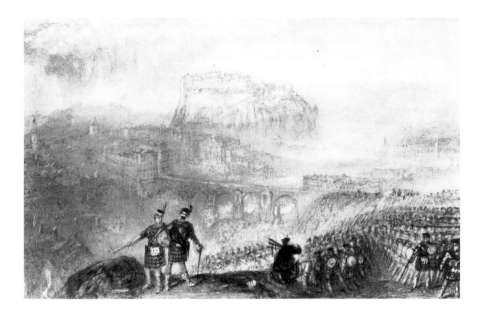

11 J.M.W. TURNER
*Edinburgh Castle, The March of
the Highlanders* c.1835–6
Watercolour on paper
8.6 × 14 (3⅜ × 5½)
Tate. Bequeathed by
R.H. Williamson 1938

change over time. Every building if it is not already ruined is a potential ruin, just as every ship is susceptible not only to decay but to obsolescence. Similarly, Britain itself must undergo the cycles of rise, decay and near oblivion that all other great powers have experienced.

In Turner's many views of specific places in oil and watercolour Britain appears as one country, but of a rich variety and complexity. Modernity is everywhere, but so is history and legend. In the watercolour of *Dudley* (Lady Lever Art Gallery, Port Sunlight) the medieval castle of the Dudleys and a forest of church spires preside over the infernal furnaces and barges at the bottom of the hill. His largest painting, *England: Richmond Hill, on the Prince Regent's Birthday*, exhibited in 1819 (Tate, London), is as its title suggests a meditation on England.[65] The birthday commemorated was probably 23 April, St George's day, and also Shakespeare's and Turner's birthday. The view of 'the matchless vale of Thames' is English, but its associations with the Prince Regent, and the extract from Thomson's *Seasons* that accompanied the painting on the wall of the Academy, make it also a depiction of Britain.

Turner's sensitivity to the traces in the landscape of myth and legend suggests that he, like Walter Scott, relished the ancient identities of Scotland and of Wales, but within a framework of loyalty to the British Crown. He visited Scotland six times in search of picturesque views, and he illustrated two series of volumes in collaboration with Walter Scott himself. He even attended the famous ceremonies around George IV's visit to Edinburgh in August 1822, orchestrated by Scott. Perhaps the most striking record of the visit is the tiny retrospective watercolour of one of the key ceremonies of the whole occasion, *Edinburgh Castle, The March of the Highlanders* c.1835–6 (fig.11), which shows an immense parade of kilted figures climbing Calton Hill to lay the foundation stone of the National Monument, with the Castle rock shimmering in the background. His interest in mythical Scotland appears in the most affecting of all Ossianic paintings, *Staffa, Fingal's Cave* 1832 (Yale Center for British Art, Paul Mellon Collection, New Haven), in which Scotland's ancient heroic past is intimated by the mysterious light around the isolated Hebridean rock of Staffa.[66] This island with its sonorous cave named after the warrior Fingal is set against the modern world embodied in a steamship trailing smoke.

Turner was equally sensitive to the Welsh past. Though he did not actually paint a version of *The Bard*, in the accompanying text to the large watercolour of *Caernarvon Castle* (Tate, London), exhibited at the Royal Academy in 1798, he refers to 'The Bard [from whom] the song of Pity pours'. His diploma work for the Royal Academy, exhibited in 1800, *Dolbadern Castle, North Wales* (Royal Academy, London),[67] was accompanied by a poem of his own invention that locates the painting in the aftermath of the destruction of the Welsh bards and rings from it a similar pathos:

12 RICHARD WILSON
Dinas Bran from Llangollen 1771
Oil on canvas
180.3 × 244.8 (71 × 96⅜)
Yale Center for British Art,
New Haven
Paul Mellon Collection

How awful is the silence of the waste,
Where nature lifts her mountains to the sky.
Majestic solitude, behold the tower
Where hopeless Owen, long imprison'd pin'd,
And wrung his hands for liberty, in vain.

Turner was of course a London artist, looking at Scotland and Wales from the centre of empire. Was there in the period a distinctively Scottish or Welsh way of looking at native landscape? We might expect the latter from Richard Wilson (?1713–82) who was Welsh born and frequently painted scenes of Wales in his later life. The large paired paintings, a *View near Wynnstay, the Seat of Sir Watkin Williams-Wynn, Bt* (Yale Center for British Art, New Haven)

and *Dinas Bran from Llangollen* (fig.12) of 1771, were painted for a patron who, as David Solkin has noted, was proud of his descent from the ancient British kings and owned an immense amount of Welsh land, inherited in 1770.[68] Both paintings have Castell Dinas Bran in the background, a building belonging to the Myddleton family that was supposed to have predated the English conquest of Wales and be associated with Celtic deities. Williams-Wynn had another existence as a fashionable London gentleman who had been on the Grand Tour and patronized Joshua Reynolds (1723–92), living in an opulent house in St James's Square designed by Robert Adam. Welsh legends of defiance and lost liberty could thus be appropriated to the life of a cosmopolitan gentleman. The landscape of Wales, legendary

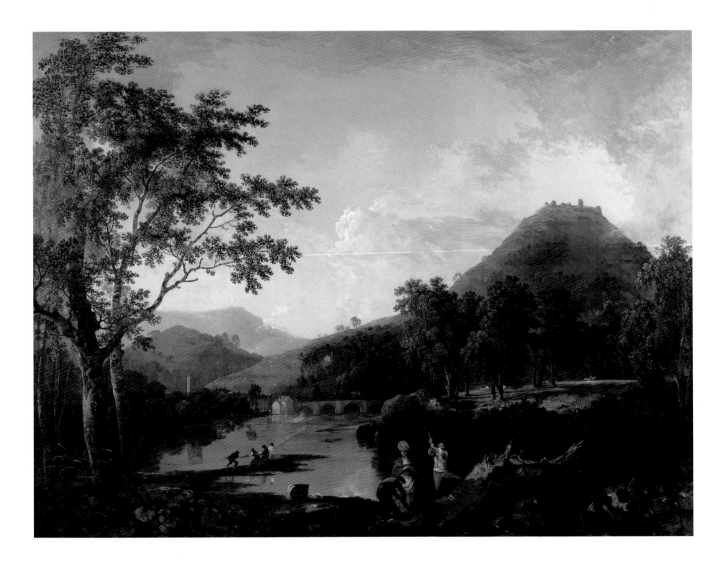

home of the Ancient Britons, had an appeal to Wilson's Welsh patrons that was compatible with a nostalgia for the ancient Rome that lived on in literature and evocative ruins.

By the early nineteenth century another Wales had emerged as the home of heavy industry and iron founding in particular. The small ironworks of Wales had since the mid-eighteenth century drawn the attention of picturesque travellers and artists like Paul Sandby (1730–1809) and Julius Caesar Ibbotson (1759–1817), but by the 1820s the huge ironworks in South Wales like Cyfarthfa attracted painters impressed by their scale and sublimity. In Penry Williams's *Cyfarthfa Ironworks* 1825 (National Gallery of Wales, Cardiff)[69] the sheer scale of the factory and the tiny figures evoke John Martin's contemporary paintings of Pandemonium.

The Scotsman Jacob More (c.1740–93) studied in Italy and made a number of classicizing landscapes of the Clyde. But the landscape of Scotland was not so easily appropriated because of its associations with Scotland's independence, an issue lurking below the surface since the defeat of the Jacobites. If Walter Scott was to redefine Scotland as 'North Britain', he needed to push aside a live poetic tradition represented by Robert Burns that saw Scottish landscape in

terms of those, like William Wallace, who had shed their blood resisting English domination. This did not, however, lead to a Scottish school of radical patriotic landscape; though Alexander Nasmyth (1758–1840) was a close friend of Burns, there is no sign of radicalism in his landscape paintings, for such a thing would have been unacceptable to his Edinburgh patrons. It was village life and the ancient customs of ordinary people that became the focus of nostalgia, with musicians like Niel Gow (1787, Scottish National Portrait Gallery, Edinburgh) becoming celebrities worthy to be painted by Henry Raeburn (1756–1823).[70] The paintings of Scottish common life by David Wilkie (1785–1841) were from the beginning as much a London as a Scottish taste among wealthy collectors of Old Masters and among the urban crowd who knew him from Royal Academy exhibitions.

There are paintings of the peasant life of Ireland before the end of the eighteenth century by the English painter Francis Wheatley (1747–1821) that attempt to make something picturesque out of extreme poverty, as in his watercolour *Buying Ale at Donnybrook Fair* 1782 (National Gallery of Ireland, Dublin). Most Irish landscape painting, however, celebrates the order and prosperity created by the Protestant

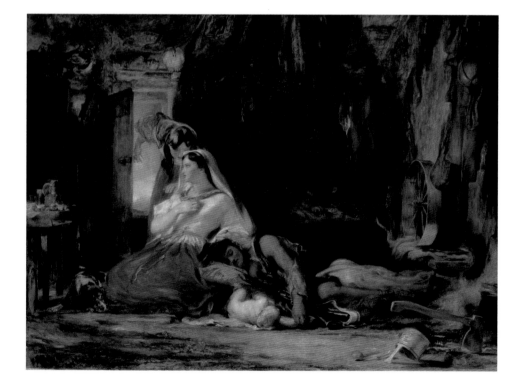

13 DAVID WILKIE
*The Peep-o'-Day Boys' Cabin,
in the West of Ireland* 1835–6
Oil on canvas 125.7 × 175.3 (49½ × 69)
Tate. Presented by Robert Vernon 1847

ascendancy. *View of Dublin from Chapelizod* 1797 (National Gallery of Ireland, Dublin) by William Ashford (1746–1824) shows an elegant town and fertile countryside, but the presence of a dominant fort and cavalry troop on the hill is a reminder of the colonial reality of Irish life.[71] Interest in the Irish picturesque was revived by Wilkie, who wondered why it had 'not been long before the object of research among painters'. Cullen argues that in Irish scenes like *The Peep-o'-Day Boys' Cabin, in the West of Ireland* 1835–6 (fig.13) Wilkie reinforces stereotypes of the Catholic Irish as picturesque criminals living in extreme poverty and a state of guerrilla warfare.[72]

The first artist to define a distinctively Irish historical language was the pioneering historian of early Ireland George Petrie, who wished 'to produce an Irish picture somewhat historical in its object, and poetical in its senti-ment'.[73] In *The Last Circuit of Pilgrims at Clonmacnoise* 1838 after a design of 1828 (National Gallery of Ireland, Dublin), he emphasizes a continuity between present worship and an ancient Christian Ireland; a distinctively Irish round tower (on which Petrie was the acknowledged expert) is silhouetted against the setting sun.

If in the eighteenth century the idea of Englishness could be a call to resist the government of Great Britain, by the 1830s its populist associations had been virtually eliminated. An idea of a distinctively English character was mobilized in the Napoleonic period, as Vaughan and Kriz have argued, to bolster an English school of landscape painting,[74] but there is also a conservative vision of English-ness embedded in the later paintings of John Constable. In the 1820s, in the face of the radical threat to undermine the traditional inequalities of the countryside, he moved away from a Thomsonian view of Britain towards an expressly English vision. Increasingly, English landscape became imbued for him with a sacramental quality, rooted in an idea of continuity from medieval times to the present day.

In *The Excursion* of 1814 William Wordsworth, repudiating his own early radicalism, delineates a uniquely English countryside defined by history, inheritance and religion, in which the Anglican church, in defiance of the modern world, exerts a benign and unifying effect on the English people and landscape. The essence of the English landscape lay not in Thomsonian providence and productivity, but in a mystical connection between nature and man:

Hail to the state of England and conjoin
With this a salutation as devout
Made to the spiritual fabric of her church,
Founded in truth; by blood of martyrdom
Cemented; by the hands of wisdom reared
In beauty of holiness, with ordered pomp.[75]

The impact of Wordsworth's vision can be seen in many of Constable's paintings of the late 1820s and early 1830s, but it appears most explicitly in the mezzotint series *Various Subjects of Landscape Characteristic of English Scenery* 1831, intended 'to promote the study, and increase the love, of the delightful Home Scenery of England, with all its endearments, its amenities and even in its most simple localities'.[76] Though Constable emphasized the distinctive effects of the English climate, he also made much of the visual harmony and image of contentment offered by the prosperous villages of Suffolk, under threat he believed from the impending Reform Act. In Constable's late paintings and mezzotints ideas of nationalism are embedded within images that claim to be truthful impres-sions of real places. The realist mode allows paintings to provide intimations and sensations that are not reducible to a series of clear symbols, but nonetheless convey in Constable's case a nostalgic and conservative idea of England that has proved remarkably enduring.

Diversity under the Crown: The Taming of the Nations

William IV's visit to the gathering of the clans in Edinburgh in 1822 completed the long process of absorbing the once feared Highlanders into a safely picturesque vision of Scotland.[77] From then on Scottish painting emphasized Scotland's cultural and historical uniqueness but almost always within the context of loyalty to the British Crown. This was the product of a remarkable transformation over a period of less than a hundred years. From early in the eighteenth century Dublin brewers, Highland chiefs and English aristocrats were educated in similar ways by private tutors and on the Grand Tour, and though they shared a certain class solidarity, they were conscious of being from different countries. In Reynolds's caricature group of 1751 painted in Rome (National Gallery of Ireland,

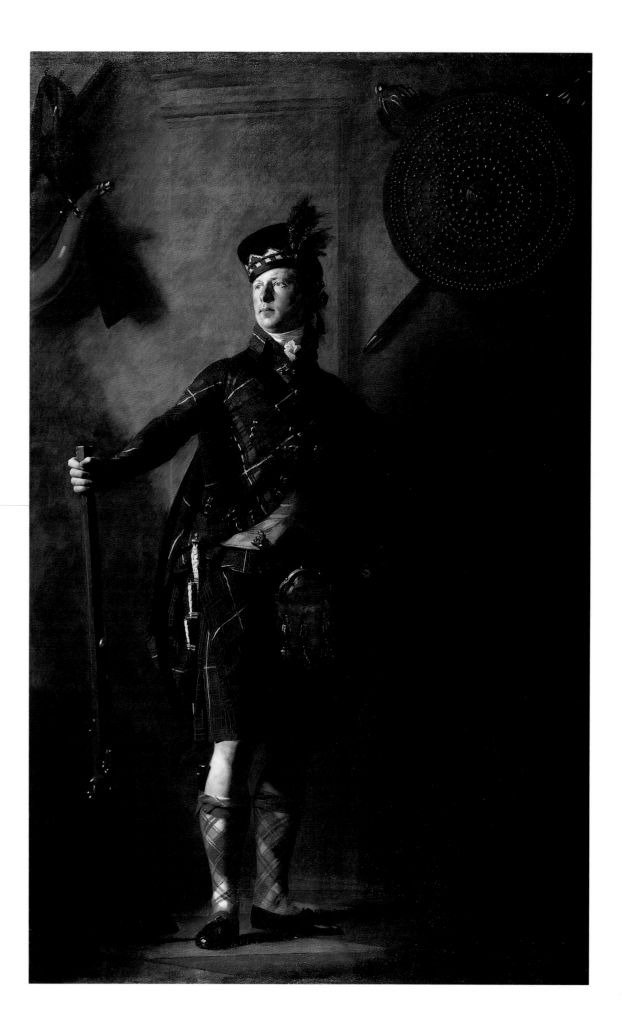

Dublin), four gentlemen wear national emblems in their hats: the Scotsman Sir Thomas Kennedy, a St Andrew's cross; the Irishman Lord Charlemont, a green shamrock; the Englishman John Ward, a St George's cross; and the Welshman Richard Phelps, a leek.[78] But many Scots, particularly those who settled in Rome in the first half of the century, were Jacobite sympathizers. From even before the Jacobites' final defeat in 1745 the Highland Scots were perceived as both a threat and a resource. They were brutally suppressed and their tartan garments were banned until 1782, but this prohibition did not apply to gentlemen like Colonel William Gordon, seen in Batoni's famous painting of 1766 (Fyvie Castle, Aberdeenshire) striding in kilt and plaid through the ruins of Ancient Rome.[79] Even before the 1745 Rebellion Highlanders had been recruited into the British army and they were given a special 'government' tartan to wear, normally in green, blue and black. The formation of Scottish regiments was increased with the outbreak of the Seven Years War in 1759, and gradually, with Scottish commanders from the gentry, they were thoroughly absorbed into the British army while retaining a distinctive and complementary identity as fierce warriors.

Battle paintings in the later eighteenth and nineteenth centuries often show victory to have been the result of a natural alliance between English and Scots, and occasionally other non-English troops. In the American painter John Trumbull's heroic *The Sortie Made by the Garrison of Gibraltar* 1789 (Metropolitan Museum, New York) the garrison commander George Eliott, later Lord Heathfield, chivalrously offers help to a dying Spaniard, and he is joined in his act of mercy by a Scottish soldier in full Highland uniform with government kilt and sporran.[80] In the dramatic 1780 portrait of Major Hugh Montgomerie by the American-born painter John Singleton Copley (Los Angeles County Museum), the subject, in a government kilt, strides like an ancient warrior as his tartan-wearing troops engage in hand-to-hand combat with Native Americans.[81]

Real commanders like Montgomerie should be distinguished from Henry Raeburn's Highland gentlemen portrayed at the height of the craze for Scottishness created by Walter Scott's novels. Colonel Alastair Macdonell of Glengarry, the subject of Raeburn's most spectacular portrait (fig.14), was described tactfully by Scott as 'a kind of Quixote in our age'.[82] He was deeply

unpopular for his much resented role in Scott's 'Plaided Panorama' put on for George IV's visit to Edinburgh in 1822. In Raeburn's portrait he is depicted as a figure of romance, but despite the ancestral setting and the tartan-covered body, he exhibited in real life no real sense of national self-determination, ancient fighting spirit or military prowess.

The Scottishness of such portraits lies in the attributes of tartan and sporran, but is there a distinctively Scottish *manner* of portraiture in the period? Here we need to look not to the Highlands but to the genteel culture of Enlightenment Edinburgh, where the dominant intellectual figure was the fiercely anti-metaphysical philosopher David Hume. The portrait painter Allan Ramsay (1713–84) was a close friend of Hume and an intellectual in his own right. Duncan Macmillan has argued that a connection between the 'naturalism' of each is irresistible, not in terms of technique but in a sense of the relationship between perception and knowledge, and the active presence in the finished portraits of artist, sitter and observer.[83] This can perhaps be seen in the 1754 portrait of Mary Adam, mother

16 JOHN SINGLETON COPLEY
Nicholas Boylston 1767
Oil on canvas 125 × 99.5 (49¼ × 39⅛)
Harvard University Art Museums
Fogg Art Museum
Harvard University Portrait Collection
Bequest of Ward Nicholas Boylston
to Harvard College, 1828

of the architect Robert Adam (fig.15). It is a forthright representation seemingly without artifice even to a large boil below the lip. The sitter is caught as if addressing the painter or viewer, and the figure refuses ingratiation; it is both spontaneous and richly contrived at the same time. Macmillan also argues for a similar relationship between Raeburn and the philosopher Thomas Reid whose idea of 'common sense' was a way of emphasizing an intuitive rather than analytical response to reality, to resolve the problem that objects change all the time according to the conditions in which they are perceived, but are nonetheless perceived as being the same.[84] This can be related to the vivacity of Raeburn's execution and his use of abrupt transitions of light, but these cases argue more for the unique intellectual climate of Edinburgh rather than a generic 'Scottish style'.

There is an argument for seeing a distinctively 'philosophical' approach to perception in the work of Ramsay and Raeburn, but realist portraiture was well established in England with Hogarth, in the provinces with Joseph Wright of Derby (1734–97) and George Stubbs, and in the most distant province of all, in Boston, Massachusetts. Their realism argues for widespread resistance to the metropolitan high style of Gainsborough, Reynolds, and George Romney (1734–1802) in their mature work, opposing a deliberate plainness of observation to artifice and the parade of rank. This can be observed especially in American painting before the Revolution of 1776, in the portraits by John Singleton Copley (1738–1815) and Ralph Earl (1751–1801), which give an overtly mercantile view of power that might have looked a little unsophisticated from a London point of view. In Copley's portrait of Nicholas Boylston of 1767 (fig.16) the wealthy importer is in 'undress' wearing a spectacular imported silk damask gown over a silk waistcoat, before a baroque curtain.[85] His left arm rests on a book, which one might expect to be a Bible or a classical work but is in fact his 'Ledger Book', and behind him a large ship comes into harbour. Such ostentatious declarations of wealth and the revelation of its source were generally avoided in portraits painted in Britain.

Some early American portraits also stand out from their British counterparts in their celebration of craftsmanship. Copley's portrait of Paul Revere of 1768 (Museum of Fine Arts, Boston) shows the silversmith in the process of completing a teapot, though admittedly not in the messy setting of a workshop.[86] Some portraits by Ralph Earl from

before the Revolution have a plain directness that converts provincialism into an assertion of national identity even before the nation was founded. His portrait of Roger Sherman of c.1775–6 (Yale University Art Gallery, New Haven) is astonishing in its forthrightness, showing a plainly dressed man seated on a plain wooden chair, looking directly at the spectator.[87] The defiant lack of artifice indicates a craftsman, but in fact he was a wealthy landowner and politician. The full-length portrait of Elijah Boardman of 1789 (Metropolitan Museum of Art, New York) postdates the American Revolution and Earle's sojourn in England, but there is something distinctively American in showing an elegantly dressed man standing in a shop, leaning against an upright desk containing stock books, with rolls of cloth to be seen through the door.[88]

Members of the Irish ascendancy were likely to commission portraits either in London or from visiting painters, the most spectacular of which is Reynolds's magnificent but faintly preposterous portrait of Charles Coote, 3rd Earl of Bellamont, c.1774 (National Gallery of Ireland, Dublin), which shows him in the robes of the Order of the Bath.[89] There is a decided hint of satire of the Earl's pretensions in the excess of 'Gothickry' in the background and the feathered hat on his head. It makes a fascinating comparison with the most intriguing of Irish portraits of the period, *Lieutenant Richard Mansergh St George* 1796–8 (fig.17), by Hugh Douglas Hamilton (1739–1808).[90] It is a full-length of a figure of excessive sensibility – despite his military uniform – standing by the tomb of his recently dead wife. Cullen has likened the subject to the Irish heroes of Gothic novels in his preoccupation 'with the past and with memory', a preoccupation that can be related to Mansergh St George's position as a Protestant landlord living in isolation in a decade of mounting fear of popular insurrection from the Catholic population. This fear proved well founded; a rebellion on his estate led to his murder by intruders in 1798.

There was no separate Welsh school of portraiture, but there are a number of portraits of Welsh harpists that carry with them a bardic aura. The most affecting is William Parry's *John Parry* probably 1770s (National Museum of Wales, Cardiff), known as 'Blind Parry', who was harpist to the Williams-Wynn family and to George III.[91] He is playing on a triple harp, an instrument he made famous, and Thomas Gray claimed to have learned from him the story of the bard that he made into the poem of the same

17 HUGH DOUGLAS HAMILTON
Lieutenant Richard Mansergh
St George 1796–8
Oil on canvas 228 × 146.2 (89¾ × 57½)
National Gallery of Ireland, Dublin

Conclusion

Britain as an entity changed its physical boundaries and type of government many times over nearly three centuries, and though it achieved a certain stability in the nineteenth century, its potential for separation into its constituent countries remains to this day. Because the unity of Britain in the earlier centuries was largely promoted by its rulers, artists were often recruited to the cause through commissions for public works. But, as they increasingly asserted their independence from state power, they were often attracted by the myths of the separate countries, which they sought to promote in mythological paintings and occasionally sculptures. In the late eighteenth century landscape began more and more to bear the weight of expressing ideological and cultural differences between the countries, initially by alluding to historical associations but later, as with Constable, through the seemingly truthful representation of the everyday.

The varieties of British landscape helped to create the idea of Britain as a benevolent guarantor of unity in diversity where differences in dress, custom, appearance and environment were brought together under the umbrella of the British Crown. The very interest of artists in the distinctive features of the separate countries of Britain contributed to it as an imagined community that hoped to inspire loyalty even from those outside the dominant country of England. But this apparent consensus eventually lost interest for most artists towards the end of the period covered by this volume as the most serious artists increasingly looked to the Continent for their *raison d'être*. Issues of artistic nationalism had for the time being effectively run their course.

name. The portrait is by Parry's son, who had been an assistant to Joshua Reynolds, and shows a man carrying in his music the inheritance of the medieval bards who offered wisdom to their rulers.

Portraiture then, like landscape, could express ideas of the different histories of the countries of Britain, despite the dominance of London in its production. If after the American Revolution Britain settled into relative internal peace between its constituent countries, national differences in portraiture tended to be more emphatic, perhaps because such differences were no longer a challenge to the unity of Britain.

Portrait Miniatures of the Sixteenth and Seventeenth Centuries

KAREN HEARN

Although portrait likenesses had appeared within medieval manuscript illumination, small-scale portraits as discrete items were first found in the mid-1520s. At the French court the Netherlandish artist Jean Clouet (c.1475/85–1540), and at the English court his fellow-countryman Lucas Horenbout (c.1490/5–1544) produced tiny half-length images of members of the French and English royal families respectively. The latter possibly taught miniature painting in London to the German Hans Holbein the Younger (1497/8–1543). All three artists painted with water-bound pigments on vellum stuck to paper card, a practice termed 'limning', though the word was often applied to other forms of painting. This technique was employed in England until the start of the eighteenth century, when miniaturists like Bernard Lens adopted ivory as a support because it gave a more translucent effect.

The leading sixteenth-century practitioner was the Exeter-born Nicholas Hilliard (c.1547–1619), whose miniatures incorporate similar elements to large-scale portraits of the period.

19 SAMUEL COOPER
Sketch of Cromwell's Head c.1650-3
Watercolour on paper 8 × 6 (3¼ × 2⅜)
Private Collection

18 NICHOLAS HILLIARD
Portrait of a Lady 1602
Watercolour and gouache on vellum
lain down on card 5.9 × 4.4 (2⅜ × 1¾)
Victoria and Albert Museum, London

Texts are included with the image, and the sitter's status and wealth are made clear through the minutely detailed depiction of rich fabrics and jewellery. The miniature was, nevertheless, a more intimate and private image and, in Hilliard's hands, offered a naturalism generally absent from large contemporary portraits (see fig.18). Hilliard's most important sitter was Elizabeth I, whom he first portrayed in 1572; at least fifteen surviving portrait miniatures of the Queen can be linked with him. In his treatise *Arte of Limning* written around 1600, though not published until the twentieth century, Hilliard claimed that she approved of a linear, unshadowed approach to portraiture. In his text Hilliard constructed the portrait miniaturist as a gentleman, who practised a clean and disciplined profession.

Almost all the early English miniatures are of court or royal sitters, though from the earliest decades miniatures from the commercial City of London survive, including Hans Holbein's *Mrs Nicholas Small* of c.1540 and Nicholas Hilliard's *Unknown Lady* of 1602 (both Victoria and Albert Museum, London). As a luxury item, a miniature might often be incorporated into an item of jewellery, such as a pendant; surviving examples include the 'Drake Jewel' (private collection, on loan to Victoria and Albert Museum, London). Hilliard himself had trained as a goldsmith, enabling him and his workshop to execute the complete package.

From the 1590s onwards Hilliard's French-born former pupil Isaac Oliver (c.1560–1617) became a rival. Oliver worked in a stippled, shadowed manner, more in line with contemporary Continental methods of portraiture. On the accession of James VI of Scotland as James I of England in 1603, Oliver was taken up by James's queen, Anne of Denmark, and by leading courtiers. Oliver also produced a few narrative works on a miniature scale – a form that his son Peter Oliver was later to make his own during Charles I's reign, as a copyist on a small scale of the King's Italian Old Master paintings.

By 1620 both Hilliard and Isaac Oliver were dead and the English-born John Hoskins (c.1590–1664/5) was now being employed by Charles I. He painted original portrait miniature images – introducing sky and landscape backgrounds to the format – and also copied works by Anthony Van Dyck (1599–1641) on a small scale. Hoskins trained his nephew Samuel Cooper (1608–72), who set up his own workshop in London in 1642, just as the Civil War was breaking out. In spite of the political situation, Cooper's career flourished. He was first employed by Oliver Cromwell in 1650, and his sketch of Cromwell's head (c.1650–3; fig.19) – which he himself kept to use for multiple copies – is particularly remarkable. Cooper conveyed a formidable sense of naturalism, the sitter caught as if in the act of turning and speaking. Cooper worked for parliamentarians and for royalists. At the Restoration in 1660 Charles II (1630–85) immediately sat for him and by 1663 appointed him 'King's limner'. Cooper was employed by many of the leading political and court figures of the period; his reputation was such that admiring comments on his work are recorded from the Netherlands, France and Italy. He was also known for his gentlemanly behaviour, exemplified by his skill at the lute and his ability at languages.

FURTHER READING

Coombs., K. *The Portrait Miniature in England*, revised ed., London 2006.
Reynolds, G. *English Portrait Miniatures*, revised ed., Cambridge 1988.

Cromwell and the Arts: 1649–1658

DIANA DETHLOFF

The period of Oliver Cromwell's Protectorate (1653–9) is often described as a decade of cultural decline. Horace Walpole wrote that 'the Arts were in a manner expelled with the Royal Family in Britain', only 'to return from their exile with our late Blessed Monarch Charles II'. With the outbreak of the Civil War, the established structure of royal and court patronage was dismantled. Cromwell was a less knowledgeable patron than his royal predecessor, but he recognized the importance of an official 'image' and a courtly setting. Thus artistic production during the 1650s was more interesting and significant than is usually acknowledged.

In 1658, the year Cromwell died, William Sanderson, a devoted royalist, published *Graphice: The Use of the Pen and Pensil or the Most Excellent Art of Painting*. He refers to many established artists, 'comparable with any beyond seas', now working in England, listing Robert Walker (c.1600/10–1658), Peter Lely (1618–80) and John Michael Wright (1617–94), who either produced Cromwell's official portraits or worked for the Cromwell family. Robert Walker's three-quarter-length portrait of Cromwell in armour, holding a baton and accompanied by a pageboy (fig.20) was the best-known image of the man from 1649 to 1656, and, according to the diarist John Evelyn, the one 'most resembling' him. It also emulated royalist imagery from the previous regime being directly based on Anthony Van Dyck's work: 'When asked why he did not make some of his own postures', Walker replied, 'if I could get better I would not do Vandikes.' By 1654 an alternative official image of Cromwell was produced by the Dutch-born Peter Lely – head and shoulders, and in armour within a painted oval; versions were sent to Denmark, Holland and Portugal as diplomatic gifts. According to George Vertue, Cromwell instructed Lely to 'use all your skill to paint my picture truly like me & not Flatter me at all but remark all these ruffness pimples warts & everything you see. Otherwise I will not pay a farthing for it.' This, however, was more probably said to the miniaturist Samuel Cooper who had been employed by the Cromwell family since 1650. Lely's portrait was, in fact, based on Cooper's miniature of Cromwell, rather than on a live sitting. Cooper produced a number of miniatures of Cromwell as well as miniatures of his family. Portraits of Cromwell's wife and daughters were also produced by the Scottish trained John Michael Wright, and although he never painted Cromwell himself, his portrait of Elizabeth Claypole, the Lord Protector's favourite daughter, as Minerva (1658; National Portrait Gallery, London), represents Cromwell allegorically in the guise of Zeus from whose head Minerva sprang fully formed.

Sanderson's *Graphice* makes no mention of printmakers but there were a number of highly skilled engravers working in England during this period. In July 1655 Pierre Lombart, a French engraver who worked in London throughout the 1650s, was paid £20 for presenting several portraits 'of his Highness to the Council'. This was probably 'Oliver Cromwell on Horseback', copied from Van Dyck's *Charles I on Horseback* (Petworth House, West Sussex). Cromwell's head in later editions was replaced by Louis XIV and then by Charles I himself. These and other celebratory images, such as Lombart's engravings after Walker's portraits, were either commissioned by Cromwell or his Council, or produced by artists in anticipation of official commissions (most anti-Cromwellian imagery was produced on the Continent). Like the medals of Thomas Simon commemorating Cromwell's successes as leader and his inauguration as Lord Protector, they ensured that his official image was widely disseminated.

Cromwell did not initiate any state building projects but two former royal palaces, Whitehall and Hampton Court, were given to him as his official residences. Although there was no attempt to reclaim major works from the royal collection that had been sold abroad, a number of paintings and tapestries, particularly those depicting Old Testament moralizing themes or imperial subjects, were reserved by the state or bought back from English-based purchasers to decorate the public and private rooms. When Evelyn returned to Whitehall in February 1656 he found it 'very glorious and well furnished'. At Hampton Court the gardens were decorated with ex-royal statuary, provoking one devout Puritan to implore Cromwell to destroy 'those monsters [of Venus, Apollo and Cleopatra] which are set up as ornaments in the privy garden'.

Contemporary and present-day writers have criticized Cromwell for failing to develop a republican discourse in his official imagery, preferring instead to follow established royal precedents. However, through established portrait conventions he astutely associated himself with sanctioned power and authority.

His approach to the arts was cautious, as was his way of government; his rejection of a proposal by Lely, Balthazar Gerbier and George Geldorp to decorate Whitehall with paintings of parliamentary victories, and his decision not to appoint an official salaried court painter, demonstrated a lack of real artistic interest. But the official patronage that he did extend enabled a number of artists to establish their careers during his Protectorate and encouraged others, such as the Catholic Wright, to return safely to England from exile abroad.

FURTHER READING

Griffiths, A. *The Print in Stuart Britain 1603–1689*, exh. cat., British Museum, London 1998.
Knoppers, L. *Constructing Cromwell: Ceremony, Portrait, and Print, 1645–1661*, Cambridge 2000.
Piper, D. 'The Contemporary Portraits of Oliver Cromwell', *Walpole Society*, no.34, 1958, pp.27–41.
Sherwood, R. *The Court of Oliver Cromwell*, London 1977.

20 ROBERT WALKER
Oliver Cromwell c.1649
Oil on canvas 215.7 × 101.6 (49½ × 40)
National Portrait Gallery, London.
Transferred from the British Museum, 1879

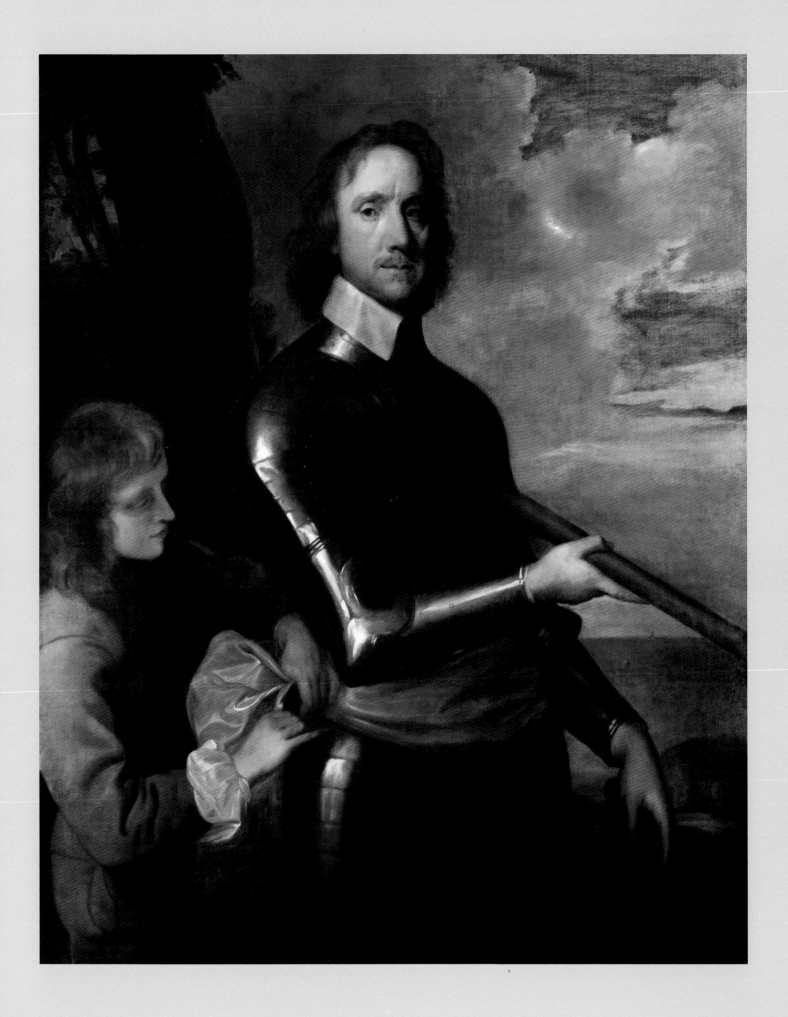

National Monuments in St Paul's Cathedral

ALISON YARRINGTON

During the early nineteenth century the sparsely furnished interior of Christopher Wren's St Paul's Cathedral was transformed into a national pantheon through the state funding of monuments raised to military and naval heroes. Dedicated to the memory of British servicemen who had died in the extended conflict with Revolutionary and Napoleonic France, it formed the equivalent of the earlier translation in Paris of Jacques-Germain Soufflot's Sainte Geneviève into the French Panthéon, a site of collective memory dedicated to 'les grands hommes'. Perhaps as much a pragmatic response to over-crowding in Westminster Abbey as the desire to match French commemorative hubris, the St Paul's scheme provided British sculptors with an unprecedented opportunity to create prestigious national monuments.

In 1795 Parliament voted the first large sums of public money for three monuments, with the Royal Academy selecting sculptors for the task. This involvement in the national promotion of sculpture was significant for the institution as well as for the nascent school of British sculpture. John Flaxman (1755–1826) acknowledged the demand for national monuments as being a major factor behind the Royal Academy's decision in 1810 to create a professorship in sculpture, an office that he was the first to hold. But the St Paul's project was to be a poisoned chalice for the Royal Academy when in 1802 its initial influence waned, after control over the choice of designs was transferred to a Treasury Committee, the so-called 'Committee of Taste'. This key shift of artistic power resulted partly from negative responses to the unveiling in that year of the first three monuments commissioned by the Royal Academy in 1798. Thomas Banks's uneasy Neoclassical essay, the *Monument to Richard Burgess* typifies the unpopular interpretation of contemporary heroism in the guise of classical antiquity. The selection process resulted in a uniformity of scale and format, and Neoclassical forms were increasingly modulated to include direct, 'transitory' references to modern heroism, in both dress and narrative.

The death of Admiral Horatio Nelson in 1805, and his public funeral and interment in the crypt of St Paul's, focused public attention on the scheme for the monument to this pre-eminent hero. The competition was fierce and in 1807 Flaxman was selected to carry out the commission, on the understanding that he should adapt his design to that of Richard Westmacott. Flaxman's monument showing Nelson dressed in modern costume with accompanying figures of Britannia instructing naval cadets to follow his example was completed in 1818, delayed partly by the difficulty in obtaining sufficient supplies of marble from Italy during the conflict. It was therefore unveiled at a point when the scheme had largely faded from public view (fig.21).

Westmacott (1775–1856) was the greatest beneficiary of the Committee of Taste, receiving £29,300 for eight monuments. His monument to General Ralph Abercromby of 1803–5 shows most clearly how he tuned in to the public appetite for heightened heroic action, showing the wounded General falling from his horse into the arms of a soldier of the Scots Greys. This was a radically different approach from earlier works in the Cathedral and one that was taken up by others such as Francis Legatt Chantrey (1781–1841). In his dramatic relief Chantrey shows Major General Foord Bowes dying in the siege of Salamanca in 1812, the hero toppling downwards towards the viewer below, while ladders are raised against the walls of the fortress. In contrast to these scenes of heroic action, John Bacon the Younger (1777–1859) created a moment of pathos in his monument to Lieutenant-General Sir John Moore (1810–15), whose uniformed body is lowered into the grave. Meanwhile, in Westminster Abbey Westmacott created two national monuments to key political figures from the early stages of the conflict: William Pitt the Younger (1807–13) and Charles James Fox (1810–23).

21 JOHN FLAXMAN
Monument to Lord Nelson
1808–18
Sculpted marble
St Paul's Cathedral

In 1841 a Select Committee reported on the role of national monuments in St Paul's, Westminster Abbey and other 'public edifices' as a means of 'moral and intellectual improvement of the people', and echoed the widespread disappointment in the scheme. The epilogue to this Pantheon was the magnificent, if ill-fated, monument to the Duke of Wellington (1856–1912) by Alfred Stevens (1817–75), completed by John Tweed (1869–1933). As controversial as its companions in the Cathedral, it marks a radical change in British commemorative sculpture from the white-marble uniformity of the so-called 'peninsular school' to the rich modelling, colour and drama of the 'New sculpture' (see fig.22).

FURTHER READING

Hook, H. 'The British Military Pantheon in St Paul's Cathedral: The State, Cultural Patriotism, and the Politics of National Monuments, c.1790–1820', in M. Craske and R. Wrigley (eds.), *Pantheons: Transformations of a Monumental Idea*, Ashgate 2004, pp.81–105.

Yarrington, A. 'Nelson the Citizen Hero: State and Public Patronage of Monumental Sculpture 1800–1818', *Art History*, vol.6, no.3, Sept. 1983, pp.315–29.

Yarrington, A. *The Commemoration of the Hero 1800–1864: Monuments to the British Victors of the Napoleonic Wars*, New York and London 1988.

22 ALFRED STEVENS (and JOHN TWEED)
Model for the monument to the Duke of Wellington in St Paul's Cathedral
1857
Plaster and wax
297 × 98 ×70 (117 × 38½ × 13)
The Victoria and Albert Museum, London

Ruskin, Morris and the Medieval

STEPHEN CALLOWAY

From about 1770 to 1840, novels and poetry based upon historic themes enjoyed a great surge of popularity. This trend was paralleled in the rise of the employment in building of medieval forms and decorative elements in the essentially light-hearted architecture of the 'Gothick' revival. This was also a time of advances in the study of political and social history, as well as of medieval architecture, costume and the decorative arts. One outcome of this scholarship was that, from the 1830s onwards, interest in the Middle Ages began to take on a new moral dimension.

Following a disastrous fire in 1834, it became necessary to build a new Palace of Westminster to house Parliament. Debate raged concerning the appropriate style in which to build. The choice of a late-medieval Gothic idiom rather than a 'modern' and 'foreign' Neoclassicism evoked the glories of the nation's ancient political traditions and of romantic chivalry. In the event, the 'battle of the styles' was resolved in a clever compromise: the overall conception and planning of the vast complex was the work of the suavely practised classicist Charles Barry, whilst all decorative detailing was entrusted to the most able, learned and polemical of the Goths, Augustus Welby Pugin (1812–52). By the 1840s Pugin and Barry's Palace of Westminster was the most conspicuous new monument of the medieval revival taste in architecture and a formidable statement of the power and confidence of the establishment.

In the visual arts the Royal Academy, founded in 1769, continued to uphold the increasingly outdated values of the annual *Discourses* of its first president Joshua Reynolds. In 1848 – throughout Europe the 'year of revolutions' – seven young artists and writers led by Dante Gabriel Rossetti (1828–82) founded the Pre-Raphaelite Brotherhood, challenging the hegemony of the Academy. Desiring a return to purer forms in painting and literature, they sought themes and ways of expression in the art of the medieval and early Renaissance periods. Attacked by the establishment, they found a champion in John Ruskin (1819–1900), then emerging as one of the most prominent commentators of the day on artistic and social matters. Ruskin, who came from a wealthy but narrowly puritanical background, was among the growing number of intellectuals who mistrusted the directions in which the nineteenth century appeared to be going.

23 JOHN RUSKIN
The North-West Angle of the Facade of St Mark's, Venice
Watercolour and drawing on paper 94 × 61 (37 × 24)
Tate. Presented by The Art Fund 1914

Ruskin had initially celebrated contemporary art, worshipping Turner as the greatest figure in English painting. However, his travels in Europe, and in particular lengthy stays in Venice in the 1840s, led him to the discovery of Gothic architecture (fig.23). His Venetian studies were the source of an idealized notion of the nobility of the work of the honest, pious craftsman, and on this foundation he began to elaborate a personal philosophy based upon the redemptive power of art and the need, as he saw it, for the modern age to return not only to the artistic and architectural styles, but also to the social values, of the Middle Ages. Such ideas seemed to many to chime with a more widely held belief in an English golden era, in which a beneficent feudal, aristocratic authority had given the nation stability and strength as well as harmony and social justice (see Bindman, pp.28–30). Ruskin's theories led ultimately to calls for radical social and political reform as much as aesthetic regeneration.

While some artists, such as Rossetti, sought to create an imaginary world steeped in the spirit and poetry of the Middle Ages, for others the period's moral dimension gained in importance as innovation in science and technology gathered speed. For a growing number of painters, writers and thinkers the past now served as more than an attractive alternative to the more undesirable aspects of the present; rather than an escape, the Middle Ages offered a model for cultural renewal, design reform and social innovation.

Rossetti's intimate circle included the young William Morris and his lifelong friend Edward Burne-Jones, both of whom shared a deeply felt attachment to a medieval world of romance. Burne-Jones, like Rossetti, was essentially a romantic dreamer; by contrast, Morris was ever more vigorously and passionately devoted to active causes. In addition to his prodigious achievements as a designer and maker of tapestries, wallpapers, textiles and the hand-printed books of his Kelmscott Press (fig.24), he was a prime mover in the formation of the Society for the Preservation of Ancient Buildings – formed to protest against unsympathetic 'restoration' –

and also gave his crusading energies and crucial early funding to the nascent Socialist Movement.

Setting himself in opposition to all that he considered to be base, ugly and meretricious in modern civilization, Morris believed in the transformative power of the beauty of life and work in the Middle Ages. His principal inspirations came from his love of natural forms and his deep study of medieval artefacts. For Morris, close in this respect to Ruskin, the two great instructors of mankind were nature and history, and every aspect of his thinking and teaching had, for all its exuberance and optimism, at its core some sense of regret for a lost, ancient rural England of the imagination.

FURTHER READING

Banham, J. and J. Harris (eds.), *William Morris and the Middle Ages*, Manchester 1984.

Clark, K. *The Gothic Revival*, London 1928, revised ed. 1950.

Strong, R. *And When Did You Last See your Father? The Victorian Painter and British History*, London 1978.

24 EDWARD BURNE-JONES
Frontispiece and title page from
The Works of Geoffrey Chaucer
(Kelmscott Press, Hammersmith) 1896
Letterpress and wood engraving
38.4 × 55 (15⅛ × 21⅝)
Yale Center for British Art, New Haven
Paul Mellon Collection

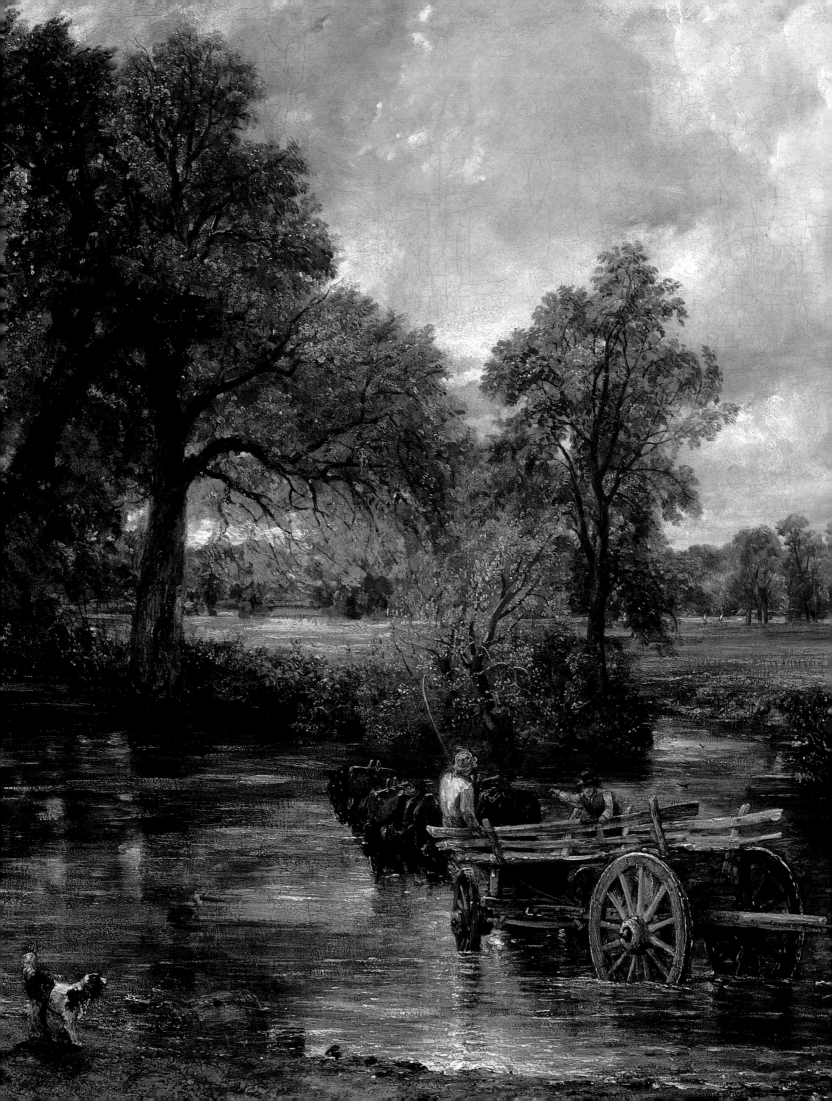

2 Britain and Europe c.1600 – c.1900

WILLIAM VAUGHAN

THE AMBIVALENT RELATIONSHIP between Britain and Continental Europe in the areas of politics and economics is matched by that in the cultural sphere. On the one hand there is a dependence, on the other a defiant show of distinctness. Yet while the patterns are similar, there are differences in scale and ratio. During the three centuries covered by this chapter Britain grew in political and economic strength compared to most of its Continental neighbours. Through its imperial endeavours it even succeeded for a time in the nineteenth century in largely replacing traditional dependence on mainland Europe, thriving instead on trade and dominions overseas. In the cultural sphere there is a similar pattern of growing separateness. However, it is only in the area of literature that this can be said to have led to a fully confident self-sufficiency. In the visual arts (as in music) matters were very different. Despite some heady claims by jingoistic critics, both at the time and later, there was never the same level of independence. And while, in the eighteenth and nineteenth centuries, Britain did sporadically become an exporter as well as an importer of artistic ideas and practices, this counter-flow never reached the level of cultural ascendancy enjoyed, for example, by France in the nineteenth and early twentieth centuries or America in the decades following the Second World War. The net result in the end was an emphasis on individuality and eccentricity – a legacy that was to have consequences for the perception of British art in the twentieth century.

The variable and uncertain position of British art had implications for its support at an official level. As the sense of nationhood developed in the eighteenth century, Britain, like other European countries, felt the need to promote a national culture as an exemplar of the country's strength and identity. Yet it was widely acknowledged that British visual culture – from at least the sixteenth century – did not provide examples of the superlative achievements of the country's major rivals, particularly France and the Netherlands. Indeed, throughout the seventeenth century the upper end of artistic production in Britain had been dominated by artists from abroad. In the eighteenth century this situation gradually changed. Official support,

however, was slow to follow. British indigenous artists had few of the training opportunities – or high level of commissions – enjoyed by their Continental rivals. Only in the mid-nineteenth century did conditions begin to improve, largely as a result of somewhat reluctant government intervention.

At the same time a new problem was presented by the achievements that did begin to emerge. From the time of William Hogarth's success with his 'modern moral subjects' in the early eighteenth century, it could be argued that a unique and independent British artistic practice had been established. Yet this was not of the kind that accorded with the image of a polite and cultivated nation. Despite being richly admired for his skill and wit, Hogarth was felt to be providing the wrong kind of visual model. In his seminal survey of British art, *Anecdotes of Painting in England* (1762–80), Horace Walpole is fulsome in his praise of Hogarth. Yet he insists on referring to him as an 'author' as he felt his work accorded more with literary than artistic practice.[1] It is a feeling that has persisted in connoisseurial circles ever since and has been one of the main reasons for a hesitancy in the celebration of British art, a hesitancy that can be seen as late as 1934 in Roger Fry's assertion that British artists 'were not quite worthy' of 'the greatness of British civilisation'.[2] There has always been a concern to show that high taste in Britain transcended the local product, causing British art to be seen as something separate from the great European tradition.

It is symptomatic of this situation that Britain is almost the only European country that has found it expedient to separate the principal national holding of indigenous art from that of the European tradition.[3] The National Gallery of British Art – now known at Tate Britain – was established in 1897 at the end of the period covered by this chapter. While European Art remained exclusively in the National Gallery of Art in Trafalgar Square, most British art was moved upstream to Millbank. The Tate's foundation marks the culmination of the culture of separateness that had been growing throughout the eighteenth and nineteenth centuries.[4]

In the main body of this essay there will be a consideration of the shifting relationship between British art practice and the Continent from two perspectives – an internal and an external one. The internal perspective will focus on the importation of Continental art and art practices into Britain and their effect on indigenous production. The external one will look at the changing assessments of British art as these developed in Continental Europe and the role that certain specific British artistic practices played in European culture as it developed during the eighteenth and nineteenth centuries, most notably in relation to concepts of liberty and modernity. To a large extent the admiration felt for British art during this period related to the interest taken in Britain as a model for certain political and social freedoms.

Before moving on to this survey, however, it may be useful to review the means by which artists and connoisseurs in Britain came into contact with Continental art, as changing patterns here had implications for what was known and how it was responded to. The most obvious and direct form of contact was that provided by the presence of artists from Continental Europe working in Britain. In the early part of the period this presence was greatly encouraged in the higher ranks of society because of the lack of confidence in the accomplishments of native British artists.

The relatively weak and provincial nature of indigenous British art in the post-medieval period has traditionally been ascribed to the effect of the Reformation. It is certainly true that the break with Rome by Henry VIII in the 1530s marked the virtual end of one of the most significant areas of patronage in the country, namely that provided by the Catholic Church. While this effect was devastating in terms of the decline of the patronage of religious imagery and related artefacts, it is not enough in itself to account for the absence of a thriving indigenous art practice. Other countries that broke with Rome and suffered a decline in religious patronage did not necessarily experience such a collapse. In the case of the Dutch Republic, indeed, the break with Catholic Spain heralded the flourishing of a 'golden age' of painting in a predominantly Protestant society. Furthermore, it should be remembered that while British medieval art had its strengths it was hardly on a par (in the figurative arts at least) with the most magnificent achievements in leading Continental countries, notably Italy, the Netherlands and France.

While religious patronage was largely absent between the early sixteenth century and the early nineteenth century, powerful areas of secular patronage flourished, and indeed increased. The most prominent was that of the Crown. Court patronage was to remain the most significant area of patronage in Britain throughout the Tudor and Stuart periods. On the whole the court tended to favour foreign artists. Henry VIII's employment of Hans Holbein the Younger started a tradition of the monarch's principal painters coming from abroad – mostly the Netherlands and Germany – that lasted (with a brief intermission in the later Tudor period, when Nicholas Hilliard, for example, was court painter to Elizabeth I) until the death of Godfrey Kneller in 1723 (see Hearn, p.47). Royalty favoured foreigners partly because of the need to maintain prestige by employing artists with international reputations, and partly because of dynastic links abroad. Even in the Hanoverian period, when British artists tended to be appointed principal painter to the monarch, connections between the royal family and Germany meant that artists from that country tended to receive a warm welcome at court. Johann Zoffany (1733–1810) in the age of George III and Franz Xavier Winterhalter (1805–73) in the age of Queen Victoria were amongst those to benefit from this connection.

In the Stuart period patronage of local artists, by contrast, tended to reside with the bourgeoisie and be limited to 'practical' commissions such as portraits. Even here, however, Netherlandish artists were often preferred when these could be found. The influx of Dutch and Flemish artists into Britain at this time was prodigious and has often led to the perception of British art as being essentially an offshoot of the Flemish school.[5] Nevertheless, bourgeois patronage was to prove a key element in the promotion of indigenous art in the eighteenth century, especially following the success of Hogarth. It might be said that the 'little Britain' defence of local art has its roots here, helping to augment the notion of a class divide between those supporting the national product and those preferring Continental varieties.

Another major source of Continental art – both ancient and modern – was provided by the collections that were amassed largely by royalty and the aristocracy. From the time of Charles I – who had possibly the greatest collection of antique and Renaissance works in Europe at the time – Britain's great houses were well stocked with examples of 'high' art. This pattern continued through the eighteenth

century when fabulously wealthy noblemen undertaking the Grand Tour to Italy brought back huge numbers of major works. An increasingly active international dealer system augmented the practice and also opened up collecting of Continental art to the growing group of wealthy members of the bourgeoisie. By the early nineteenth century British private collections of works of art were so substantial that they were attracting international attention. A sign of this is the survey of such collections undertaken by the distinguished German art historian Gustav Waagen (1794–1868) in the 1830s.[6] Gradually, in the nineteenth century, with the establishment of the National Gallery in London and other public art galleries, much of this work entered the public domain. In the first instance, at least, much of the stimulus for the development of these collections was to provide instruction for local artists in the traditions of Great European art.

Apart from the impact of foreign artists settling and working in Britain, and the example of works acquired from overseas by collectors, there was constant contact between British artists and European art (ancient and modern) via travel. In the seventeenth century travelling was highly expensive and dangerous, particularly for Protestants in Italy and other Catholic countries. However, a privileged few did make the journey. In the eighteenth century travel was more habitual, especially to Rome to see the antiquities. Even at this time extensive travel was not possible for most artists without assistance and most went under aristocratic patronage. There was no system in place like that offered by the French academy to their artists – whereby successful winners of the *Prix de Rome* would enjoy a funded state residency in Rome with continued instruction.[7] Such contrasts fuelled complaints about lack of patronage and educational opportunities for artists in Britain.

As the Grand Tour became more common, so this offered new opportunities for travelling British artists, who would often find Rome a good place to gain patronage from their compatriots – and occasionally from others. Such contacts became severely limited for a generation with the French Revolution and the Napoleonic wars. After 1815, however, travel became easier politically, but also physically, due to the improvement of transport systems. Now the bourgeoisie travelled as well as aristocrats, and artists addressed this potential patronage as much as they had the former. This was the great age of topographical art, where artists (most notably J.M.W. Turner) toured widely

throughout Europe making views of far-flung regions. Such travelling led to some contact with artists from other countries, though not as much as might have been supposed.

The nineteenth century also saw a significant shift of place of study abroad from Rome to Paris. Other schools of art – notably in the Netherlands and Germany – were popular at times but there was no doubt that by the mid-nineteenth century Paris was the artistic Mecca. British art had paced itself against France since the age of Louis XIV. Now, however, the influence of Paris increased yet further, and by the end of the period there were few serious painters in Britain who did not regard Paris as the principal locus for art.

Contact was also enhanced from the later eighteenth century by other means. The most significant was print-making. This had, since the Renaissance, been the main method by which artistic imagery had been circulated to a wide audience. In the mid-eighteenth century print production grew to become a vigorous international market, spreading knowledge of contemporary art from country to country in a far more extensive manner than previously. This both increased British artists' knowledge of Continental European art (particularly that of France, Italy and Germany) and gave them in turn an unprecedented way of reaching an international audience. The first artist to benefit from this on a large scale was Hogarth, whose celebrated 'Progresses' became rapidly known throughout Europe in the 1730s. From this time there was a new curiosity about British art in most major European countries.

In the nineteenth century knowledge of art from other countries was further enhanced by another practice – that of the art exhibition. Like printmaking, regular exhibitions were a growing phenomenon throughout Europe in the later eighteenth century. There were many reasons for this, of which the most important were national and institutional prestige and a market expanded by the bourgeoisie's increasing interest in art. In the first place exhibitions were largely local phenomena servicing a particular artistic community. However, as most exhibiting bodies were prepared to consider works submitted from elsewhere (such an interest in itself being taken as a sign of the prestige of the organizing institution), the practice developed for artists to 'try their luck' by sending works abroad. Sometimes the results could be spectacular, as when John

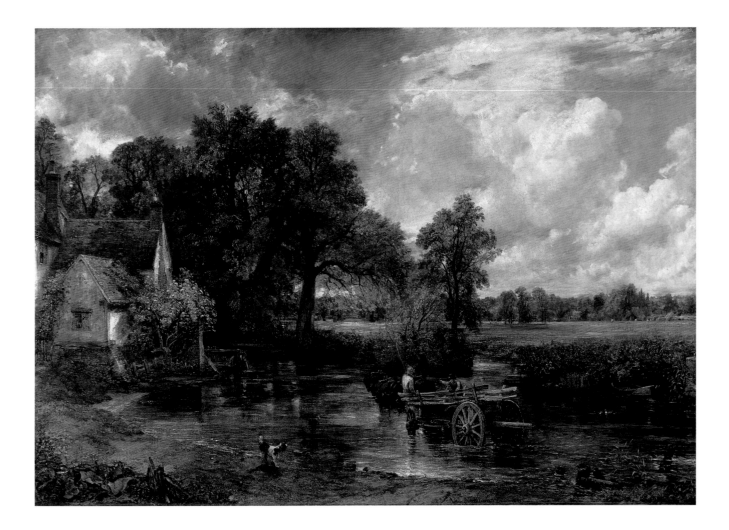

Constable gained a medal at the Paris Salon in 1824 for *The Haywain* (fig.25). In mid-century a new source of comparison and competition became available with the establishment of regular, government-sponsored international exhibitions of arts and manufactures. The *Exposition Universelle* in Paris of 1855 was the first to give a significant space to the fine arts. For the first time countries throughout the world were invited to send representative selections of their artistic productions to be displayed together on the same site. Perhaps spurred on by traditional rivalry with the French, Britain was one of the countries that took this invitation most seriously. The result was the stimulation of a new curiosity about British painting that was to remain – with shifting fortunes – until the end of the nineteenth century. Throughout the later nineteenth century these exhibitions provided the opportunity for art from many nations to be seen side by side, thus inspiring new speculation about artistic styles and national identity (also supported by current racial assumptions). It was in this context that the 'separateness' of British art was most frequently signalled.

The above has provided an outline of the means by which British artists both came into contact with examples of Continental European art and made their own work known abroad. I now wish to return to a historical survey of the principal moments and developments over the long three hundred years covered in this chapter.

The Stuart monarchy set the pattern for the Continental influence on British art through overwhelming patronage of major figures, notably the Flemish artists Peter Paul Rubens and Anthony Van Dyck. The fact that both these artists received knighthoods – an honour accorded to no indigenous artist until the eighteenth century – is a sign of the respect they commanded. The relative cultural isolationism of the court of Elizabeth gradually changed during the age of James I, particularly with an influx of artists from the Netherlands. However, it was his son Charles I who made the most significant move. Coming to the throne in 1625, Charles was determined to establish a mode of kingship on the model of the absolute monarchies of France and other Continental countries. It was a move that was eventually to precipitate rebellion, but in the first fifteen years of his reign it led to the establishment of a court with a truly Continental profile. He gained the services of Rubens for a time and more consistently the younger Van Dyck, who acted as his principal portraitist.

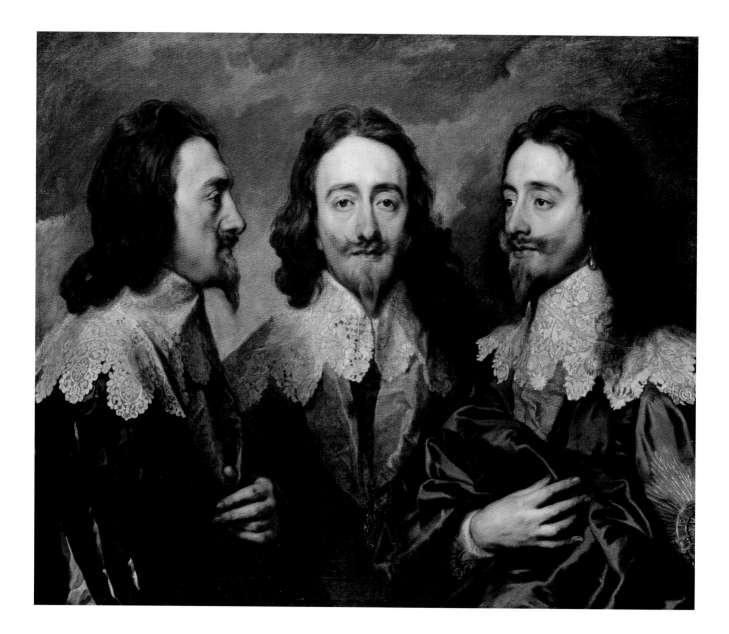

Van Dyck's elegant portrait style proved a watershed. Not only did it provide an ineradicable, near spiritual, image of the king as the ill-fated martyr for the cause of absolutism (fig.26), it also created a model of grand portraiture that remained a source of emulation for British artists for centuries to come. Even the belligerently chauvinistic Hogarth venerated Van Dyck as a portraitist.

Van Dyck's achievement was part of a wider cultural programme of Charles I's that involved the wholesale adoption of Renaissance principles in art and architecture (he was well served in the latter by the work of Inigo Jones). Part of the motivation here was to establish the court on an equal footing with that of other European monarchies. There was, however, a further national agenda. Like his father James, Charles combined the monarchies of England and Scotland. He united in his person two countries that remained at that time politically separate. Both kings produced propaganda to present themselves as the creators

in their personal reigns of Magna Britannia – uniting the islands of Britain into one realm (see Bindman, p.24). The cultural profile of this new Magna Britannia was to be developed with the aid of the finest artists available. As well as encouraging a wide variety of Netherlandish, French, and Italian artists to work here (see Alexander, p.78 and Liversidge pp.80–1), Charles further enhanced the status of his court (as has already been seen) through a massive collection of works of art both ancient and modern.

Charles employed artists according to merit. Those British artists and architects who showed that they had the appropriate capabilities were employed alongside the foreigners, the most significant beneficiary of this policy being the architect Inigo Jones. The artists active in Charles's court also provided new training opportunities for British artists, as can be seen in the case of William Dobson (c.1610/11–46), the young portraitist who developed his art through the encouragement of Van Dyck and

26 (left) ANTHONY VAN DYCK
Triple Portrait of Charles I c.1636–7
Oil on canvas
84.4 × 99.4 (33⅓ × 39⅛)
Royal Collection, Windsor Castle

27 (right) WILLIAM DOBSON
Endymion Porter 1642–5
Oil on canvas
149.9 × 127 (59 × 50)
Tate. Purchased 1888

knowledge of the Renaissance masterpieces in Charles's collection, and who eventually went on to act as Charles's court painter during the Civil War (see fig.27).

Charles's promotion of international art in Britain, while undoubtedly bringing in a new era, also had its problems. The very identification of the court with such culture aroused suspicions at a time of growing conflict between Crown and Parliament. Such suspicion added fuel to the Puritan distrust of the visual image. The fall and execution of Charles I brought the progress of the new culture to a halt for a time. Charles's collection was sold off by Cromwell – largely to foreign buyers. Yet such eradication proved no more permanent than did Cromwell's attempt to replace the monarchy. And while a full return to such culture had to await the resumption of the throne by Charles II in 1660, there was much work by Continental artists during the Interregnum. Unsurprisingly, those from Protestant countries tended to fare best – most notably the

Dutchman Peter Lely, who arrived in England in the final years of Charles I's reign and went on to become court painter to Charles II in 1661 (see Dethloff, p.48).

Court patronage in the later Stuart period was also guided by rivalry with the increasingly splendid creations of Louis XIV in France. This stimulated a taste for more flamboyant expressions of the Baroque style and provided new opportunities for decorative artists, largely from France and Italy, who could manage such schemes. The dominating figure in this area was the Italian Antonio Verrio (c.1639–1707) who was brought over from France in around 1671 by Charles, 1st Duke of Montagu, 1671 (see Liversidge, p.80). Verrio was joined in the 1680s by Louis Laguerre (1663–1721) and worked with him at Blenheim and a number of other major places (see fig.28). Through Verrio and Laguerre Britain became accustomed to the grandiose decorative schemes of the Baroque – if at a somewhat cold and pedantic level. Their work also stimulated the first major British-born

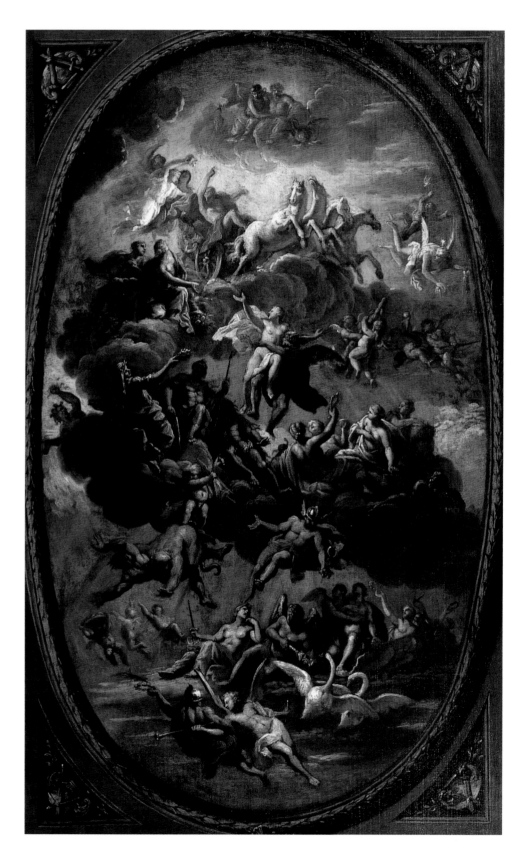

28 ANTONIO VERRIO
*Sketch for a Ceiling Decoration
for Moor Park, Hertfordshire:
An Assembly of the Gods*
c.1680–1700
Oil on canvas
169.2 × 82.9 (66⅝ × 32⅝)
Tate. Purchased 1967

29 Circular pond in the Vale of Venus
at Rousham, Oxfordshire, designed
by William Kent c.1740

decorative painter, James Thornhill. Thornhill initially learned from Verrio (it would seem) and went on to decorate the painted hall at Greenwich and the dome of St Paul's cathedral.

With Thornhill British painting might be said to have gained a new level of respectability. Not least amongst his achievements was the ability – at the iconographical level at least – to accommodate such art to the interests of a Protestant constitutional monarchy, thereby freeing large-scale decorative art – still regarded at the time as the height of artistic achievement – from negative associations with Catholicism and absolutism.

As with so many aspects of British intellectual and cultural life, the new 'dispensation' that emerged from the establishment of the Protestant constitutional monarchy of 1688 led to a growing confidence in the visual arts. Continental influences – and indeed immigration – remained, but were on a different footing, with a much greater element of dialogue. While in the Stuart era the prime mover in the patronage of art had been the monarchy, this now became more fully the domain of the aristocracy. Many of the leading figures here were actively engaged in aesthetics and the promotion of taste, interpreting this in terms of the empiricism of Lockean philosophy and classical concepts of the civic responsibilities of the independent gentleman. In the visual arts these noblemen looked particularly to classical antiquity. A key figure here was Anthony Ashley Cooper, 3rd Earl of Shaftesbury, whose *Characteristics* encouraged a perception of the beautiful in terms of stoic morality. Shaftesbury's favoured artist was the Dutchman John Closterman (1660-1711). However, the principles that he established were important for encouraging a new classicism. One of the principal British beneficiaries was the portraitist Jonathan Richardson (1665-1745). While rarely more than a sober and dignified artist, Richardson achieved fame through his writings on art, which bore witness to his connoisseurship and learning, as well as to his experience of classical art in Italy. His defence of portraiture, in particular, gave a new dignity to the profession, one that was to be important for understanding it as the depiction of noble character on classical principles later promoted by Joshua Reynolds. A further significant promoter of classical taste, based on knowledge of the antiquities of Rome, was Richard Boyle, 3rd Earl of Burlington. The principal beneficiary of Burlington's patronage was the painter and architect William Kent (1685-1748), who was

a key figure in the reintroduction of Palladian architecture into Britain.

It was through the activities of this circle of aristocratic humanists that one of Britain's most important contributions to European art emerged: the landscape garden. Kent's garden design at Rousham (fig.29) is an early example. As with so many pictorial innovations in Britain, it is in effect the transposition of an art form absorbed from abroad into a new medium. The visual stimulus for the landscape garden was the classical landscape painting dominant in Rome in the seventeenth century, particularly as exemplified by the French painter Claude Lorrain (1600-82). Such works had been seen by aristocratic travellers on their Grand Tour of Italy and were being imported back into Britain in increasing numbers. Claude's vision was responded to as if it was, indeed, the embodiment of a classical arcadia, a lost golden age. It represented the spatial ideal to complement that of the 'civic humanist', the noble classical gentleman. Later in the century Archibald Alison (1757-1839) was to observe in his *Essay on Taste* (1790) that the landscape

garden was the product of two circumstances 'which may at first appear paradoxical, viz., to the accidental circumstance of our taste in natural beauty being founded on foreign models; and to the difference or inferiority of the scenery of our own country, to that which we were accustomed peculiarly to admire.'[8] Certainly the desire to recreate an arcadia inspired by Italianate scenery lay behind it. Yet, however much an imposition on the existing features of the English countryside, its planned informality came to have connotations of liberty. The 'free' forms of the informal English garden became contrasted to the 'artificial' nature of the French garden, especially as evidenced in the gardens of Versailles.

The landscape garden symbolized liberty, even though in practice such gardens were often constructed at the expense of the liberty of the local peasantry. Emerging at a time when British social organization was beginning to be celebrated as a 'democratic' opposite to the hierarchies of feudal *ancien régime* governments on the Continent, it became Britain's most influential visual export. In the later eighteenth and early nineteenth centuries 'English gardens' emerged throughout Europe, notable examples being the Englischer Garten designed by Count Rumford for the Elector of Bavaria in Munich in 1789 and the Mikhailovsky Garden by Carlo Rossi in 1822 for the Russian court in St Petersburg.

As well as representing the first significant visual export from Britain since the Renaissance, the English garden also set the stage for the perception of British art as being essentially naturalistic in its aims. It was a perception greatly strengthened by the next major export: the satirical art of William Hogarth. In 1731 Hogarth – already known for his satirical engravings and conversation piece paintings – invented a new form of narrative art, in which moral tales of modern life were told in a series of pictures packed with detail (see Wagner, pp.174–5). The first of these, *A Harlot's Progress*, tells the story of an innocent young girl who comes to London, where she is seduced, becomes a prostitute (fig.30) and eventually dies a sorry death. At first sight this series appeared to burst into a world in an unprecedented manner. Certainly there had been little in the visual arts to prepare for it. Innovation in landscape gardening had not been matched in painting and sculpture, where foreign practitioners continued to set the norms following patterns already established on the Continent. The leading sculptors of the early eighteenth century –

notably John Michael Rysbrack, Peter Scheemakers (1691–1781) and Louis-François Roubiliac (1702–62) – were all from either the Netherlands or France. In painting, meanwhile, figures such as Thornhill and Richardson were holding their own against foreign competition, but innovation came for the most part from abroad, and the most significant of these was the arrival of the new rococo style from Regency France. The leading protagonist of this style, Jean-Antoine Watteau (1684–1721), was himself for a time in London, though this was more to consult Dr Mead about the tuberculosis that was soon to kill him than with the intention of setting up a practice here. The rococo style was also greatly promoted by that great army of French artists and craftsmen, the Huguenots, many of whom had fled to England from France following Louis XIV's 1685 revocation of the Edict of Nantes – the act that had allowed them, as Protestants, freedom of worship in their native country.

The most innovative pictorial form of the period, the informal conversation piece, was also of Continental origin, though in Britain it soon developed its own kind of stilted charm as a genre of portraiture. It was as a master of the conversation that Hogarth first achieved fame as a painter. Trained as an engraver, he had previously earned a precarious living as a Grub Street pictorial satirist. His *Harlot's Progress*, like his succeeding modern moral subjects, effectively brought the two practices of the conversation piece and the satirical engraving together. As is so often the case, innovation was sparked by cross-fertilization of existing genres. Hogarth's training as an engraver also did him a further service, for it gave him the means of reproducing his pictorial cycles. This move enabled his innovation to become known quite rapidly throughout Europe. Hogarth's engravings were already selling well in France by the end of the 1730s, and commentaries on his works were being published soon after.

Hogarth was the first British painter since at least the Renaissance to achieve international fame. He is also the one who has most consistently sustained that fame throughout the centuries. While misgivings may always have been felt about his harshness and seeming subjugation of image to text, he has remained an inspiration for artists who wish their work to have a political and moral dimension ever since. It is typical of this that in the 1920s the German satirist Georg Grosz should have proclaimed his intention to become the 'German Hogarth'.[9]

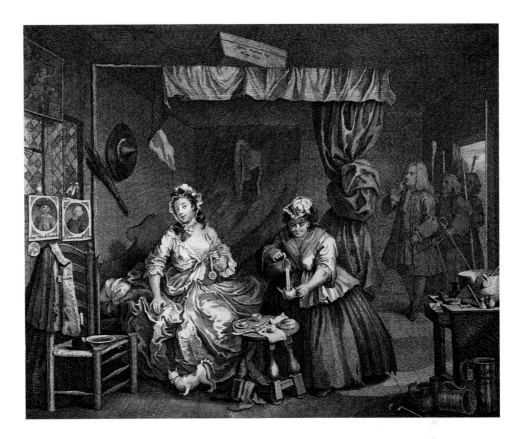

30 WILLIAM HOGARTH
A Harlot's Progress, Plate III 1732
From *The Original and Genuine Works
of William Hogarth* 1820–1
Engraving 30.2 × 37 (11⅞ × 14½)
Yale Center for British Art, New Haven
Paul Mellon Collection

Hogarth's international acclaim was matched by his
own strident xenophobia and belligerent nationalism.
Signing himself on one occasion 'Hogarth *Anglus*', he was
virulently anti-French. When in Paris in 1748, he character-
ized the artefacts he encountered as 'all gilt and besh-t'.[10]
Yet despite this, there were few artists of the time who
drew more from French art than he did. His whole painting
manner can best be understood in terms of the new
sensuality and lightness of the rococo, and he was himself
intimately aware of the art of Watteau, François Boucher
(1703–70) and Jean-Baptiste-Siméon Chardin (1699–1779).
Partly this knowledge was achieved in London – through
engravings and works seen in collections such as that of
Dr Mead and partly it was gained directly through visits
to Paris. Typically, too, he had many French and French-
trained artists amongst his close acquaintances, including
Hubert-François Gravelot (1699–1773), Roubiliac and the
French-Swiss miniaturist Jean-André Rouquet (1701–58).
Rouquet's *Present State of the Arts in England*, 1755, provides
an invaluable glimpse of English art when Hogarth was in
his prime.[11] It is a sympathetic view, originally aimed at
explaining the peculiarities of English art to the French.
It makes clear the limitations of the English art world,
particularly the dominance of portraiture and 'practical'
art forms at the expense of imaginative and ideal art. But
it also makes clear the existence of a spontaneous practice
not found elsewhere. Born perhaps of necessity – the need
to work rapidly in a competitive commercial market – this

stimulated a vigorous and vivid manner that inspired
admiration abroad. Hogarth was the first to show such
spontaneity, though the portraiture of Gainsborough takes
it to its highest degree of brilliance, leading to an admira-
tion for the British portrait style that was to last well into
the nineteenth century. As with the English garden, the
informality of this manner was widely interpreted as the
sign of a country that enjoyed a particular form of political
and social liberty.

However much the Hogarthian revolution achieved
for the international reputation of British art, it was little
favoured by the arbiters of taste within Britain itself.
Instead, a very different strand rose to prominence. This
was a development from the patrician classicism of the
earlier eighteenth century, though this time artists them-
selves were more dominant. These artists were not the
self-taught variety like Hogarth, but ones who had had
the benefit of a Continental tour and, often, Continental
training. The Scottish painter Allan Ramsay was the first
to establish the new form in his urbane portraiture, but it
was Joshua Reynolds who gave it widespread prominence.
His portrait of Commodore Keppel – striding the seashore
with the gait of the Apollo Belvedere (fig.31) – set the
pattern for a new kind of classically inspired *gravitas* in
portraiture. While loosely relatable to the Neoclassical
taste that was then gathering pace in Rome, it was equally
connected to a more timeless version of classicism. But
Reynolds was most important of all for establishing art

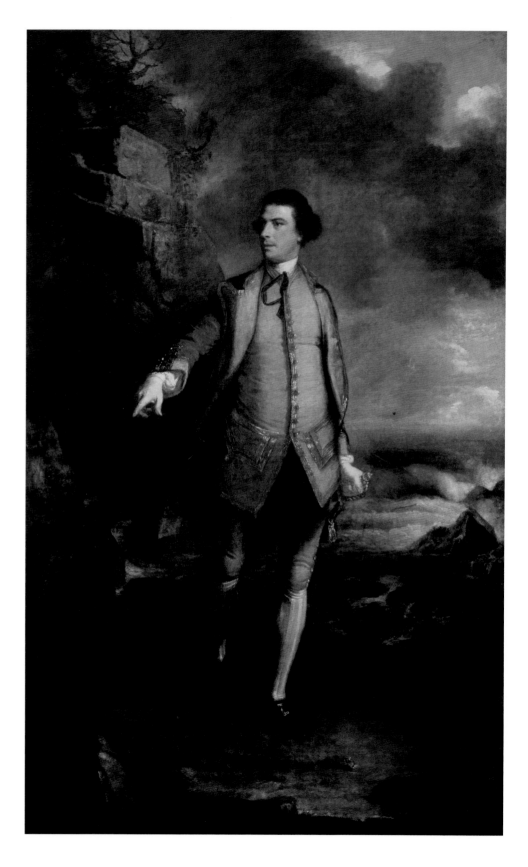

31 JOSHUA REYNOLDS
Captain the Honourable
Augustus Keppel 1752–3
Oil on canvas
239 × 147.5 (94 × 58⅛)
National Maritime Museum,
Greenwich

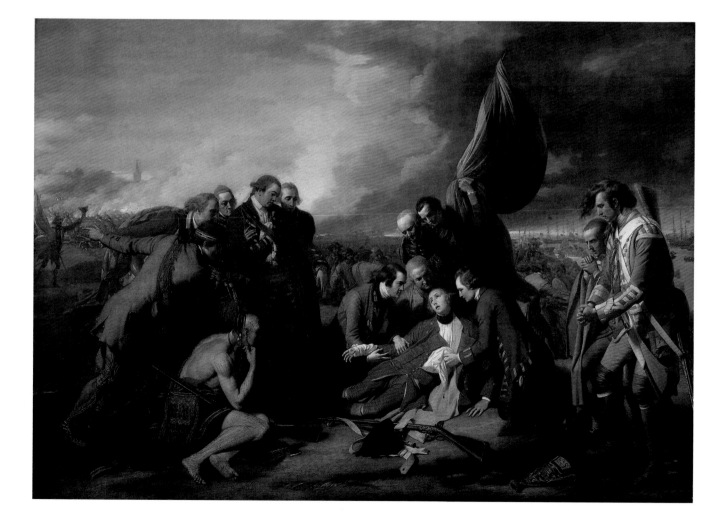

practice on a fully professional basis, being the prime mover in the establishment of an Academy emulating that of France in its educational and promotional ventures, and setting the tone for the perception of the artist as an intellectual through his celebrated *Discourses on Art*. Like Hogarth's Progresses, Reynolds's *Discourses* became known and valued internationally.

Reynolds was also valued in his own time as a history painter – a reputation sufficiently strong to encourage Catherine the Great of Russia to commission a historical work from him on the subject of his choice.[12] He was a prime mover in establishing an unprecedented reputation for British artists as history painters. British painters and sculptors had indeed played a full part in the revival of serious historical work that accompanied the growing

Neoclassical taste. One, the Scotsman Gavin Hamilton (1723–98), had been at the forefront of the revival of Homeric subjects in Rome.[13] They were also gaining an increasing reputation for their imaginative faculties, particularly the Burkean-inspired horror of the Swiss-born Henry Fuseli (1741–1825). Yet typically the work that achieved greatest fame was one that accorded with the reputation that British artists had enjoyed as modernizers and naturalists since the time of Hogarth. This was *The Death of General Wolfe* 1770 (fig.32) by the American painter Benjamin West (1738–1820). This scene of the victor of Quebec's dying moments was widely hailed for bringing together the *gravitas* of classical art with the representation of a modern scene in modern clothes. It was even praised in the most fulsome terms by the leading

French history painter of the day, Jacques-Louis David (1748–1825).[14]

The international fame of Reynolds, West and other British history painters of the period was intimately connected with the availability of their art in engraved form. Since Hogarth the British print industry had enjoyed a remarkable ascendancy and by the last decades of the eighteenth century was the most successful in Europe. The strength of the British economy had much to do with this extraordinary rise. It was a movement that also encouraged a general spread of British art manufactures, especially the pottery of Wedgwood. Yet tribute must also be paid to the superlative quality of the craftsmen who made the prints. In fact it is hardly an exaggeration to say that they frequently exceeded the technical skill of the artists whose works they were engraving, and thereby disguised for those who did not know the originals the often indifferent qualities of much British historical painting in the period. This was undoubtedly a significant factor in promoting their reputation abroad. It should be recorded that David, who so greatly admired West's Death of Wolfe, which he knew only in engraved form, was bitterly disappointed when he saw an actual painting by West, dismissing it as a 'caricature of Rubens'.[15]

The growing sense of the independence of British art was augmented after 1790 by a growing physical isolation from the Continent. The latter was brought about by the wars that followed the French Revolution of 1789. Travel abroad became increasingly difficult for the British as the French – at war with Britain from 1793 – gained control of larger areas of the Continent. The process intensified after 1806 when Napoleon set up his Continental blockade in an attempt to sever all trade links with Britain.

It is in the context of this wartime isolation that the first confident rhetoric about the British school of art emerges. Although attempts to characterize an English or British school of art reached back to the first years of the eighteenth century, these had largely been apologetic in tone.[16] The most fulsome treatment on the subject, that by Horace Walpole, was entitled 'Anecdotes' by its author as he did not think that British art yet merited the designation of a 'history'.[17] There could hardly be a greater contrast with the bullish volume *The English School*, published by the aptly named antiquarian John Britton fifty years later in 1812.[18] Replete with lavish engravings, this book proclaimed British art to be the best in Europe, giving full honour to history painting as the artistic flowering of a 'philosophical nation'. There were many other voices who made similar claims. Contemporary French art – in particular the art of the 'man of blood', the regicide David – was presented as artificial, either mechanical or full of 'glitter'.[19] British art was held to have preserved a true classical tradition and also to have shown a welcome honesty and naturalism. The Dutch-inspired naturalism of the genre painting of David Wilkie was considered to be a prime example of the latter, as was landscape painting. The quality of British landscape painting had indeed developed remarkably during this period, most notably at the hands of J.M.W. Turner. Once again the patriotic mood of the country had done much to stimulate the practice, particularly when it could be seen to celebrate the beauties of the local land. Indeed, the growing interest in local scenery had been one of the dominating characteristics of the later eighteenth century, leading to the promotion of a whole practice of making 'Picturesque' tours to areas of great natural beauty. Although such a movement was well under way before the Napoleonic Wars, the appreciation of British countryside was immensely enhanced by the wartime mood.

Although the product of isolation, this new mood of bullishness about British art could be supported to some extent by signs of interest abroad. While opportunities for selling prints abroad became limited – particularly after the Continental blockade – works by British artists still did become known. The 'simplicity' of British taste was much appreciated in the outlines of the British sculptor John Flaxman (see profile of sculpture depicted in fig.33), which became the rage amongst devotees of Neoclassicism from their first appearance in 1793.

At the other end of the scale British prints of a very different kind were being appreciated for their unbridled satire. The development of the political cartoon, like the English garden, is one of the greatest of British visual exports. Yet, as so often, it is the result of an import. Caricature was an Italian practice – especially portrait caricature – and comes from the Italian word *caricare*, 'to overload'. Portrait caricature became a fashion in England as a result of encounters with the practice by Grand Tourists. In the early 1740s the work of one of the most prominent Italian portrait caricaturists, Pier Leone Ghezzi, was made available to the London public through the publication of engravings after them by Arthur Pond.[20] It gained a new dimension in this country by being linked

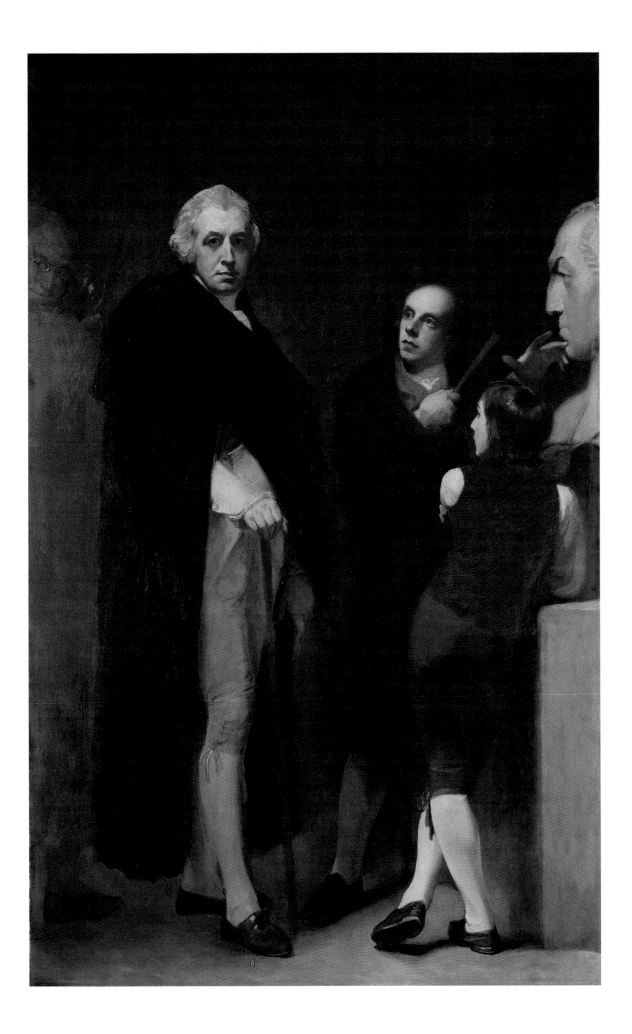

to political cartoons, notably those by George, Marquess Townshend (1724-1807). Although such work was popularly associated with the satire of Hogarth, Hogarth himself rejected it as an unskilled and unnatural form of exaggeration. His own art, he claimed, was based on accurate observation of both visual forms and social practices. Yet Hogarth's innovative kind of visual narrative and attitude of irreverence undoubtedly gave the cartoonist a new armoury. Finally, the development of the sublime in history painting sanctioned a new form of exaggeration (seen especially in the work of Fuseli). All this was to the benefit of political cartoonists in the age of George III. The master was James Gillray. It has been noted already that a level of political freedom is needed for political cartoons to flourish – they are significantly almost absent in Napoleonic France. For admirers abroad Gillray not only enthralled people by the flights of fantasy that could be brought to bear on politicians – and the insight that these provided – but also epitomized a society that allowed open debate and commentary. All these qualities can be found in such works as the masterful *Plum-pudding in danger* (fig.45, p.86). In this Napoleon and the English Prime Minister are shown at table helping themselves to large slices of the world – the sea for Britain, the European Continent for France. Following the Napoleonic period, the political cartoon in Britain lost its edge, but it continued to remain an inspiration for cartoonists elsewhere from Honoré Daumier (1808-79) onwards.

In the post-Napoleonic period opportunity for contact with the Continent was renewed. There was, for a time, a particularly intense relationship that developed in France between British naturalists and the young *Romantiques* – particularly Théodore Géricault (1791-1824) and Eugène Delacroix (1798-1863). Though short-lived, this moment of *anglomanie* set the reputation of British artists as naturalists with particular skill in portraiture, animal painting, genre and landscape. British history painting, by contrast, was felt to be no match for the idealist work produced by French and other Continental artists. British history painting – with the partial exception of imaginative work by Fuseli and (where he was known) Blake – suffered a decline in reputation. It was never to be revived, except briefly in the form of later Pre-Raphaelite and Symbolist work by Edward Burne-Jones and George Frederic Watts (1817-1904) in the last decades of the nineteenth century.

While subsequent generations have also not applauded

the reputation of British genre painters at this time, the case with landscape painting is somewhat different. Although Constable, Richard Parkes Bonington (1802-28; fig.34) and other naturalistic landscape painters only enjoyed a high reputation in France for a relatively brief period in the 1820s, the ideal that their art was held to represent – that of the unvarnished observation of nature – became one of the dominating motifs in French art up to the emergence of the Impressionists in the 1870s. Constable's *Haywain* (fig.25) – awarded a medal at the Paris Salon of 1824 – showed a tranquil country scene with a vivid freshness that suggested a new direction for landscape. This heroic story of the struggle of the avant-garde for visual truthfulness has kept British landscape painting an honoured niche in the history of modernism.

Yet, even in Britain, confidence about the local product began to wane again after the 1820s. Whereas defenders of the naturalist tradition celebrated this as an emanation of the vigorous spirit of enquiry that was endemic to Britain and had been given its full head in culture and society since the Reformation,[21] others felt that the situation was being undermined by the all too rampant commercialism of the developing industrial society. Artistic arguments followed social and economic ones here. As concern mounted about the growing inhumanity of the new order (and its potentially destructive effects on the cohesion of society), so it was felt that the quality of British art was being compromised by materialism. The liberty that had promoted the vigorous and independent voice of Hogarth was now seen as encouraging flashy and meretricious work in the market place of the exhibition. Such concerns were voiced by Continental visitors, many of whose comments were published in Britain. A key example is provided by Gustav Waagen, the distinguished art historian and Director of the Berlin Museums who made a special art tour of Britain in 1835. Waagen had been attracted to Britain – as has been mentioned above – by its magnificent aristocratic collections of Old Masters.[22] However, in his publication on these he also included a section that surveyed the progress of the British school. While full of praise for Hogarth and the painters of the eighteenth century, he was shocked by what he saw as the sloppiness and commercialism of contemporary British art. He singled out Turner for censure because of the incompleteness of his style. This characteristic came as a shock to Waagen – as to many Continental observers – as he had only known Turner's work through engravings

34 RICHARD PARKES BONINGTON
French Coast with Fishermen c.1825
Oil on canvas 64.3 × 96.7 (25¼ × 38⅛)
Tate. Purchased with assistance from
the Heritage Lottery Fund, The Art Fund
and Tate Members 2004

where such lack of detail is disguised.[23] It was Waagen's contention – supported by other German commentators such as J.V. Adrian and J.D. Passavant – that commercial competition had brought Turner to this low condition.[24] Despite the evident absurdity of this idea (Turner's indistinct manner was, after all, deeply uncommercial), it was taken seriously by those British commentators who wished to reintroduce a sense of the higher ideal into British art.

The 1830s were, in fact, a time of intense public debate about the public and social role of art. The call for official state support of art in order to enable it to perform its higher functions was not new. In one form or another it reached back to the Renaissance and had been argued with particular urgency in the later eighteenth century when British history painting was first being thought of as a developing school. But there was a new urgency to the issue in the 1830s when the country as a whole was felt to be going through a time of moral crisis.

In the past the call for state support for British art had been accompanied by contrasts with the state system operating in France. In the early Victorian period, however, this model was supplemented by one from a more unusual source: Germany. Prior to the nineteenth century, and despite a significant achievement including such international figures as Albrecht Dürer (1471–1528), German art had not figured large on the international scene. Its emergence in the early nineteenth century requires some explanation. In the first place it related to a rise in the profile of German intellectual life and culture in the period, exemplified by the emergence of such figures as Immanuel Kant, Johann Wolfgang von Goethe and Ludwig van Beethoven. In the second place it related more specifically

to the success of the Nazarenes, a group of artists who had achieved fame in Rome for their move to revive the art of the Middle Ages. Such a move not only astonished by its visual rigour, it also gained respect – in a post-Napoleonic and post-Revolutionary world – for its moral rigour. It became the 'official' art of the new German regimes. In Munich, in particular, the Nazarenes and their followers were afforded huge opportunities to create overwhelming murals: 'The Germans are the first artists in Europe' declared the Art-Union magazine in 1839.[25]

The rise in the reputation of the Germans coincided with a new crisis of faith in British history painting. While confidence in British naturalistic art remained high – volume one of John Ruskin's *Modern Painters* (1843) assumed that there was no other contemporary art worth talking about in this regard – it was recognized that current British history painters enjoyed neither the training nor the opportunities offered to their Continental colleagues. The German example was also brought to the fore by the monarchy, particularly after the marriage of Prince Albert to Queen Victoria in 1840. In an attempt to provide opportunity, competitions were organized for the decoration of the new Palace of Westminster. For a brief period British history painters adopted a 'Germanic' mode of design in the hope of employment. So prevalent was this craze that it led to much satire by Punch. Indeed, it was at this juncture that the word 'cartoon' became primarily associated with political satire rather than with its original designation as a design for history painting – so much did Punch send up the new 'cartoons' for the Westminster competition.

It might seem that this short-lived Teutonic input had little lasting impact on British art. However, while the

35 DANTE GABRIEL ROSSETTI
Beata Beatrix 1864–70
Oil on canvas 86.4 × 66 (34 × 26)
Tate. Presented by Georgiana,
Baroness Mount-Temple, in memory
of her husband, Francis, Baron
Mount-Temple 1889

Westminster project was far from being the most glorious moment in British art, it did signal more far-reaching and significant changes. At the time Anglo-German relations were close and admiration for the official organization of art in German states was considerable. In effect this brought about a change of government attitude. When the history painter Benjamin Robert Haydon (1786–1846) had tried to interest the Prime Minister Lord Melbourne in official reform and support for the arts, the response had been 'God help the minister who mingles in art'.[26] Now it was understood as an important aspect of manufacture and national prestige. The result was the development of government schools of design, reform of the Royal Academy Schools (on several occasions) and ,further, support for a move towards the development of public collections of art, both for the instruction of artists and for the edification of the public. It is symptomatic of this move not only that national and civic collections of art were established throughout the country, but also that these were organized on didactic lines. Charles Eastlake

(1793–1865) – one of the most prominent artistic Germanists – led the way by reorganizing the hang of the National Gallery on historical lines during his time as director there.

As well as providing a new stimulus for the whole concept of officially promoted history painting, the German model also encouraged a new level of seriousness in less conventional genres. The most significant innovation artistically in early Victorian Britain was the emergence of the Pre-Raphaelite Brotherhood. This group, with its stirring reformist programme, has been seen as a quintessentially British phenomenon. Certainly its unique mixture of visual literalness and intellectual high-mindedness had no parallel elsewhere. Its most poetic form – that innovated by Dante Gabriel Rossetti (see fig.35) – was certainly the most successful painterly export in the last decades of the nineteenth century, where it coincided with the development of Symbolism. Yet this original emergence can be seen as a kind of riposte to the 'German Manner' – much as the originality of Hogarth was a riposte to French rococo art a century before. Despite claims by William Holman Hunt (1827–1910) never to have been interested in German art or to have known of the Nazarenes, many members had been participants in the Westminster cartoon competitions when Germanism was all the rage. Furthermore, the agenda of the Pre-Raphaelites and the Nazarenes is so close that it is inconceivable that the one could have been forged without knowledge of the other. The difference lies in the way that the Pre-Raphaelites – encouraged by Ruskin – aligned their high-minded medievalism with a naturalist manner and a freer attitude to the imagination.

The success of the Pre-Raphaelites also stimulated a return to a more upbeat attitude to indigenous art in Britain, a move greatly supported by Ruskin. Claims here were soon put to the test when direct comparison between national art movements was made possible by the new practice of staging international exhibitions. In this context promotion of British art was taken seriously at official levels, as can be seen in the care with which the British submission of works for the Universal Exhibition in Paris was organized in 1855. Contemporary British artists, including both Pre-Raphaelites and the most established Academicians, were strongly represented. The resultant body of work created astonishment and some admiration. While some dismissed it as symptomatic of *l'isolation britannique* – the bizarre outpourings of an island of irredeemable eccentricity – there were others who felt there

was much to admire and wonder at in the unusual works. Once again enthusiasm was felt that particularly for naturalism and individualism – the latter often being manifested in extraordinary fantasy. Some of the most percipient observers could see genuine pictorial innovation amongst the strangeness. Delacroix – reviving the enthusiasm of his youth for British naturalism – admired the treatment of colour in the shadows of Holman Hunt's *Our English Coasts* exh.1853 (fig.36), a work that adumbrated in this aspect the techniques of the Impressionists.

The *Exposition Universelle* of 1855 established a pattern that was to be repeated throughout the rest of the nineteenth century. Large-scale international exhibitions remained a prime site for countries to show their art productions in

rivalry with each other. While such exhibitions took place throughout Europe, special importance was attached to those in Paris. By the mid-nineteenth century the prestige of Paris – always high since at least the early eighteenth century – had made it unrivalled as the cultural capital of the modern world. The redesigning of Paris by Georges-Eugène Haussmann (1809–91) under Napoleon III represented the culmination of this development. Whatever the claims of London on the economic and political front, it could provide no rivalry to Paris in cultural matters after that; and neither could any other city in the world.

This fact in itself helps to explain the growing focus on Paris and French art that was evident in Britain in the later part of the nineteenth century. Such a movement was also

37 EDWARD BURNE-JONES
King Cophetua and the Beggar Maid 1884
Oil on canvas
293.4 × 135.9 (115½ × 53½)
Tate. Presented by subscribers 1900

helped by the gradual cooling of relations between Britain and Germany after 1870 as political and commercial rivalry between the British Empire and the new German Reich intensified.

In France curiosity about British art continued to grow, aided not just by exhibitions but by publication. A key work was Ernest Chesneau's *La peinture anglaise* (Paris 1882), which surveyed the development of English art and gave fulsome praise to the Pre-Raphaelites. Yet his overall conclusion was that the British were a race of individualists and that this individualism was evident in the diversity of their art. At a time when French artists were themselves seeking to break with the authority of officialdom such individualism seemed highly attractive. The growing interest in Symbolism, furthermore, gave a particular allure to the dreamy idealist work of British Pre-Raphaelites and aesthetes. By 1890 certain British painters – notably Burne-Jones and Watts – had acquired cult status in Symbolist circles. 'For a long time among the Symbolists,' wrote the French critic Robert de la Sizeranne in 1895, 'one heard the warm mention of the names of Watts and Burne-Jones, and many accepted them and passed them on as one does with a magical word requiring no explanation.' [27]

Burne-Jones had been a force to reckon with in Paris since the exhibition of *Love among the Ruins* 1870–3 (a second version of 1894 is in Wightwick Manor, West Midlands) and the *Beguiling of Merlin* 1874 (Lady Lever Art Gallery, Port Sunlight) at the Universal Exhibition in 1878. His reputation reached a new height in 1889 with the exhibition that year of *King Cophetua and the Beggar Maid* 1884 (fig.37) at the Universal Exhibition, where he was awarded the Cross of the *Légion d'honneur*. Burne-Jones's etiolated picture of a waif-like beggar enchanting a monarch with her wan beauty chimed well with the current interests of French Symbolists, particularly its archaism and use of the motif of the *femme fatale*. Significantly, the award of the *Légion d'honneur* was campaigned for on behalf of the artist by the *grands maîtres* of French Symbolism, Pierre Puvis de Chavannes (1824–98) and Gustave Moreau (1826–98), for, as has already been suggested it was the growing popularity of Symbolist art that was the basis of his success. With the decline of interest in Symbolism around 1900 this French interest in Burne-Jones also abated. A change of mood can indeed be detected in a number of publications on British art that appeared in Paris in the mid-1890s, notably those by Olivier-Georges Destrée, Gabriel Mouray and Robert de

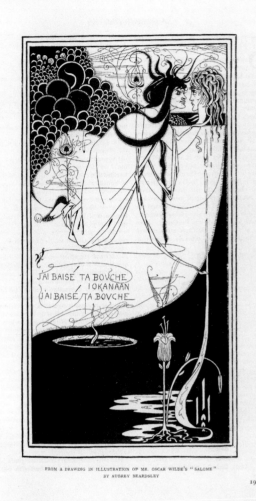

FROM A DRAWING IN ILLUSTRATION OF MR. OSCAR WILDE'S "SALOME"
BY AUBREY BEARDSLEY

la Sizeranne. [28] For these writers British art was still seductive, but dangerous to imitate as it appeared to look backwards rather than forwards. Critical attention by now had tended to move from Burne-Jones to Aubrey Beardsley (1872–98), who, while admirable for his daring use of black and white, seemed ultimately to exemplify dead-end decadence. [29] Beardsley's illustrations to Oscar Wilde's *Salome* – particularly the scene where Salome kisses the decapitated head of John the Baptist (fig.38) – combined exquisite formal elegance with brutality, blood and death. Perfect in itself, Beardsley's consummate art seemed to represent the end of a line, an awesome final achievement.

Yet there was one area in which British art – or at least British art practice – continued to attract interest and admiration. This was the Arts and Crafts movement. William Morris's radical combining of art and politics – his attempt both to save craft from the debilitating effects of industrialization and to break down the division between artist and craftsman – may not have led to the establishment of the earthly paradise that he envisaged. But it was an inspiring vision, all the same, and one that had an alluring visual manifestation in the highly decorative medievalizing products of his own firm. While in Britain it was perhaps most effective in the long run in setting up a specialist and largely reclusive craft revival, on the Continent it ushered in an age of design reform that was eventually to be one of the generative forces of the Bauhaus and hence the hub of modern design. As with Hogarthian satire and the naturalism of British landscape painting, it would seem that Morris's movement formed yet a further example of a British artistic innovation whose widest ramifications took place abroad.

While later Pre-Raphaelitism and design reform formed the basis of Continental interest in British art at this time, British artists were looking abroad for quite different things. Ironically the stimulus provided by British naturalism in the early nineteenth century had encouraged the French avant-garde to move towards a form of empirical observational art, which now far surpassed that of British artists. From the time that Barbizon painters began to gain some renown in the 1850s it was clear that the relationship between Britain and France in the field of naturalism had shifted, and the evidence of this became overwhelming once Impressionist painting began to emerge outside France in the 1880s. While French realist art was stoutly resisted in official circles, its allure for younger generations of artists was increasing. Such a tendency was augmented by the growing habit of studying in Paris, made easier both by the growing cheapness and ease of communication and by the spread of the French atelier system, by which means students could enrol for instruction in a freer atmosphere than that imposed by the official academy schools. After 1870 a similar institution was available to British art students in the Slade School of Fine Art in London. Yet Paris remained the ultimate lure for all art students in the later nineteenth century – as it did for those working in all other European countries and in North America.

As French-trained artists returned to settle in Britain,

the interest in and knowledge of French practices increased. Nobody exemplified these changes more fully than the American James McNeill Whistler (1834–1903). After studying in Paris, Whistler came to settle in London, where he had relatives and connections. Yet he continued to maintain his association with the Parisian avant-garde and played a part in forging links between leading artists in France and Britain's nearest approximation of an avant-garde – that of the Pre-Raphaelite Rossetti and his circle. A compulsive publicist, Whistler sought simultaneously to charm and shock London society with provocative protestations of a French-inspired Aestheticism and a stylish elegance. The Aesthetic Movement itself in Britain seemed to signal a peculiar shift towards the French, while remaining distinctly British. On the one hand it built on local idealist tendencies – particularly those of Pre-Raphaelitism and the classical revival in figures such as Albert Moore (1841–93) and Frederic Leighton (1830–96) – while on the other it paid court to the 'shocking' amorality of modern French art and culture, the espousal of the doctrine of 'art for art's sake'. There were also deeper roots in the aesthetic idealism of German philosophy. Even more than the Pre-Raphaelite movement it followed Continental avant-garde tendencies in promoting an artistic creed as an alternative lifestyle. It was a consequence of this that the Aesthetic Movement functioned largely outside official art circles, with the independent Grosvenor Gallery providing a focus as dealers in France were doing for avant-garde movements such as Impressionism and Symbolism. Yet the whole movement was ultimately less radical and confrontational than Continental models. Always dependent upon the support of high society, it dissociated itself from scandal, as Whistler found to his cost when he sued the critic John Ruskin for libel.

Yet whatever the vicissitudes of Whistler's career in Britain, his art and propaganda left few perceptive observers in doubt about the strength and importance of contemporary French art. From the 1880s onwards British artists could be seen to be conducting an essentially rearguard action. The British art world divided into those like Whistler and Walter Sickert (1860–1942) who openly and provocatively championed the cause of contemporary French art, and those who tried to counter this with some alternative form of British modernity. The New English Art Club, originally an organization founded by dissident academicians, negotiated the complexities of the situation, becoming at one moment the domain of artists close to

Impressionism but moving in the 1890s under the influence of Philip Wilson Steer (1860–1942) and Henry Tonks (1862–1937) towards a revived form of British nationalism with Constable as their hero. In general those seeking to revive a British naturalist tradition moved to the country, often setting up artist colonies, like that at Newlyn in Cornwall. It is symptomatic of this revival that the 'English garden' should be revised at this time, moving away from the eighteenth-century Claudian image to an evocation of the traditional cottage garden.[30]

However, even those who were setting up a critique of modern French art by reviving or developing a British naturalist tradition could be seen in a sense to be paying their respects to the French model. Not only did they emulate the institutions of the French avant-garde – the breakaway groups, manifestos and dealers' galleries – they also basically accepted the aesthetic premises of French naturalism, whether this be inspired by the Barbizon painters, Impressionism or the sentimental rural focus of painters such as Jules Bastien-Lepage (1848–84). The resurrection of Constable and Turner as models was dependent upon the more sketch-like side of their work, precisely the work, indeed, that was held by some to be generative of Impressionism.

Response to France can even be found in the move to secure the status of modern British art by according it its own gallery. Henry Tate's magnificent gift to the nation of his collection of recent British art, and the funding of a gallery in which to house it, was widely seen as a move to emulate the French Luxembourg, the state gallery of modern art in Paris. Interestingly there was one significant difference between them in the initial phase. Whereas the Luxembourg was committed to modern art on an international basis, the Tate (or National Gallery of British Art) was restricted to the local product. It was an ambivalent gesture. On the one hand it could be seen as a celebration of the glory of British art, on the other it could be viewed as providing it with a protective environment, away from the competition of other schools. Whatever the intention of the founder, there is no doubt that the National Gallery – its designated parent institution – saw it from the start as a convenient site for offloading its surplus of British painting. Ambiguity about the status of British art was by no means resolved by the founding of the Tate.

By 1900 it was clear that the interest British art had aroused in Continental Europe since the time of the Pre-Raphaelites was waning. The last contemporary British artist to stimulate widespread international interest was Aubrey Beardsley, whose decadent style, while greatly admired, seemed to epitomize an art that had become self-obsessed and inward looking. Critics who had looked to British art to provide models of modernity now stressed its conservative nature. This change can be seen, for example, in the criticism of the German historian Richard Muther, whose monumental *Art of the Nineteenth Century* – a work that was remarkable for its range – had given British art a prime place in the generation of artistic modernism. For him modern art had begun with Hogarth. Yet when visiting the Paris Exposition Universelle of 1900 he recorded his disappointment at finding innovative qualities no longer present in British art.[31]

Rightly or wrongly the perception was that British art no longer had a contribution to make to the modern world. It was an opinion of extraordinarily long duration, still being expressed by Nikolaus Pevsner in his largely supportive and appreciative book on British art, *The Englishness of English Art* in 1956.[32] And, indeed, it was not until Henry Moore won a prize at the Venice Biennale in 1948 that British art was considered once more to have a significant role in the modern international art world. Today, thankfully, this isolationist view of British art is rapidly disappearing.

During the period covered by this chapter, British artists can be seen to have been developing practices that, while distinct, retained at all time strong links with those on the Continent. At different times relations with the Netherlands, Germany, France and Italy have been particularly important. In the later nineteenth century those with France dominated in particular and have subsequently had the strongest effect on the perception of the nature of the British school. Nationalist interests have encouraged readings of British art that stress difference and individuality. Yet the main impression gained from a study of relationships between Britain and the Continent is of the importance of dialogue and interaction. Britain may be an island physically, but culturally it has never existed, still less thrived, in isolation.

Van Dyck in England

JULIA MARCIARI ALEXANDER

The Flemish artist Anthony Van Dyck (1599–1641) is credited with single-handedly transforming courtly representation in seventeenth- century Britain. His virtuoso style, which blended a sense of the modern with the traditions of Venetian painting, was central in creating the image of the court of Charles I, who reigned from 1625 until 1649.

Van Dyck entered the Antwerp workshop of Peter Paul Rubens sometime around 1615, and quickly became known as the most gifted of the master's assistants. Although he was made a Master of the Guild of St Luke in Antwerp in 1618, he continued to work in Rubens's studio until 1620 when, armed with letters of introduction from Rubens, he left for London. There, he found employment at James I's court, though there are, surprisingly, only two securely dated paintings from his English sojourn. By March 1621 he was back in Antwerp, and in October he left for Italy, where he assiduously studied the Renaissance Masters, especially the Venetians. Throughout the 1620s he made his reputation by painting religious and mythological subjects as well as portraits of European monarchs and aristocrats. Returning to London in 1632, he brought not only those paintings he had made himself, but also his collection, which included works by Titian (c.1485–1576).

His arrival in London was a coup for Charles I, whose unparalleled collection of European art displayed his ambition to rank among the great monarch-collectors. The King knighted Van Dyck in July 1632 as 'principalle Paynter in Ordinarie to their Majesties', a post that carried a stipend of £200 per year. From the outset Van Dyck's portraits of the royal family and their allies glorified the King and his courtiers, and solidified his international reputation. His approach to portraiture had certainly been developed before he arrived in England, but now he took the opportunity to capture the ethos of an entire court culture. Indeed, he seems to have revelled in the elegant and urbane atmosphere of the Caroline court.

His royal portraits blended the image of thoroughly modern rulers with the iconography of past sovereigns. *Equestrian Portrait of Charles I* c.1636–7 (fig.40) recalled Titian's portrait of Emperor Charles V of 1548 (Museo del Prado, Madrid) and Rubens's of Philip IV of Spain of 1628 (formerly Spanish royal collection, destroyed in the 1734 fire at the Alcazar; a contemporary copy is now in the Uffizi). Van

39 ANTHONY VAN DYCK
Queen Henrietta Maria with Sir Jeffrey Hudson 1633
Oil on canvas 219.1 × 134.8 (86¼ × 53¹⁄₁₆)
Samuel H. Kress Collection
National Gallery of Art, Washington

Dyck's life-size portrait depicts the king as both stylish and martial: he sports a fashionable hairstyle and beard, while he seems at ease in his well-worn riding boots and armour. Van Dyck's Charles I is an imposing but contemporary monarch, whose control of his enormous steed embodies his ability to reign with a firm and easy hand.

In his compelling 1633 portrait of Henrietta Maria (1609–69), the French princess who had married the King in 1625, Van Dyck constructs a misleadingly informal image of the Queen, posing in a hunting dress alongside her dwarf Jeffrey Hudson (fig.39). The artist's flickering touch gives a vibrancy to the sitters, and his juxtaposition of fabrics emphasizes their delicacy while demonstrating his painterly prowess. He engages in a subtle use of symbols to impart the majesty of his modern queen: her crown is unceremoniously placed just behind her, and she effortlessly controls the monkey held by Hudson. Van Dyck's penchant for flattery could often lead to disappointment: Henrietta Maria's niece,

having only seen Van Dyck's portraits of her, was shocked to meet 'a little woman with long lean arms, crooked shoulders and teeth protruding from her mouth like guns from a fort'.

Although Van Dyck's portraits reflected and contributed to the aura of easy glamour that pervaded the Caroline court, political and religious tensions ran high throughout the 1630s, eventually leading to the Civil War and the execution of the King in 1649. The painter endowed all his English patrons with the attributes of beauty, wit and power, and, like all successful artists in seventeenth-century Europe, he inevitably worked for patrons with varied political and religious affiliations. Among his most powerful portraits is that of Robert Rich, 2nd Earl of Warwick (c.1633; Metropolitan Museum of Art, New York), a prominent court figure who nevertheless became a leader in the parliamentary cause.

Van Dyck's painterly virtuosity itself affirmed his patrons' taste, and his portraits became status symbols for later generations eager to demonstrate their own. In their debt to the conventions of past masters and in their often playful allusions to contemporary life, his English portraits set the standard for eighteenth-century painters and patrons.

FURTHER READING

Barnes, S.J., N. De Poorter, O. Millar and H. Vey. *Van Dyck: A Complete Catalogue of the Paintings*, New Haven and London 2004.
Brown, C. and Hans Vlieghe (eds.). *Van Dyck, 1599–1641*, exh. cat., Koninklijk Museum voor Schone Kunsten, Antwerp 1999.
Millar, O. *Van Dyck in England*, exh. cat., National Portrait Gallery, London 1982.

40 ANTHONY VAN DYCK
Equestrian Portrait of Charles I c.1636–7
Oil on canvas 367 × 292.1 (144½ × 115)
National Gallery, London

Italian Painters in Britain

MICHAEL LIVERSIDGE

During his stay in England in 1629–30 Peter Paul Rubens was astonished by the number of Italian pictures in the collections of Charles I and his courtiers. But while the best Italian art was highly prized at the Caroline court, the best Italian artists could not be enticed to England; Charles I tried in vain to persuade Giovanni Francesco Barbieri ('Il Guercino'; 1591–1666) and Gianlorenzo Bernini (1598–1680), although with Orazio Gentileschi (1563–1639) who arrived in 1626 he attracted one of Italy's most accomplished painters whose luminously poetic version of early Baroque realism can be seen in the ceiling of *The Liberal Arts* he painted for the Queen's House at Greenwich.

The Civil War and Commonwealth extinguished Charles I's glittering Renaissance court, but the Restoration in 1660 inaugurated a revival inspired by European models encountered in exile on the Continent, which culminated in an English version of the late Baroque splendours of France and Italy. However, while architects defined a distinctively English Baroque style, in almost every department of painting foreigners were dominant. In *An Essay towards an English School* Bainbrige Buckeridge diagnosed in 1706 why so few native painters could compete with the visitors who were employed in England: 'Had we an academy, we might see how high the English genius would soar; and as it excels all other nations in Poetry, so, no doubt, it would equal, if not excel, the greatest of them all in Painting.'

From the Restoration, Italians significantly influenced and participated in the mainstream of English painting for over a century. The more voluptuous tastes of the time are typified by Guercino's pupil and heir Benedetto Gennari (1633–1715), whose seductive *Death of Cleopatra* 1686 (Victoria Art Gallery, Bath) superbly characterizes his work in England for royal and court patrons between 1674 and 1688. Most Italians practising in England from the 1670s to the 1730s were principally employed in decorating the sumptuous baroque interiors that the new generation of architects from Christopher Wren to John Vanbrugh created for royal palaces, London houses and country mansions. The first to arrive was Antonio Verrio who probably learned his version of the high Baroque idiom in Naples and Rome before moving to France in 1671. Brought to England by Ralph Montagu, ambassador in Paris, to decorate his London house, Verrio was chosen in 1675 to paint Charles II's new state rooms at Windsor in the

41 Wall paintings on the staircase of Kimbolton Castle by Giovanni Antonio Pellegrini, 1708–12

Versailles manner. He went on to execute a series of royal commissions, his last being at Wren's Hampton Court state apartments for William III and Queen Anne, which he worked on from 1699 to 1705; his other works included painting interiors in the grandest Baroque manner at Chatsworth and at Burghley.

An influx of Venetian decorative painters followed, the first of whom – Giovanni Antonio Pellegrini (1675–1741) and Marco Ricci (1676–1729) – were brought back to England in 1708 by another ambassador, Charles Montagu, Earl (later 1st Duke) of Manchester, for whom John Vanbrugh was completing Kimbolton Castle. These painters introduced a radiantly painterly approach, particularly apparent in the wall paintings and fitted canvases that Pellegrini made for Kimbolton (fig.41) and Castle Howard. The same sensibility distinguishes the staircase paintings at Burlington House, Piccadilly, executed by Sebastiano Ricci (1659–1734). Pellegrini and the two Riccis (Sebastiano had arrived in England in 1712) left England in 1716 when they were passed over in favour of James Thornhill for the commission to paint St Paul's Cathedral dome. They were followed by two more arrivals from Venice: Antonio Bellucci (1654–1726), who worked extensively at the Duke of Chandos's splendid house, Canons, in Middlesex from 1716 to 1722, and Jacopo

Amigoni (?1682–1752), who stayed ten years from 1729. Amigoni's best work in England was a set of rococo mythologies for Moor Park, Hertfordshire, but by the 1730s Palladian Revival architects favoured more purely architectural interiors and he turned to portraits painted in a style described by James Ralph in 1734 as 'calculated to please at a Glance by the artful Mixture of a Variety of gay Colours'.

The traffic in works of art to England meanwhile flourished through dealers and agents (like Joseph Smith, the British Consul in Venice), who supplied the British travellers making the Grand Tour. The cultural and artistic exchanges effected by the Grand Tour largely account for Italian artists finding their way to work in eighteenth-century England. Landscape and view paintings were in particular demand, especially those of Canaletto (1697–1768), whose presence in London for all but a few months from 1746 to 1755 had a lasting impact on English topographical artists (see fig.42). He was preceded in 1742 by another view painter he had already influenced in Venice, Antonio Joli (c.1700–68), who painted stage scenery as well as making city prospects. Another painter from Venice, and like Canaletto one of Consul Smith's artists, was Francesco Zuccarelli (1702–88), whose picturesquely arcadian landscapes complete with ornamentally rococo rustics

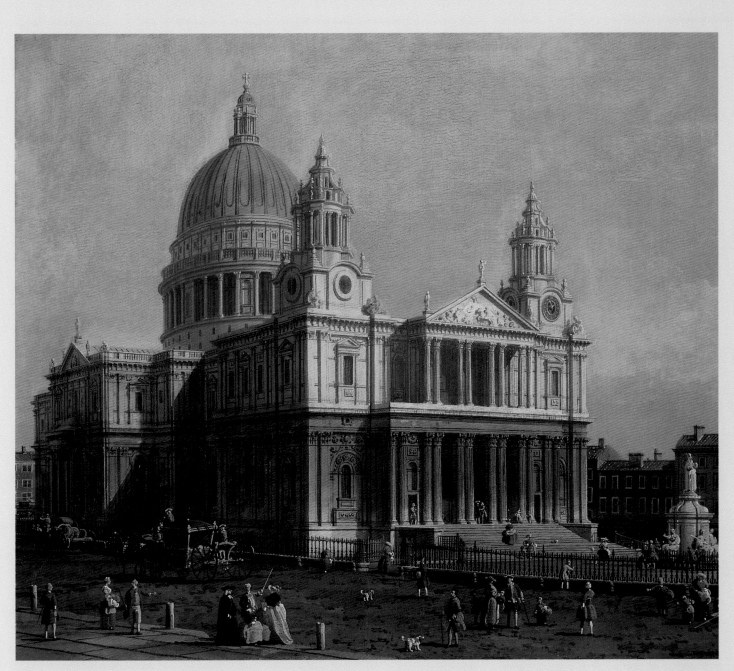

42 CANALETTO
St Paul's Cathedral 1754
Oil on Canvas 52.1 × 61.6 (20½ × 24¼)
Yale Center for British Art, New Haven
Paul Mellon Collection

sold well enough for him to stay from 1752 to 1762, and brought him back again from 1765 until 1772 when he became President of the Accademia in Venice.

The classical taste of British Grand Tourists and artists going to Italy gave a fresh impetus to Italians seeking employment in Britain. Among the more important was Giovanni Cipriani (1727–85), who arrived in 1755 and stayed for the rest of his career. An instructor at the St Martin's Lane Academy and in the Duke of Richmond's sculpture gallery in Whitehall, he produced work for interiors by Robert Adam and William

Chambers. Another Italian associated with Robert Adam was Antonio Zucchi (1726–95), who helped him prepare drawings of the ruins of Diocletian's Palace in Croatia. In 1766 he moved to London and became one of Adam's principal suppliers of refined decorative Neoclassical subjects for insertion into wall and ceiling compartments. In 1781 Zucchi married Angelica Kauffman (1741–1807; see Rosenthal, pp.82–3). She, Cipriani and Zuccarelli were foundation members of the Royal Academy, a measure of the enduring Italian influence on British art in the later eighteenth century.

FURTHER READING

Allen, E. 'Venetian Painters in England in the earlier eighteenth century', in Michael Liversidge and Jane Farrington (eds.), *Canaletto & England*, London and Birmingham 1993, pp.30–7.
Croft-Murray, E. *Decorative Painting in England 1537–1837*, 2 vols., London 1962, 1970.
Waterhouse, E. *Painting in Britain 1530–1790*, 4th ed., Harmondsworth 1978.

Angelica Kauffman

ANGELA ROSENTHAL

The Swiss-born, Italian-trained artist Angelica Kauffman (1741–1807) was one of the most important and influential woman artists of the eighteenth century. Kauffman lived most of her life in Rome, but during the years she spent in Britain (1766–81) she established an international reputation, receiving royal patronage and, in 1768, becoming one of only two female founding members of the Royal Academy in London. Extremely ambitious and hard working, Kauffman later became a central figure in the Roman art world. Although it was as an acclaimed portrait painter that Kauffman gained access to a wide patrician and aristocratic clientele, she was considered extraordinary on account of her ambitious forays into history painting. The popularity of prints, decorative paintings and the range of consumer goods (including porcelain, fans and calendars) based on her designs led one contemporary to exclaim, 'The whole world is *Angelicamad*!'

During her early artistic training in Rome Kauffman met Johann Joachim Winckelmann, who helped to stir her interest in allegorical painting, ancient art and the aesthetics of Neoclassicism. Her remarkable portrait of Winckelmann 1764 (Kunsthaus Zürich), captures the German expatriate as an inspired author and thus celebrates his foundational *History of Ancient Art* in the year of its publication, 1764. During that period Kauffman also completed her first paintings of ancient Greek and Roman subjects, one of which represents Penelope, the virtuous heroine of Homer's *Odyssey*, seated at her loom (fig.44). This painting, her first documented single-figure history painting, serves as an allegory for Kauffman's own artistic ambitions as an emerging history painter, presenting on a monumental scale an alternative to the 'master' texts of the *Odyssey*. It initiated Kauffmans's lifelong fascination with powerful female characters such as Sappho, Clio, Constanza and subjects that privilege feminine virtue, sensuality and courage.

In 1766 Kauffman's powerful portrait of David Garrick (Burghley House Collection, Cambridgeshire), painted in Naples in 1765 and shown at the Free Society in London that year, established her professional career and, preceded by word of mouth, was the basis of her later fame in London. The celebrated actor seems to avoid all role-playing as he poses informally, looking over the back of a chair at the viewer. Yet it was Kauffman's painting of

43 ANGELICA KAUFFMAN
Portrait of Joshua Reynolds
Oil on canvas 127 × 101.5 (50 × 40)
Saltram House, Devon. National Trust

Britain's leading portraitist, Joshua Reynolds (fig.43), that introduced her into the artistic community of London. Lauded in the press, the portrait flatters Reynolds's intellectual and theoretical ambitions, while representing him as a personable and intimate conversational partner.

Throughout her career Kauffman's portraits of men received praise, but also criticism for

their softness and effeminacy. Similarly, her male heroes in history paintings display a restrained and blunted masculinity. These qualities were in part the product of a broader demand for subjects or themes that increasingly privileged private emotions and virtues as feminine. Kauffman expands on Winckelmann's aesthetic ideal of subdued masculinity, and in her choice of subject matter promotes delicate

modelling and softened contours, the visual expression of a new form of sensibility. Her narrative paintings often skilfully probe and dissolve any rigid contrast between masculine and feminine, rational and emotive, public and private, and homo- and heterosexual. This becomes especially clear when one considers images that employ masquerading and disguise, and history paintings that focus on cross-gender role-playing.

Kauffman's widely celebrated portraits of women include a series depicting female sitters in Turkish garb, inspired by the perceived freedom and beauty of Turkish women vividly described in Lady Mary Wortley Montagu's travel accounts of the Levant, her celebrated *Embassy Letters* (1763). Among Kauffman's most remarkable portraits of female sitters, however, is a group dating from the 1790s depicting other creative women, including the writer Cornelia Knight, the improvisational poets Teresa Bandettini and Fortuna Fantastici, and the actress Emma Hart, Lady Hamilton. In these striking paintings Kauffman registers the quasi-mythological relations she enjoyed with her muse-like sitters and sister-artists.

Kauffman's *oeuvre* also contains a fascinating array of more than two dozen drawn, printed and painted self-portraits. In these images the artist balances her public and professional visibility with contemporary notions of ideal female decorum. They reveal Kauffman's ability, conscious or otherwise, to position her creative and created persona in relation to diverse and changing audiences, within an artistic culture of male privilege. Apart from direct self-representation, Kauffman also inscribes her artistic position in her history paintings representing the legendary artists Apelles and Zeuxis. In this manner, one can read in Kauffman's paintings not only a reflection and propagation of Enlightenment sensibility, but a subtle critique of the male-dominated art world of her day.

FURTHER READING

Rosenthal, A. *Angelica Kauffman: Art and Sensibility*, London and New Haven 2006.

Roworth. W.W. (ed.). *Angelica Kauffman: A Continental Artist in Georgian England*. London 1992.

44 ANGELICA KAUFFMAN
Penelope at her Loom 1764
Oil on canvas 169 × 118 (66¾ × 46½)
Royal Pavilion, Brighton and Hove

3 Britain and the World Beyond c.1600 – c.1900

ROMITA RAY AND ANGELA ROSENTHAL

45 JAMES GILLRAY
The Plum-pudding in danger; – or – State Epicures Taking un Petit Souper 1805
Published by Hannah Humphrey,
26 February 1805
Etching with hand colouring
26 × 36.3 (10¼ × 14¼)
Courtesy of The Lewis Walpole Library,
Yale University

JAMES GILLRAY'S *The Plum-pudding in danger; – or – State Epicures Taking un Petit Souper* of 1805 (fig.45) shows William Pitt the Younger and Napoleon Bonaparte slicing up the world. The former, skinny and tall, stabs defensively with his fork into the Atlantic Ocean to claim no less than half of the globular and steaming pudding, whilst a tiny Napoleon impishly rises from the edge of his seat, eagerly securing a healthy slice comprising rich parts of Europe (France, Holland, Spain and Prussia). As this print indicates, by 1805 Anglo-French appetite for overseas territorial acquisition was 'insatiable'.[1] The long-established rivals Britain and France could hardly be imagined in isolation from one another or from the rest of the world. In the nineteenth century Britain laid claim to a substantial portion of the plum pudding, a complex international empire here transformed into a familiar English dish, sweetened with sugar from West Indian plantations and flavoured with spices such as nutmeg, indigenous to tropical Southeast Asia and Australasia.

The British had tasted imperialism, and the patterns of consumption that developed in the global market had profound effects on the cultures of both Britain and the world beyond. As Britain came to govern, explore and exploit its imperial holdings, it simultaneously exported its own cultural norms and assimilated those of the cultures it encountered, developing a particular form of imperial Britishness still visible today.

Already in 1711 Joseph Addison described the physical complexity of Britishness, based as it was on an immense diversity of imports:

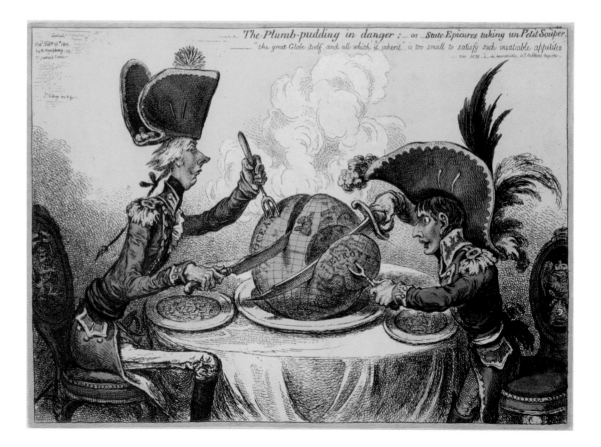

Our Ships are laden with the Harvest of every Climate: Our Tables are stored with Spices, and Oils, and Wines: Our Rooms are filled with Pyramids of *China*, and adorned with the Workmanship of *Japan*: Our Morning's-Draught comes to us from the remotest Corners of the Earth: We repair our Bodies by the Drugs of *America*, and repose our selves under *Indian* Canopies. My Friend Sir Andrew calls the Vineyards of *France* our Gardens: The Spice-Islands our Hot-Beds; the *Persians* our Silk-weavers, and the *Chinese* our Potters. Nature indeed furnishes us with bare Necessities of Life, but Traffick gives us a great Variety of what is Useful, and at the same time supplies us with every thing that is Convenient and Ornamental.[2]

Addison's insistent repetition of the possessive pronoun 'our' makes clear the process of assimilation by which the world's goods were seen to signify British identity.

Gillray's widely circulated print views Britain in a global rather than just a European context. But we need to see Britain's relation to the world not as a one-sided assimilation and consumption of other cultures, but in terms of multiple encounters that entailed various forms of cultural exchange. This chapter suggests some ways in which we might broaden and reconfigure the history of British art by exploring the territorial and imaginative impact of global exploration, colonial expansion and imperial domination on British visual culture in the period, both at home and abroad. The often aggressive transformation of the world by British power, as well as scientific and exploratory encounters with different cultures and peoples, brought about such changes in British visual culture that it is impossible to consider British art in isolation from its new global environment.[3]

From the assimilation of colonial objects into British collections and the infusion of non-European aesthetics into British art to subtle shifts in cultural identity, British art during the colonial and imperial periods was inextricably bound up with matters of taste and consumption. As increasing numbers of British artists travelled to distant parts of the world and explored new subjects, a fresh sensibility towards light, colour and atmosphere evolved. Our essay revisits familiar genres like portraiture and landscape painting within the larger scope of British colonial and imperial histories, but also examines how different parts of the world were assimilated into painting and the decorative arts.

Britannia's Heroes

Throughout the seventeenth and eighteenth centuries Britain and France engaged in a series of wars on the European mainland and in the Americas. Imperial ambitions soon expanded eastwards and, following economic competition in India, by the end of the 1700s colonialism was a matter of state-sponsored expansion. Nearly two hundred years after the Virginia Company established the Jamestown Colony in 1607 under the auspices of King James I, Benjamin West's *The Death of General Wolfe* 1770 was displayed at the Royal Academy in London in 1771 (fig.32, p.67). The painting commemorated the consolidation of Britain's power in colonial America at the Battle of Quebec in 1759, during which British Major-General James Wolfe perished after defeating the French army. West transformed the mortally wounded Wolfe on the battlefield into a Christian martyr, who had died dutifully beneath the furled Union Jack.[4] Shown surrounded by fellow officers, including Sir William Johnson, who had convinced the Six Nations to join forces with the British during the French and Indian War,[5] and a kneeling Iroquois figure, the British commander's death was represented as a sacrifice for colonialism.[6] West had helped modernize history painting, not only by departing from the traditional use of classical dress, but by depicting the global stage of Britain's ongoing conflicts with France. Five years after the painting was completed, the Americans declared their independence from Great Britain. It was at this turning point in British colonial history that another distant region emerged as a colonial battlefield. From antiquity onward India had long attracted Western European conquerors, merchants and other travellers; now, like the Greeks, Portuguese, Danish and Dutch, the British and French also tried to establish their presence in that hub of colonial competition.

In 1761-2 Francis Hayman (1708-76) completed a now lost history painting, known only from an engraving and a preliminary oil study (fig.46), for Vauxhall Gardens in London. It depicted Lord Clive Meeting Mir Jafar, Nawab of Murshidabad, after the Battle of Plassey and celebrated the victory of British East India Company officer Robert Clive over the Mughal army in Bengal, the battle that secured the Company's power in India. Clive is portrayed alongside Mir Jafar, commander of the Nawab of Bengal's forces, who in reality had conspired with the British commander against the Nawab, Siraj ud-Daula. Like West, Hayman used the

46 FRANCIS HAYMAN
*Robert Clive and Mir Jafar after
the Battle of Plassey 1757* c.1760
Oil on canvas 100.3 × 127 (39½ × 50)
National Portrait Gallery, London

British flag to establish the patriotic tenor of the composition and also presented a military officer as a hero beneath the flag. Unlike the dying Wolfe, however, Clive steps forward to greet his ally Mir Jafar; the act of treachery is glossed over as a military triumph. The victory assured the erosion of Muslim power in Bengal, and it also put an end to any possible alliance between the Nawab and the French. Thus, Hayman's painting is as much about the foundation of British rule in Bengal as it is about the elimination of British enemies. Exhibited in the annex to the rotunda at Vauxhall Gardens, the image was commissioned from Hayman in 1760 by Jonathan Tyers, proprietor of the gardens, along with three other scenes of British victories, including the surrender of Montreal.[7]

In such displays a new type of colonial hero had emerged as a grand spectacle – willing to die on a battlefield in distant lands, fight against powerful foreign armies, or strike alliances with Native Americans and Indian Muslims. Characterized as virtuous Christian soldiers, West's Wolfe resembles a dying Christ and Hayman's Clive is shown as a compassionate leader. In reality Wolfe was a controversial general and none of the companions depicted by West on the battlefield had been present when he died.[8] Similarly, Clive had met Mir Jafar two days after the battle, not immediately after its conclusion as Hayman's painting suggests, and had triumphed at Plassey by colluding with

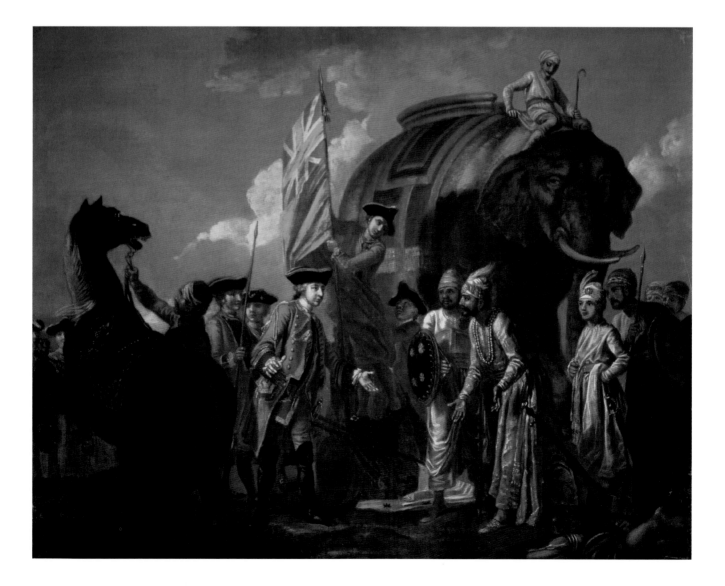

treachery.[9] Yet both images appealed to patriotism by emphasizing lofty ideals of virtue and character. The two generals, though neither were noblemen, were nonetheless portrayed in a manner reserved for those who were. Represented within the traditional framework of history painting, Wolfe and Clive became modern British heroes not through lineage, but in their safeguarding of Britain's colonial assets.

Imperial Frontiers: Travel and Exploration

If generals marched across battlefields abroad to keep the British flag flying, there were others who travelled to the colonies in search of adventure, a career, scientific investigation, and in the case of artists, appealing and saleable views. Since the 'age of exploration', dominated by Iberian travellers, artists, had been employed on such voyages to record the natural riches of the world: exotic plants, animals and meteorological and astronomical events, as well as indigenous peoples. Portraiture and ethnographic studies satisfied European curiosity about different peoples and their environment.

Some artists worked for the state, others for wealthy patrons like Sir Humphrey Gilbert, who organized an expedition to Newfoundland in 1583, and Sir Walter Raleigh, who was granted permission in 1584 by Queen Elizabeth I to colonize North America. Raleigh's determination to invest overseas led to the foundation of the colony of Virginia named in honour of his Queen. During the expeditions to Virginia, that he helped sponsor between 1584 and 1590, a remarkable collaboration emerged between the gentleman-amateur artist John White (fl.1855–93) and the scientist Thomas Harriot. The result was a series of extraordinary watercolours by White and an account of their journey written by Harriot, which was illustrated by White and published in 1590 by Theodor de Bry. Entitled *A Briefe and True Report of the New Found Land of Virginia,* it was the first of a series of New World texts that made de Bry famous. Immensely popular, the book, unlike other travel narratives published before it, combined pictures with text, enabling its readers to visualize the New World. White's watercolour drawings constitute a visual ethnographic record of the Algonquians who inhabited present-day

North Carolina and Virginia, though they also employ poses and gestures derived from Greek and Roman sculpture. De Bry's engravings classicized these features even further. Such pictorial scrutiny of non-Europeans and their customs became the norm throughout the history of colonial European art, transforming human subjects into curiosities. More specifically, White's illustrations became so iconic that numerous artists used them to depict other Native Americans.[10]

Nearly two centuries later, yet another groundbreaking set of journeys took place in the age of scientific revolution: Captain Cook's three voyages to the Pacific Ocean. Cook employed artists Sydney Parkinson (c.1745–71) and Alexander Buchan (?d.1769) on the first voyage across the Pacific (1768–71); William Hodges (1744–97) joined him on the second voyage to the South Pacific and Antarctic (1772–5) and the third navigation to the Northern Pacific and the Arctic (1776–9) was conducted with John Webber (1751–93) as artist on board. Artists were collaborators in a scientific team, which sought to render the 'new' environments visible and legible to a British public. Engravings after many of the still extant drawings, watercolours and oil paintings produced images of an unfamiliar world, geared to British eyes (see Quilley, p.116–17).

Such sponsored visual accounts were complemented by those by independent travelling artists, such as the itinerant Englishman, Augustus Earle (1793–1838), who travelled extensively in Australia and New Zealand. Framing his endeavour as that of a romantic adventurer, Earle's works present a story of dramatic encounter at the fringes of the known world. In his painting *Waterfall in Australia* 1826 he depicts himself in the remote and imposing Blue Mountains, far removed from the hustle and bustle of the nearby colony of Sydney (fig.47). Coat and hat flung aside, the artist appears to have paused spontaneously to sketch the aboriginal guide posed against the dramatic backdrop of a waterfall and cliffs. Another guide points towards this picturesque *tableau vivant*, while four other members of the expedition struggle to gain a foothold among the nearby rocks. On the one hand, the image reflects the Romantic love of exploring nature's boundless beauty; on the other, it echoes the spirit of colonial adventure exemplified by Australian frontiersmen who, by the 1820s, were regarded by fellow colonists as heroes who had overcome the harsh challenges of frontier life in a foreign land.[11] In 1813 Australian landowners George Blaxland, William Lawson

and William Charles Wentworth became the first explorers to cross the formidable ridge of the Blue Mountains.[12] Their journey quickly became legendary, inspiring the poet Michael Massey Robinson to contemplate the wilderness of these mountains where 'scarcely human Footsteps ever trac'd The craggy Cliffs'.[13] But Blaxland, Lawson and Wentworth's mountainous trek was more than just a heroic exploit; their goal was to find viable land for grazing and farming, and their victorious journey paved the way for the expansion of agricultural prospects into the Australian interior.[14] Painted just over a decade after the historic expedition, Earle's image evokes the pioneering journey while drawing attention to the artist's own role as an explorer.

The magnificent Blue Mountains were difficult terrain. Earle's composition manages to hold onto the tension between their visual appeal and their harsh setting by filtering the mountains' rugged character through the aesthetic framework of the sublime, based on a taste for darkness, dramatic ratios of scale and height, and unlimited expanses of space. Although such properties disoriented the viewer by departing from expected notions of visual harmony and balance, they were valued for their capacity to create aesthetic dissonance, following Edmund Burke's influential treatise *Philosophical Enquiry into the Origin of our Ideas of the Sublime and the Beautiful* (1757).[15] In paintings like *Gordale Scar* (exh.1815; Tate, London) by James Ward (1769–1859) and John Martin's *The Bard* (exh.1817; Yale Center for British Art, New Haven), fissures, craggy cliffs and the dizzying drops of mountains were emphasized.[16] Earle may have seen both paintings displayed at the Royal Academy.

British colonialism and imperialism were dependent on the geographical expansion of power. As land was acquired in the colonies and occupied gradually by British citizens, the colonial frontier became an ever-evolving political and cultural boundary. The historic crossing of the Blue Mountains reveals just how one such border was reconfigured as British cities and towns evolved and expanded in New South Wales. If the changing political economy of land in Britain lies at the heart of late eighteenth- and nineteenth-century British landscape paintings, paintings like Earle's reveal an equally if not more complex relationship between land in the colonies and its loci of power shaped by British colonists.[17] Earle's painting shifts away from the more urban setting of Sydney to the countryside, where the heady prospects of agricultural expansion often came up against harsh surroundings. By recalling Blaxland, Lawson and Wentworth's much celebrated expedition, the artist represents the Blue Mountains as a marginalized landscape of isolation, a stark reminder of the hardship of frontier life.[18] Yet he can also be seen as endorsing the Blue Mountains as a landscape of colonial conquest, beyond which pioneering graziers had discovered fresh pastures for their sheep to manufacture wool, the foundation of Australia's early nineteenth-century settlement economy.[19]

As visitors travelled to and fro between the colonies and the homeland, different types of British communities evolved – from tourists like Earle to permanent settlers and frontiersmen who set down roots in their adopted countries.[20] Given the long and often arduous journey by sea, even the tourist tended to stay in colonial destinations for several months, if not several years. A British-born painter of American origin, Earle visited Australia from 1825 until 1828, after touring the Mediterranean, North America and South America. He explored more places in New South Wales than any previous artist, crossing the Blue Mountains to visit Bathurst and the Wellington Valley, and later journeying to the Hunter River, Port Stephens, Port Macquarie and the Illawarra District.[21] In this regard, Earle's picture of the Blue Mountains is as much a heroic self-portrait cast in the guise of an explorer, as it is a landscape painting. His accoutrements like the coat, hat and rifle may be cast aside as he prepares to draw, but they remind the viewer of the artist's love of adventure. Isolated, Earle romanticizes himself by adopting the ethos of the frontiersman's love of the outdoors and of freedom and exploration. But primarily he identifies himself as an artist, undaunted by the perilous grandeur of his surroundings, his composure contrasting dramatically with the discomfort of his white companions. Earle's impulse to draw the scenic view before him suggests the process of drawing as a calming force in the unpredictable and untidy experience of exploring an unfamiliar environment.

The ability to organize visual information extracted from nature into a visually appealing view of a landscape setting posed the challenge of coping with and articulating infinite natural variety. Sketching the outdoors required concentration and discipline, and discerning choices had to be made about vantage points, textures, surfaces, colours, lines and shapes in an ever-changing environment. A spate of drawing manuals offered guidelines about making such choices, for example David Cox's *Treatise on*

Landscape Painting and Effect in Water Colours (London, 1813–14).[22] They took into account the British and European climate and landscape, but in colonial settings different atmospheric effects and unusual geographical and natural features challenged the artistic sensibility that they promoted.

Earle's travels across the world necessitated modulating the density of watercolour to depict the climate and atmosphere of every new place. His predecessor William Hodges, who had journeyed to the South Pacific in 1772 as an official artist for Captain Cook's second voyage, found himself re-evaluating basic elements like light and colour when he arrived at Fort St George in Madras in 1780: '[The] clear, blue, cloudless sky, the polished white buildings, the bright sandy beach, and the dark green sea, present a combination totally new to the eye of an Englishman.'[23] Accustomed to radical geographical and atmospheric changes, he acknowledged just how stimulating such encounters could be for artists, 'who, accustomed to the sight of rolling masses of clouds floating in a damp [English] atmosphere, cannot but contemplate the difference with delight'.[24] Hodges surrendered to the visual pleasure of

recognizing the unfamiliar, relishing the visible differences between the English and Indian settings. Such remarks can be understood not only within the framework of the sublime but also within the picturesque, a landscape style defined by aesthetic variety and difference. Both could be applied to any natural setting and became popular filters through which exotic colonial locations and peoples were articulated.[25]

Exciting though it was to draw and paint in colonial locations, at times the experience could be overwhelming. As Edward Lear (1812–88) observed in his journal when visiting Benares in 1873, 'Drew till 3.45, & gave it up – "cruel folly!" Nothing, – short of a moving Opera Scene, – can give any idea of the intense & wonderful Colour & detail of these Benares River Banks!!! And nothing is more impossible than to represent them by the pencil.'[26] Although separated by nearly a century, Lear and Hodges clarify the British artist's desire to seek out fresh views in distant parts of the world where the changing scenery offered endless stimulation, but also required practical tools like watercolour paints and sketchbooks to enable artists to record views on the spot.[27] The results were a portable empire made accessible back at home in Britain through prints, drawings, sketches and paintings. Lear jotted notes alongside his pencil and watercolour sketches

in order to keep track of specific colours and times of day, and make other observations. Earle also kept field notes and made small drawings.[28] While such meticulous documentation registers the immediacy of sensory experience, it also evinces a desire to control one's foreign surroundings by compartmentalizing it into specific views.

As a medium dependent on portable tools, drawing was ideally suited to travel and exploration. Topographically accurate pictures were in especially high demand prior to the invention of photography in the early nineteenth century. Wars with France and a growing global presence had resulted in a greater need for surveillance and the mapping of different territories. Thus drawing became part of the curriculum at British military schools where accomplished artists were hired to train soldiers who would later travel throughout the British colonies and empire. The eminent watercolorist Paul Sandby was appointed to the position of Head Drawing Master in 1768 at the first Royal Military Academy at Woolwich.[29] While military officers and engineers produced detailed field drawings for official purposes, they also drew for pleasure, from studies of coastlines to encampment scenes. The vast and varied corpus of pictures that remains still needs to be examined thoroughly; it would provide valuable insights into the expansion and protection of Britain's imperial geography.[30]

48 WILLIAM SIMPSON
Mine in the Bastion du Mat, Sebastopol 1856
Watercolour and gouache over graphite on wove paper
26.4 × 40.5 (10⅜ × 15¹⁵⁄₁₆)
Yale Center for British Art, New Haven
Paul Mellon Collection

Drawing was also incorporated into the curricula of boys' schools established in the colonies. For instance, at Upper College Canada established in 1829 in Toronto, training in architectural drawing and surveying was considered an important part of a student's education.[31]

From the middle of the nineteenth century onwards artists began serving as war correspondents to record the nitty-gritty of camp-life and battle scenes. Through such artists as William Simpson (1823–99), who was commissioned in 1854 by the London firm of Paul and Dominic Colnaghi to cover the Crimean War, war correspondents' renderings reached the British public through illustrations in books, newspapers and magazines.[32] Between 1854 and 1855 Simpson travelled with the British troops and drew 'on the spot', a point noted in the title of the book published with lithographs made after his drawings, *The Campaign in the Crimea . . . from Drawings Taken on the Spot by William Simpson* (1855; see fig.48). Pictures like these appeared as candid records and the artist's very presence in the Crimea was promoted as an authentic experience. So popular were Simpson's images that he was

widely known as 'Crimean Simpson', a sobriquet that adhered long after he had travelled on many other colonial military expeditions, including one to Ethiopia in 1868 with Robert Napier and another to Afghanistan in 1878. He visited India in 1859 to cover the impact of the Indian Rebellion and again in 1875, as a correspondent for *The Illustrated London News* to record the Indian tour of the Prince of Wales.[33]

The Crimean War also provided plenty of material for photographers like Roger Fenton (1819–69). Official photographer for the British Museum, Fenton was commissioned by the Manchester print dealer and publisher Thomas Agnew to cover the war. The results were staggering – 360 collodion-on-glass plates. Fenton's photographs in their black-and-white starkness demonstrated the gritty reality of war that the artist had confronted on site (fig.49). Fenton's photographs, like Simpson's watercolours, follow in the footsteps of *Disasters of War* 1810–20 by Francisco Goya (1746–1828), but he also presented military life as a picturesque trail of aesthetically appealing views. Such an approach reveals photography as oscillating between the documentary and the artistic. Photography became

instantly popular in different parts of the empire as soon as it was invented in Europe. Local amateur photographic societies also cropped up in imperial cities attesting to the desire to clarify, aestheticize and commemorate. Like letters, photographs became memorabilia that gave a sense of cohesion to families fragmented and scattered across the world. Yet photographs could also create a world of illusion. Fenton, for instance, wrote of disease and mismanagement in the Crimean War but did not photograph them. British war efforts needed to be recognized as heroic exploits and they were treated as such when Fenton exhibited his images at the Gallery of the Old Water-colour Society in London in 1855, and Agnew and Sons published them in elaborate portfolios.

The demand for pictorial information about Britain's imperial frontiers indicates a desire to collapse the geographical separation between the nation and its worldwide territories. The exotic far-away lands of the eighteenth-century empire were by the end of the nineteenth century no longer quite so foreign. Despite their familiarity, however, artists continued to travel their expanse in search of new views and returned repeatedly to the familiar trope of the unexplored frontier. Such images celebrated the local beauty of their natural surroundings, but they also demonstrated just how far and wide the empire was, and how its frontiers differed from place and to place, and from Britain itself.

Edward Lear's view of Kanchenjunga ('Kinchinjunga') seen from Darjeeling (1879; fig.50) was completed from watercolour drawings made during his visit to the area in 1874. A popular hill-station in the lower range of the Himalayas, Darjeeling was, by the time Lear arrived, a sanatorium for British soldiers and a successful hub of tea cultivation. It was here that Joseph Banks's enterprising idea to transplant Chinese tea into India proved successful, resulting in the lucrative imperial experiment of tea cultivation. Painted for Thomas Baring, Lord Northbrook, the Indian Viceroy, who was Lear's host and patron, the artist focused on the dense foliage of the region, the imposing Kanchenjunga range in the distance, and the dramatic slopes of the surrounding terrain.[34] A bare hint of tea cultivation is presented in the composition, in the figures of the wood-pickers and tea-labourers in the foreground gathered near the Buddhist shrine. Like Augustus Earle's aboriginal guides, Lear's figures also functioned as picturesque elements, but they are not transient travellers exploring the area. Instead, they were local inhabitants who lived in Darjeeling amid other Sikkimese and Tibetans and alongside British tea planters. Despite their presence, however, Lear emphasized the region as a remote destination rather than as a bustling scene of cultivation.

The tradition of sketching, drawing and photographing exotic places and peoples continued to flourish throughout

the nineteenth century. The resulting images reveal the extent to which imperial frontiers varied in distance but also in the imagination. In this sense their compositions differed from those produced by artists travelling in places like Egypt that had a strong British presence but never became official colonies.[35] Nelson's victory over Napoleon at the Battle of the Nile loomed large in the nineteenth-century British imagination as did English translations of Dominique Vivant Denon's lavishly illustrated *Description de l'Egypte,* first published in Paris in 1802, a result of the author's participation in Napoleon's Egyptian expedition. There were British artists like David Roberts (1796–1864) and John Frederick Lewis (1805–76) whose visual encounters in Egypt belonged with Orientalist painting and travel illustration, no doubt inspiring Lear who also visited in 1849. Yet their accounts differ fundamentally from those of the far-flung reaches of colonial expansion depicted in Earle and Lear's pictures. Egypt was closer to Britain physically and also historically, through its connections with ancient Greece and Italy as well as through the Bible; Australia and India were literally and figuratively much further away. Thus the formation of the British Empire pulled into focus many different ideas about distance and isolation given form by the global presence of Britons. Yet the very concept of empire in the long term levelled out those differing notions of distance. Over time, Earle's Australia and Lear's India became as familiar as Egypt, a country whose history had overlapped closely with that of Western Europe since antiquity.

Colonial Curiosities and Imperial Cabinets

Travel has always been associated with the history and practice of collecting. For many young men of noble birth the Grand Tour provided the opportunity to establish collections of Continental Masters, and explorers acquired curiosities, from indigenous artwork to specimens of natural history. Among the great collectors in eighteenth -century England was Sir Ashton Lever, whose 'Holophusikon' in Leicester House was a vast private collection and museum of natural history, that included many specimens from Captain Cook's voyages. Such collectors also employed artists, and in Lever's case this was Sarah Stone (1760–1844), who exhibited at the Society

of Artists in 1780 and at the Royal Academy in 1781 and who was known for her renditions of exotic birds, reptiles, shells, fossils, mammals and native artefacts that documented his collection.[36] From the 1790 frontispiece illustration of a companion catalogue to the collection based on a design by Sarah Stone and C. Reyley (fig.51), we glean that the Leverian Museum's display of zoological and botanical specimens as well as man-made artefacts in the spectacular Rotunda 'Wunderkammer' also served to educate children, who are here instructed by an accompanying parent in the marvels of the world.[37]

Benjamin West's monumental portrait of the distinguished scientist Joseph Banks of 1773 (fig.52), also engraved by John Raphael Smith that same year, depicts the botanist wearing a Maori cloak, whilst also displaying other treasures from New Zealand and Polynesia that Banks had acquired when he accompanied Captain Cook on the *Endeavour*.[38] West's composition resembles Grand Tour portraits from Italy, which show the traveller with ancient Greek and Roman sculptures and vases, often set against noteworthy architectural backdrops or Arcadian vistas. However, Banks's decisive step forward and engaging eye-contact with the beholder, as well as the way he holds up

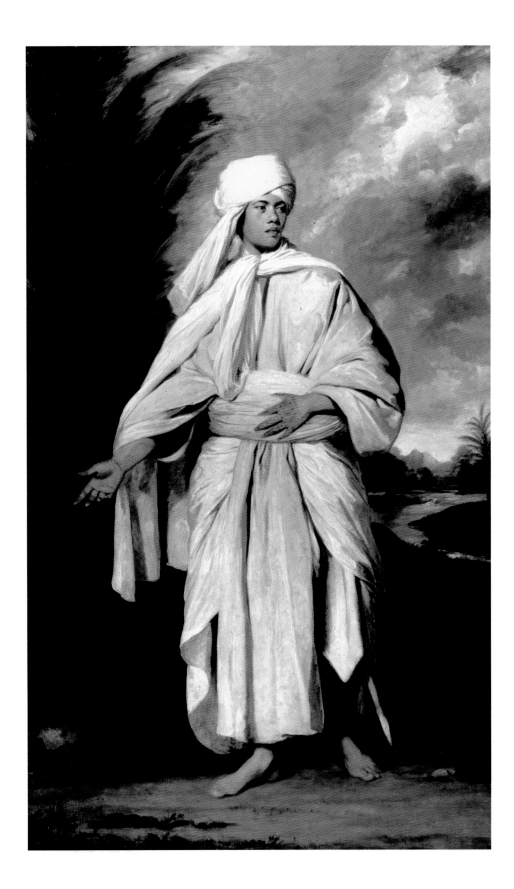

the fabric of his wrap for the viewer's critical attention, gives the work a more didactic character.

Portraits of visitors from far-flung parts of the world, including the images of four 'Indian Kings' (1710; Library and Archives Canada, Ottawa) by John Verelst (fl.1697–1734), George Romney's 1776 picture of *Joseph Brant* (*Thayeadanegea the Mohawk Chief*) (National Gallery of Canada, Ottawa), the 1749 rendering of William Ansah Sessarakoo (Menil Collection, Houston) by Gabriel Mathias (1719–1804) and Franz Winterhalter's 1854 image of Maharaja Dalip Singh (Royal Collection), among many others, negotiated complex issues of identity in relation to race, nationality and gender in order to grasp, fix and control or diminish difference.[39] Among such portraits of foreign visitors to London, Reynolds's full-length painting of *Omai*, or *Mai* (1776; fig.53) stands out. Omai, as he was called by the English, had travelled aboard Captain Cook's ship the *Adventure* during the second voyage (1772–5). The first Polynesian visitor to Britain, his arrival in London caused a sensation.[40]

Reynolds's full-length portrait grafts his Polynesian sitter's identity onto European traditions: the grand pose of an ancient Apollo and the magisterial robe of a Roman magistrate are combined with turban, natural backdrop and 'exotic' native tattoos.[41] Omai embodies the oxymoronic category of the 'noble savage'. Both the reception of the painting and its recombination in different media such as prints participated in the larger context of an eighteenth-century desire for global spectacle and display, which included the burgeoning culture of collecting and the formation of museums.

Assembling collections of objects from and images of the 'world' not only served to render the non-European manageable for European consumers, it also represented a form of virtual imperialism. As Maya Jasanoff puts it: 'Empires themselves are collections: collections of people, territories and resources; and collections formed, ordered and classified by the imperial powers that acquire them.'[42] Although most accounts of collecting focus on Old Master paintings, eighteenth-century acquisitions of objects often ranged beyond Europe. Charles Townley (1737–1805), best known for his substantial collection of ancient sculpture, also acquired a collection of South Indian art; his collection of the former is memorialized in a conversation-group portrait painting by Johann Zoffany, who, following his return from India, housed his own substantial collection

in his studio in London (see Eaton, pp.118–19).[43] Large collections of 'exotica' and memorabilia were acquired by many travellers, including diplomats like Warren Hastings (Governor-General of Bengal 1772–85); soldiers like Claude Martin, who worked in Lucknow between 1776 and 1800; and wealthy adventurers such as Lady Mary Wortley Montagu, wife of the English Ambassador to the Sublime Port, who was celebrated for her detailed descriptions of Ottoman society and whose apartment, it is reported, looked 'like an Indian warehouse'.[44] There were also British collectors who actively sought out Indian objects; they included Lady Mary Impey, who commissioned a series of natural history paintings from Indian artists when she lived in Calcutta; William Beckford (1760–1844) of Fonthill; and the Irish Major-General Charles Stuart, who stood out for his extensive collection of Hindu sculpture.[45] Sir Robert Clive amassed an enormous fortune (condemned by Edmund Burke) and built an impressive art collection, including sumptuous Mughal artefacts. Clive's daughter-in-law Lady Henrietta followed her husband to India when in 1798 he was appointed Governor of Madras, and she added substantially to the collection. By 1801 such individual collecting was balanced by institutional display. In that year the East India Company was exhibiting objects in the India Museum in East India House, which shaped collecting and display more directly as propaganda for economic and imperial expansion.[46]

The passion for collecting and enjoying exotic objects spilled over into botanical gardens, with the Royal Botanic Gardens at Kew as its nucleus. Throughout the nineteenth century, as Britain's empire expanded, seeds and plants were shipped home to Kew and redistributed throughout the imperial expanse to botanical gardens in places as diverse as Calcutta, Jamaica, Mauritius and Singapore.[47] In 1882 an unusual collection reflecting the natural beauty of the British Empire was exhibited at Kew. The display comprised 627 images of plants from all over the world, painted by Marianne North (1830–90), who had donated them to Kew along with the gallery in which they were shown (fig.54). Designed by James Fergusson, famous for his research on ancient Greek and Indian architecture, the Marianne North Gallery was inspired by Greek and Indian temples. By 1883 additional gallery space was added to the building and the permanent exhibition was expanded to include 221 more paintings by North. The interior walls were also adorned by 246 types of wood collected by the

54 Interior view of the Marianne
North Gallery, Royal Botanic Gardens,
Kew Gardens, Richmond, which opened in 1882.

artist during her travels.[48] The display of painted plants stands out in a botanical garden otherwise filled with living plant specimens. Equally importantly, it reveals how the geographical and cultural diversity of Britain's empire provided an aesthetic space for Victorian women artists, for whom botanical drawing was a socially acceptable feminine pursuit.[49] While North travelled to the British territories of Singapore, India, South Africa and Australia, she also went to places such as Brazil and Chile that were not a part of the British Empire. Her pictures combine botanical scrutiny with the picturesque love of variety; displayed together, they represent a cabinet of curiosities in which painted specimens stand in for living plants, and memories of different travel experiences are infused with the colours and textures of the imperial landscape. Thus, the gallery collapses geographical distance by bringing home the staggering range of natural beauty encountered throughout the length and breadth of empire. In the process, the imperial geography is transformed into an ornamental

hot-house in which visitors could observe a monkey-puzzle tree from Chile next to the bright red blossoms of the waratah from Australia.

Ornamental Empire: Chinoiserie

William Alexander (1767–1816) was one of two draughts-men who accompanied George, 1st Earl Macartney, during the first British Embassy to China, then the largest and oldest surviving empire in the world. Commencing in 1793, the goal of the two-year diplomatic mission to the court of Qianlong on behalf of George III was to open new ports for international trade, and to establish a diplomatic residence in Peking. Alexander's role was to document the experience of the visit.

Despite the mission's diplomatic failure – as Aeneas Anderson, Macartney's servant, put it, his master clearly

55 WILLIAM ALEXANDER
*A Chinese Military Post from an Authentic Account
of an Embassy from the King of Great Britain to
the Emperor of China,* engraved by J. Pass,
published by G. Nichol, London, 12 April 1796
Engraving 43 × 57.5 (17 × 22½)
UK Government Art Collection

'felt the insult, as it appeared to us, which was offered to the crown and dignity of the first nation in the world' – Alexander's two years in China were well spent.[50] His sketchbooks – filled with landscapes, buildings, people and costumes – framed the British reception of China in the nineteenth century, forming the pictorial scaffold not only of his own publications, *The Headlands and Island . . . of*

China (1798) and *The Costume of China* (1814), but also George Staunton's *Account of the Embassy* (1797) John Barrow's *Travels in China* (1804) and later *Voyage to Cochin-China.* Alexander's records may be seen as recompense for diplomatic and colonial failure; his renditions of China emphasized prevailing perceptions about the country's quaint backwardness to a British audience.

Images such as a genre scene of a water-carrier and another of two men fighting with outdated swords and shields offer a decidedly unthreatening, picturesque image of China and the Chinese (fig.55). The picture of the culture that emerges from Alexander's fragmentary visual account is one of disjunction and disorder, which visually confirms Macartney's claim that the 'awesome-appearing country had grave internal weaknesses that threatened to destroy it'.[51] It is this emasculated version of China that had long appealed to European consumers, as it had been disseminated through the ornamental style known as chinoiserie.[52] Although chinoiserie had since the late seventeenth century played a significant role in landscape gardening and architecture, it was predominantly associated with the

56 BERNARD BARON after
WILLIAM HOGARTH
Marriage A-la-Mode, Plate II:
The Tête à Tête 1745
Engraving 47 × 58.5 (17 × 23)
Whitworth Art Gallery,
University of Manchester

feminine and domestic. This fanciful and extravagant style owed much to the importation of Chinese goods, especially porcelain and lacquerware, which increased with the success of the East India trading companies in the seventeenth and eighteenth centuries. British artisans emulated them by sprinkling their products with intricate motifs of human figures, exotic birds, flowers and pagodas. Pottery makers imitated fine translucent Chinese porcelain (the Chelsea Porcelain Factory was founded in 1745) and Thomas Chippendale produced his decorative furniture type known as 'Chinese Chippendale'.[53] Thus, in a manner different from the Continent, in Britain chinoiserie represented the assimilation of Chinese culture into an indigenous, domestic and fundamentally British style.

In the early eighteenth century chinoiserie was still associated with the 'femininity' of the French rococo and, in William Hogarth's *Marriage A-la-Mode* (see, for instance, scenes 2 and 4), could symbolize tasteless foreign influence. Scene 2, 'The Tête à Tête', shows the unhappy Viscount and his new wife framed by a jumble of exotic objects displayed on their mantelpiece (fig.56). A fake 'ancient' bust rubs shoulders with clownish Chinese dolls, while a Buddha figure – stripped of its religious authority – nestles below a majestic cat in the foliage of a rococo clock mounted on the wall. Such exotic goods suggest a lost sense of national identity. It was only later in the century that the Old Master paintings, oriental

carpets, imported fans, sofas, hot chocolate and Chinese figures that crop up throughout Hogarth's series became integrated into a distinctively British colonial domestic style. Just as tea from China and India became markers of British identity, so imported objects became constitutive elements of British visual culture.

Some of the landed gentry in the eighteenth century erected 'Chinese' garden follies on their estates, often based on the designs of Sir William Chambers (1723–96), who had repeatedly visited China and India as an employee of the Swedish East India Company and resided for several months in Canton (Guangzhou). Chambers took a great interest in Chinese architecture and gardening and later published *Designs of Chinese Buildings* (1757) and *Dissertation on Oriental Gardening* (1772). Chambers's buildings included the Turkish Mosque and the Alhambra that flanked what was the most remarkable of the buildings to emulate Chinese architecture, the Kew Pagoda. Although made of brick, not wood, this octagonal, 50-metre-high structure comprises ten storeys that successively diminish in circumference.[54]

The most striking example of chinoiserie in Britain – though not exclusively inspired by Chinese examples – was the lavish Royal Pavilion built for the Prince Regent (later George IV, 1820–30) in the early nineteenth century (fig.57). Located in the seaside town of Brighton, the palace and its grounds were a whimsical royal playground and

58 JAMES ABBOTT
MCNEILL WHISTLER
*Purple and Rose: The Lange Leizen of
the Six Marks* 1864
Oil on canvas 93 × 61 (36⅝ × 24)
Philadelphia Museum of Art
John G. Johnson Collection

residence filled with motifs of flying dragons, life-sized paintings of mandarins, faux bamboo furniture and luxurious brocades. Architects John Nash, Henry Holland and William Porden, together with the decorating firm of John and Frederick Crace and garden designer Humphrey Repton, combined chinoiserie elements with Indian-inspired architectural motifs like onion-shaped domes and lattice-work. Ideas were borrowed from many sources including Sezincote, the estate of the retired Indian nabob Sir Charles Cockerell.

Such aesthetic borrowings were highly complex in their fusion, revealing how different styles could also reflect colonial attitudes. Politically, Britain had a very different relationship with China to that with India; with the exception of Hong Kong, ceded to Britain in 1842, China was not colonized, whereas India was an established British colony by the later eighteenth century. Yet, the Pavilion's hotchpotch of designs results in a hybrid form that is neither strictly Chinese nor Indian, but a British colonial style domesticated and legitimized as princely taste.[55] The Prince Regent's palace also foreshadowed the grand spectacle of empire that was the Great Exhibition of 1851 and, later, department stores like Liberty of London that claimed to sell goods from all four corners of the globe.

Victorian art was increasingly influenced by global styles and forms that spilled into paintings, prints, books, household manuals, furniture design, ceramics and domestic interiors in general. James McNeill Whistler, Frank Huddleston Potter (1845–87), James Tissot (1836–1902) and Atkinson Grimshaw (1835–93), among many other Victorian artists, included Chinese and Chinese-style objects in their compositions, while advocates of the Aesthetic Movement like Oscar Wilde, Dante Gabriel Rossetti and Walter Crane (1845–1915) fostered the taste for blue-and-white porcelain. Whistler's *Purple and Rose: The Lange Leizen of the Six Marks* of 1864 exemplifies the preference for chinoiserie to the extent that the artist's Irish mistress Joanna Heffernan was posed as a Chinese vase-painter in a studio (fig.58). The viewer's eye skims the gleaming surfaces of porcelain placed throughout the composition, affirming not only the domestication of Chinese goods but also the transformation of aesthetic sensibility and sensory experience that emerged through contact with exotic objects. Whistler staged the appreciation of Chinese blue-and-white porcelain, but Atkinson Grimshaw depicted Victorian interiors where British men

and women appeared at ease alongside blue-and-white china, Persian rugs, peacock feathers, Indian fabrics, and Japanese fans, porcelain and prints. In *The Cradle Song* 1878 (private collection) a young woman is surrounded by carefully arranged blue-and-white porcelain vases, plates, ginger jars and tea cups and saucers that in turn mingle with Japanese fans. Her pale complexion and sunlit cream-coloured outfit are complemented by the glistening white surfaces of the chinaware. Madonna-like, this delicate young mother exemplifies British womanhood – devoted to her child and comfortably ensconced in a home filled with exotic items that could be purchased in shops and department stores in any British city.

Thanks to a global empire, Britons could avail themselves of items brought home and redistributed through domestic retail networks. Such patterns of circulation could

also be found in department stores in colonial cities like Cape Town, Calcutta and Hong Kong where Britain's colonial citizens purchased goods from all over the world. Such density of consumption ensured that the British Empire was palpable and tangible in every corner of its vast expanse. But the proliferation of imports was not always welcomed. The satirist George du Maurier (1834-96) poked fun at the preference for Chinese items and chinoiserie in general. Du Maurier's caricatures published in *Punch* throughout the late nineteenth century lampooned prominent advocates of the Aesthetic Movement, especially Oscar Wilde. Changing taste was clearly troublesome, even if it was sanctioned by Britain's own imperial endeavours; the very popularity of chinoiserie signalled the recalibration of home-grown ideas about aesthetics and design. However, while such a shift in taste may have unsettled du Maurier, it did not deter eager consumers who decorated their homes with products channelled through imperial networks of trade and commerce. Department stores across the empire enabled a wide dissemination of aesthetic preferences. Even the former colony of America became an important hub of the Aesthetic Movement and chinoiserie, demonstrating the transmission of artistic ideas across imperial borders.

Performance and Display

The British collected more than Chinese and Indian objects: artefacts from the South Seas and the Middle East also poured into British houses. As one eighteenth-century journalist quipped, 'the present mode of exploring only appears to be an expedition to pick up shells and preserve butterflies for the Fair Sex ... these jaunts to the southern latitudes are only to amuse the Court, and encrease [*sic*] our collections of trifles.'[56] These global accumulations and self-fashionings were also lampooned in popular prints. Macaroni and foppish nabobs surrounded by exotic bric-a-brac symbolized the misguided taste for things foreign that could be seen to challenge a stable sense of national identity. But such criticisms actually betray the way in which collecting became a marker of British selfhood, a way of promoting a form of cultural control over the empire and a sense of Britishness built on the power to evaluate other cultures.

This acquisitiveness also spawned its opposite: the acquisition of European art by non-European collectors, signalling both assimilation of European values and resistance to them. Maharao Lakhpatji of Bhuj, Asaf ud-Daula and Tipu Sultan in Mysore bought European art in the eighteenth century, while Asaf ud-Daula, the Nawab of Awadh, established 'what was probably the largest European art collection in India'.[57] Muhammad Ali Khan, Nawab of Arcot, commissioned British artists like George Willison (1741-97) to paint portraits of himself and his family, at least two of which were sent to England by the Nawab as gifts for King George III and the East India Company offices in London.[58] Later, in the nineteenth and early twentieth centuries, powerful maharajas with a taste for European art like Sir Sayajirao III Gaekwad of Baroda, the Nizam of Hyderabad, and wealthy Bengali merchants also collected European paintings, sculpture and decorative arts.

Omai (see pp.97-8) was also something of a collector. He returned with Cook on the *Resolution* to the South Pacific in 1777 with a number of European objects, including a barrel organ, an electrical machine, cooking and eating utensils, portraits of the King and Queen, small pieces of furniture, and 'toy models of horses, coaches, wagons', as well as actual cattle, sheep, and seeds to plant. The hope was that Omai would be able to interpret these objects to his people, with the goal of bringing Western progress and civilization to the South Pacific. These expectations were disappointed, as Omai proved unable to explain the relevance of the diminutive toy-like quality of the items or extract a larger meaning from this 'miniaturized ... simulacrum of civility'.[59] Instead, his regression back into a supposed state of childlike simplicity and effeminacy conformed to European ideas of the natural hierarchy.[60]

Similarly, Maharaja Dalip Singh's portrait, painted by Franz Winterhalter in 1854, presents the Sikh prince as a Victorian subject loyal to his queen (fig. 59). Removed from his mother Rani Jindan, the prince was thoroughly anglicized and promoted by Queen Victoria to the rank of a European prince.[61] Winterhalter made sure the young prince's allegiance to the British queen was clarified in the portrait: a painted jewel-framed miniature portrait of the Queen was shown suspended from a string of pearls around his neck. The miniature was painted by Emily Eden (1797-1869), the Governor-General Lord Auckland's sister,

59 FRANZ XAVIER
WINTERHALTER
Maharaja Dalip Singh 1854
Oil on canvas
204 × 110 (80¼ × 43¼)
Royal Collection

and was originally given to the Maharaja's father, Ranjit Singh, in Lahore by the senior British officer, William Osborne, on behalf of Lord Auckland. In this single detail of a miniature portrait, Singh's lineage as a proud Sikh ruler is divested of all authority.[62]

Such cross-cultural dynamics led in certain cases to their theatrical enactment: Omai's experiences in England and subsequent return to Tahiti became the subject of a dramatic production.[63] The publication of Cook's third voyage to the South Pacific, which appeared in 1781, rekindled interest in Omai and the South Sea and led directly to the immensely successful stage production of John O'Keeffe's *Omai; or, A Trip Round the World*. The play, which went on to be staged thirty-two times between 1785 and 1788, was first performed on 20 December 1785 at Covent Garden. Joshua Reynolds, who attended the first performance, reportedly 'expressed the utmost satisfaction at all the landscape scenes'.[64] *The Times* praised the play on 28 December for its sensational introduction of 'numerous tricks, drolleries, and farcical situations'. '[T]he stage', the review continued, 'never exhibited such a combination of superb and various scenery – enchanting music and sheer fun.'

The scenery was the result of a collaborative effort of several artists, foremost among them the Alsatian artist and Royal Academician Philippe Jacques de Loutherbourg (1740–1812), with the assistance of scenery painters Matthew William Peters, John Inigo Richards and Robert Carver. De Loutherbourg went out of his way to bestow an aura of authenticity on the play, consulting with John Webber, the official draughtsman on Cook's last expedition, and drawing on engravings after Hodges and Webber for his stage and costume designs.[65]

De Loutherbourg had only recently transformed theatrical technology with his 'Eidophusikon' (a mechanical theatre first mounted in 1781), allowing for special effects of light and motion that evoked dramatic natural phenomena, including showers of hail, the eclipse of the moon and sunrise effects. These were achieved mechanically with the aid of mirrors and pulleys and accompanied by evocative sounds and theatrical music to maximize the sublime impact on the senses. Such atmospheric representations were particularly suitable for 'exotic' and ethnographic themes that catered to the sensationalist craving for things foreign, far-flung and curious. De Loutherbourg, in fact, stressed that it should 'display in the liveliest manner those

captivating scenes which inexhaustible Nature presents to our view at different periods and in different parts of the globe'.[66]

Far from being pleasurable diversions, without social, political or aesthetic significance, such theatrical performances and 'fancy' masquerades were important sites for the cultural formation of Britain as a modern imperial nation.[67] The performance of various identities within a global context made sense of Britain's place within the new imperial order and also reassured Britons of their centrality within it. A comparable performance of centrality within an expanding universe may be seen in the painting of the *Orrery* (exh.1766; Derby Museum and Art Gallery) by Joseph Wright of Derby (1734–97), in which the plotting of man's place in the universe is given a palpable form and a scientific aura. Like such demonstrations, de Loutherbourg's theatrical enactments were, according to *The Times*, equally 'worthy the contemplation of every rational being, from the infant to the aged philosopher'.[68]

The Royal Academy was conceived as an institutional space for the systematic articulation of a British art; it also posited an ideal form of Britishness. The picturing of personality and place structured British nationalism through the representation of exemplary national ideals, but also through difference. Paintings exhibited there like Omai offered spectators a glimpse of an exotic persona, but also enabled them to plot out their own position relative to such novelty. Between 1795 and 1800 William Alexander annually exhibited watercolours of Chinese landscapes and sketches of Chinese subjects, West Indian scenes by Agostino Brunias (1730–96) were frequently on display, and in 1787 William Hodges exhibited no less than eleven works, including 'one of his large views of Benares, made for Hastings' and 'his view of Fort William, Calcutta'. Hodges's works were prominently displayed and noted by the press: 'Confine yourself to interesting scents, and you will please, Mr. Hodges; – give us Asiatick palaces, mosques, &c. and they will be charming history.'[69] Nineteenth-century painters who either visited different countries throughout the length and breadth of Britain's empire, like Edward Lear and David Roberts, or who incorporated chinoiserie and a taste for things exotic in their works, like Whistler, continued to exhibit at the Royal Academy. Artists who actually lived overseas were not far behind their colleagues in Britain. George Chinnery (1774–1852), who lived in the imperial cities of Macao and Hong

Kong between 1830 and 1846, sent pictures regularly to the Royal Academy. This dialectic between an assumed centre and its periphery can be seen in all the genres of painting and sculpture displayed at the Royal Academy, as well as at other venues. It is vividly apparent in Britain's visual framing of the West Indies and the institution of slavery.

The Visual Culture of Slavery

The image of the British West Indies in the eighteenth century is inextricably bound up with that offered by the Italian painter Agostino Brunias (1730–96), who spent over twenty years in the Caribbean. Brunias began his career painting pictures connected with the Grand Tour, but his life took a decisive turn when in 1764 he accompanied Sir William Young, who was taking up an administrative post in the West Indies and later, would become Governor of Dominica). Brunias's colourful images, against a background of azure skies and flocked with richly patterned fabrics, embodied for a British audience the tropical bounty of the West Indian islands. These paintings occluded the savagery of slavery and the ravages of disease that befell so many British settlers. Instead, Brunias highlighted the progressive (and illusory) symbiosis of exchange between natives, settlers and forced labourers.

In his work the figure of the mulatto woman embodies an ideal melding of slave owner and slave.[70] The ideal of corporeal whiteness promoted in Neoclassical aesthetics confronted an alternative idea of beauty in the paintings of Brunias. Disengaged from slave labour, the mulatto woman enjoys in Brunias's pictured world a privileged status: though she is shown as not white, her difference from the working black woman elevates her above physical labour. Bryan Edwards, an eighteenth-century apologist for slavery, affirms that fairness of skin, even in the 'poorest white person' connotes a higher status; the 'pre-eminence and distinction which are necessary attached even to the complexion of a white man, in a country where the complexion, generally speaking, distinguished freedom from slavery'.[71]

In Brunias's work the mulatto woman represents an aesthetic ideal, aligned by Brunias with the eroticized image of Venus in, for example, his *French Mulatresses and Negro Woman Bathing* c.1770 (Peabody Museum of Archaeology and Ethnology, Harvard University). The women are oblivious to the white male voyeur peeping through the leaves of a tree. Their arcadian ease contradicts the suffering and abuse of slavery, while recalling William Hodges's scenes of bathing female natives of the South Pacific. Both artists, the authority of whose work resides in the claim to ethnographic veracity, allude to and partake in the sexual politics and exploitative practices of Britain's imperial culture.[72]

Brunias's colourful and busy rendition of market scenes with linen and vegetable sellers such as in *Market Day, Roseau, Dominica*, c.1780 (Yale Center for British Art, New Haven) and *Linen Market, Dominica*, c.1780 (fig.60) might convey something of the crowds where 'many hundred negroes and mulattoes' would 'expose for sale poultry, pigs, kids, vegetable, fruit, and other things', but his rendition shares little with the contemptuous description of a market in Antigua offered by the British traveller, John Luffman, who was insulted by the 'noise occasioned by the jabber of the negroes and the squalling and cries of the children basking in the sun [that] exceeds anything I ever heard in a London market'. 'The smell is also intolerable,' he continues, 'proceeding from the strong effluvia, naturally arising from the bodys [sic] of these people, and from the striking salt-fish and other offencibles [sic] sent for sale by hucksters, which the negroes will buy, even when in the last stage of rottenness, to season their pots with.'[73] While Luffman aligns the smelly bodies of 'negroes' with the rotten food that they sell and buy, Brunias offers a very different image of the market. The crisp, unblemished fruit matches the rich and spotless clothes of the clients and traders. There is no trace of slave labour, nor does the glimpse of ocean carry with it any reference to the atrocities of the middle passage.

The success of colonies like the West Indies depended on their being perceived as attractive and habitable places with well-developed urban and cultural climates to suit the needs of modern British citizens. Brunias paints the symbols of wealth and abundance made possible by slave labour, depicting the inhabitants of the colonies in happy social engagement, adorned in fashionable dress yet retaining the mysterious and exotic quality of a tropical region. One can imagine that successful sugar planters at home in Britain, as well as their family and friends, would have appreciated Brunias's calm and ideal vision of the origin of their wealth and well-being.

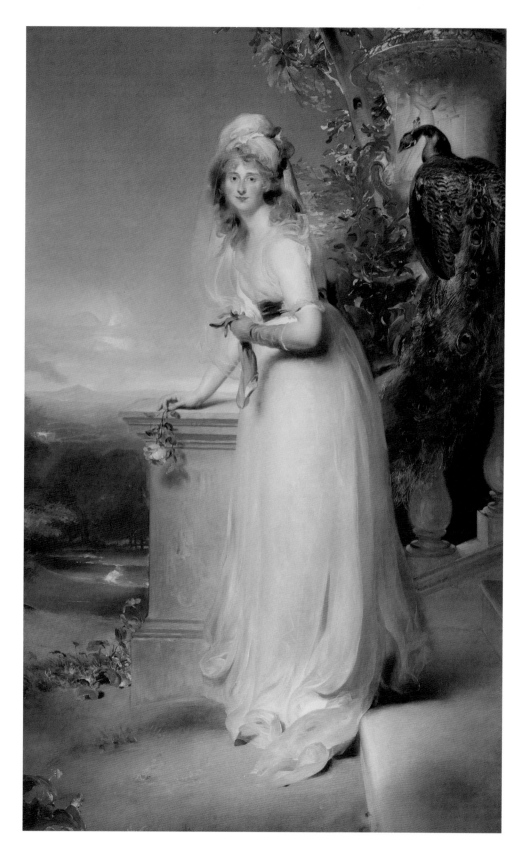

61 THOMAS LAWRENCE
Catherine Rebecca Gray,
Lady Manners 1794
Oil on canvas
255.3 × 158 (100½ × 62¼)
Cleveland Museum of Art.
Courtesy of the Cleveland
Museum of Art, Bequest of
John D. Rockefeller, Jr.

62 THOMAS GAINSBOROUGH
Ignatius Sancho 1768
Oil on canvas 73.7 × 62.2 (29 × 24½)
National Gallery of Canada, Ottawa

But larger political purposes lay behind the ideal economics of Brunias's scenes. They were painted at a time when slavery was coming under threat from the burgeoning abolitionist movement. The paintings and subsequent prints implicitly allay fears about slave revolts, which had taken place in Jamaica and which were to break out later in St Domingue (1791–3). Slaves of African origin in the paintings are presented implicitly as better off on the plantations than they would be in Africa, a key argument of the pro-slavery lobby. Given that a high percentage of plantations were owned by absentee landowners, the gracefulness and charm of Brunias's visualization of colonial life, encouraged by his patron and supporters among the plantation owners, would have given a positive face to slavery, economic exploitation and political repression.

Abolitionism and Aesthetics

Brunias's rosy vision of life in the West Indies belied the actual decline of the slave plantation economy and the rise of the abolitionist movement that culminated in the abolition of the British slave trade in 1807 and the final emancipation of slaves in the British West Indies in 1838. From the 1770s onwards the ethical views of European thinkers began to challenge the institution of slavery in the West Indies, recognizing that the comfortable lifestyle they enjoyed was sustained by the brutal physical and sexual exploitation of thousands of Africans sold into slavery. The abolitionist movement contested existing assumptions of European racial superiority, and many caricaturists sympathetic to abolition used images of violence towards blacks to illustrate the injustice of slavery.

Yet the issue of abolition had a more subtle impact on artistic attitudes and practice. Towards the end of the eighteenth century one notices a striking fetishization of gendered whiteness in the art of the period. Artists such as Joshua Reynolds, George Romney and Thomas Lawrence (1769–1830) represent their female sitters with pale white skin and strikingly flushed cheeks (fig.61). Far from being just a marker of beauty or virtue, the blushing cheeks of these 'British Fair' also came to signify racially in a culture where the circulation and mixing of blood was a cause of subliminal anxiety about racial purity, and a means by which the English formulated ideals of femininity and nationhood. This visual trope can be seen as a visceral act of blushing that served as a representational norm for 'natural British' femininity, in contrast, for example, to the supposed artificiality of French women and the opacity and muteness of black skin.[74]

A notable example of a portrait of a person of African descent belonging to the earliest phase of the abolition movement is provided by Thomas Gainsborough's swiftly executed oil portrait of Ignatius Sancho of 1768 (fig.62). A slave child and subsequently butler to the family of

63 WILLIAM BLAKE
Flagellation of a Female Samboe Slave,
from John Gabriel Stedman's *Narrative
of a Five Years' Expedition against the
Revolted Negroes of Surinam, in Guiana,
on the Wild Coast of South America,
from the year 1772 to 1777* 1796
Engraving
British Museum, London

Flagellation of a Female Samboe Slave.

George, 1st Duke of Montagu, Sancho became a distinguished musical composer, and later ran a grocery shop in Westminster. Gainsborough's portrait avoids traditional stereotypes to emphasize the sensitivity of his sitter's features; Sancho appears with open eyes under raised eyebrows and parting lips. His complexion, however, only tentatively emerges from the dark background, and his eyes evade contact with the viewer. This makes Sancho a sympathetic though reticent presence despite the boldness of his gold-rimmed red coat and his early opposition to the slave trade.

The tendency in the visual arts of this period was to celebrate abolitionism as an achievement of white enlightenment thinkers, politicians, and men and women of feeling; the profusion of monuments and other commemorations to abolitionists like Fox and Wilberforce tends to play down the active role played by black activists and former slaves. Among the very few portraits commemorating abolitionists of African descent is the frontispiece to the *Narratives* (1789) of Olaudah Equiano, also known as Gustavus Vassa. Equiano was – according to his own written accounts, recently challenged – taken in slavery from his native land in West Africa and, having earned his freedom, became a successful businessman and abolitionist.[75] The frontispiece shows Equiano as a gentleman and preacher with the Bible in hand.

In the 'sentimental age' of the late eighteenth century sympathy for Africa was sometimes conveyed not through the representation of slave labour but through the tortured and abused black female body. For example, for a 1796 book recounting the British soldier John Gabriel Stedman's experience in Surinam, William Blake engraved a scene entitled *Flagellation of a Female Samboe Slave* to illustrate the economic and sexual licentiousness of the African slave trade (fig.63). The image portrays a black woman hung by her tied wrists. The idealized body in agony recalls less images of Christ than erotically charged representations of Andromeda awaiting her hero. Although Blake was an abolitionist, his imagery employs a rhetoric of sensationalism that often draws on sexual titillation, while also reflecting the violence of slavery. The tears in the light drapery hung around the woman's hips, which reveal dark skin beneath, are worked up with the engraver's burin and align with the imagined lashes of the whip used to torture the woman.

Visual imagery was a powerful vehicle for the abolitionists; it could spread knowledge of the inhumanities of slavery in a direct and engaging manner that would appeal to sentiment, but the opposite case could also be put persuasively. Caricature prints were the favoured medium, allowing high print-runs and rapid dissemination to

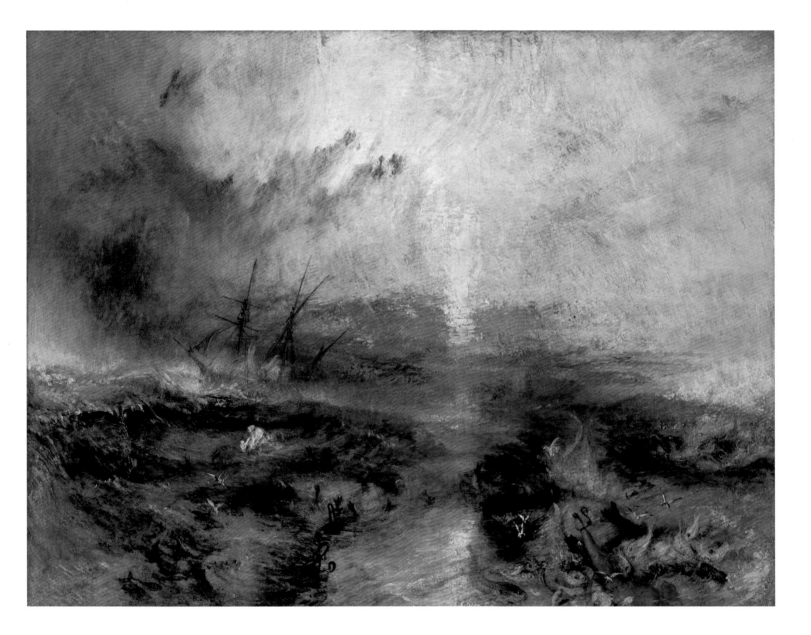

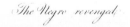

shape public opinions. Artists sympathetic to abolition like
Isaac Cruikshank (1764–1811) and James Gillray produced
a number of images critical of slavery, and though in
general they outnumbered those produced by the slavery
interests, pro-slavery caricatures were not unknown.

Anti-slavery paintings, on the other hand, were rare;
the most prominent ones were in any case probably
designed to be engraved. The paintings by George Morland
(1763–1804) depicting *Execrable Human Traffick; or the
Affectionate Slave* 1788 (Menil Collection, Houston) and
European Ship Wrecked on the Coast of Africa, also known as
African Hospitality (exh.1790; Menil Collection, Houston),
were engraved and printed in colour by John Raphael Smith
in 1791. They show contrasting scenes of slavers breaking
up an African family and the kindness of Africans to a
white family shipwrecked off the African coast.[76] Henry
Fuseli's *The Negro Revenged* 1806, by contrast, depicts
African resistance to white atrocities (fig.66). A freed slave
stands erect on a cliff, overlooking the destruction of slave-
trading ships; a beautiful mulatto woman – likely the
offspring of a brutally raped slave woman by white sugar
planters – flings herself around the black man's waist.
Crouched on the dirty ground sits a pitiful figure of a
deformed old African woman, whose body anchors the
composition like a pile of discarded matter on the right.
Sitting exhausted, she inverts the contented black figures
in so many of Brunias's compositions.

Fuseli's image calls upon the sublime in a manner
that demonstrates a kind of aestheticization of evil. Such
ambivalence poignantly suffuses J.M.W. Turner's *Slavers
Throwing Overboard the Dead and Dying, Typhoon Coming
On* of 1840 (fig.64). The pathos of this image is overwhelm-
ing. Turner represents an incident that occurred on the
slave ship *Zong* in 1781, where sick slaves were thrown
overboard by slavers seeking to collect insurance money
for their lost human cargo.[77] Turner's Aeolean gift for
summoning up nature is on full display: the smouldering
sky seems, colouristically, to capture the plight of the
sacrificed humans in the churning waves. Highlighting
the horrors of slavery, the painting draws the spectator into
an uncomfortable equation between the sublimity of nature
in representation and the diabolical effects of human evil.

One of the most prominent and powerful emblems of
abolition was Josiah Wedgwood's immensely popular
medallion showing a shackled and imploring slave, with
the Christian motto above his head: 'Am I not a man and
a brother?' (fig.65).[78] The image was made in 1787 as the
official seal of the Society for the Abolition of Slavery and
it quickly came to be reproduced on all kinds of consumer
goods, and paraphernalia of the abolitionist movement,
including cups, plates, women's needlepoint, tobacco

boxes, tokens and buttons. Its widespread use suggests a form of consumerism and an expanding visual culture within the abolitionist movement.[79] The subjugation of the kneeling black man, begging to be freed, implies an upright, unthreatened and paternalistic whiteness outside the frame.

Richard Westmacott's hugely popular statue in Westminster Abbey uses a similar image to pay tribute to the celebrated Whig politician, Charles James Fox (1749–1806; fig.67). While Fox expires in the arms of Liberty, mourned by the personification of Peace, the classically proportioned, kneeling, half-nude figure of an African slave has seemingly stepped out of Wedgwood's medallion, clasping his hands, no longer in supplication but in grateful acknowledgement of his noble intervention. It was Fox, as

supporter for the rights of the North American colonies and ardent abolitionist, who, in his last speech to the House of Commons on 10 June 1806 following William Wilberforce's long campaign, proposed the successful motion that would result in the abolition of the slave trade in 1807. The white marble of Westmacott's monumental group subsumes the black figure, in a celebration of whiteness as the salvation of all peoples whatever their colour.

By the middle of the nineteenth century the figure of the kneeling black man and the civilizing force of Christianity exemplified by the Bible appeared alongside Britain's most visibly pious public figure – Queen Victoria herself. In *The Secret of England's Greatness* 1863 by Thomas Jones Barker (1815–82), the Queen presents a Bible to a kneeling African prince in the Audience Chamber at Windsor Castle

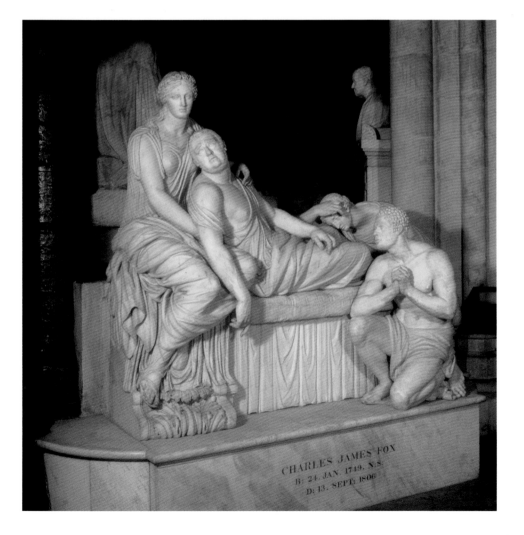

67 RICHARD WESTMACOTT
Monument to Charles James Fox
1810–23
Marble, height 195.6 (77)
Westminster Abbey, London

68 THOMAS JONES BARKER
'The Secret of England's Greatness'
(Queen Victoria Presenting a Bible in
the Audience Chamber at Windsor)
c.1863
Oil on canvas 167.6 × 213.8 (66 × 84⅛)
National Portrait Gallery, London

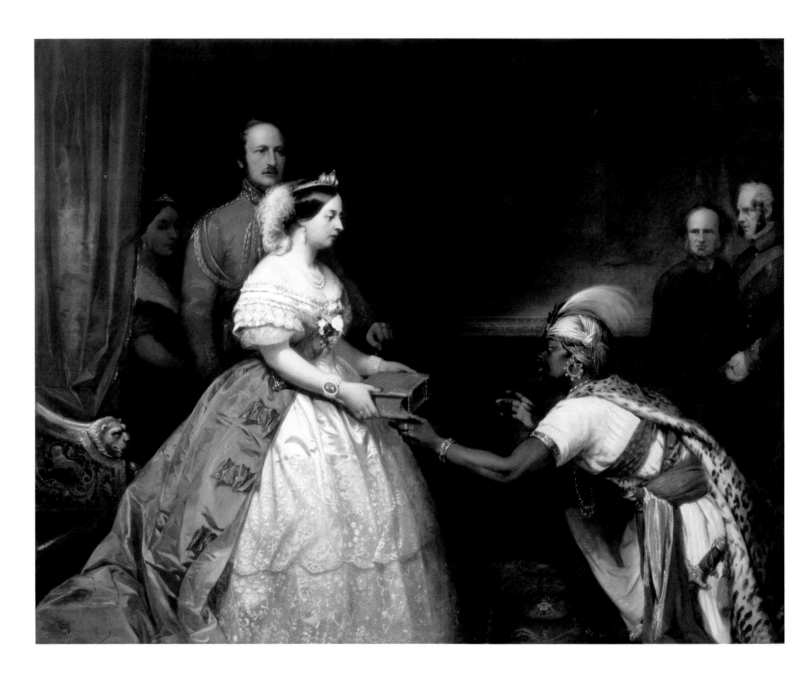

(fig.68). Although no official record of this meeting survives, Barker based his composition on a widely circulated anecdote praising the humble Christian Queen for her noble gesture of handing a Bible to the African prince who in turn, had presented her with expensive gifts. While the Queen was sympathetic to the rallying cries of the abolitionists and Prince Albert was a patron of the Society for the Extinction of the Slave Trade and the Civilization of Africa, the composition is nonetheless steeped in the rhetoric of colonial and imperial power. Specifically, it recalls Spiridione Roma's image of Britannia receiving the riches of the East painted in 1778 for the ceiling of the East India Company's headquarters in London, among other similar representations.[80]

Sovereignty is underscored by Christian largesse on the part of the Queen and supplication on the part of the African. Christian identity was inseparable from an imperial one, fostering a sense of national identity for Britons stationed throughout the imperial territories. At the same time, conversion to Christianity was justified as an important imperial objective, although it triggered a great deal of debate. The London Missionary Society (1795) had focused on the newly conquered Cape of Good Hope as its point of entry into Africa, and by the 1880s large sections of the continent, including the Congo, were the focus of missionary activity.[81] Missionaries also advocated human rights, taking up the cause of the neglect or ill-treatment of indigenous peoples. In this sense, their goals matched those of William Wilberforce, the ardent abolitionist who was also devoted to the propagation of Christianity in India. Seen within the context of empire building, the Queen's gesture, therefore, can be interpreted as more than a benevolent one, but also as a sign of her authority as a Christian monarch.[82] If Elizabeth I had sanctioned Britain's initial forays into colonial expansion, then Victoria represented her nation's imperial ambitions and conquests. As such, Barker's composition reveals the intimacy of empire embedded in this exchange in the royal chambers at Windsor. Yet the picture also reiterates the marked divisions of power, and cultural and racial difference that would eventually split apart the British Empire.

Conclusion

Reaching beyond Europe to the African diaspora, the Americas, India, China, the South Pacific and the 'Levant', this chapter has applied to the period of the rise and apogee of the British Empire current conceptions of centre and periphery, metropolis and colony, national identity and difference in order to interrogate the peculiar character of British art, which has inherited today some of the conditions created by an imperial past. In the present era of globalization British art has been energized by the conspicuous achievement of artists who derive ancestrally from countries that were once part of the British Empire. The art of the British Empire, paradoxically, given its nationalistic objectives, can be considered to have foreshadowed and made possible in Britain the first truly global art scene.

Imperial art can, therefore, be broadly understood as an outcome of Britain's most ambitious international encounters at home and abroad. Aesthetic assumptions and artistic practices were in continual flux as fresh ways of representing the world emerged. Whether born of American parents like Earle or settled in China like Chinnery, colonial and imperial artists hailed from different backgrounds, but although they reached far beyond Europe, these artists rarely broke away from European artistic conventions. In this sense they remained fundamentally British, but their subject matter, their sense of colour, light and texture, and in some cases their sense of design reveal their identity as simultaneously imperial as well. Thus, the production of imperial art renders visible Britain's global power at the same time that it reveals a tenacity to hold onto a sense of Britishness amid the ebb and flow of imperial culture and politics.

The Art of the Cook Voyages

GEOFF QUILLEY

The year 1768 saw both the foundation of the Royal Academy of Arts in London and the start of Captain James Cook's first voyage to the Pacific (1768–71). Little has been made of this coincidence, but Cook's voyages were significant on several counts for the development of British art.

These were the first British voyages of exploration to take artists on board as part of a professional team of scholars and intellectuals, whose task it was to record and interpret the expedition's findings; they were thus important in connecting artistic practice with the incipient sciences of botany, geography, ethnography and anthropology. The appointment on the first voyage of the botanical illustrator Sydney Parkinson and the topographical draughtsman Alexander Buchan (who died in Tahiti in 1769, his role being assumed by Parkinson) was closely tied to the predominantly botanical interests of Joseph Banks, whose protégés they were. However, with the Admiralty appointment of professionally trained artists – William Hodges on the second voyage (1772–5) and John Webber on the third (1776–80) – the artistic role assumed greater independence and increased cultural importance.

Cook's voyages produced the earliest graphic records by Europeans of the environment and peoples of the Pacific. While Buchan's and Parkinson's drawings from the first voyage are perhaps of greater historical than artistic significance, Hodges's and Webber's works mark the first properly artistic response to the conditions and cultures of the southern hemisphere. Hodges's oil paintings done *en plein air* during the voyage are not only the earliest landscape paintings of the Pacific, they are among the earliest *plein air* oil studies in British art, produced almost forty years before the rise of 'English naturalism' centred around J.M.W. Turner and John Constable in the early 1800s.

The art of Cook's voyages also marked the introduction of important and lasting new subjects for British art, centred on the imagery of exoticism and tropical scenery. These increased the visibility of non-European subjects, which fed the contemporary cultural interest in ideas of the 'noble savage' and of primitive innocence, generating a fascination with the allure of the exotic that would underpin subsequent representations of the Pacific and inform representations of other parts of the non-European world. Paintings such as Hodges's

Tahiti Revisited 1776 (fig.70) or Webber's 1777 portrait of *Poedua* (fig.69) gave visual form to the prevalent idea of Polynesia – above all, Tahiti – as a new-found paradise of natural, exotic abundance and pleasure, while reworking traditional Western artistic themes within a novel context. Poedua, in one of the earliest portraits of a Polynesian woman, is posed in the manner of the classical sculpture of the *Venus Pudica*, while in Hodges's idyllic landscape the placement at the far right of a *ti'i* (a monument of ancestor worship) and a distant funerary platform, adjacent to the carefree young beauties swimming like classical nymphs in the river, makes the painting a Tahitian adaptation of the well-known poetic and artistic subject *Et in Arcadia Ego*, associated with paintings of shepherds in Arcadia by Nicolas Poussin (1594–1665). The art

of Cook's voyages, therefore, filters 'European vision' through the lens of the Pacific, providing an insight into Western cultural preconceptions.

Both Hodges and Webber were employed after their return to produce illustrations for the Admiralty's official publications of the expeditions, the most profusely illustrated voyage accounts of their day. Both also made large-scale paintings for public exhibition, of which those by Hodges contributed to a revision of landscape aesthetics in the later eighteenth century. Traditionally, landscape painting had been divided between topographical record and ideal landscape following the model of Claude Lorrain. Hodges in his Pacific paintings (and his later views of India) aimed at a hybrid genre of 'historical landscape', in which the moral or philosophical imperatives traditionally

69 JOHN WEBBER
Poedua 1777
Oil on canvas
145.4 × 95.9 (57¼ × 37¾)
National Maritime Museum,
London, MoD Art Collection

70 WILLIAM HODGES
Tahiti Revisited 1776
Oil on canvas
92.7 × 138.4 (36½ × 54½)
National Maritime Museum, London,
MoD Art Collection

associated with history painting were invoked
through reference to landscape and its artistic
representation.

The art of Cook's voyages has been of consid-
erable art historical importance, and much of the
academic study of this work has been undertaken
by scholars from outside Europe, pioneered by
the Australian art historian, Bernard Smith – a
form of postcolonial 'writing back' in British art
history. This has had a formative influence upon
the subsequent study of British art's relation
to imperial history, now a subject of increasing
and wide-ranging scholarly concern. (See also
Rosenthal and Ray, pp.84–115.)

FURTHER READING

Joppien, R. and B. Smith, *The Art of Captain Cook's
Voyages*, 4 vols., New Haven and London 1985–8.
Quilley, G and J. Bonehill (eds.). *William Hodges
1744–1797: The Art of Exploration*, New Haven and
London 2004.
Smith, B. *European Vision and the South Pacific*,
2nd ed., New Haven and London 1985.
Thomas, N. *Discoveries: The Voyages of Captain Cook*,
London, 2003.

Zoffany in India

NATASHA EATON

It was not India but the Pacific that initially tempted Johann Zoffany (1733–1810) to venture beyond Europe. However, the withdrawal of his sponsor Sir Joseph Banks led to Zoffany being replaced as the official artist on James Cook's second voyage (1772–5) by William Hodges (see Quilley, pp.116–17). Hodges travelled to India in 1780–3, and even before his return to London, Zoffany had also made an application to the English East India Company's Court of Directors to work in the colonial Presidencies of Madras and Calcutta.

Although Zoffany executed numerous portrait commissions and painted a *Last Supper* altarpiece for St John's Church, Kolkata (Calcutta), it was the support of Governor-General Warren Hastings (1772–85) that enabled him to experiment with innovative artistic subjects and pursue non-British clients (see Rosenthal and Ray, pp.84–115). He accompanied Hastings to the north Indian court of Lucknow, capital of Awadh, where he took the likenesses of the Nawab (ruler) Asaf ud-Daula and his chief ministers. He would later combine these portraits in the comic history painting, *Colonel Mordaunt's Cock Match* c.1784–6 (fig.72). Shown sparring with his red-faced English bodyguard Mordaunt in the Tate painting, Asaf ud-Daula is encircled by ministers,

dancing girls, a Company official and his *bibi* (woman), and by a group of Europeans who had worked for both the Company and the nawab whilst remaining faithful to their own private interests. At the apex of this European collective, Zoffany with brush in hand poses under a green umbrella – a principal insignia of Indo-Islamic sovereignty.

All of the Europeans represented in *The Cock Match* (including Zoffany and the miniaturist Ozias Humphry, here seen pressing his hand on the artist's shoulder) wanted to make fortunes by selling Western luxuries – including pictures – to Asaf ud-Daula. In debt to these private traders and owing extortionate reparations to the Company, the nawab played these Europeans, including Zoffany, at their own game by promising to pay their fees but then delaying; in this case deferral acted as a form of resistance to colonial demands.

At Lucknow Zoffany became involved with three important art collectors – the Swiss Antoine de Polier, the Frenchman Claude Martin and the Company's Paymaster John Wombwell, all of whom feature in *Colonel Mordaunt's Cock Match* c.1784–6 and in the conversation piece *Colonel Polier, Claude Martin and John Wombwell with the Artist* c.1786–7 (fig.71). In contrast with

his famed depictions of *The Tribuna of the Uffizi* 1772–8 (fig.113, p.179), *The Royal Academicians* 1771–2 (fig.128, p.200) and *Charles Townley and his Friends* 1781–3 (Townley Hall Art Gallery, Burnley), Zoffany places himself and his pictures at the centre of the scene rather than Old Masters and classical sculpture. These paintings within the painting display one of Zoffany's other artistic interests – the portrayal of Indian manners and customs including widow burning and bathing in the Ganges.

On his return to London in 1789, Zoffany acted as a dealer for Claude Martin whilst establishing a studio crammed with Indian artefacts (see Rosenthal and Ray, p.98). However, he appears to have sent only two paintings with an Indian subject matter to the annual exhibitions of the Royal Academy, of which he was a founding member. Although Zoffany did not defend Warren Hastings as intensely as Hodges, whose choice of exhibition oils, published *Travels* and political affidavit supported the former Governor during his trial for impeachment (1788–95), he did commemorate Hastings's acquittal with an exhibition piece. Its style and comic subject, *The Embassy of Hyder Beg Khan to meet Governor-General Cornwallis with a View of the Granary Erected by Hastings at Patna* 1787

71 JOHANN ZOFFANY
Colonel Polier, Claude Martin and John Wombwell with the Artist c.1786–7
Oil on canvas 138 × 183 (54⅜ × 72)
Victoria Memorial Hall, Kolkata

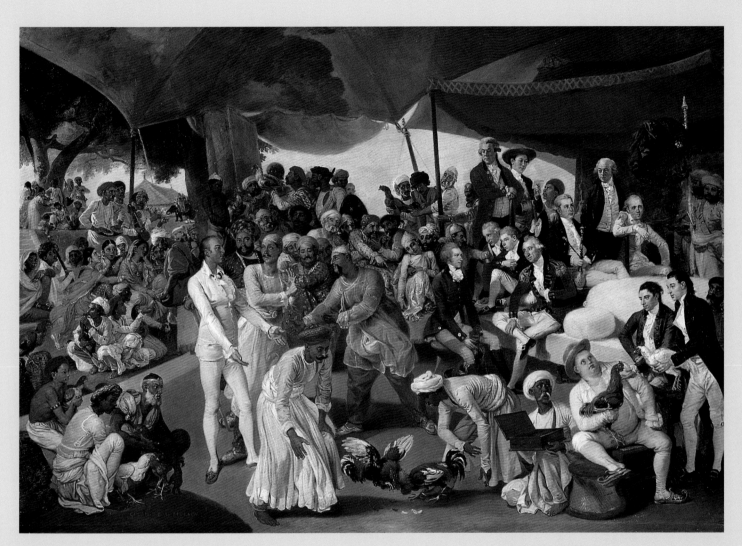

72 JOHANN ZOFFANY
Colonel Mordaunt's Cock Match c.1784–6
Oil on canvas 103.9 × 150 (40⅞ × 59)
Tate. Purchased with assistance from
the National Heritage Memorial Fund,
The Art Fund, the Friends of the Tate Gallery
and a group of donors 1994

(Victoria Memorial Hall, Kolkata) was viciously
received by the critic Anthony Pasquin: 'He has
laboured hard to sacrifice the dignity of humanity
to the pride and parade of aristocracy; indeed he
seems so familiar with slavery and so enamoured
with its effects that we doubt if the black cata-
logue of governing infamy can furnish a subject
equal to his hunger for degradation.'

In 1810 Zoffany applied to the Company's
directors to return to India to retrieve the money
he felt the court at Lucknow owed him. But the
artistic and political landscape in India had
changed dramatically. Asaf ud-Daula, Polier and
Martin were long since dead; Awadh had been
annexed to the Company while economic reces-
sion led to a drastic decline in art patronage.
As so few European painters could make money
from portraiture, they devised ambitious
topographical or ethnographic projects for
publication on their return to Europe. Soon after
his application to the Company was accepted,
Zoffany died. Following his wife's death from
cholera, Zoffany's Indian possessions and his
own paintings and drawings were burnt.

FURTHER READING

Archer, M. *India and British Portraiture, 1770–1825,*
London 1979.
Llewellyn Jones, R. *A Very Ingenious Man: Claude Martin
in Early Colonial India,* Delhi 1998.
Webster, M. *Johann Zoffany,* London 1976.

4 New Ways of Seeing: Landscape Painting and Visual Culture
c.1620 – c.1870

NICHOLAS GRINDLE

Why 'New Ways of Seeing'?

Q. What does landscape (as a phenomenon) and landscape painting in particular, have to do with changing attitudes to vision?

A. Since the 1960s, philosophers and literary theorists such as Nelson Goodman and John Barrell have asserted that landscape as a phenomenon is a product of the way we see things: it has no independent existence.[1] This view has now become widespread and underpins most recent literature on landscape painting.[2] It therefore makes sense to address landscape painting by looking at the ways in which people saw things.

Q. So did ways of seeing that developed in the period 1570–1870 produce a particular way of seeing the landscape or a specific kind of landscape painting?

A. The same people who have said that landscape is a discursive phenomenon (that is to say a product of the way we see or talk about things rather than something with its own independent existence) have tended to say that such phenomena are complex and cannot be linked to any one specific cause.

Q. Then why look at new attitudes to vision at all?

A. Because they are a consistent presence in the discourse of landscape painting in Britain. The thesis of this chapter is that from the late seventeenth century the whole discourse of landscape saw no distinction between questions about the visual organization and imagery of landscape painting, and the kind of viewer and nature of the viewing experience that such imagery implied. Stemming from this thesis, three main arguments will be made here.

Firstly, the chapter will try to show that specific attitudes to vision, often collectively referred to as natural philosophy or 'Baconianism', preoccupied artists in their practice, as well as theorists and critics. It provided the basis for the view that nature was superior to art because it led to the mind to God. This didn't mean, however, that it provided an exclusive paradigm for theory and practice. We shall see that many artists cheerfully held to an ideal of Continental academic art at the same time as thinking of themselves as working within an empirical and specifically British tradition.

Secondly, the chapter will examine how landscape painting offered a precedent for representing social relations as part of the natural order. One important theme is the way that some people perceived a relationship between responses to nature and socially progressive ideas. This is implicit in strands of Baconian thinking from the mid-seventeenth century to the mid-nineteenth century in a range of contexts, and lies behind many of the disagreements about what kind of imagery and what kind of response was appropriate for landscape painting, and indeed who was qualified to look at landscape and painting in the first place. In many cases these tensions are closely related to Christian theology and eschatology.

Finally, the chapter will argue that landscape painting in this period is deeply implicated in modern forms of life, whether through its imagery, its modes or its implied viewing constituency. I will suggest that popular characterizations of landscape painting – especially of its more prominent practitioners such as John Constable and J.M.W. Turner as painters of national sentiment and rural retreat – are misplaced.

'More Boundless in My Fancy than My Eye'

In this first part of the chapter I will look at the introduction of landscape painting to Britain and the classical conventions of poetic landscape imagery, and also at the emergence of empirical philosophy and its associated practices. I will explore the ways in which different types of landscape imagery invited different kinds of viewing, and sometimes inferred a different kind of viewer. The section will finish by looking at how 'ways of seeing' had become a central issue in defining gentlemanliness by 1700.

A good place to start would be a painting of a landscape (fig.73) reputedly by Nathaniel Bacon (1585–1627) and a self-portrait by the same (1618–20; Collection Earl of Verulam, Gorhambury, Hertfordshire). The landscape

73 NATHANIEL BACON
Landscape 1620s
Oil on copper 7.1 × 10.7 (2¾ × 4¼)
Ashmolean Museum, Oxford

painting is tiny, measuring only 7 by 10 centimetres. It depicts a rocky outcrop topped by trees, with a path cutting tangentially across it. A horseman climbs the path, and a figure on foot with a load is shown at the bottom of the hill. To the left are cottages with a church behind them; on the right are more substantial buildings, and another church in the distance. The subject is not clear but does not appear to be a Flight into Egypt or Abraham and Isaac, so may well be a contemporary scene. It has been dated to the 1620s, when landscape painting was 'an art soe new in England, and soe lately come ashore, as all the language within our fower Seas cannot find it a name, but a borrowed one from the Dutch, *landschap*'.[3] The composition, if not execution, suggests that Bacon was familiar with those landscapes 'lately come ashore' or else he had seen works by Joachim Patinir (d.1524), Paul Bril (1554–1626), or Adam Elsheimer (1578–1610) while travelling on the Continent.

Bacon's self-portrait is altogether different. Two metres high and painted with real flourish, Bacon is surrounded with objects that signify his gentlemanly status and also his commitment to the liberal arts: a sword, statues, a painting of Pallas Athene, a perspective diagram, pen and ink, brushes and palette, closed books and an open map. He solicits our gaze and in the centre of the picture holds up a sheet of paper that appears to have a platemark, but is blank: perhaps a pun on 'impression', as the visible world makes an impression on his senses.[4] It would be tempting to say that he is signalling his commitment to observation and that this manifests itself in the creation of a kind of proto-naturalistic landscape. This is clearly not the case, as is demonstrated by the fact that there is only one landscape painting by Bacon; still, while there were precious few other landscape paintings in Britain at this time, the fact that

Bacon did paint one suggests how readily available the concept was. The question we should therefore be asking is what was the point of his doing so?

Painting the landscape could be an effective gesture because it signified a familiarity with a specific cultural ideal, that of *virtù* in a rural setting. A growing corpus of translation from Virgilian and (to a lesser extent) Horatian poetry during the seventeenth century marked a recognition of how the Roman ideal of philosophical retirement was appropriate for the English landed classes. Virgil's pastoral and heroic ideals were echoed in Philip Sidney's *Arcadia*, and Virgil's georgic poetry (with its practical rural focus) offered a model for how social concerns could be addressed through the imagery of the country estate, a concept most famously taken up by Ben Jonson in poems such as 'To Penshurst'. Masques at the Stuart court used depictions of the landscape as a setting for drama rich in political allegory, from *The Masque of Blackness* in 1605 to *Salmacida Spolia* of 1640 (the latter a prospect 'as might express a country in peace, rich and fruitful').[5] It is in such a setting that Peter Paul Rubens depicted Charles and Henrietta Maria in *Landscape with St George and the Dragon* 1630 (fig.74), which like the masques contained sufficient references for contemporaries to recognize it as a specifically English landscape. The idea that the landscape is a site of *virtù* also informs the imagery of Rubens's famous *View of Het Steen in the Early Morning* c.1636 (National Gallery, London) and his other later studies of his estate, images that take their overall concept as much from Flemish print culture and chorographical surveys, as from Latin poetry.

St George and the Dragon is over 400 times the surface area of Bacon's contemporary landscape, its size under-

74 PETER PAUL RUBENS
*Landscape with St George and
the Dragon* 1630
Oil on canvas 152.4 × 226.7 (60 × 89¼)
Royal Collection

lining not only Rubens's technical brilliance but also the point that landscape could be scaled up so confidently because it could give voice to meanings that were widely shared and understood in early Stuart culture, and between England and the Continent. The extent to which this language was shared can be see in the example of the parliamentarian general Thomas Fairfax and the royalist general William Cavendish, Marquis of Newcastle, who fought each other at Adwalton Moor in June 1643 during the Civil War. Fairfax lost this battle but won the war, and retired victorious to his Yorkshire estates where he sponsored landscape poetry that reflected on the political turmoil of the previous decades. Cavendish fled abroad and spent his exile in Rubens's house, similarly using his retirement to reflect on recent events. They were ideologically opposed but their gestures spoke the same language of classical retirement and its associated virtues.

If the poetry of Andrew Marvell and John Denham

shows how landscape could act as a setting for courtly *virtù*, it also distinguishes between the viewer of the landscape and the landscape they were looking at. In doing so, they demonstrate a good grasp of the technicalities of vision, because ideas about spectatorship were increasingly linked, in a rather generalized way, to a knowledge of optics. Hence Denham, standing on Cooper's Hill:

> Nor wonder, if (advantag'd in my flight
> By taking wing from thy auspicious height)
> Through untrac't ways, and aery paths I fly,
> More boundless in my fancy than my eie;
> My eye, which swift as thought contracts the space
> That lies between
> (*Cooper's Hill*, lines 9–14)

In 1604 Johannes Kepler was the first to offer an explanation of the physiological basis of vision through the theory of light impressions on the retina. This theory became widely

accepted in the seventeenth century, and was reiterated by Descartes in his *Optics* in 1637. As Svetlana Alpers has observed, Kepler conceived of the retina as a kind of canvas and the rays of light as similar to paint, a model that proved influential.[6] Equally significant for visual culture in Britain was the work of Francis Bacon, Nathaniel Bacon's uncle, in the years that his nephew was painting his *Self-Portrait*. The elder Bacon's significance was that he offered a model of investigative procedure that was based on observation. His work considered epistemological rather than physiological issues: he was more interested in how we can know things by seeing them, than by the actual optical processes. Robert Boyle's *Proëmial Essay* (1661) reinforced the connection between observation and pictorial representation by stressing the importance of clarity and trustworthiness in both observing an object or event, and representing it in pictures.

It is difficult to pin down precise instances where the 'new philosophy' may have had a bearing on visual culture, although persuasive cases have been made for its influence in literature and theatre. Topographical surveys and natural histories stressed the accuracy of their plates and avoidance of dramatic effects, referred to as 'the distorting effects of rhetoric'.[7] The scope of an artist's profession required work in a number of fields, and Francis Place (1647–1728), Wenceslaus Hollar (1607–77), William Lodge (1649–89) and Francis Barlow (?1626–1704) are all examples of artists working in the mid- to late seventeenth century whose practice encompassed engraving, bodycolour, oil paint, and pen and wash drawing of a range of subjects from insects to Windsor Castle, for patrons from the Royal Society to their immediate friends (who in some instances were one and the same). Place himself was closely involved with a group of 'virtuosi' (men who collected and studied natural or antiquarian objects) in York, and was familiar with the latest scientific developments and literature; the same group also circulated treatises by artists such as Gian Paolo Lomazzo (1538–1600) and Edward Norgate (1581–1650). Place's work shows his conception of drawing as a systematic procedure, but we also see him moving comfortably between different genres: studies of natural features in the landscape, minute topographical surveys and fantastic harbourside compositions.

Gentlemen virtuosi such as Place became the butt of many jokes for their myopic attention to natural phenomena. Beneath the joking was a serious question about what

modes and objects of looking were appropriate for a gentleman. In part this was due to the tensions between a poetic, idealist notion of beauty and an empirical philosophy that stressed the importance of controlled and detailed observation. Place may not have seen a contradiction here, but two men who did were Anthony Ashley Cooper, 3rd Earl of Shaftesbury, and Joseph Addison. Shaftesbury rejected close observation altogether and called for an art that pleased the mind, inferring the viewer to be a man of independent means whose autonomy was the basis for his liberal intellect and therefore of his capacity to act in the public interest. Addison on the other hand tried to develop a theory of the imagination that recognized the moral supremacy of idealism but couched it in terms borrowed (and altered) from John Locke. He didn't talk about art but discussed spectatorship at great length, proposing that social and economic progression was incipient in the way that a man's mind is designed for improvement through judicious use of the senses. His 'new model gentleman' is in social terms a broader phenomenon than Shaftesbury's philosopher.

Shaftesbury's and Addison's responses to empiricism may have been conditioned by its association with the Puritans' millenarian programs of social reform. But both were agreed that viewing was an attribute of a gentleman, a badge of cultural distinction to mark them from the 'vulgar', and that was why it mattered. How artists responded to this will be the subject of the next section.

'A Fig for Prospects!'

Having examined the mode of spectatorship deemed appropriate for a gentleman in the later seventeenth century, I will now consider how artists struggled to find a language of composition and imagery that complemented these notions of 'polite', or gentlemanly, spectatorship, and will suggest that after mid-century this way of seeing was being challenged by a new kind of imagery.

I would like to begin by comparing two paintings: *Nottingham from the East* (fig.75), painted c.1700 by Jan Siberechts (1627–1703), and *A View of Box Hill, Surrey* painted by George Lambert (1700–65) in 1733 (fig.76). Landscape painting from the later seventeenth century is sometimes seen as an aspect of aristocratic, leisurely conspicuous

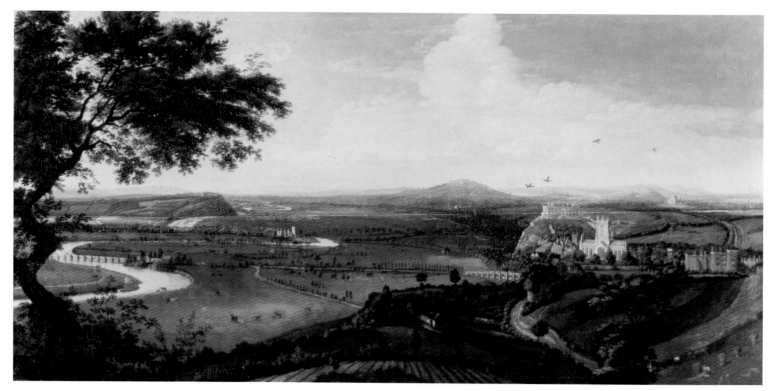

75 JAN SIBERECHTS
Nottingham from the East c.1700
Oil on canvas 58.4 × 120.7 (23 × 47½)
Nottingham Castle Museum

consumption. In fact a review of Siberechts's *œuvre* reveals that much of the imagery is strikingly contemporary, with barges, locks, enclosures, roads and other improvements recorded in painstaking detail. In *Nottingham from the East* Siberechts has drawn attention to the almost biblical fertility of the plain: cattle graze, sheep are driven to market, the harvest is gathered in, and the Trent carries the produce to London. Lambert's painting is similar in regard to its composition as well as its subject matter, being a wide prospect of a specific site with a harvest scene, an imagery of contemporary prosperity if not industrious progress.

One significant difference between the paintings is that Lambert uses the gentleman in the foreground gesturing to his companion, who is sketching the view, to embody the viewer and give him a social identity, suggesting that the viewer is in fact another gentleman. This is in contrast to Siberechts, who like many Flemish painters depicts a specific site but suggests the spectator is some distance above the ground. The landscape imagery of Lambert and Siberechts's paintings surely has something to do with the perceived identity of the spectator. Rather than introducing a greater dose of contemporary life to counter an aristocratic vision of the idle pastoral life, as has been suggested, Lambert has, I think, toned down his image of labour and emphasized the poetic elements instead, above all the warm tones that give the painting such an air of repose, despite the harvest work.[8] This is because what seems to

have mattered for Lambert's patrons was *who* was doing the looking in a way that was not as central for Siberechts when painting *Nottingham from the East*, where there is an unsettling ambiguity about the viewer's identity. This point was also important for how the artists saw themselves. If Lambert was able to suggest the poetry of his view and that the spectator of his view is a gentleman who would appreciate such refinement, he could present himself (the painter of the view) as a man of similar social standing. This might explain why Siberechts was paid on the same scale as a highly skilled craftsman, £75 for up to two years' work between 1672-4, whereas Lambert was able to sell his works individually for over £15 per painting in 1732, over £100 for the year. Yet landscape was still a low genre: even Lambert's pay compares badly with a painter such as Sir Godfrey Kneller (1646-1723), who could command £50 for a single full-length portrait.

Lambert's painting is of the Downs, and a contemporary discussion of the same subject from Henry Fielding's novel *Joseph Andrews* (1741) highlights the issues at stake here:

> The chariot had not proceeded very far before Mr. Adams observed it was a very fine day. 'Ay, and a very fine country too', answered Pounce. – 'I should think so more', returned Adams, 'If I had not lately travelled over the Downs, which I take to exceed this and all other prospects in the universe'. – 'A fig for prospects!'

76 GEORGE LAMBERT
A View of Box Hill, Surrey 1733
Oil on canvas 90.8 × 180.4 (35¾ × 71)
Tate. Purchased 1951

answered Pounce; 'one acre here is worth ten there, and for my own part, I have no delight in the prospect of any land but my own' . . . Adams answered, 'That riches without charity were nothing worth; for that they were a blessing to him only that made them a blessing to others'.[9]

Parson Adams's willingness to let the view of the land fire his social feelings would have been recognized by contemporaries as an echo of the natural and social harmony that was the theme of James Thomson's bestselling poem *The Seasons*. First published as a complete poem in 1730, *The Seasons* aimed to reveal social, cultural, natural, historical and cosmic harmony through the description of nature and the study of its design. Thomson based his survey of 'the various parts of nature, ascending from the lower to the higher' on the notion that all nature was indissolubly linked by design.[10] As Nigel Everett has explained:

> In the tradition of analogy developed by [Joseph] Butler [Bishop of Bristol 1738–50], it is argued that there are consistent patterns throughout nature, that its laws of organization may be the same as those of society, that the same methods of analysis and criticism may be appropriate throughout experience, and that patterns of organization found in individual systems might reveal the pattern and regularity of the whole creation.[11]

The Seasons was enlarged and republished in 1744 and 1746, when Thomson added set-piece descriptions of the view from Hagley Park and Richmond Hill, following seventeenth-century models such as Denham's *Cooper's Hill*. These 'prospect' views had become well known, and they only enhanced what was already a notable feature of the poem, the emphasis on the spectator and the role of the senses: in *The Seasons* the 'eye' is mentioned about once every fifty lines, over a hundred times in total. But unlike Bacon, Thomson's eye does not simply observe 'individuals'. Historians have noted that in *The Seasons*, the visual sense is transformed into an imaginary power, and we might suggest that Thomson's spectator is like Addison's, and indeed like the spectator that the viewer of Lambert's painting is invited to become.

Fielding's point was that Thomson's spectator is a fiction: as Pounce's and Adams's names suggest, commerce and virtue exist in mutual tension. Historians have seen this tension at the heart of landscape painting in the early eighteenth century. John Barrell has argued that painters substituted a pastoral vision of landscape for one that increasingly admitted the realities of economic production, modelled on georgic poetry. This overlooks the innovations of later seventeenth-century landscape painting, but he is right to point to Lambert's search for new pictorial models to fit changing circumstances. For example, in four views of Westcombe House, Blackheath, for Lord Pembroke

77 RICHARD WILSON
The Cock Tavern, Cheam, Surrey c.1745
Oil on canvas 43.6 × 73 (17⅛ × 28¾)
Tate. Bequeathed by
Revd. A. Stopford Brooke 1916

78 RICHARD WILSON
*The Thames near Marble Hill,
Twickenham* c.1762
Oil on canvas 46.4 × 73 (18¼ × 28¾)
Tate. Purchased 1937

(Collection Earl of Pembroke), Lambert represents the grounds as a space of genteel amusement, much as Siberechts did, but sprinkled with labourers and beggars, the latter receiving charity from the gentlefolk. In the distance he has represented shipping on the Thames passing Greenwich, a prospect both visual and temporal to be enjoyed in the viewer's imagination. The grounds as an arena of polite refinement and the distant prospect of London characterizes the viewer as a Thomsonian spectator, ruminating on material and moral improvement supposedly ordained in the very pattern of creation.

Pembroke's paintings were the luxury end of a rapidly expanding market in the years 1715–55: the topographical prospect view. Beginning in 1707 with *Nouveau Theatre de Grande Bretagne*, a printed survey of Britain's notable country estates often called *Britannia Illustrata*, topographical images flooded the print market: William Stukeley began publishing antiquarian surveys in the 1720s, Nathaniel and Samuel Buck issued their prospects of towns and cities from the same decade onwards, and Robert West and William Henry Toms began to publish similar work in the 1730s.

Together they accounted for nearly two-thirds of the market for these images, which averaged nearly ten titles per year until the late 1750s. In them the country estate and increasingly the city were represented as clean and orderly, an appropriate environment for inhabitants engaged in genteel leisure and imaginative pleasure. The figures that populate the foregrounds are well-dressed and engage one another in conversation while observing the view. They suggest that looking was not simply an activity but an integral part of their style, becoming 'fully internalized, unconscious behaviour',[12] and was evidently of sufficiently widespread concern to keep a number of draughtsmen fully employed, whereas landscape painting *alone* could not even support one painter in the same period.

The 'prospect' view fell into sharp decline after about 1750. This was partly due to the age of those artists, but also due to the pressures of newer forms of formal and thematic innovation. Antonio Canal (Canaletto) arrived in England in 1746 in the wake of patronage by English 'milordi' on the Grand Tour in Venice. The paintings he produced and advertised in England are executed on a

scale and with a technical assurance and flourish that utterly outshines even Lambert's work. Canaletto painted London as a polite, sanitized city. Perhaps most distinctively, his viewpoints were specifically identified as being from a particular site and his bold compositions had the function of embodying the experience of seeing the city: *Westminster Bridge* 1747 (Yale Center for British Art, New Haven) is perhaps the most well-known example. The outcome is a representation of how the viewer experiences the city as a spatially specific and socially encoded phenomenon, as they are admitted to take the prospect from Richmond House or the terrace of old Somerset House. It is important to note how the topographical specificity of the viewing experience is accompanied by technical virtuosity. Canaletto is able to offer an image of the city that is utterly refined: clean and coherent to a degree appropriate to the rank of the person viewing it. This is something that even Lambert was never really able to do, not least because he lacked a formal training. It is worth noting that even Hogarth and Reynolds fail to show a confident grasp of linear perspective.

The artist who perhaps best understood the needs that were met by Canaletto and not by the Bucks or by Lambert was Richard Wilson. The defining event of Wilson's forty-year career was his visit to Italy 1750–7. This exposed him to a greater range of paintings and subjects, leading to subtle changes in his practice, which can be seen if we compare *The Cock Tavern, Cheam, Surrey* c.1745 (fig.77) with *The Thames near Marble Hill, Twickenham* c.1762 (fig.78). In terms of size and composition, both are relatively similar: the horizon is in the centre, and nearer to us a white house peeps through the trees on the right, whilst an object in the left foreground brings our eyes to the picture plane. Both are of subjects near the river Thames. But *Cock Tavern* is painted in a freer and more lively manner, with warmer colours, whereas cooler colours predominate in *Marble Hill*, and there is a more disciplined treatment of trees and a more calligraphic treatment of highlights in the clouds and elsewhere, in a manner recalling Canaletto. The house has acquired a pediment, the tavern and its rustics have disappeared and been replaced by youthful refugees from one of Wilson's paintings of Lake Nemi.

It might be easy to see the appeal that Wilson had for patrons such as Henry Herbert, 9th Earl of Pembroke, architect of Marble Hill. Wilson's painting, as David Solkin has shown, fuses contemporary life with the pastoral ideal. This can be compared to Lambert's paintings of Westcombe House for the same patron. There the artist struggled to suggest that the pleasures that a polite spectator may take in contemplating (in Thomson's words) 'the various parts of nature, ascending from the lower to the higher', sit comfortably with the reality of the social differences on which such pleasures are based. This is not to imply that Lord Pembroke had a Damascene conversion to pastoral

landscape, but it is clear that Wilson has a level of sophistication, enhanced by his use of palette and composition to bring a cool and rational air to contemporary subjects and specific sites, that other painters lacked.

Wilson was able to do this because on his travels to Italy he acquired a greater knowledge of seventeenth-century French landscape painting, especially works by Nicolas Poussin, Claude Lorrain and Gaspard Poussin (1615–75), as well as visiting specific sites. Paintings like *Rome: St Peter's* c.1753 (Tate, London) offer topographical accuracy, rich associations (it is taken from the site of one of Martial's epigrams) and, more importantly, a form of composition based on Claude Lorrain's landscape painting. Claude was influential because his compositions offered, in John Barrell's words, 'a grammar, as it were, of landscape patterns and structures, established so thoroughly in [the connoisseur's] language and imagination that he became less and less able to separate any one landscape from any other, because he applied the same visual and linguistic procedures to them all'.[13] Wilson takes up Claude's vocabulary and grammar, and in so doing he makes the landscape itself a polite subject, as well as the act of viewing it. The appeal of Italianate landscape is evident in the ubiquity of pastiches of Poussin that form part of classical fireplace arrangements everywhere from Blenheim Palace library to London terraces (architectural decoration was still the most common setting for landscape painting). But Wilson brought this image to bear on his representation of *British* landscape, and this explains why his patrons might pay double what they would for a painting by Lambert.

Wilson was working for an urban audience. He, Canaletto and Lambert were all able to live and work in London, although there was fierce competition for patronage. The most successful landscape painting of the eighteenth century, both critically and commercially, was Wilson's *Destruction of the Children of Niobe*, exhibited in 1760.[14] *Niobe is* an attempt at heroic landscape in the highest academic traditions with a serious public function (it was the model for Turner's bid for Academy recognition), but ultimately it was a phenomenon not of aristocratic retirement but of metropolitan culture. The painting was a success because it was exhibited publicly. It was engraved and earned its publisher John Boydell a massive £2000 (a medium-sized oil by Wilson was £30, which itself was twice a labourer's annual income). In his engraving of

Niobe William Woollett (1735–85) mixed line engraving and etching in order to achieve a range of effects, and this is what gained the print its reputation. The *Critical Review* noted how 'the effects of the lightning appear by the city on fire; and the violent agitation of the water between the mountains is very finely represented . . . the mountains seem to project out of the print, and the water is perfectly in motion; the distances are delicately softened away, and the sky nicely managed.'[15] The emergence of a critical discourse of effect, addressed to a discerning audience, demonstrates the appropriation of landscape imagery by an urban audience, along with a new set of concerns: high drama, intense emotion and visual effect. It is to this audience and these concerns that we now turn.

'To Be a Person of Taste . . .'

Niobe preceded only by a few years a growing appreciation that the physical environment might have a visual appeal that was akin to the appeal of a picture: that is to say, that it might be considered pictorially, or as picturesque. William Gilpin (1724–1804) did more than anyone else to encourage this feeling through his *Picturesque Tours*, published between 1782 and 1809. Gilpin's work suggested that 'effect' was a key issue in addressing the visual worth of a painting, a print or an actual piece of land. This section will explore how the idea of 'effect' had both physical and moral sides to it, and how this broadened the moral viewing constituency of landscape imagery and at the same time undermined the traditional hierarchy of genres within which artists such as Wilson had worked.

The context of Gilpin's development of a notion of 'picturesque beauty' was provided by Edmund Burke's *Enquiry into the Origin of our Ideas on the Sublime and Beautiful*, published in 1757 and immediately successful. In the *Enquiry* Burke suggested that pleasurable excitement fell into one of two categories: the sublime, which was related to feelings of self-preservation, or the beautiful, whose objects aroused emotions of society and love. Although both sublimity and beauty had pedigrees stretching back to antiquity, Burke's initiative was to place them within the context of the senses. His thesis of 'efficient causality' held that a person's given response to something that was seen or heard was necessarily

79 PAUL SANDBY
Roslin Castle, Midlothian c.1780
Gouache on laid paper
mounted on board
45.7 × 62.9 (18 × 24¾)
Yale Center for British Art,
New Haven. Paul Mellon Collection

related to the object that touched their senses, because it had a physical cause.

Burke's *Enquiry* appeared two years after his *Vindication of Natural Society*, in which he poked fun at Tories who held that older states of society offered a better moral and social model than those currently extant.[16] Burke, on the contrary, suggested it was modern society that provided the conditions for moral improvement. His *Enquiry* offered a corollary by proposing that man's senses and mind, and by extension his morals, had been formed in a way that invited improvement through the incremental experience of sublime and beautiful things.

Burke did not discuss painting in his thesis, but the *Enquiry* was taken to present appropriate ways of addressing the landscape in terms of its effects on the viewer. Gilpin's work implicitly acknowledged this, and while it suggested that not all sublime or beautiful objects go well in pictures, it retained the principle that the key for judging the pictorial values of a landscape was its effect on the viewer. Contemporary sources reveal the degree to which landscape effects occupied people's attention. Horace Walpole wrote an extensive review of painting in Britain, but his personal correspondence says little about painting, whilst frequently discussing the effects of an actual view as though it were a painting. Here is an example from 1763: 'We walked to the belvedere on the summit of the hill [at Esher, Surrey], where a threatened storm only served to heighten the beauty of the landscape, a rainbow on a dark cloud falling precisely behind the tower of a neighbouring church,

between another tower, and the building at Claremont.'[17] Walpole could be describing a seventeenth-century French or Dutch painting here; the important point is that he was anxious to demonstrate his own sensitivity to the effects of the view.

Being affected by the view of a landscape was by this time a prerequisite of demonstrating good taste. Many writers agreed with Burke that the cultivation of taste was a moral responsibility, and that insofar as it refined a person's feeling, it provided one of the foundations of social relations in modern society. The orthodox notion that sensibility consisted in a confluence of bodily sense and morals was unwittingly demonstrated by Katherine Plymley when she wrote in her diary:

> to be a person of taste, it seems that one have 1st, a lively and correct imagination; which however, will avail but little if it is not regulated by the knowledge of nature, both external or material, & internal or moral . . . 2ly, the power of distinct apprehension . . . 3ly, the capacity of being easily, strongly, & agreeably affected, with sublimity, beauty, harmony, exact imitation, &c . . . 4ly, Sympathy, or that sensibility of the heart . . . & 5ly, judgement, or good sense, which is the principal thing, & may not very improperly be said to comprehend all the rest.[18]

The women in Paul Sandby's drawing *Roslin Castle, Midlothian* (fig.79) demonstrate the same kind of taste,

albeit with more assurance than Plymley. In their case a taste for the picturesque is displayed by drawing the scene using William Storer's Royal Delineator (patented in 1778), which was a portable camera obscura that could work even with low levels of light. The picturesque qualities of Sandby's own drawing suggest that the women, Frances Scott and Anna Maria Elliott, are following the precepts provided by Gilpin, Alexander Cozens (1717–86) and other drawing masters who stressed the use of masses of light and shade to draw out the pictorial harmonies of nature. The women are not drawing Roslin Castle itself, which could be considered a sublime topographical subject and therefore appropriate only for the sensibilities and technical experience of a man, but the wooden bridge with a poor woman and child crossing it. The viewer is asked to believe that their exposure to nature has moved them to what

Katherine Plymley called 'sympathy'. The drawing itself is one of the largest of Sandby's works and is meant to be the object of the same kind of sensitive pictorial attention that the female subjects give to their surroundings.

Picturesque beauty provided a model by which un-familiar places could be assimilated into a viewer's visual repertoire by means of a pictorial vocabulary already in use. The Wye Valley, north Wales, the Lakes and the Scottish Highlands became the principal picturesque tours, all of them geographically peripheral to southern England and relatively new in terms of pictorial subject matter. In some cases the tour enjoyed associations with the sublime, as with the tour of the Scottish Highlands and its evocation of the supposedly ancient rediscovered poetry of Ossian. In other cases, such as Derbyshire, geological research was the pull. Robert Southey poked fun at the craze, likening

81 THOMAS GAINSBOROUGH
*Wooded Moonlight Landscape with Pool
and Figure at the Door of a Cottage*
c.1781
Transparent oil on glass
27.9 × 33.7 (11 × 13¼)
Victoria and Albert Museum, London

tourists to migrating birds, 'some to mineralogize, some to botanize, some to take views of the country, – all to study the picturesque, a new science for which a new language has been formed', but the underlying point was that appreciation of nature's pictorial qualities (be it in rocks, plants, people or landscapes) carried with it implications of fashionable good taste and politeness.[19]

One means of reconciling unfamiliar places with a viewer's concept of 'landscape' was through sketching, which offered the chance to 'improve' the less attractive features of the terrain. A range of instruments also became available to enhance the enjoyment of viewing. One popular device was the Claude glass, a darkened mirror that could be taken out of the pocket and used (with the viewer standing with their back to the view) to see a framed and harmoniously toned image of the landscape in a form that recalled prints and paintings after Claude.

One of the most significant attempts to cash in on the vogue for nature's effects was Philippe Jacques de Loutherbourg's work for David Garrick at Drury Lane Theatre, and later on his own. After a decade of successful innovation in lighting, sound effects and stage design, de Loutherbourg left Drury Lane in 1781 and opened his Eidophusikon, a stage 6 feet (1.8 metres) in width that allowed him to co-ordinate dramatic visual and aural productions based on scenes from battles, natural phenomena and Milton's *Paradise Lost*. De Loutherbourg's large oil paintings such as *Lake Scene, Evening* (fig.80) combine dramatic lighting and bold colour with a strong sense of planar gradation, drawing the viewer from the foreground into the central middle ground, so that there is plenty going on but no specific element overrides the general effect. They give some idea of the technical mastery needed to stage such scenes, which would prove influential for Turner's generation.

The Eidophusikon was very popular. Sited on the edge of Leicester Square, it was at the heart of fashionable London but on the periphery of what could be considered acceptable showmanship. Although friendly with de Loutherbourg, Thomas Gainsborough did not approve of his Eidophusikon or his earlier work for David Garrick. Writing to Garrick about his employment of de Loutherbourg's 'lights' and 'new discoveries of transparent painting &c &c', Gainsborough suggested that Garrick 'maintain all [his] light, but spare the poor abused Colours, until the Eye rests & recovers'.[20] This charge was a familiar

one in painting, but Gainsborough's specific point was that the eye rather than the mind is the feeling organ, and so runs the danger of becoming sated and insensitive through constant exposure to dramatic sensations. The designs that Gainsborough protested about were in strong contrast to his own interest in light displays. His showbox, a device for viewing scenes painted with oil on glass slides and illuminated by candles placed at the rear, offers a private view for the spectator, in the sense that it was only used in Gainsborough's drawing-room, but also that the lens replicates the experience of seeing a view in a personal viewing device. Its use of gentle contrasts and warmer tones was meant to display the 'modest truth' of nature, which he characterized as 'mild Evening gleam and quiet middle term', meaning the centre of the stage, away from the footlights (see fig.81).[21] Likewise, in his publicly exhibited oil paintings such as *The Watering Place* 1777 (National Gallery, London), Gainsborough painted a landscape that was meant to touch the viewer's feelings. Historians have seen in his handling of paint a 'broken syntax and typographical exuberance', developed through a process of experiment with different tools and media.[22]

Here, however, Gainsborough faced problems. He attempted to make landscape a vehicle for high art through large paintings (*The Watering Place* is the same size as *Niobe*), generalizing effects and reference to the Old Masters (Rubens, in the case of *The Watering Place*). But the idea of using landscape to appeal to a viewer's private sensibility threatened the pre-eminence of history painting as a vehicle for public moral improvement. As both Gainsborough and Reynolds recognized, the idea that there is a place for feeling in the experience of viewing a painting on public display not only threatened the collapse of artistic distinctions but also broadened the viewing constituency, threatening the gentlemanly preserve of viewing the landscape. This male dilemma was humorously explored by Jane Austen in

Northanger Abbey: when Henry Tilney teaches Catherine Morland about picturesque beauty, Catherine proves herself capable of learning, but Henry, as a man, is careful not to weary her 'with too much wisdom at once'.[23]

An artistic place for the irrational, and a suggestion that moral sense was not solely the preserve of the rational gentleman-citizen, were also found in evangelical discussions of pictorial effects. For the circle around the portraitist John Russell (1745–1806), 'effect' was a pictorial and moral quality. It moved the viewer and led the mind to the contemplation of God through an association with sin and salvation rather than through an analogy between the Creation and the Creator. The sculptor John Bacon the Elder (1740–99), a neighbour of Russell, suggested that 'Contrast is the great thing in our being. Dark parts give the brilliancy and effect.'[24]

Doubtless this was a view shared with the nonconformist Russell, whose evangelical opinions at times drove relationships with patrons almost to breaking point. It did not follow on from the tradition of analogy, where the regularity of the natural world was used to deduce evidence of God's existence and the order of society as a whole. Rather it suggested the compatibility of observation and revelation: how the observation of nature might lead to contemplation of the Creator as revealed in scripture, and the need for personal salvation.

Russell was followed by a group of artists like Cornelius Varley (1781–1873), John Linnell (1792–1882) and Samuel Palmer (1805–81), who based their practice on a close observation of the natural world, suggesting both an artistic and evangelical sense of 'witness'. 'A Martin Luther in painting is called for, as in theology, to sweep away the abuses by which our divine pursuit is encumbered', said David Wilkie, echoing the sentiments of Linnell's circle in terms that recall Gainsborough's language.[25] He meant that moral reform would mean a reform of artistic procedures, abandoning de Loutherbourg's dramatic colouring and Gainsborough's poetic effects for a reliance on systematic observation. As Harry Mount has pointed out, the strongest proponents of observation and particularity in this period, such as Russell, Varley and Wilkie, came from low-church backgrounds.[26]

In distinction to evangelical views we can also see the development of an antiquarian aesthetic, which used the visual appeal of Gothic architecture to outline a social and moral vision based on adherence to the Crown and the established Church. Abandoning prospect views and Claudean formats for the 'visual appeal of the surfaces and textures of decaying stonework', artists such as Thomas Hearne (1744–1806) used tinted drawings and engravings to review the historical progress (or decline) of the arts and liberty in Britain.[27] In this they found an energetic backer in a vigorous Society of Antiquaries, whose membership was largely aristocratic and which reasserted the ideal of the gentlemanly viewer as the only being fully capable of registering the moral tenor of Tintern Abbey or the site where Harold fell at Hastings.

'And All This, My Countrymen, Our Own'

In the previous section I attempted to explain the emergence of a picturesque aesthetic in the later eighteenth century and suggested how it presented challenges to established patterns of landscape imagery and to established ways of seeing. This section will address the development of 'naturalism' in landscape painting from roughly 1800 to 1830, which can be considered as both a response to picturesque imagery and an intensification of the debates about what seeing meant, and what and who was implied in its various modes. It will also consider intellectual and cultural developments that might help us to understand the thematic and formal innovations of these years, such as association aesthetics, and the situation of landscape painting within the Royal Academy. The section will finish by looking at the question of whether naturalistic painting is more 'true' than other styles, as the name implies, or whether no such claims can be made for it.

In 1815 J.M.W. Turner exhibited a large oil painting titled *Crossing the Brook* at the Royal Academy's annual show (fig.82). It is a grand essay in the Claudean mode, its composition and upright format deriving from Sir George Beaumont's (see p.139) famous painting by Claude, *Hagar and the Angel* 1646 (National Gallery, London). Painted after visits to Devon in 1811 and 1813, *Crossing the Brook* combines specific observations of a recognizable site with a breadth of handling and grandeur of composition that would lead contemporaries to recognize it as English in its subject, but dignified through its sheer size (it is substantially larger than Wilson's *Niobe*) and through its reference to the Old Masters. But the range of pictorial effects in

82 J.M.W. TURNER
Crossing the Brook exh.1815
Oil on canvas 193 × 165.1 (76⅛ × 65)
Tate. Accepted by the nation as
part of the Turner Bequest 1856

Crossing the Brook has not been derived from a close study of Wilson or Claude. Turner's palette is broader, and the eye is drawn more to specific foreground details: he wants the viewer to know he has spent time studying the appearance of this particular place.

Crossing the Brook follows a period in which Turner had started painting outside, had adopted a broader palette and a greater range of brushwork, and had also turned to agricultural themes in his large oil paintings. He exhibited seventeen oils of scenes on the Thames between 1808 and 1810, and other large paintings of agricultural landscapes in the years up to 1813. Turner prepared the ground for these latter paintings with a campaign of outdoor sketching along the Thames from 1805 onwards, applying oil paint directly onto small mahogany board (which was portable and required no stretching or priming) to study local colour and the details and effects of specific sites. While the topographical detail and atmospheric effect of large native scenes such as *Ploughing up the Turnips, near Slough ('Windsor')* (exh.1809; Tate, London) are a direct outcome of these studies, reeds and detritus from the Thames also find their way into the foreground of ambitious historical paintings such as *The Goddess of Discord* 1806 (Tate, London). So *Crossing the Brook* draws on the Old Masters but it also departs from them, and we may see its attention to the specificity of the site as a muted critique of picturesque beauty. This is especially the case with the more

radical naturalism of his later Thames paintings.

Turner was one of a generation of artists who worked outdoors using pigments to sketch the motif in both oils and watercolour. In this practice they differed from their predecessors such as Wilson and Gainsborough, who would generally use chalk to sketch from life, or Edward Dayes (1763–1804) and Thomas Hearne, whose watercolour method was to apply thin tints of colour over areas already shaded with grey and black wash. Turner and associates such as Thomas Girtin developed methods of working in colour in front of the subjects themselves (see fig.83). As an example we can compare Gilbert White's 1776 account of the approach of Samuel Hieronymous Grimm, who 'first of all sketches his scapes with a lead-pencil; then he pens them all over, as he calls it, with Indian ink, rubbing out the superfluous pencil-strokes; then he gives a charming shading with a brush dipped in Indian ink; at last he throws a light tinge of water-colours over the whole'[28], with William Collins's diary entry in 1814 where he discusses the methods of his friend John Linnell: 'I think [Linnell] right in insisting upon the necessity of making studies – without much reference to form – of the way in which colours come up against each other. The sharpness and colour of the shades, as well as the local colour of the objects, may be got in this way.'[29] Linnell's watercolour sketches lack the 'charming' and unified appearance of Grimm's work, instead showing

an unfinished quality, a level of observation and an equivalence of subject matter that is evidence of a rigidly systematic sketching procedure. In oils Linnell developed a radical naturalism of 'tight surfaces and brightly-lit details' that is seen both in his sketches and in large finished pieces such as *Kensington Gravel Pits* 1811–12 (Tate, London).[30]

Linnell's methods were developed in Dr Thomas Monro's 'academy', where students were paid a small fee for copying the work of earlier artists in watercolour such as Girtin, who himself had copied the work of Dayes and others; and in John Varley's Sketching Club, where issues of composition, method and the use of instruments such as the camera lucida (soon to be developed by Cornelius Varley into the Graphic Telescope) were discussed. The Royal Academy itself found no place for any tuition in relation to landscape painting, and indeed it did not teach painting at all. Having said this, the confident treatment of the figures and forms in a work such as Constable's *Boat-*

Building at Flatford Mill 1814 (Victoria and Albert Museum, London) surely shows the benefit of lectures on perspective and attendance at the life class for the generation of artists who were born after the Academy was founded in 1768.

The practice of sketching outdoors was recognized as a specifically British style, although it was taken partly from the work of Continental artists working in Rome, such as Jakob Philipp Hackert (1737–1807) and Pierre-Henri de Valenciennes (1750–1819). British artists who had earlier worked in Rome, such as Francis Towne (1739/40–1815) and Thomas Jones, developed similar patterns of sketching, but Jones's sketches were never exhibited, and Towne unsuccessfully staked his reputation on his oils. His proud remark 'I never in my life exhibited a drawing' demonstrates the prestige accorded to oil as a medium when compared with watercolour.[31]

A more practical consideration when looking at the working methods of artists at the end of the eighteenth century is that travel abroad was restricted with the onset

of the Revolutionary wars with France in 1793. These restrictions, lifted only briefly in 1802–3, intensified the vogue for picturesque travel to sites such as Wales and the Lakes, and help explain the proliferation of sketching tours within Britain. War, however, also provided a rationale for thematic innovation. Put simply, paintings of native scenery were regarded as patriotic and appropriate in a time of struggle against a foreign enemy. The patriotic note sounded by Turner's selection of subjects, for example, is unmistakable, and at a time of naval blockade it is hardly surprising that the catalogue entry to one painting proclaimed: 'And Britain, Britain, British canvas fill'.[32]

Subjects that elicited patriotic sentiment and allowed the viewer to draw the right kind of associations might not be very elevated in themselves, however. There is no avoiding the fact that a significant percentage of landscape paintings during the war years consisted of what one historian has described as 'agricultural landscape in the raw'. It is well known, for example, that Constable's *Stour Valley and Dedham Church*, exhibited at the Royal Academy in 1815 (see fig.1, p.37), featured a large pile of manure in the foreground. Dung was and is a central part of agricultural life, but not something that featured high up the academic hierarchy (see Bindman, p.36).

If Constable's painting is 'in a minor against Turner's major key', what made both *Stour Valley* and *Crossing the Brook* acceptable were the associations that their subjects elicited.[33] Through the latter part of the eighteenth century a body of (mainly Scottish) writers developed the notion that a viewer's pleasure in an object lay not in the qualities of the object itself, but rather in the ideas that it excited in the viewer. This, broadly speaking, is what historians term 'philosophical criticism', because it was based on the natural philosophy of Locke. Such critics suggested that there was no necessary relationship between an object and the pleasure that a viewer took in looking at it: an object's beauty, they argued, derived from its function as a sign. Whilst this view gave succour to socially progressive views by suggesting that tastes, like morals, were subject to improvement, it militated against established notions of beauty because it argued that there was no object that could be considered intrinsically pleasing to the eye.

There is no evidence that the key theorists of this aesthetics of association such as Archibald Alison and Richard Payne Knight (1751–1824) approved of the new artistic practices that were developing in the years around 1800, but their work did 'seem to be a license for some aspects of naturalistic landscape painting', with its focus on local subjects.[34] There is more to suggest that artists such as Constable, Cornelius Varley and Richard Ramsay Reinagle (1775–1862) were able to regard philosophical criticism as offering support for the attention to local subjects in their work and that of their colleagues.

If association aesthetics underwrote the patriotic celebration of turnips, dung and gravel pits, its broader significance lay in its suggestion that the observation of nature could lead the viewer to contemplate that to which nature pointed: its Creator. This idea, influentially if controversially expounded in William Paley's *Natural Theology* (1805), is especially evident in Constable's comments on the moral values of landscape painting. Moreover, it lies behind visions of British art's probity against the corruption of Continental painting, a point made when critics compared the British artist's careful study of nature and use of local colour with the foreigner's confinement to his studio and gaudy, 'unchaste' colouring.[35]

Taken in conjunction, new artistic practices and philosophical criticism raised a number of issues. Perhaps the most significant of these was the tension between naturalistic landscape painting and the principles of theory and practice upheld by the Royal Academy. The new practice of sketching *en plein air* undermined the Academy's insistence that drawing was the most important achievement for an artist. Furthermore, association aesthetics seemed to argue that beauty was not a quality inherent in an object such as the *Venus de Medici* or the *Apollo Belvedere*, casts of which stood in the entrance to Somerset House; instead, it lay in the associations that the viewer was able draw from the object. While Reynolds was President of the Royal Academy in the late eighteenth century, he had himself been prepared to make limited accommodation to new psychological models of taste, but the idea that any object could be considered beautiful – undermining notions that beauty was a universal and unchanging norm available only to those able to transcend their particular circumstances – proved to be too radical for the Royal Academy of the new nineteenth century.

One of the core issues at stake here was not only the question of beauty within the landscape, but the related question of virtue in the viewer. These issues might be seen more clearly if we compare the amateur and patron

Sir George Beaumont (1753–1827) with Walter Fawkes (1769–1825), another patron. Beaumont upheld the idea that landscape was an appropriate subject of political and moral reflection for a gentleman, which was why he sketched it in a Claudean vein, but also why he saw it as his duty to patronize serious antiquarian publications such as Thomas Hearne's *Antiquities of Great Britain* (1786), and oil paintings by Constable and David Wilkie. His collections were eventually bequeathed to the fledgling National Gallery in London in 1826. Fawkes, on the other hand, sponsored watercolour painting – an altogether more private medium – and was a huge patron of Turner. When he did show his collection to the public in 1819, it was in his private apartments in St James's. Beaumont's activities were characterized as those of a serious and dutiful patron, Fawkes's as those of a private individual.

This perhaps explains why relations between artists and patrons could, in some cases, differ so widely. Turner was close to Fawkes and his family because, at one level, they were prepared to acknowledge that he exercised the same private and intellectual mode of consciousness that they did. The same has been said of John Sell Cotman (1782–1842), whose beautiful drawing of *Greta Bridge, Yorkshire* 1810 (fig.84), one of a number of the same subject, was done whilst he was staying with the Cholmeley and Morritt families in Yorkshire in 1803–5.[36] Cotman's work is fresh and vivid in its pigmentation, suggesting it was coloured on the spot, and demonstrates a clarity of form and balanced composition that, taken with the use of colour, distinguishes it from the Gilpin-influenced version of picturesque beauty. Andrew Hemingway has suggested that the drawing evokes local associations and, along with its site, indicates

a personal pleasure that was shared by artist and patron. In a similar manner, as Dian Kriz has argued, artists such as Cotman, Turner, Girtin and Augustus Wall Callcott (1779-1844) could be fashioned as distinctively English, not only for the subjects that they depicted or the technical virtuosity of their works, but also for the specifically private qualities of an independent imagination that was required to draw associations from local subjects to broader concepts such as patriotism.

When addressing the formal and thematic innovations in landscape painting from the first decades of the nineteenth century, it is important to recall Kriz's point that artists were searching for a form of art that was both commercially successful and seen to be aloof from commercial society. Successive presidents of the Royal Academy called for a serious public art in the form of history painting, and required landscape painting, ideally, to display a unity of effect and avoid unnecessary detail in order to signify its poetic status as an object of contemplation. The British Institution, founded in 1805 'for the encouragement of landscape', countenanced a greater latitude in the handling of landscape scenery as well as encouraging respect for the old masters such as Wilson through retrospective shows of their work drawn from the governors' collections. It was watercolour painting, banished from the British Institution and the Great Room at the Royal Academy, that was most identified with commerce. This was partly because so many artists associated with the medium practised as drawing masters, teaching watercolour to their patrons. Moreover, the genre was deemed incapable of exercising a serious public function, although artists such as Turner, Girtin, Reinagle and Joshua Cristall (1768-1847) worked in watercolour on an increasingly ambitious scale. When the Society of Painters in Water Colours was established in 1804, and its first public exhibition held in 1806, they exhibited the prices alongside the works displayed, thereby explicitly inserting themselves in a commercial framework.

A growth in the volume of printed criticism accompanied the increasing prominence of landscape painting in the early nineteenth century. Historians have noted that, where landscape painting did generate comment, remarks about handling of paint and the subject, as well as the exhibition as a whole, the host institution and the visitors, were often related to broader political positions, albeit in an inconsistent manner. The way people thought about landscape painting was evidently criss-crossed by other concerns. Thus, when

The Examiner's critic wrote in a review of Constable's work in 1827 that 'All art is progressive. What is discovered and done in the early stage of society is advanced upon in the next, and thus continues gradually improving, till it reaches the summit of capability', he was speaking against corruption and arguing the need to reform the political establishment, seeing in Constable's 'progressive' painting a model for culture as a whole.[37]

This brings us to a much broader question that has faced historians in recent years: how much significance should we give to the culture of which painting was a part? In other words, is the 'natural' of 'naturalism' really natural or is it cultural? Constable famously remarked that 'painting is a science, and the pictures experiments'. Ernst Gombrich used the comments to characterize Constable as an experimental painter in the Baconian mode, investigating nature by means of observation and record. His view of Constable was informed by his thesis that painting is like science in its methods, and its results may be verifiable and therefore just as 'true'. Gombrich was thus able to place Constable within a positivist tradition from Leonardo da Vinci (1432-1519) to Edouard Manet (1832-83), which he identified as a 'consensus . . . about the aims and functions of image making in our culture'.[38] However, Gombrich's claim has been subject to criticism, with historians suggesting that ideas about what is 'natural' change: some ideas emerge as formations of knowledge that are made possible at certain times and not at others. So it has been pointed out that Constable's idea of what was 'natural' was specific to a man who had read Paley, disagreed with Gilpin's model of picturesque beauty, was the son of a mill-owner and so on. Some historians have taken this further, suggesting that 'landscape' itself is a discursive category, as we saw in my introduction.

In the wake of these debates the question then arises as to whether ideas about 'landscape' and what is 'natural' are relative, holding no fixed value at all. At bottom, this is a question of truth. In a careful and even moving analysis of Constable's *Chain Pier, Brighton* 1826-7 (fig.85), Andrew Hemingway has tried to show a way out of the 'epistemological impasse' reached by postmodern approaches to these issues.[39] He holds that ideas are socially produced but is keen to suggest that this does not in itself explain a painting, because ideas are not simply reproduced as images in a painting: they are internalized, reproduced as behaviour that is complex, individual, and may even

86 JOHN CONSTABLE
A Cottage at East Bergholt:
The Gamekeeper's Cottage c.1833
Oil on canvas 87.6 × 111.8 (34½ × 44)
Lady Lever Art Gallery, Port Sunlight

87 J.M.W. TURNER
The Falls of the Clyde c.1845
Oil on canvas 89 × 119.5 (35 × 47)
Lady Lever Art Gallery, Port Sunlight

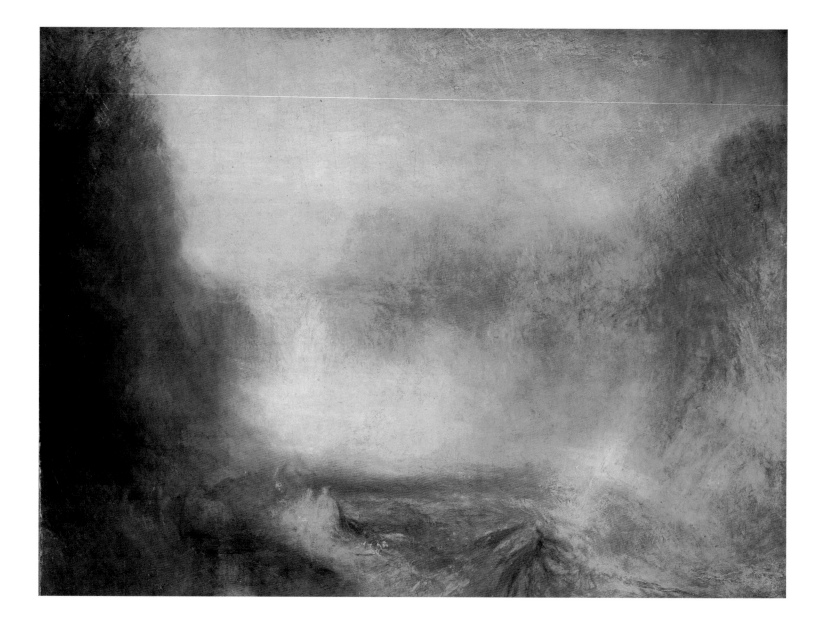

be contradictory. Looking at Constable's paintings of Brighton and Waterloo Bridge, he notes how the artist as a 'whole, historically-formed social being' encounters these tensions when he addresses his experience of modern life (in this case, the new pier and hotels at Brighton) through his ideologies (for example, his prefer ence for picturesque beauty and consideration of whether the subject matter could lead the mind to God) 'and work[s] through their implications for pictorial forms'. The outcome is 'one of the most aesthetically significant landscape paintings of the early nineteenth century', significant precisely because it is 'true to his experience as he understood it'.

'Emphatically an *English* Painter'

It was suggested above that Constable's painting is 'art appropriate to its time' but that this proved challenging for the artist, who struggled to reconcile picturesque composition with a modern subject. Constable's example points to the heterogeneity of landscape imagery in the early nineteenth century and the mode of consciousness that it implied, and the same has been said of Turner's paintings of the same period. How then have their paintings come to stand for a nostalgic image of the nation, and they themselves as quintessentially English painters?

This question is thrown into sharp relief by a display in the Lady Lever Art Gallery, Port Sunlight, where Constable's *A Cottage at East Bergholt: The Gamekeeper's Cottage*, painted in c.1833 (fig.86), hangs beside Turner's *The Falls of the Clyde* (fig.87), which dates from c.1845, just a few years before the artist died. Both are examples of the artists revisiting old subjects late in their career, and undoubtedly one function of the hang is to offer a chance to compare the late styles of two of Britain's most famous painters. Contemporaries might have been more ready to draw comparisons with Claude Lorrain, but critics, as well as the artists, did recognize a quality of 'Englishness' in their landscapes: 'Mr Constable is emphatically an *English* painter', said the *New Monthly Magazine* in 1831.

Contemporary comments such as these tended to focus on the appearance of the landscape, rather than the significance of the subject. Likewise, it is through the formal comparisons prompted in the display that we are invited to draw the conclusion that both painters, along with their paintings, are somehow national icons. Constable's heavily worked canvas, and Turner's surprisingly coherent but formally challenging surfaces preclude any easy identification with a specific place. Elizabeth Helsinger has noted that in Constable's late work, and we might say Turner's as well, we can observe a shift 'from place to a feeling for it'.[40] This suggests a change both in the subject – it is a specific place but also representative of the nation – and the viewing consciousness, where the display invites the viewer to assume an identity as 'English', and thereby identify with the sentiments of the painting, just as the artist becomes an English painter. This may recall the dynamic that we saw between Cotman, his work and his patrons (see pp.139–40), and clearly it is as problematic now as it was then. It serves as a reminder that the whole discourse of landscape, the imagery of landscape painting and the mode of viewing consciousness it implies, is still with us today.

Grand Manner Portraiture

SHEARER WEST

Joshua Reynolds, in his thirteen *Discourses* delivered to students of the Royal Academy, defined the 'grand manner' or 'great style' in history painting as the learned invention of artists translated into a style that was generalized and monumental in composition, expression and colour: 'Perfect form is produced by leaving out particularities, and retaining only general ideas' ('Discourse'). However, as the metropolitan art market was dominated by portraiture rather than history painting, Reynolds's *Discourses* addressed the possibility that portraiture could

also possess the qualities of the grand manner.

The problem for Reynolds was reconciling portraiture's need to produce a likeness with the higher ideals of history painting: 'An History-Painter paints man in general; a Portrait-Painter, a particular man, and consequently a defective model' ('Discourse IV'). Nevertheless, he claimed that portraitists could elevate their work by 'taking the general air' rather than 'observing the exact similitude' of the countenance, by avoiding the specificities of contemporary dress, and by 'borrowing from the grand' – alluding in

their works to the classical world or the art of Old Masters.

Reynolds was proficient at translating his theory into practice. His *Three Ladies Adorning a Term of Hymen* 1773 (fig.88) demonstrates his idea of grand manner portraiture. The portrait represents the three daughters of Sir William Montgomery, draping a statue of the Greek god of marriage, Hymen, with garlands of flowers. The work was commissioned by Luke Gardiner, the fiancé of the eldest daughter, Elizabeth, who takes centre stage in the composition. Anne,

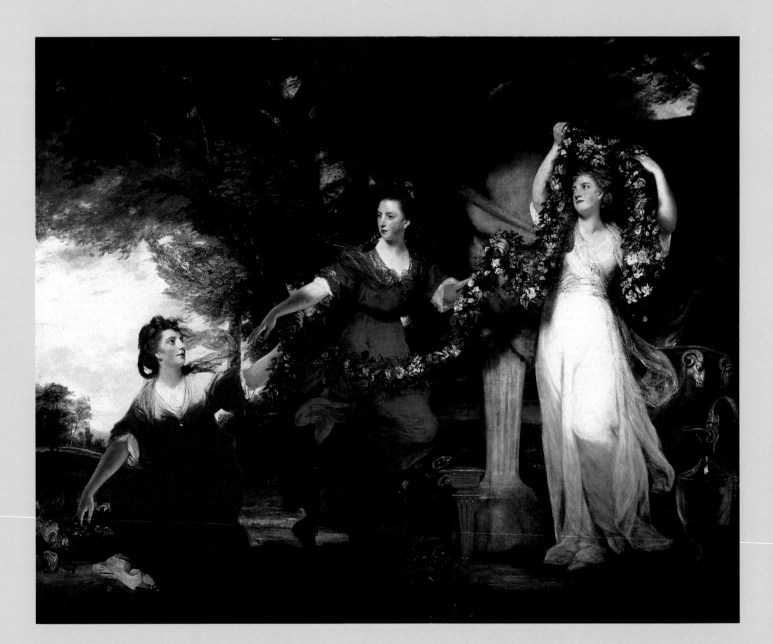

88 (opposite) JOSHUA REYNOLDS
*Three Ladies Adorning a Term
of Hymen* 1773
Oil on canvas
233.7 × 290.8 (92 × 114½)
Tate. Bequeathed by the
Earl of Blessington 1837

89 (left) THOMAS LAWRENCE
Duke of Wellington on Horseback 1818
Oil on canvas
73.7 × 50.8 (29 × 20)
Private Collection

version of the grand manner in portraits of heroes of the Napoleonic Wars, including those he was commissioned to produce for the Waterloo Chamber at Windsor Castle. In his portrait of the Duke of Wellington (fig.89), Lawrence, like Reynolds before him, recalled his distinguished artistic predecessors – this time the equestrian portraiture of Titian and Anthony Van Dyck. However, Lawrence painted Wellington in his battle clothes, thus representing the contemporary dress that Reynolds felt detracted from the great style. Lawrence characteristically adopts a low viewpoint to enhance Wellington's stature and includes a vast, moody landscape with the fires of battle flickering in the distance to give a romantic allure to his victorious stance.

Although there were a number of imitators of both Lawrence and Reynolds, few artists of the nineteenth century quite achieved the bravura and uniqueness of their approaches to portraiture in the 'great style'. An exception was John Singer Sargent (1856–1925), whose society portraits from the 1880s revived Reynolds's grand manner with a modern twist. Sargent's *Madame X* 1884 (Metropolitan Musuem of Art, New York), with its stark profile, theatricality, its debt to the court portraiture of Velázquez, and the stunning inventiveness of the composition, carries on the legacy of Reynolds's grand manner. But this portrait, which scandalised the 1884 French salon, had an air of sexual tension and unabashed vulgarity that give it a character entirely different from the classical learning of Reynolds's 'great style'. Grand manner portraiture from the early twentieth century retains many of Sargent's mannerisms, but frequently without his vitality or virtuosity. Nevertheless, despite its excesses, the grand manner can be associated with some of the most imaginative and novel British portraiture in the eighteenth and nineteenth centuries.

who stands on the far right, was already married when the portrait was painted, but the third sister, Barbara, was not yet betrothed. A plethora of classical references pervades the work. Although the three sisters are individualized, their clothes are simplified versions of contemporary fashion, redolent with overtones of the Greek *peplos*. The setting is an Arcadian landscape, and the presence of three youthful women echoes the Three Graces. A number of possible Old Master sources for the composition have been suggested, but the dominant influence on the rhythmic gestures of the women and the unifying garland of flowers was probably Nicolas Poussin's bacchanals.

Reynolds's combination of sometimes incompatible classical and Old Master allusions attracted the criticism of the artist Nathaniel Hone (1718–84), whose painting *The Conjuror* 1775 (Tate, London) represented Reynolds as a shameless imitator. But Reynolds's grand manner portraiture gained great favour among

the aristocracy and gentry. The attraction for patrons rested not so much in its high ideals, but in the theatricality and salacious undercurrents of some of its themes; in *Three Ladies Adorning a Term of Hymen*, for instance, the associations with fertility and bacchanal remind the viewer of the sitters' desirability and sexual maturity. Reynolds's inventive approach to portraiture also broke with a convention of stilted posing; these unexpected compositions as well as the size of the canvases drew the admiring attention of audiences at Royal Academy exhibitions. Grand manner portraiture could be serious, even ponderous, in its classicism, but it could also be playful, inventive and theatrical.

When the style was applied to male portraiture, the ludic and theatrical qualities of female grand manner portraits were replaced by grandiloquence and authority. Male sitters tended to wear ceremonial robes, uniforms and decorations, rather than a version of classical dress. Thomas Lawrence employed his own

FURTHER READING

Breuer, D. et. al., (eds). *Citizens and Kings: Portraits in the Age of Revolution 1760–1830*, exh. cat., Royal Academy, London 2007.
Simon, R. *The Portrait in Britain and America 1680–1914*, London 1989.
Wilton, A. *The Swagger Portrait: Grand Manner Portraiture in Britain from Van Dyck to Augustus John*, exh. cat., Tate, London 1992.

Stubbs and Horse Painting

STEPHEN DEUCHAR

90 GEORGE STUBBS
The Grosvenor Hunt 1762
Oil on canvas 150 × 241.3 (40⅞ × 95)
Duke of Westminster Collection

George Stubbs (1724–1806) has long been acknowledged as Britain's most accomplished and sophisticated painter of horses, yet the full scope of his role as an artist enmeshed in the wider culture of late Georgian society remains only partially explored. Despite his robust singularity in personality as well as in output, and his own complaints that he seemed consigned to operate at the margins of the art world's mainstream, his career touched or exemplified many of the most significant distinguishing cultural movements of eighteenth-century Britain. A self-taught anatomist, he produced the *Anatomy of the Horse* – a set of engravings published in 1766 following his personal dissection of several horse carcasses – whose originality and precision formed a landmark in research and documentation, and also gave him an incomparable level of equine expertise with

which to underpin a career initially in the service of aristocratic sportsmen. The rise of a landed elite with time and resources to spend on country pursuits and their enshrinement in art provided Stubbs with a great opportunity to flourish. Several commissions from the Duke of Richmond (still at Goodwood House, Chichester) and *The Grosvenor Hunt* 1762 (Duke of Westminster Collection) for the Earl of Grosvenor unlocked a network of lucrative patronage.

The Grosvenor Hunt (fig.90) reveals Stubbs as both a reliable recorder of sporting fact and action – his patrons' first requirement – and a most gifted designer of complex compositions. No British sporting picture before, despite the competent work of John Wootton (1682–1764), Peter Tillemans (1684–1734) and James Seymour (c.1702–52), had reached such heights of pictorial

refinement. The anchoring role of the oak tree balancing the leftward surge of the animals is a formula borrowed from the French artist Jean-Baptiste Oudry (1686–1755) and his Flemish predecessors, adding both a sense of monumentality and a European inflection to the (ostensibly) profound Englishness of subject and setting. Established links between stag hunting and royalty also enabled the picture to affirm Grosvenor's nobility at the very highest level, a form of flattery in which Stubbs's serenely constructed, immaculately rendered and ruthlessly edited representations of the world generally excelled.

In reality, an enthusiasm for riotous rural sports was held in increasing disdain in polite urban circles and Stubbs's wider reputation as an artist was undeniably compromised, regardless of the erudition and sophistication of his own approach to a traditionally lowly genre. His involvement with the Society of Artists in its early days was one attempt to develop his status more assiduously within the London art world (though he was never to achieve the rank of Royal Academician), but his attempts to elevate horse painting to the higher realms of history, especially through the *Lion and Horse* series, were another, dramatic form of response. Having seen the subject of lions attacking horses widely addressed in classical sculpture (either during his visit to Rome in 1754 or through Giambologna's more portable interpretations in bronze), he embarked on a series of essays on the theme, little admired by contemporary critics but acknowledged today for their proto-Romantic verve. In *Horse Devoured by a Lion*, (?exh.1763; fig.91), one such encounter is staged in wild, apparently Italianate scenery, which was in fact inspired by Creswell Crags in Nottinghamshire (a site at which, coincidentally, archaeologists have recently found England's earliest animal remains), a strategic merger of the contemporary and the apparently timeless that distinguishes so much of his work.

Stubbs's modern scientific interests led him to experiment in techniques and materials, for example from the late 1770s producing in conjunction with Josiah Wedgwood a number of ceramic plaques onto which lion and horse and several other subjects were painted. He was also a printmaker of great originality and accomplishment, though he relied on professional engravers to create versions of his work for public consumption beyond the exhibition space: the series of four *Shooting* scenes (Yale Center for British Art, New Haven) were, for example, engraved by William Woollet in 1769–71 and aimed at a broad urban market. Of much narrower appeal were two projects that preoccupied him towards the end of his life: from 1790 the *Turf Review*, a series of paintings and engravings of famous racehorses of the day, a money-making venture aimed at the narrow sporting circles on which he reluctantly acknowledged his main livelihood still depended; and from 1795 the *Comparative Anatomy*, a hugely ambitious set of drawings of dissected animals and humans that explored the commonality and contrasts of their physiological structure. With one foot in the lowbrow sporting world and another in loftier realms where art and modern science met, Stubbs may have seemed enigmatic to his peers. Today we do not properly grasp the eighteenth century without him.

FURTHER READING

Deuchar, S. *Sporting Art in 18th-Century England: A Social and Political History*, New Haven 1988.
Egerton, J. *George Stubbs, Painter: Catalogue Raisonné*, New Haven and London 2007.
Myrone, M. *George Stubbs*, London 2002.

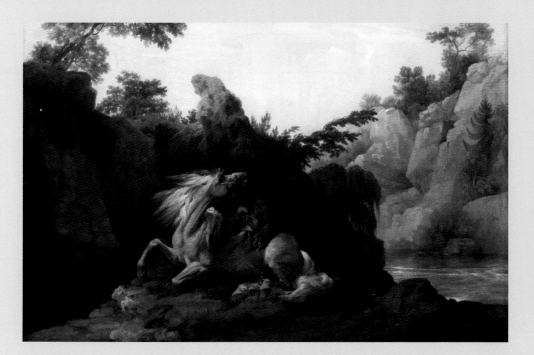

91 GEORGE STUBBS
Horse Devoured by a Lion ?exh.1763
Oil on canvas 69.2 × 103.5 (27¼ × 40¾)
Tate. Purchased 1976

The Impact of Photography in the Nineteenth Century

HEATHER BIRCHALL

The announcement in 1839 of a device that could capture an image permanently on a chemically coated surface was to have an enormous impact on the world. For nineteenth-century artists, illustrators, writers and scientists, the ability to produce accurate representations of themselves, as well as the familiar and exotic aspects of the world around them, aroused curiosity and excitement. The first 'daguerreotype' process, named after Louis Jacques Mandé Daguerre, enabled highly detailed images to appear, as if by magic, on a sheet of copper plated with a thin coat of silver. However, it was the parallel process, the calotype, patented in England in 1841 by William Henry Fox Talbot (see fig.92), that became the forerunner of modern photographic techniques, allowing any number of prints to be developed from one negative. There followed an incessant demand for photographs, and few homes were complete without cabinet portraits, scrapbooks containing prints of views from around the world, cartes-de-visites, and stereoscope cards, looked at through a stereo viewer to create an illusion of three-dimensionality.

Although practical methods of reducing exposure times continued to be developed throughout the century, photography remained a complex and (particularly in the early years) dangerous process until 1883, when the American inventor George Eastman announced the invention of rolled photographic film and the Kodak camera. Kodak's advertising slogan, 'You click the button, we do the rest', announced a new era of photography in which a pursuit once open solely to the leisured classes, who had had both the time and inclination to experiment with chemicals and unwieldy glass lenses, became available to everyone.

From the outset artists felt the challenge presented by the new reproductive tool. In his enthusiasm for the new Daguerreotype process, the French artist Paul Delaroche (1797–1856) had exclaimed: 'From today, painting is dead!'

He continued to enthuse that the photograph would provide, even for the most accomplished painters, material from which to observe and study. Some artists, including William Holman Hunt and William Dyce (1806–64), followed Ruskin's advice in *Modern Painters* literally and began to use photography as an aide-memoire and to correct errors in perspective, and light and shade. Their microscopic vision of nature demonstrates an attempt to compete with the camera (while at the same time making use of it), to produce an image equally, if not more, faithful to nature. However, the threat of the photographic lens to other artists, especially miniature and portrait painters who could not contend with the ever-increasing number of photographic studios, compelled them to give up painting and become photographers. One of the most successful of these was Roger Fenton (1819–69), who had studied painting under Delaroche, and in 1853 became a founder member of the Photographic Society of London.

92 WILLIAM HENRY FOX TALBOT
Reverend Calvert Jones Seated in the Cloisters, Laycock Abbey c.1847
Salt paper print from Calotype negative
16.5 × 20.6 (6½ × 8)
Indianapolis Museum of Art

93 HENRY PEACH ROBINSON
The Lady of Shalott 1861
Albumen print from two negatives
30.4 × 50.8 (12 × 10)
The Harry Ransom Humanities Research Center,
University of Texas, Helmut Gernsheim Collection

He immediately became involved in discussions surrounding photography's legitimacy as an art form, a philosophical preoccupation that has continued to this day.

The photographic debate was keenly taken up in the periodical press, with advocates of photography attempting to counter the accusation that photographs were merely 'mechanical contrivances' (*Art Journal,* 1 Jan. 1858, vol.21, p.121). Henry Peach Robinson (1830–1901), who began his career as an artist, was one of a number of photographers who began applying artistic principles to photography. Known as the 'King of photographic picture-making', Robinson took Pre-Raphaelite painting as his inspiration and overcame the limitations of the medium by cutting up and stacking multiple negatives to make a single print. For example, with only a faint chance of a windless day, he took separate photographs of the boat and the landscape to produce his best-known photomontage, *The Lady of Shalott* 1861 (fig.93). In 1869 Robinson

published *Pictorial Effect in Photography*, in which he elaborated his confidence in 'artistic' photography: 'A great deal can be done and very beautiful pictures made, by a mixture of the real and the artificial in a picture.' This aesthetic provided the stimulus for the Pictorialist movement in photography throughout Europe and the USA.

Artists responded in diverse ways to photographic processes, though often denying any association with the mechanical device. The belief continued that a work produced with the aid of a camera was incapable of making a spiritual statement. In the long term photography released artists from the burden of producing accurate representations. Photographers also moved away from the mere recording of facts, and from the 1890s societies devoted to photography as fine art were formed, including the Linked Ring in England and the Photo-Secession in the USA.

FURTHER READING

Coe, B. *The Birth of Photography: The Story of the Formative Years, 1800–1900*, London and New York 1976.
Gernsheim, H. and A. *The History of Photography from the Camera Obscura to the Beginning of the Modern Era*, Oxford 1965, rev. ed., London and New York 1969.
Scharf, A. *Art and Photography*, London 1968.

New Techniques in Printmaking

DAVID BINDMAN

The development of printmaking was in some respects a classic case of the industrialization of art, though its origins went back to the fifteenth century and its evolution was not directed solely by the desire to increase and rationalize production. Printmaking in Britain, as William Blake, himself a commercial printmaker, pointed out, evolved through a tension between its role as an independent art form, with traditions of engraving and etching going back to Albrecht Dürer, and newly invented means of imitating other art forms, like painting, wash drawing, chalk drawing and watercolour. The first 'invented' medium to enter Britain was the mezzotint, which came from Holland in the late seventeenth century and involved scraping out the design from a copper plate that would, if a design was not applied to it, have printed black. Mezzotint was particularly associated with multiplying copies of portrait paintings, and it was favoured by Godfrey Kneller and Joshua Reynolds, who admired the richness of tone it could achieve, though relatively few impressions could be taken before the plate began to wear. Other techniques that were brought over in the eighteenth century – aquatint and soft ground etching – were imitative of pen and wash drawing, and chalk drawing respectively.

The most inventive practitioner and most eloquent theorist of printmaking was the poet and painter William Blake, who invented a technique of 'Illuminated' printing using relief etching, which involved printing from the surface of the copper plate by etching away the parts that did not take on ink, like woodcutting using copper rather than wood. This had the advantage of allowing the artist to combine text and design seamlessly in extraordinary self-published prophetic books. He also took pride in belonging to the 'medieval' tradition of engraving and etching, and fiercely excoriated new techniques as slavish imitations of other media in an unpublished manuscript, 'A Public Address'.

Blake's fame as a printmaker, however, was as nothing compared to that of his contemporary, the Newcastle-based wood engraver Thomas Bewick (1753–1828). By printing from end grain of boxwood, Bewick was able to produce minutely detailed and durable printing blocks that virtually revolutionized the mass production of images (fig.94), allowing in one case the production for a newspaper of a colophon that was printed more than a million

94 THOMAS BEWICK
The Ovingham Dyers Carrying a Vat of Urine (from Bewick's *British Birds*) 1805
Wood engraving
3.8 × 8 (1½ × 3⅛)
Private Collection

times. The poetic delicacy of Bewick's wood engravings was rapidly and widely disseminated through his London-based pupils, and became the basis of periodical illustrations throughout most of the nineteenth century.

The other mass technique, lithography, was invented by Aloys Senefelder in Germany just before the end of the eighteenth century. This was essentially a chemical technique, reliant initially on a special Bavarian stone though other media were rapidly developed. As it involved drawing directly on to the stone with a greasy crayon it was more directly 'artistic', hence many of the greatest artists of the day used it, though it was more popular in France and Germany. It was also capable of producing a great many impressions and was used for advertising well into the twentieth century.

Because copper was prone to wear and lithography required cumbersome imported stones, successful attempts were made to produce steel plates, which facilitated particularly the production of large editions of illustrated books. It was possible by the 1820s to make mezzotint plates in steel and these were pioneered in large format for a series of apocalyptic engravings by John Martin. Though wood engraving, lithography and steel plates became immensely popular and widespread, allowing the development of the mass-produced illustrated periodical, traditional methods of copper engraving underwent a revival in the 1830s, and large-scale display engravings after the work of well-know artists became a popular adornment of the Victorian parlour. Copper mezzotint printing also held its own, and Constable found it particularly suitable for representing 'The

Chiaroscuro of Nature', employing David Lucas to reproduce samples of his painting in *Various Subjects of Landscape Characteristic of English Scenery* (1831). Etching also went through a process of revival by artists themselves, from the 1850s onwards, in reaction against mass printing culminating in the intensively handcrafted aesthetic work of James McNeill Whistler and his followers, in which each impression was treated as a separate work.

The nineteenth century thus presents opposing but interrelated trends in printmaking, towards industrialized methods of production that led to the most enduring technique of printmaking, photography, but also towards resistance and an emphasis on exclusivity deliberately aimed at collectors of relatively modest means. Yet this dichotomy should never be taken as absolute, for lithography, steel engraving and photography could be used both for mass communication and for work of a deliberately 'artistic' nature.

FURTHER READING

Bain, I. *Thomas Bewick: An Illustrated Record of his Life and Work*, Newcastle-upon-Tyne 1979.
Essick, R. *William Blake, Printmaker*, Princeton 1980.
Godfrey, R. *Printmaking in Britain*, Oxford 1978.

The Influence of John Ruskin and his Response to Art through *Modern Painters*

HEATHER BIRCHALL

In October 1836 *Blackwood's Magazine* published a scathing review of three paintings that J.M.W. Turner had exhibited at the Royal Academy earlier that year: *Juliet and her Nurse, Rome from Mount Aventine* (both private collections) and *Mercury and Argus* (exh.1836; fig.95). In contrast to the baffled critic, Reverend John Eagles, who could see nothing more in *Juliet and her Nurse* than a 'strange jumble', the young John Ruskin believed that the paintings marked a turning point in the development of Turner's art as he strove to mimic the effects of light, space and the elemental forces of nature with paint and paintbrush alone. Aware that the exhibition going public would find little correlation between the title and the abstract canvas before them, Ruskin wrote a fervent defence, which he sent to Turner, who discouraged him from publishing it. Seven years later, at the age of twenty-four (see fig.96), Ruskin expanded his apologia into a weighty volume, *Modern Painters*, under the pseudonym 'a Graduate of Oxford'.

Despite its seeming impenetrability, many reviewers praised the volume and *Modern Painters* was read by the wealthy intelligentsia of Victorian England, although Turner kept a stubborn silence until October 1844, when he thanked Ruskin for his efforts for the first time. The title did little to help the reader understand the book's central thesis, which aimed to reverse the accepted view that painting from the Renaissance and the French and Dutch schools of the seventeenth and eighteenth centuries surpassed the work of contemporary artists, notably his hero Turner. The earlier artists, Ruskin argued, relied on painterly conventions to represent their surroundings, and neglected to look at nature with any understanding of its diversity. Claude Lorrain, considered to be the greatest of the ideal landscape painters, came in for particular criticism, as did Gaspard Poussin who was 'more ignorant of truth than Claude, and almost as dead to beauty as Cuyp'. The opinons of the young Ruskin had been formed on prolonged tours of the Continent, supplementing what he had studied in the National Gallery in London and Dulwich Picture Gallery. On the same tours he saw paintings that he felt had not previously received proper recognition, especially those of Jacopo Tintoretto (1518–94) and Sandro Botticelli (1444/5–1510).

Ruskin matched his study and examination of art with an equally careful investigation of nature. From an early age he sketched the forms of the minerals and flowers he encountered on his climbing expeditions in the Lake District or the Alpine regions of France. Ruskin's concern to find literal truth in every detail from rocks and foliage to clouds and water, as expressed in *Modern Painters*, influenced a new generation of artists, particularly the Pre-Raphaelites (see Prettejohn, pp.184–5). Dispensing with the compositional conventions of their predecessors, they began to depict their natural surroundings with an unequalled scientific precision. Two of Ruskin's early drawing masters Samuel Prout (1783–1852) and James Duffield Harding (1798–1863) were amongst a number of artists singled out for praise alongside Turner, for capturing what he believed they saw with their own eyes. Like the Pre-Raphaelites, they were encouraged to believe that, through the act of looking (as opposed to copying from others) and recreating God's creation, their art could serve both a moral and a spiritual purpose. Ruskin's survey of landscape painting was not completed until 1860, by which time four further weighty volumes of *Modern Painters* had been published. The second volume, appearing in 1846, was informed by a tour abroad with his parents where he encountered both Fra Angelico and

96 GEORGE RICHMOND
Portrait of John Ruskin
Engraved by Francis Holl
60 × 43.2 (22 × 17)
Private Collection

Tintoretto. Ruskin's discussion had by now become more complex and far-reaching, the chapter headings only hinting at the discussions about the relationship between man, God and the natural world which followed. Ruskin later admitted: 'Had I wished for future fame I should have written one volume, not five'. *Modern Painters* is now read mainly by academic specialists, but in its time it appealed to the general reader, whose critical appreciation of contemporary art was stimulated by his appreciation of Turner's innovative representations of the forces of nature. *Modern Painters* represents the dawn of a period of greater involvement in and understanding of art by a broader public.

FURTHER READING

Barrie, D. (ed.), *Modern Painters by John Ruskin*, London 1987.
Cook, E.T. and A. Wedderburn (eds.). *The Works of John Ruskin*, 39 vols., London 1903–12.
Hilton, T. *John Ruskin: The Early Years 1819–1859*, London and New Haven 2000.
Hunt, J.D. *The Wider Sea: A Life of John Ruskin*, New York 1982.

95 J.M.W. TURNER
Mercury and Argus exh.1836
Oil on canvas 151.8 × 111.8 (59¾ × 44)
National Gallery of Canada, Ottawa

5 British Art and the Social World

FRÉDÉRIC OGÉE

THE RISE OF GREAT BRITAIN and that of British art occurred simultaneously during the period from the seventeenth to the nineteenth century, for a number of related reasons that make it more than a coincidence. In 1650 England was a dynamic but minor power on the outer edge of Western Europe, with a population of about five million (compared to France's twenty million), crippled by a civil war and incessant strife between Crown and Parliament. The artistic brilliance of Charles I's court, and the prestigious art collections assembled by the King and his main adviser Thomas Howard, 2nd Earl of Arundel, were short-lived and mostly based on the presence of foreign art and artists. Although Anthony Van Dyck, the most prominent of them, left an indelible mark on portraiture for later generations of prominent British artists, his cosmopolitan aura and the controversial politics and religion of his patrons, at odds with the expansionist drive of the nation, prevented his genius from fertilizing the local artistic soil during the years that he spent in London (1632–41). Two centuries later, the population of Britain had tripled sixteen million according to the 1841 census), and the country was by far the wealthiest and most powerful in the world. Meanwhile, the 'English school of art' with Thomas Lawrence, John Constable and J.M.W. Turner as figureheads ranked among the most prominent and prestigious.

What is most striking and unique in this parallel rise is the way that art and society contributed to each other's definition and visibility throughout the period. Indeed, the emergence and encouragement of a national approach to art were fuelled by British society's urge to define and 'picture' itself at a time when the traditional social boundaries were being thoroughly disturbed by, on the one hand, the combined pressure of the vast circulation of wealth and the new market economy and, on the other, a remarkable increase in population and urban development. The gradual but swift diminution of Crown and court and of the vertical organization they commanded, orchestrated by the Glorious Revolution of 1688 and its immediate aftermath, gave rise to the idea (before the reality) of a freer, more horizontal conception of social relations. Coming from a wider

spectrum of the population, the new actors in this societal change equated the country's success with their own progress, and devised new, resolutely British forms of expression that could promote and advertise both. In art the genres of portraiture and landscape were instrumentalized and adapted to represent the politeness of British conversation and eventually the unique picturesqueness of the landscape.

In the latter part of the seventeenth century a remarkable generation of scientists and philosophers promoted a new intellectual framework – Britain's decisive contribution to the Enlightenment – that shook up age-old hierarchies in all fields and thoroughly modified the approach to nature, including human nature. Combined with the rise in Britain of a population involved in the practicalities and priorities of trade, it affected the way that the British looked at the world and wished to see themselves in it, and this in turn favoured the quick development of new forms of expression (in literature, in gardens, in art) that, in all meanings of the term, would 'represent' those new values.

After a first phase when social portraiture known as the 'conversation', or the conversation piece, became popular, offering models of social behaviour, British artists, in theory as much as in practice, sought ways of gaining wider recognition and independence while still promoting forms of artistic expression that would meet the demands and communicate the priorities of a now widening public. While exhibitions of their works in pleasure gardens or charities, and later in dedicated spaces, allowed artists more and more to place the public in direct contact with their work (see Bindman, pp.176–7), they also attempted to create a professional community and enhance their respectability and social prominence. The foundation of the Royal Academy of Arts in 1768 crowned their efforts with a prestigious national but independent institution that gave them the possibility of educating artists and viewers, and of establishing art as an important contribution to the nation's image.

Revisiting and adapting the traditional hierarchy of academic genres, with a view to devising a resolutely

English or British approach that would be free from any Continental influence, some artists developed portraiture and landscape along clearly idiomatic lines, to compensate for the lack of an indigenous tradition of history painting, reputedly the highest genre in art. Most artists and commentators supported an empirical approach to art as distinctively British, and one that made art immediately accessible. From the late eighteenth century onwards regular exhibitions, private galleries and public museums, auction rooms and a buoyant print market created more of a shared visual culture than hitherto.

The four chronological sections of this chapter attempt to account for the successive stages of the advent of an English school of art in relation to the social evolutions it reflected and accompanied. Together they provide a core narrative of art in Britain that inevitably focuses on some of its most prominent actors. This means telling the story of the way British art became a valuable enterprise for the British upper classes in the course of the period, a story that concerned a widening section of the population, though not the whole social order, at home or overseas: people on the outer edges of the growing empire or in the suburban parishes along the City of London's eastern and northern borders rarely participated in the artistic world. When Sir Robert Peel, in the 1830s, defended the idea of a National Gallery in London that would offer a free public display of pictures in order 'to cement the bonds of union between the richer and poorer orders of the state', his words expressed both the triumph and the limitations of art's position in Britain's social world.

Restoration and Revolutions

In 1662 the Licensing Act was passed, which put the world of print under the control of the religious authorities and established the very restrictive conditions under which any publication could appear. Like the Act of Uniformity of the same year, which codified the form of public prayers, of the administration of sacraments and other aspects of the Church of England, the Act was part of a series of laws aiming at restoring order in all fields – political, religious and social. It put a brutal end to the remarkable freedom of public debate that had marked the first years of the Restoration of the Stuart monarchy, after the severity of Cromwell's ten-year Puritan Commonwealth.

Voted to last for two years, the law had to be confirmed regularly to remain in force. In reality, it proved increasingly difficult to enforce, and it eventually lapsed in 1695 when it was not renewed. This did not mean that the governments under William III (1689–1702) and then Anne (1702–14) were more open-minded towards the press: the restriction simply collapsed under the force and importance of public opinion and the increasing demand for both political and military news and debates. From then on freedom of the press became a reality and grew in symbolical importance throughout the next century as the emblem of Britain's modernity and liberty. Newspapers in London and in the provinces began to play a prominent part in the circulation of ideas and in the self-awareness of its new public.

The history of the Licensing Act reflects the great social and cultural divide that characterized the last decades of the Stuart monarchy (1660–1714) and created the conditions for the rise of an autonomous art world and a public that supported it. Charles II and his court indulged in a lavish cultural life that overtly emulated the splendours and political programme of the French court that they had recently experienced in exile. They wished to promote forms of entertainment in which the court's constant self-display would assert the King's power and his divine right to rule as he pleased. Great musicians and a revived choral tradition with odes and anthems were employed to celebrate the glorious monarch.

Although they relied on the spectacular visibility of the Baroque, the Stuarts' artistic activities were in fact exclusive, designed to astonish the English public and keep it at bay. The new theatres were run by friends of the King and put on performances that catered for a small coterie, on a protruding 'thrust' stage lit by the same candles as the theatre, blurring the difference between actors and audience. The brilliant comedies of George Etherege and William Wycherley portrayed with cynical amusement the moral laxity in which the audience indulged, while heroic plays such as Thomas Otway's 1682 *Venice Preserved* displayed the conflicts between private and public priorities among 'the great' and heroized their indulgence of licentious or corrupt behaviour for the sake of political stability and social order.

The Poet Laureate John Dryden made a wishful attempt, in *Absalom and Achitophel* (1681), to believe in the future of his monarch:

The Almighty, nodding, gave consent,
And peals of thunder shook the firmament.
Henceforth a series of new time began,
The mighty years in long procession ran;
Once more the godlike David was restored.

But it could not quite cover up the stark reality that cost John Wilmot, 2nd Earl of Rochester, his place at court:

Restless he rolls about from whore to whore
A merry monarch, scandalous and poor.[1]

The excitable amorality and self-obsession of that brilliant court were the symptoms of its profound lack of ease. There was a sense that such an entrenched, arrogant attitude was not likely to last long. As they increasingly failed to impose the absolutism for which they envied France, they developed a form of desperate, *carpe diem* cynicism that their favourite artist, Dutch-born Peter Lely (1618–80), managed to catch in the hundreds of portraits that he made of them (see Vaughan, p.61). Thus, in his *Portrait of an Unknown Woman* c.1670–5 (fig.97), composed as a three-quarter length clearly inspired by Van Dyck, the overall impression is one of barely controlled carnality, with the sitter's heavily rouged cheeks and bared breast, and her attempt to quieten the restless spaniel emerging from underneath her dress, ready to jump at her nipple.

Most of the artists employed by the court (Lely, Antonio Verrio, Louis Laguerre) were foreign or foreign trained, as the turmoil of the previous decades had prevented the Continental Baroque from gaining a foothold in England. Like the formal gardens that the King tried to create in front of his various palaces, they put forward a conception of art as sophisticated artifice, as the expression of an elite's dominating control over nature, as the search for 'superior beauties'.[2] Examples of this can be seen in Verrio's ceiling decoration for the Saloon at Moor Park, the 'Heaven Room' at Burghley House (see Liversidge, p.80) and in Laguerre's wall paintings at Petworth, Chatsworth or Blenheim Palace, which Alexander Pope later satirized as the epitome of bad taste in his seminal 1731 'Epistle to Richard Boyle':

On painted ceilings you devoutly stare,
Where sprawl the saints of Verrio or Laguerre,
On gilded clouds in fair expansion lie,
And bring all paradise before your eye.[3]

However splendid it may have been, such a vision of culture – Continental, artificial, exclusive – was the vehicle of a political and social ideology that proved increasingly at odds with the desires of the nation. The easy, 'glorious' expulsion in 1688 of Charles's tactless Catholic brother James II (reigned from 1685) confirmed that the Stuart court was less and less in phase with the dynamic forces of the country. Significantly, the same year as the Licensing Act Charles II granted a royal charter to found the 'Royal Society of London for the Improving of Natural Knowledge'. As he and the ecclesiastical authorities around him were soon to realize, however, the Society's commitment to the establishment of truth in scientific matters was to proceed from objective, unprejudiced experimentation, and to take nobody's word for it ('Nullius in Verba' was the Society's motto). Abraham Cowley's ode 'To the Royal Society' defined the task of the 'Natural Philosopher' with words that not only epitomized the pragmatic, empirical vision that modern Britons would now endorse, but could also be read as a programmatic prefiguration of the method and subject matter of a modern *and* British approach of representation in art:

. . . he before his sight must place
The natural and living face;
The real object must command
Each judgment of his eye, and motion of his hand.[4]

The main aim of the 'Natural Philosophers' (like Robert Boyle, Robert Hooke and Isaac Newton), inspired by the ideas of European humanism, was to move away from a 'hypothetical' (read theological) approach to knowledge, which, as Britain well knew, could lead to bloody conflicts and internal strife. Instead, they encouraged an objective, empirical observation of God's creation which, as they hastened to make clear, would

meddle no otherwise with *Divine things*, than onely as the *Power*, and *Wisdom*, and *Goodness* of the *Creator*, is display'd in the admirable order, and workmanship of the *Creatures*. It cannot be deny'd, but it lies in the *Natural Philosophers* hands, best to advance that part of *Divinity*: which, though it fills not the mind, with such *tender*, and *powerful contemplations*, as that which shews us Man's *Redemption* by a *Mediator*; yet it is by no means to be pass'd by unregarded: but is an excellent ground to establish the other.[5]

97 PETER LELY
Portrait of an Unknown Woman c.1670–5
Oil on canvas 125.1 × 100.3 (49¼ × 39½)
Tate. Bequeathed by Cornelia,
Countess of Craven 1965

They insisted that 'the general constitution of the English' was ideally suited to such a project:

> the position of our climate, the air, the influence of the heaven, the composition of the English blood; as well as the embraces of the Ocean, seem to joyn with the labours of the *Royal Society*, to render our Country, a Land of *Experimental knowledge*. And it is a good sign, that Nature will reveal more of its secrets to the English, than to others; because it has already furnish'd them with a Genius so well proportion'd, for the receiving, and retaining its mysteries.[6]

This dual mindset - natural-philosophical and nationalistic - coincided perfectly with the wishes of the active commercial community who wished ardently for the end of domestic disputes in order to pursue their own expansionist exploitation of nature more powerfully abroad. The first experiments of the new scientists were mostly concerned with the reliable resolution of navigation problems. This was clearly at odds with the Stuarts' reluctance to engage in conflicts with the Catholic powers of the Continent. The Stuart court's French-inspired culture spurred the development of the nation's search for a proper English alternative, and the emergence of an English school of art in the eighteenth century can certainly be seen as an important contribution to that response.

The Church of England, as so often, tried to bridge the gap between two conflicting forces. The Great Fire of 1666 gave it an opportunity to conceive a new native architectural style of churches, that culminated with the state-supported Cathedral of St Paul's designed by Christopher Wren. He and his associates - most prominently Nicholas Hawksmoor - thoroughly transformed the London skyline with buildings that express restraint, common sense and light, a far cry from the dazzling displays of Continental Baroque. This new architecture allowed for the first time an English history painter, James Thornhill, to obtain important state commissions, like the eight grisaille scenes for the cupola of St Paul's or the allegorical decorations for the Painted Hall at Greenwich Hospital (also designed partly by Wren), which depicted the succession of Protestant monarchs from William III of Orange to George I.

The guiding principle behind the major achievements of England's modernity at the time - parliamentary monarchy, scientific and philosophical empiricism, the creation

of the Bank of England in 1694 and the development of commercial companies - was the commercially inspired principle of *contract*. Justifying the problematic replacement of James II by William, inspiring the new scientists' approach to nature's phenomena and fuelling the demand for newspapers, the notions of exchange and flux became emblematic of the new culture in all its forms. On the social level this was seen in the remarkable and rapid development of clubs and coffee-houses where all this frictional energy could be domesticated and polished by the art of conversation.

Conversation

The driving force behind the development of British society between the seventeenth and the nineteenth centuries was the growth of trade: 'Is not trade the inexhausted fund of all funds, and upon which all the rest depend?' wrote Defoe in *The Compleat English Tradesman* (1727). With the sudden and fast development of merchant banking and insurance, as well as warehousing and trading, London expanded at a remarkable speed, with 'new squares, and new streets rising up every day to such a prodigy of buildings, that nothing in the world does, or ever did, equal it, except old Rome in Trajan's time'.[7]

The new prosperity, which was to prove essential to the development of art, resulted from the modernization of the economy, based upon a systematic use of public credit and the free circulation of goods and capital. The City, the Royal Exchange, the Excise Office and the Bank of England were now felt to be the centre of the world, and offered a functional model for the whole nation and the nations of Europe:

> Here business is dispatch'd with such exactness, and such expedition and so much of it too, that it is really prodigious; no confusion, nobody is either denied or delayed payment ... No accounts in the world are more exactly kept, no place in the world has so much business done, with so much ease ... We see nothing of this at Paris, at Amsterdam, at Hamburgh, or any other city, that ever I have seen, or heard of.[8]

Possibly as a reaction to the traumas of the civil wars and their bloody disturbance of social harmony - always detrimental to what Defoe called 'the grand affair of

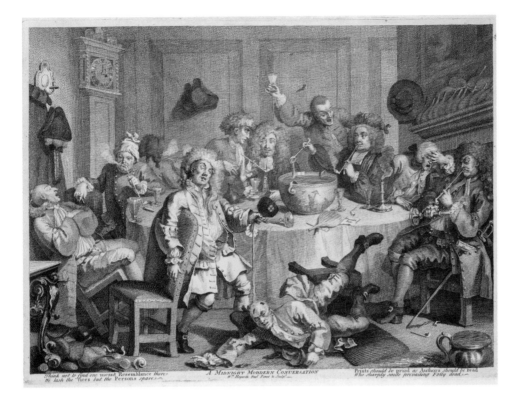

business' – the post-1688 Revolution generations also promoted an array of institutional and social instruments (coffee-houses, clubs, societies, pleasure gardens) that primarily encouraged the practice of conversation, the social equivalent of trade. Mediating between the two, the new periodicals (the *Tatler, The Spectator,* the *Guardian* and later the *Gentleman's Magazine*), which became a vehicle for the circulation and exchange of ideas, ensured the polishing of market practices into social values and affected the realm of artistic expression, in literature with the novel in the visual arts with the landscape garden, the 'conversation piece' or Hogarth's 'modern moral subject'.

Coffee-houses, where these periodicals were avidly read and discussed, played a prominent part in the circulation of ideas during the first half of the eighteenth century, for the first time allowing the emergence of a proper public culture. It was there that the new social groupings formed their ideas and acquired visibility and self-awareness, with different coffee-houses catering for specific interest groups. Fellows of the Royal Society, including Newton, Halley and Hans Sloane (whose collections were later sold to the nation to create the British Museum in 1753), met at the Graecian on the Strand. Whig and Tory politicians discussed their ideas respectively at the St James's and the Cocoa-Tree near Pall Mall. Stock-jobbers, removed from the Royal Exchange by the merchants in 1697, conducted their business at Lloyd's, Jonathan's and Garraway's coffee-houses, which developed steadily during the century before becoming proper insurance companies (Lloyd's of London was created in 1771).

Less professionally, some were dedicated to 'Gallantry,

Pleasure and Entertainment', as *The Tatler* described them (12 April 1709), and offered dangerous gaming and gambling activities to idle gentlemen who often lost fortunes overnight (the fate of Tom Rakewell at the most infamous of them, White's, in scene six of William Hogarth's 1733–5 *Rake's Progress*). Coffee-house culture was also crucial in the managing and 'progress' of literary and artistic taste among 'the public'. Following a skilful campaign in the periodical press, Will's Coffee-House, where John Dryden had passed judgement for nearly thirty years, was replaced by Button's, where Joseph Addison and his coterie (Richard Steele, with whom he published *The Spectator* from 1711 to 1714, Dr Arbuthnot, Jonathan Swift, Alexander Pope) endeavoured to stimulate new interest in arts and letters, underlining their social value and relevance as well as their accessibility to all the 'polite'. Button's was in turn supplanted by the Bedford, the haunt of Henry Fielding, William Hogarth and David Garrick, where 'every branch of literature is critically examined, and the merit of every production of the press, or performance at the theatres, weighed and determined'.[9]

The invention of public opinion and the ideology of politeness, defined and diffused by influential groups like the Kit-Cat Club, whose members included politicians (Lord Somers, Robert Walpole, William Pulteney), financiers (Lord Halifax, Thomas Hopkins) and men of letters (William Congreve, John Vanbrugh, Joseph Addison),[10] expressed a general belief that a great civilized nation like the emerging 'Great Britain' should banish confrontation in favour of conversation:

Conversation with Men of a Polite Genius is another Method for improving our Natural Taste. It is impossible for a Man of the greatest Parts to consider anything in its whole Extent, and in all its Variety of Lights. Every Man, besides those General Observations which are to be made upon an Author, forms several Reflections that are peculiar to his own Manner of Thinking; so that Conversation will naturally furnish us with Hints which we did not attend to, and make us enjoy other Mens Parts and Reflections as well as our own.[11]

In reaction to the writings of philosophers like Hobbes and Mandeville, who cynically – and convincingly – described the political, economic and social benefits of selfishness, these men argued that individual liberty could only exist within a network of social relations that ensured the rubbing of personal angularities into a 'polished' harmonious ensemble.

The novelty of this social programme created a great demand for guidelines and models, which was met by a flurry of 'books of conduct' (for example, Defoe's 1715 *The Family Instructor*) but also by a 'modern' form of episodic prose narrative that told the histories of many individuals. Their titles, unlike the 'Venus and Adonis' or 'Antony and Cleopatra' of aristocratic literature, bear the English names of ordinary heroes (*Moll Flanders, Pamela Andrews, Tom Jones, Clarissa Harlowe*, etc.), and they all represent the main characters' empirical integration into society. The English 'novel' which thus emerged became the literary genre of the new 'middling sort' and gradually modified the nature and function of literature, replacing the high-flown flights of elite classical culture with more down-to-earth pictures of modern Britain.

For exactly the same reasons portraiture, or 'Face-painting' as it was then called, was given a new programme to contribute to the enterprise of general refinement. For, if 'no Nation in the World delights so much in having their own, or Friends, or Relations Pictures; whether from their National Good-Nature, or having a love to Painting', Mr Spectator also 'lamented and hinted [his] Sorrow in several Speculations, that the Art of Painting is made so little Use of to the Improvement of our Manners'.[12]

Conversation paintings, which depicted groups of individuals naturally occupied in various 'polite' activities and social commerce, became very fashionable in the 1720s and 1730s. Examples of the genre could be found in late

seventeenth-century Holland, and artists like Marcellus Laroon (1679–1772), Egbert van Heemskerk II (c.1634–1704), Pieter Angelis (1685–1734) or Joseph van Aken (1699–1749), who came primarily in the wake of the court of Orange in the 1690s, had introduced it into England. A more 'polished' form, known as the *fête galante*, was also practised in France by artists like Jean-Antoine Watteau, whose influence, after his visit to London in 1719–20, was sustained by his pupil Philip Mercier (?1689–1760), who was a friend of Hogarth's. Responding to the new demand, young British artists such as William Hogarth and later Arthur Devis (c.1711–87) adapted the genre to offer their clients harmonious models of social success and self-satisfaction. Devis's *The James Family* of 1751 (fig.99) for all its surface stiffness, offers a remarkable example of such social display, its elegantly dressed characters posing casually on the terrace of their country house, a kind of proscenium stage whose corner has been left clear in the middle of the picture to allow a good view of their land-scaped park and the surrounding countryside. The new portrait painters created works in which the sitters – 'well disposed, genteel, agreeable'[13] – are seen engaging in a whole catalogue of conversational activities (drinking tea, playing games, strolling in parks, examining books or pictures). Hogarth's prominence in the genre came from his success at 'composing' the variety of such groups and activities into what David Solkin has called 'a collective tapestry of politeness',[14] even if his more characteristic work was often devoted to the 'discovery' of the covering-up staged by the polite, and revealed the less flattering aspects of such conversations. Works like the tavern scene (scene 3) in *Rake's Progress* 1735, or his famous 1733 print *A Midnight Modern Conversation* (fig.98), which repre-sents the various stages of drunkenness in a dishevelled composition, can be seen as 'conversations' gone wrong.

An important feature of this form of portraiture was its insistence on the naturalness of behaviour, as opposed to the static artifice of grand aristocratic portraiture. The con-versational ideal called for more emphasis on movement and exchange, and the new paintings were therefore designed to be more narrative than allegorical or emblematic. Thus Hogarth's *The Strode Family* c.1738 (fig.100) pictures an informal family scene, in which William Strode is shown inviting his tutor to interrupt his solitary reading to join the tea party, while his brother, standing by the door on the right, tries to prevent the dogs (i.e. animality) from spoiling

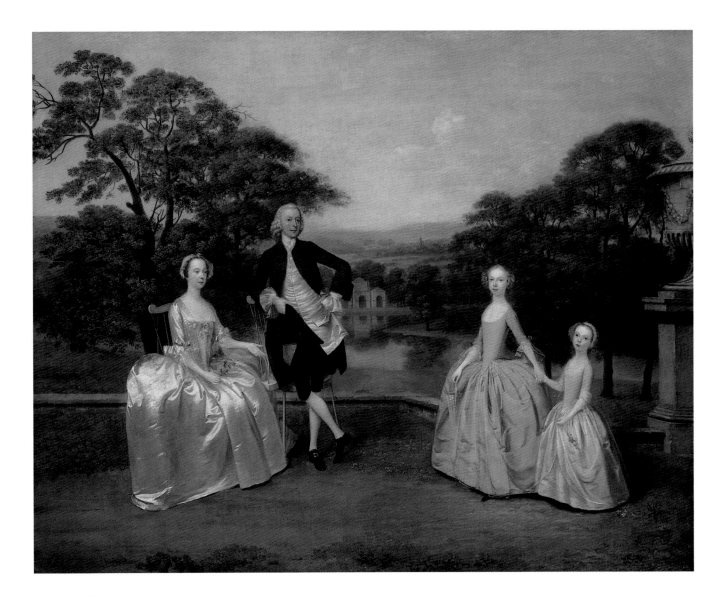

the harmonious conversation, whose fragility is suggested
by the tiny China teapot in the centre of the picture.

This double characteristic – natural and narrative –
which was to prove so important in the definition of British
art, can be seen as the consequence in painting of the
influence of empiricism on Britain's modern thought,
which was also apparent, in the same years, in the emer-
gence of the English landscape garden. Rather than the
spectacular theatrical display of man's rational control
over nature that the French garden, for ideological as much
as for aesthetic reasons, had imposed on Europe as the
ultimate model, the new English garden was designed as
a field of successive, individual experiments based on the

meaningful friction of natural and architectural elements.
The combined stimulation of the visitors' senses by nature
– using eye-catchers, textural combinations or effects of
light and shade – and by architecture, in the form of minia-
ture classical or exotic buildings, allowed the designers
of the landscape garden (itself a most frictional phrase)
to guide the energy of that friction towards a more direct
perception of nature, and of man's place within it. No
longer considered a walled-in sanctuary (like that of the
medieval *hortus conclusus*) or a feat of intellectual display
(which the Italian and French baroque gardens clearly
offered), the English landscape garden was designed to
invite each visitor on a progressive, cumulative experience

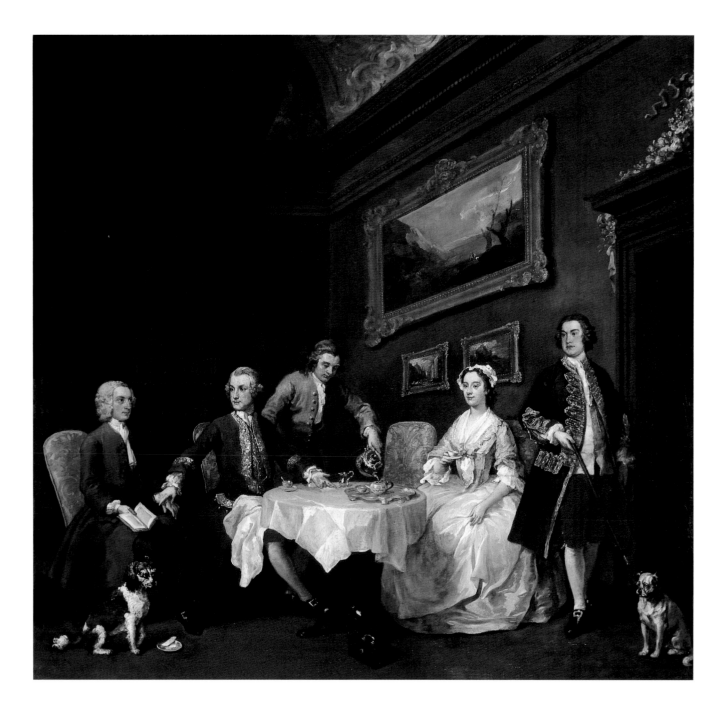

of a series of sensorial and imaginative 'conversations' between natural and architectural features, which gave intimations not of immortality but of that 'supreme' Edenic fiction that all nature was a garden.

The governing principle of these landscape gardens, the progressive series of viewpoints, was a direct transcription in nature of the new empirical epistemology, and as such showed strong similarities with the new episodic or epistolary novel. John Locke had presented progressive experience as the only path towards knowledge, while, as we have seen, the new science inaugurated by the Royal Society advocated in all fields of enquiry the accumulation of observations and data to bring out the truth of the object observed. Gardens and novels – at the forefront of Britain's

artistic avant-garde – offered narratives, or 'histories', of (human) nature, and it is therefore no surprise to see English art, with William Hogarth, take the same direction. Not only did he develop conversational portraiture with such idiomatic force that its presence can be felt in British art even today but he also designed original works in which the beholder's visual pleasure came from the gradual discovery ('a wanton kind of chace [sic]' Hogarth called it) of contiguous or successive images.

As well as remarkable paintings and engravings of urban crowd scenes such as *Southwark Fair* 1733 and *The March to Finchley* 1749, which offer clusters of visual motifs and require a dynamic, progressive form of visual scanning, Hogarth became famous for works that unfurled

over several pictures, following either a cyclical or a
continuous pattern: *Before & After* 1736, *Gin Lane & Beer
Street* 1751, *Four Times of the Day* 1738, *Four Stages of
Cruelty* 1751, and *Industry & Idleness* 1747, for example.
His grandest series were presented as 'Modern Moral
Subjects', and, like the novels published in the same years,
described successively the tragic histories of a young lady
(*The Harlot's Progress* 1732), a young man (*A Rake's Progress*
1735) and a young couple (*Marriage A-la-Mode* 1743).
As his contemporary Henry Fielding put it, underlining
the artist's Newtonian search for causes and effects,
'In Hogarth's excellent works, you see the delusive scene
exposed with all the force of humour and, on casting your
eyes on another picture, you behold the dreadful conse-
quences'.[15] Taken up by later commentators well into
the nineteenth century (Georg Christoph Lichtenberg,
William Hazlitt, Charles Lamb), this observation confirmed
Hogarth's pioneering role in imposing narrativity as a crucial
idiomatic feature of modernity in British art, as later artists
like Constable, William Frith (1819-1909), Walter Sickert
and David Hockney (b.1937), were in their different ways
to confirm (see Wagner, pp.174-5).

In his own 'Autobiographical Notes' Hogarth wrote
'I have endeavoured to treat my subjects as a dramatic
writer; my picture is my stage, and men and women my
players, who by means of certain actions and gestures,
are to exhibit a dumb show.'[16] Insisting on the difficulties
rather than the ideal of social conversation, Hogarth repre-
sented human society as the combination of individual
'progresses', thus offering an authentically British alterna-
tive to both idealized portraiture and history painting, the
two highest genres in academic hierarchies, which British
artists were thought incapable of practising successfully.
His was a truly radical take on the possibilities of art in
Britain, which in effect tried to bypass the academic
traditions that ruled the profession on the Continent.
Meanwhile, aristocratic patrons like Richard Boyle,
3rd Earl of Burlington, advocated a more Neoclassical,
'Palladian' conception of art, for which they continued to
employ mostly foreign artists, with the notable exception
of William Kent ('Kentino' as Hogarth nicknamed him).
It was the generation after Hogarth, led by Joshua Reynolds,
who would try to bridge the gap between the two. In their
ambition to raise 'public' painting to the level of a highly
respectable social and moral pursuit, they set out to
improve the practical and intellectual training of British
artists, but also to form the taste of the British public, that
it might sustain a demand for works of the best standards
and thus allow local artists to progress (and make a decent
living). The urgent necessity was then to create a prestigious
national institution that could carry out that programme,
and to enhance the visibility of British art by increasing its
contacts with the buying public.

Exhibition

Conversation painting was at its height in the 1720s to
1740s. The booming development of London made it
a very attractive place for artists, with its concentration
of potential wealthy patrons. Artists flocked to the capital,
often impoverishing the artistic scene in other places
(Edinburgh, Glasgow, Dublin), and settled near Covent
Garden, where for the first time they experienced a sense
of community. The market they catered for was buoyant
and wide, allowing small and great talents to survive and
coexist. Portraits could be ambitious and large-sized, or
simple and smaller, depending on the finances and social
status of the patrons, and they required little theoretical
culture. Soon, however, the more ambitious artists felt
estranged from serious art. Most of them came from the
middle classes, and their lack of a classical education was
a handicap to engaging in history painting, preventing them
from practising the most prestigious genre of art. Aristocratic
patrons continued to buy foreign paintings and to invite
Continental artists to decorate their houses, while commis-
sions for British artists were limited to portraiture. It was
a very difficult trend to reverse. William Hogarth offered to
decorate St Bartholomew's Hospital for free, to make sure
his rival Jacopo Amigoni did not get the commission.

British artists were caught in a dilemma. They almost
exclusively painted portraits for private patrons, which
meant that they produced works that had little visibility
outside the private sphere of their sitters, and little or no
currency on the art market, which was primarily concerned
with works that had a universal dimension. On the other
hand, portraiture was increasingly considered a genre in
which British artists excelled (as many a foreign commen-
tator observed) and which allowed them to make a living,
often a good one. It became clear that they had to strengthen
their trade and reputation, which could only be done

through an improvement in training, with a proper art school and better social visibility of their art through public displays (see Myrone, pp.186–213).

British artists' wish to found and run some form of art academy indicated a desire for artistic autonomy, paving the way for a more modern status, that would be less dependent upon patronage. The generation of artists around Hogarth, Francis Hayman or Thomas Gainsborough expressed some dissatisfaction with a career that could only prosper if they stuck to profitable 'Face-painting' or joined a wealthy aristocrat on his grand tour and emulated foreign classical art. They also sought to attract a new clientele among the prosperous middle classes by circulating their works through engravings and advertisements in the press. Scientists like Richard Mead, merchants like Thomas Coram (see fig.101) and actors like David Garrick began to play an important part in the promotion of artists' careers. Only later, once the discoveries made on the sites of Pompeii and Herculanum in the first half of the century had revealed their inspirational potential, did artists such as James Barry, Nathaniel Dance (1735–1811), and Joseph Wright of Derby find new reasons to go to Italy, in the tutelary wake of artists like Joshua Reynolds and Richard Wilson.

A new phenomenon that enhanced the visibility and accessibility of art was the emergence of professional auction houses, whose sales provided opportunities for public exhibition and contributed to the transformation of works of art into market commodities. Hogarth's representative in France, the Swiss Jean-André Rouquet (1701–58), who wrote descriptions of Hogarth's engravings for the French market, was struck by this new social practice on his visit to London. Comparing those occasional displays to the French salons, he underlined in *The Present State of the Arts in England* (London 1755; translated from the French) the crucial part that the auction houses played in developing a taste for art among the British population. The results of such sales were ambiguous, however, as some unscrupulous art dealers exploited the gullibility of the new public, getting them to buy works of dubious quality or provenance for often vast sums of money. This fostered disgust among those trying to promote the cause of a good national product; see for instance Hogarth's engravings, *The Battle of the Pictures* 1744–5 and *Time Smoking a Picture* 1761, or Robert Campbell's comments in *The London Tradesman* (1747).

Hogarth was instrumental in organizing the first public displays of British art, at a time when the absence of museums or galleries made it difficult for artists to reach potential buyers beyond visitors to their studios. He evidently convinced Jonathan Tyers, the entrepreneur who had created Vauxhall Gardens in the late 1720s and early 1730s as a pleasure garden for the prosperous middle classes, to make it into a showcase for artists and musicians. In addition to Roubiliac's famous 1738 marble statue of Handel in the character of Orpheus seated on a plinth plucking the strings of a lyre, with a boy underneath taking down the notes (see fig.111, p.177), Hogarth's friend Francis Hayman was commissioned to decorate the buildings and the several private boxes around the place where people organized their private functions, thus allowing the first public showing of contemporary British art (see Bindman, pp.176–7). In 1746, it was Hogarth who convinced the other governors of the new Foundling Hospital (erected thanks to funds from the retired sea captain Thomas Coram, who obtained a royal charter for it from George II in 1739) to let British artists enhance the visibility of the place with the free gift of history paintings that would adorn its walls and thus attract the public and donations (see fig.51). Hogarth himself, but also Hayman, Joseph Highmore (1692–1780), Gainsborough, Reynolds, Wilson and others, thus created the first permanent collection of modern British art in London, and a visit to the Hospital became one of the prime social attractions of the town.

Strengthened by such a success, and wishing to cash in on it, in 1759 Hayman convinced his fellow artists to organize annual exhibitions of their works. First staged in a room lent by William Shipley (1714–1803), the Secretary of the Society for the Encouragement of the Arts, Manufactures and Commerce, on condition that entrance remained free, the first exhibition in 1760 was a great success, but it also created a rift among the community of artists between those who wanted such events to remain free and accessible to all (they formed the Free Society of Artists) and those who thought that access should be restricted, allegedly to prevent the place from being 'thronged with multitudes', but in effect to select a 'polite' clientele, whose more informed custom would boost the respectability of the art. This second group, who gathered together as the Society of Artists of Great-Britain, went on to play a decisive part in the creation of the Royal Academy of Arts at the end of the 1760s.

101 WILLIAM HOGARTH
Portrait of Thomas Coram 1740
Oil on canvas 239 × 147.5 (94⅛ × 58⅛)
Coram Family in the care of the
Foundling Museum, London

felt an increasing need to protect their new social space from both aristocratic and 'vulgar' encroachments (coffee-houses increasingly turned into more exclusive, private clubs), the wealthier artists were eager to mark out a new territory that would free their art both from dependence on old-style patronage and from mass commodification. It was in this context that the campaign for a royal support of a 'distinguished' academy of art was fought and won.

Several attempts had been made since the beginning of the eighteenth century to create an art academy in England, but it took decades before the right compromise could be reached, between the wish to foster a distinctly British and 'free' approach to art (which meant the rejection of Continental models) and the need to raise and refine standards, in technique as much as in connoisseurship, to a level that would place the English school of art on a par with its Continental rivals. In 1711 Godfrey Kneller had gathered a group of prominent artists, Jonathan Richardson, James Thornhill, Louis Laguerre, Giovanni Antonio Pellegrini to form the 'Great Queen Street Academy', whose originality lay in the fact that it was designed by and for the artists themselves, rather than as a club of virtuosi. As Serjeant Painter to King George I, Thornhill succeeded Kneller as the head of the Academy, a decision that displeased fellow artists Laguerre, Louis Chéron (1660–1725) and John Vanderbank (1694–1739), who thought him too close to the ruling oligarchy. They opted to move out and create a rival academy in St Martin's Lane in 1720, which only survived a few years. Meanwhile, Thornhill opened a free school of drawing in his own house in Covent Garden, which lasted until his death in 1731. In 1735 Thornhill's son-in-law Hogarth reunited the two sides and opened a new academy in St Martin's Lane, where artists were given equivalent status and facilities, and held their annual meetings on Guy Fawkes' Day (rather than the day of St Luke, the patron saint of artists) to mark their Britishness and stress their Protestant identity. This was no academy on the Continental model, but a place entirely devoted to the improvement and promotion of a national and 'free' practice of art. Most important artists of the Hogarth generation received their training there, and except for its democratic organisation, which some deemed too 'popular', it played a crucial part in making British art a social reality, paving the way for the foundation of the Royal Academy in 1768.

This quarrel among artists is revealing of the social evolution of the times: the 'restricted access' debate was the symptom of an important political shift in the social positioning of the middle classes. While the artists were looking for a wider acknowledgement and support of their work beyond the closed circles of aristocratic patronage and traditional connoisseurship, the appearance of paintings in the homes of wealthy tradesmen was felt by some to be a debasement of their art. It was therefore becoming necessary to ensure the 'distinction' (to borrow Pierre Bourdieu's famous notion) of the social function of art by restricting it to those with sufficient financial and cultural capital to appreciate it.[17] Just as the middle classes now

Soon after Samuel Johnson had proposed the first *Dictionary of the English Language* (1755) based on the occurrence of words borrowed from the best English authors, the opening of this prestigious art institution marked the culmination, in conscious emulation of Athens or Rome, of a great imperial project – the rise of Great Britain. The Royal Academy joined the remarkable array of modern institutions (the Royal Society, parliamentary monarchy, the Bank of England) that were transforming the nation from a marginal European country to the strongest power in the world. George III was the first Hanoverian king to have been educated in Britain and to have a good command of the English language. He had also had some artistic training, with William Chambers in architecture and George Michael Moser (1706–83) in drawing. This raised great hopes in the cultural circles of London, who eventually managed to convince him of the national necessity of founding a prestigious art institution.

In the Dedication he wrote to King George III for the first edition of his *Discourses*, the Royal Academy's first President, Joshua Reynolds, summed up this historical progress: 'The regular progress of cultivated life is from necessaries to accommodations, from accommodations to ornaments. By your illustrious predecessors were established marts for manufactures, and colleges for science; but for the arts of elegance, those arts by which manufactures are embellished and science is refined, to found an academy was reserved for your Majesty.' And in the opening words of his first Discourse (2 January 1769) he immediately underlined the momentous national importance of the event: 'An Academy, in which the Polite Arts may be regularly cultivated, is at last opened among us by Royal Munificence. This must appear an event in the highest degree interesting, not only to the Artists, but to the whole nation.'

Financially independent, thanks to the proceeds from its annual exhibitions, the Academy provided a perennial institutional answer to the two basic demands of English artists since the beginning of the century: an ambitious training programme (including travel grants, prizes and financial assistance for their families) and enhanced visibility, due to annual prestigious exhibitions. Between an aristocratic elite who demanded and bought 'high art' and local artists deemed unable to cater for it, the appearance of an intermediary group of buyers whose values and priorities were closer to those of the practising artists had *de facto*

created a link between the two extremes and allowed the emergence of a kind of continuum between supply and demand. The Royal Academy provided a framework that could regulate the process, elevate buyers and artists, promoting national artistic ideals while protecting everyone's interests. Being less subordinated to the monarch than its French counterpart, the 'English School of Art' progressed with greater freedom to become a more independent, artist-oriented elite.

The emergence of buyers who were more commercially interested than connoisseurs created tensions that the new academy also had to take into account during the annual exhibitions it organized every summer to promote the works of British artists. But the institution's main *raison d'être*, and the formidable success it met with from the start, can primarily be understood from its founding members' wish to define it as a functional arena for the enlightened, or 'polite', conversation of living artists and the general public, of artistic ideals and market pressures. Designed to promote the fine arts of oil painting, sculpture and architecture, and excluding the 'minor' arts of watercolour and engraving, it was not always successful in its ambition to steer a 'middle' course between the elitist, cosmopolitan nostalgia of the aristocracy and the business-minded, nationalistic impatience of the new middle classes, to which the artists belonged.

There were inevitable discrepancies between theory and practice, and between ideal and reality in the actual practice of the Academy. While history painting continued to be taught as the highest genre, exhibitions and transactions dealt mostly in portraiture, genre scenes and increasingly landscape. Moreover, the way that the Academy was originally planned and launched by one group of artists who were in obvious favour at court triggered hostile reactions and envy. As John Brewer sums it up:

The foundation of the Academy marked a triumph for an oligarchy among painters, a self-perpetuating body that decided what art should be exhibited as a public statement of good taste. Not surprisingly it was accomplished in the teeth of vociferous opposition, especially from those who still carried the banner for a British art of the sort advocated by the recently deceased Hogarth ... Many artists resented and resisted the Academy's claims to represent all painters, to shape the public and to arbitrate taste.[18]

Criticism came from all sides. Some, like Robert Strange (1725–92), expressed surprise at the exclusion of engraving, crucial as it was to the social dissemination of art. Others, like portrait painter James Wills (1740–1777) – a former Director of Hogarth's St Martin's Lane Academy – criticized the King for having founded 'a foreign, "Parisian" academy'. On the other side of the social spectrum aristocrats like Richard Payne Knight vented their scorn at the upstart artists' pretensions:

One of the evils of academies . . . is the spirit of corporate pride and vanity engendered and nourished in them . . . An assembly of such dignitaries becomes, in their own estimation at least, a legislative synod of taste and science; which fixes arbitrarily the *criteria* of excellence, and thus sanctions and renders systematic every error, which the caprice of fashion or wantonness of theory may have accidentally brought into practice.[19]

The debate never lost its intensity, and an impressive list of British artists (Gainsborough, Wright of Derby, William Blake, James Barry, George Romney, Constable and Benjamin Robert Haydon), however much they may have been opposed to it, shaped their careers in reaction to the Academy's practices and structures. The Academicians' appointments and decisions, as well as the annual selection of pictures for exhibition, fuelled a constant flow of criticism in the press and elsewhere. Yet the institution allowed British artists for the first time to occupy a stage from which they had been denied access, and ensured their work visibility and respectability, allowing them to compete on their own terms with Continental art. Thanks to its first president's steadfast, if ambivalent, search for an intelligent compromise between ancient and modern, the Academy emerged as an original, independent structure whose influence was on the whole beneficial to both artists and the nation's cultural development. In the *Discourses* that Reynolds delivered every other year at the Academy's prize-giving ceremony he developed an ambitious artistic programme that ensured the institution's long-term survival beyond the early attacks on it. In 'Discourse IX', written the year when the Academy moved to its new, prestigious premises in Somerset House (designed by William Chambers in 1779–80), he recalled the ambitions and successes of the project, including the emergence of a national school of art, and summed up its contribution to the nation's moral progress:

The Art which we profess has beauty as its objects; this it is our business to discover and to express; but the beauty of which we are in quest is general and intellectual; it is an idea that subsists only in the mind . . . which [the artist] is yet so far able to communicate, as to raise the thoughts, and extend the views of the spectator; and which, by a succession of art, may be so far diffused, that its effects may extend themselves imperceptibly into publick benefits, and be among the means of bestowing on whole nations refinement of taste . . . till that contemplation of universal rectitude and harmony which began by Taste, may, as it is exalted and refined, conclude in Virtue.[20]

Reynolds's concern for 'the spectator' is quite revealing of a new public approach to art that was clearly, for all the reasons mentioned above, more reception-oriented than ever. Since the beginning of the century, the discourse on art in England, inspired by the emphasis on conversation and the new relation to nature, had moved away from Continental academic deliberations on theory and technique to focus increasingly on the sensorial activity of perception and the work of art in the beholder's imagination. Combining with the new relation to nature developed by philosophers, scientists and landscape gardeners, it contributed to the opening of a new territory for British artists, which was to allow them to expand beyond the enclosed field of portraiture and offer a British alternative to classical history painting and 'high art' in the form of landscape painting.

Diversion and Continuity

While the missions and ethos of the Royal Academy nourished the conversations of the cultural elite, British art, and visual culture more generally, took on a direct political dimension with the growing popularity of satirical cartoons. The social unrest around John Wilkes's attacks on George III in the late 1760s, followed by the anti-Catholic Gordon Riots in 1780 and the hot debates caused by the American then French Revolutions, had led to the emergence of a newly politicized body of urban citizens. Their concerns and opinions were relayed and fuelled by the press, but now also by printshops, which produced daily images, often of great satirical power. The 'English

102 JAMES GILLRAY
A great stream from a petty-fountain; – or –
John Bull swamped in the flood of new-taxes; –
cormorants fishing in the stream 1806
Published by Hannah Humphrey
Coloured etching; plate: 24.3 × 35 (9⅝ × 13¾)
paper: 26.3 × 37.3 (10⅜ × 14⅝)
National Portrait Gallery, London

art of caricature', soon known and praised throughout Europe as the emblem of English liberty, gave rise to a generation of remarkably gifted cartoonists like Thomas Rowlandson (1756–1827), James Gillray and later George Cruikshank (1792–1878), who brought a captivating form of art to the streets and shop windows. In Gillray's 1806 *A great stream from a petty-fountain; – or – John Bull swamped in the flood of new-taxes; – cormorants fishing in the stream* (fig.102), for instance, we see a very effective satire on excessive taxation: John Bull sinks in a boat, having lost an oar labelled with Pitt's name, while the 'cormorants' (among whom are Lord Grenville and Charles James Fox) stuff themselves with the resulting abundance of fish.

Caricature, though seemingly at an opposite pole to the Royal Academy, to an extent shared an audience with it, as is clear in Gillray's and also Rowlandson's responses to it, and it is not coincidental that they were both early students there. This surely lies behind their constant recourse to a mock-heroic language, and their sharp satires of the Academy and its members.

The first artistic consequences of the Royal Academy on British art were felt in portraiture, which was refined and 'elevated' by a combination of the aristocratic style inherited from Van Dyck and informality first seen in conversation pieces. Although in a different category from the history painting that Reynolds, Barry and Benjamin West still promoted as the noblest form of art, the large-

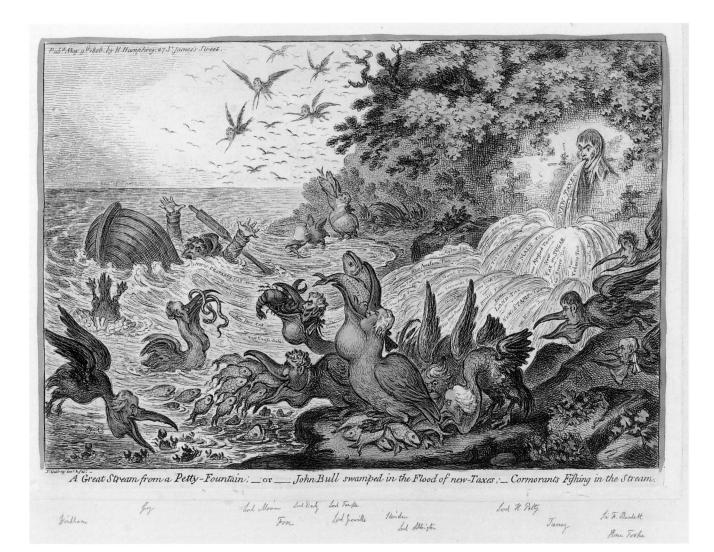

A Great Stream from a Petty-Fountain; — or — John Bull swamped in the Flood of new-Taxes; — Cormorants Fishing in the Stream.

scale elegant portraiture that was now produced, most prominently by Reynolds, Gainsborough, Allan Ramsay, Henry Raeburn, Romney and Thomas Lawrence, established the genre as one of the richest of the British school all the way into the twentieth century. Reynolds's application of the 'grand style' to portraiture was conceptual in intention, since 'the beauty of which we are in quest is general and intellectual' (see West, pp.144–5). Aiming for the grandeur of High Renaissance painting, his portraits often combine likeness and allegory, attributing to the sitters a sense of historical dignity. In the 1776–7 portrait of *Lady Bampfylde* (fig.103), the pose is a clear allusion to the Venus of Medici, the embodiment of ideal beauty. In clear opposition, Gainsborough's approach was instinctive and natural, more in tune with the 'age of sensibility' to which he belonged. His grand portraits are remarkable symphonies of sensorial effects, conveying the fragilities and complexities of the sitters' personalities in expressive landscapes and skies, as in the 1785–7 portrait of *Mrs Richard Brinsley Sheridan* (fig.106).

History painting in the strictest sense only flourished in two directions, first with the representation of famous scenes from Shakespeare's plays, which the picture dealer John Boydell commissioned at vast expense from the most prominent artists of the time (Reynolds, West, Fuseli, Kauffmann). A lot of these paintings were later lost, but a few remarkable examples survive, like Fuseli's *Titania and Bottom* c.1790 (fig.104), which allowed the artist to offer a 'Gothic' representation of Shakespeare's supernatural world. Boydell partially recouped his investment with the lucrative sale of engravings made after the paintings, but his Shakespeare Gallery was short-lived when foreign trade was hit by the consequences of the French Revolution. The second successful outlet for history painting was found in religious art, with Philippe Jacques de Loutherbourg and later John Martin's huge biblical scenes, but theirs were mostly isolated careers. James Barry also produced large history paintings, working in a Neoclassical style, but he antagonized patrons and colleagues with his unflinching defence of high art and criticism of the modern art market and was eventually expelled from the Royal Academy in 1799, dying in poverty seven years later. In effect, both in scale and in artistic sophistication the 'grand' style in British art mostly developed in landscape, with an uninterrupted line of prominent artists from the 1760s, with Richard Wilson, Gainsborough and Wright of Derby, to the middle

of the nineteenth century, with Constable and Turner. Shedding the Italian influence of Claude, Gaspard Poussin and Salvator Rosa (1615–73), so long cherished by British collectors returning from their Grand Tour and perceptible in the work of Richard Wilson (his views of England are often bathed in a Tuscan light), they gradually imposed scenes from the English landscape, with their myriad features and nuances, as the proper central subject for British artists. Landscape as they saw and represented it allowed them to combine and perhaps reconcile all the conflicting demands made on them – 'great' art, Englishness, careful observation of nature – and thus produce images that perfectly matched the artistic expectations of

a public who had gradually been persuaded to understand their iconic value (see Grindle, pp.120-43).

In 1711 Joseph Addison wrote that 'Musick, Architecture, and Painting, as well as Poetry, and Oratory, are to deduce their Laws and Rules from the general Sense and Taste of Mankind, and not from the Principles of those Arts themselves; or, in other Words, the Taste is not to conform to the Art, but the Art to the Taste.'[21] This provocative statement, which inaugurated the reign of public opinion, undisputed since in matters of cultural trends and value, led to a large educational enterprise that tried to provide guidelines and explanations for 'the general Sense and Taste of Mankind'. Already that same year, in some of

the texts collected in his *Characteristics of Men, Manners, Opinions, Times*, the 3rd Earl of Shaftesbury had endeavoured to consider the forms of exchange between art and beholder, praising 'Things of a *natural* kind, where neither *Art* nor the *Conceit* or *Caprice of* Man has spoil'd their *genuine Order* by breaking in upon that *primitive State*.' Taking up some of those ideas and turning them into periodical essays, Addison published in 1712 a remarkable series of *Spectator* essays entitled 'The Pleasures of the Imagination', in which he considered the artistic experience solely from the receiver's point of view. Opening the series with Lockean considerations on the primacy of sight, 'the most perfect and most delightful of all our

senses ... It is this sense which furnishes the imagination with its ideas', he went on to explain how 'polite' spectators can engage in fruitful conversations with visual objects, again emphasizing the importance of nature:

A man of polite imagination is let into a great many pleasures, that the vulgar are not capable of receiving. He can converse with a picture, and find an agreeable companion in a statue. He meets with a secret refreshment in a description, and often feels a greater satisfaction in the prospect of fields and meadows, than another does in the possession. It gives him, indeed, a kind of property in everything he sees, and makes the most rude, uncultivated parts of nature administer to his pleasures: so that he looks upon the world, as it were in another light, and discovers in it a multitude of charms, that conceal themselves from the generality of mankind.[22]

After repeating boldly that the works of nature are always superior to those of art ('There is something more bold and masterly in the rough careless strokes of nature than in the nice touches and embellishments of art'[23]), he concluded that the best art is that which imitates nature, setting out a programme for the nascent English school of art in portraiture and landscape.

Addison's seminal series of essays was followed throughout the century by a long and quite remarkable line of texts that accompanied the formation of public taste and contributed to the emergence of aesthetics as an autonomous philosophical discourse on art, increasingly freed from ethical and academic considerations. Jonathan Richardson in his *Essay on the Theory of Painting* (1715) and his *Two Discourses* (1719) – one on the art of criticism, the other on connoisseurship – Francis Hutcheson in his *Inquiry into the Original of our Ideas of Beauty and Virtue* (1726) Hogarth in his *Analysis of Beauty* (1753), Edmund Burke in *Philosophical Inquiry into the Origins of our Ideas of the Sublime and Beautiful* (1757), Alexander Gerard in *An Essay on Taste* (1759) and Henry Home, Lord Kames, in *Elements of Criticism* (1762), to mention only a few, joined with the numerous periodicals, but also the poets (Alexander Pope, James Thomson, Thomas Gray), to shape the contours of the new public's artistic sensibility.

One of the most important features of their empirical, sense-based approach of 'the works of imagination' was the encouragement to experience the boundless treasures of nature and engage in a true dialogue with her. Not only could this now be done within the carefully contrived 'mirrors of nature' offered by the new landscape gardens, it also became possible along the roads, lanes and paths of the English countryside, which an increasing number of illustrated guidebooks were mapping out for the newly fashionable activity of tourism. While theoreticians and artists discussed the merits of the beautiful and the sublime in artistic representations, a new category, the picturesque, emerged in the second half of the eighteenth century, which, although it had its own zealots and special language (see Jane Austen's take on it in *Northanger Abbey*, discussed in Grindle, p.134), seemed more immediately accessible to viewers and wanderers. Introduced by the Reverend William Gilpin with his *Observations on the River Wye, and Several Parts of South Wales, &c. Relative Chiefly to Picturesque Beauty; Made in the Summer of the Year 1770* (published in 1782), it launched the fashion for local tourism, which was soon to take on a nationalistic dimension during the wars against France between 1793 and 1815 when travelling to the Continent became virtually impossible. British citizens were encouraged to travel around the countryside in search of views that would in their eyes make for good pictures (hence the name), and which they could draw or paint for themselves thanks to the portability and immediacy of watercolour. A remarkable prefiguring of modern tourism, with its cameras and postcards, it developed among British travellers a dynamic, personal experience of framing the landscape, which turned them into eager first-hand consumers of artists' more elaborate views.

The later career of Thomas Gainsborough (1727–88) was mostly devoted to the genre of the picturesque, which, as can be seen in the portrait of Mrs Sheridan (fig.106), he also increasingly combined with portraiture, to enhance and 'sentimentalize' his viewers' personalities. The next generation, with Joseph Wright of Derby, George Morland, or the Frenchman Philippe Jacques de Loutherbourg, offered more dramatic representations of the landscape, more in tune with the post-French Revolution anxieties of the *fin de siècle*. J.M.W. Turner's own career was also launched in that context, and he first made a name for himself as an illustrator of tour books like *The Beauties of England and Wales* and Byrne's *Britannia Depicta* (1803). He later issued his own books, *Rivers of England* (1824) and *The Picturesque Views in England and*

105 (left)
JOHN CONSTABLE
Cloud Study 1821
Oil on paper laid on panel
21.3 × 29.2 (8⅜ × 11½)
Yale Center for British Art, New Haven
Paul Mellon Collection

106 (opposite)
THOMAS GAINSBOROUGH
Mrs Richard Brinsley Sheridan 1785–7
Oil on canvas 220 × 154 (86⅝ × 60⅝)
National Gallery of Art, Washington
Andrew W. Mellon Collection

Wales (1827). These views belong to the genre of topography, which enjoyed great success from the 1780s onwards with remarkable artists like Paul Sandby. Turner then developed his own revolutionary style of landscape, linked to his dark, Romantic view of history and decline, in which the attention to extreme natural phenomena like snowstorms or tempests at sea is combined with sublime light effects to carry the genre almost into abstraction, dizzying its viewers with the elimination of perspective and vanishing point, and offering them some of the boldest visual experiments in paint ever attempted.

In the same period John Constable, while meeting with little success at the Academy, produced numerous views of the English landscape that were to become nostalgic icons of the nation in the later nineteenth and twentieth centuries. His objective was a meticulous recording of the variations in light and shade, famously illustrated by his numerous cloud studies (fig.105). Acknowledging like Turner, though in different terms, the profound debt of British art towards the philosophy and science of the two previous centuries, he conceived art as the continuation of the 'enlightening' project, as an important contribution to the progress of knowledge: 'Painting is a science, and should be pursued as an enquiry into the laws of nature. Why, then, may not landscape painting be considered as a branch of natural philosophy, of which pictures are but the experiments?'[24] By producing landscapes in formats usually

reserved for history painting (his famous 'six-footers'), he made it clear that 'modern' history painting in England was to be found in such 'great' landscapes and their meditations on the hidden heroism of everyday country life as well as on the centrality of land in the English mind (see also Grindle, pp.120–43).

Through the combined achievements of those great artists, the English school of art had by now established itself not only as one of the most active and creative on the European scene, thanks to their exemplary defence and illustration of an idiomatic 'natural' approach of picturality, but also as a visual summation of the values of a whole nation. The new intellectual context of the early eighteenth century allowed the gradual promotion and production of 'modern' and 'British' art that both contributed to man's better understanding of nature and had an unashamed presence in the marketplace. At the same time, true to Hogarth's programmatic self-portrait *The Painter and his Pug* 1745 (fig.126, p.197), in which he clearly signified that English artists should search for their inspiration in Shakespeare's free drama, Milton's free verse and Swift's free speech, the English 'school', *pace* Reynolds, was (and has since mostly been) the work of independent artists who proclaimed liberty – of genre, of style, of subject, of tone – to be the defining character of their art.

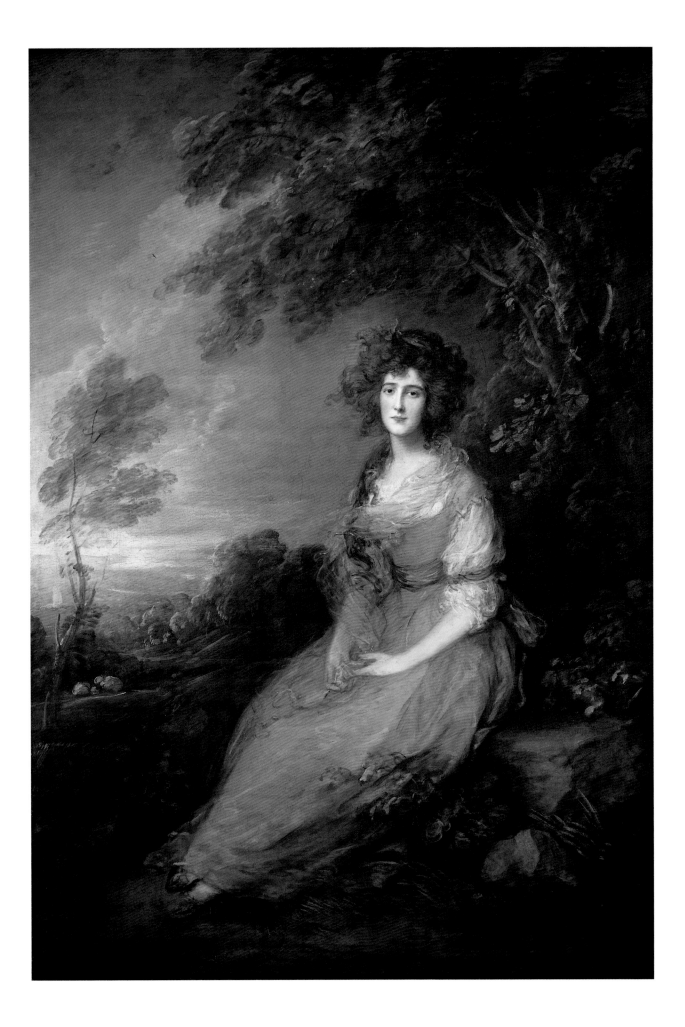

Hogarth's 'Modern Moral Subjects'

PETER WAGNER

In his 'Autobiographical Notes' William Hogarth remarks that around 1730, frustrated with illustrating books and his lack of success as a portrait painter, he turned 'his thoughts to ... painting and Engraving moder[n] moral Subject a Field unbroke up in any Country or any age'. This was not quite true, for the field of picture stories had already been tilled by such Continental artists as Jacques Callot (1592/3–1635), Giuseppe Maria Mitelli (1634–1718) and Abraham Bosse (1602–76), who provided models for Hogarth's commercially successful series. The term 'modern moral subjects' is generally applied to the six scenes constituting *A Harlot's Progress* 1732 and the two sequels, *A Rake's Progress* 1735 and *Marriage A-la-mode* 1745. However, most of Hogarth's satirical art works published between 1731 and his death in 1764 could be considered 'modern [i.e. satirical] moral subjects' and they are listed as such in the catalogue raisonné of his graphic art (1989). This includes the series on the two apprentices, *Industry and Idleness* 1747, and the triptych manqué – *Beer Street and Gin Lane* 1751, *The Four Stages of Cruelty* 1751, and *Four Prints of an Election* 1755–8 (see Ogée, p.163).

Until the publication of *Industry and Idleness* and *The Four Stages of Cruelty*, directed at a less educated audience and accompanied by biblical quotations and moralistic doggerel verse respectively, Hogarth had engraved most of his major series from his own paintings. The paintings of *A Harlot's Progress* were destroyed by fire in Hogarth's lifetime. He had started the picture series in 1730 with a sketch of a prostitute in a garret (scene 3), adding five more scenes when he noticed the great public interest in the subject. Focusing on the life of a prostitute, with the telling name of Moll or Mary Hackabout, in a narratological manner that is indebted both to the theatre and to the lives of saints and Christ in church art, *A Harlot's Progress* represents her arrival as a virgin in London (scene 1; fig.107), her brief spell as a kept mistress (2) and her decline into criminality and squalor (3 and 4), followed by infection and death (5 and 6). The enormous success of the picture story and its sequels can be attributed to several factors. Most importantly perhaps, Hogarth pictorially reiterated the prejudices and perceptions of the urban culture of his day and age: the figure of the prostitute allowed both moral and erotic exploration, the rake could be a warning against aristocratic vice, and a later work,

107 WILLIAM HOGARTH
A Harlot's Progress, Plate 1 1732
From the *Original and Genuine Works of William Hogarth* 1820–2
Engraving 30 × 37.3 (11¾ × 14⅝)
Yale Center for British Art, New Haven
Paul Mellon Collection

Marriage A-la-Mode (fig.108), highlighted the tragic consequences of a union of capitalism and patriarchy in an arranged marriage, a popular concern at the time. In addition, Hogarth's art offered a dazzling mixture of topical allusions to London locales and characters that could be easily identified, like Colonel Charteris and 'Mother' Needham in *Harlot* scene 1 (fig.107) alongside references to popular and polite texts, and to mythological and high art. The artist borrowed his effects from Old Masters and the urban visual culture of his time, including popular shows and public fairs. This mixture rendered his series attractive to a large public, both illiterate and educated. The satirical allusions and the reportorial elements make up the universe of visual and verbal discourse orchestrated in each print, contributing to the meaning made by the reader. Some of the details are polysemous: the stolen gold watch Moll presents to us can be

108 WILLIAM HOGARTH
Marriage A-la-Mode, Plate 1 1745
From the *Original and Genuine Works*
of William Hogarth 1820–2
Engraving 38.5 × 46.7 (15⅛ × 18⅜)
Yale Center for British Art, New Haven
Paul Mellon Collection

read allegorically as time running out, but also as an allusion to Defoe's story of a prostitute in *Moll Flanders* (1722), which inspired Hogarth's work. It is this witty combination of realism, the debunking of (classical) allegory, and satirical allusion that keep his serial art ambiguous and interesting.

A Rake's Progress, engraved after the paintings produced between 1733–5, (John Soane's Museum, London) was published in 1735 after Hogarth had obtained legal copyright for his work as engraver (his *Harlot* series had been immediately plagiarized). Told in eight scenes referencing the life of Christ (who, like the harlot, was also a victim of society) and Bunyan's *Pilgrim's Progress*, this picture story throws satirical light on the wealthy bourgeois trying to ape aristocratic manners. *A Rake's Progress* tells a different story from the harlot's, but artistically and as a narrative it offers no real

advance. This came in 1745, with the sophisticated satire on the modern marriage, *Marriage A-la-Mode* (National Gallery, London). Hogarth had travelled to Paris to engage French engravers for the work, but what distinguishes the series is less its aesthetic accomplishment in style or theme, but the ironic interplay, on three levels, of animals, humans and art objects. Partly modelled on Jean-Antoine Watteau's art-filled *L'Enseigne de Gersaint*, this series demonstrates the kind of satirical intermediality, in which pictures refer to texts and vice versa, always at work in Hogarth's art (see, for instance, scene 1 of *Industry and Idleness*). It thus becomes what Roland Barthes called an 'echo chamber', a visual representation resonating with a plurality of voices from polite and popular culture.

The persistent attraction of Hogarth's modern moral subjects lies in their internal and structural ambiguity. The verbal and visual

allusions enrich the reading process. Like Sterne in *Tristram Shandy*, Hogarth offers the observer a role in completing the work, filling the gaps and decoding the allusions in the individual scenes and in the ellipses between the plates where the plot is continued; the reader is free to enter into what Sterne called a 'conversation'. Hogarth's visual serial art invites this conversation, too, perhaps more so than Sterne's fiction.

FURTHER READING

Bindman, D., F. Ogée and P. Wagner (eds.), *Hogarth*, Manchester 2001.

Fort, B. and A. Rosenthal (eds.), *The Other Hogarth*, Princeton 2001.

Hallett, M., *Hogarth*, London 2000.

Vauxhall Gardens

DAVID BINDMAN

Vauxhall Gardens as a space notionally open to all visitors has been seen by recent art historians as a touchstone for the rise of a new middle-class public for art in eighteenth-century London. Jonathan Tyers's transformation of the Gardens into a major destination for fashionable London in the 1730s was a turning point in the public dissemination of English art. In the absence of public venues it became one of the few places before the 1760s, when exhibiting societies were formed, where those who could not or did not buy paintings could actually see works by contemporary artists. The Gardens on the south bank of the river Thames offered the cultivated pleasure of wandering in formal gardens adorned with paintings and sculpture to any citizens who were suitably dressed and prepared to pay the entrance fee (see fig.110). It presented a distinctively urban character as a place of spectacle, with pavilions, music, dining and fireworks, and occasional visits from Frederick, Prince of Wales. There were notable sculptures throughout the grounds, and the supper boxes were adorned by large paintings by Francis Hayman (1708–76) and his assistants (see fig.109). Though Tyers evidently tried to involve William Hogarth, he did not contribute directly to the project.

The most important single work of art in the Gardens was Louis-François Roubiliac's 1738 statue of the composer George Frederick Handel, then still mid-career. He is seated as Orpheus playing Apollo's lyre (fig.111) as if to calm the spirits of those who entered the gardens. The composer is shown in informal dress, with his slippers hanging off, as if transported unawares by the onset of heavenly inspiration. Originally it was set into a niche with the source of inspiration as a cherub carved above, but shortly after its installation it was moved away from its niche to become free-standing. The sculpture is remarkable for its wit and light-heartedness, derived from Roubiliac's experience of the rococo in his native France, which he had left only a few years before. It celebrates the Handel of his Italian operas and oratorios, before he wrote *Messiah* and other sacred works. It stood for Tyers's ideal of Vauxhall Gardens as a place of cultivated and aristocratic enjoyment, though in reality Tyers was notoriously unable to ensure that only the respectable were allowed in.

The paintings in the 'Chinese-Gothick' supper boxes, of which some fifty are recorded and eighteen were issued as engravings, were evidently all made under the supervision of Francis Hayman in the 1740s. A number of the paintings have survived, much overpainted because of damage inflicted by the weather and visitors. Though many of the subjects are of English customs (such as *See-Saw*, fig.109), popular literature, history and children's games, their main visual inspiration is French painting. Their concern with such subjects indicates a nostalgia for a bygone England and a leaning towards the idea of the 'Patriot King' associated

110 GRAVELOT (b. HUBERT-FRANCOIS BOURGUIGNON)
The Adieu to the Spring-Gardens
(night view of Vauxhall Gardens, with song sheet below) 1737
Engraved by George Bickham after Gravelot
Print on paper 35 × 21 (13¾ × 8⅜)
Guildhall Library Print Collection, London

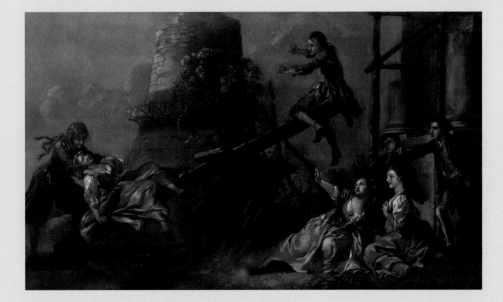

109 FRANCIS HAYMAN
See-Saw c.1742
Oil on canvas 163 × 259 (64¼ × 102)
Tate, London. Presented by the friends of the Tate Gallery 1962

with the opposition and Frederick, Prince of Wales. This is most evident in the engraving after a lost painting of *The King and the Miller of Mansfield*, that depicts a scene in which the medieval King Henry II is happier in the company of common people than of his courtiers.

This longing for a lost England contrasts with Hayman's later scheme for the Rotunda in Vauxhall in the early 1760s, which expresses a burgeoning awareness of the British Empire. The subjects (all the paintings are now lost), including *The Triumph of Britannia, The Surrender of Montreal to General Amhurst, Lord Clive Receiving the Homage of the Nabob* and *Britannia Distributing Laurels to the Victorious Generals*, precede as examples of

'contemporary history painting' Benjamin West's celebrated *Death of General Wolfe*, painted in 1771 (see fig.32, p.67), which is usually taken as the beginning of a distinctive and long-lasting genre of British art.

Vauxhall Gardens may be compared with the Foundling Hospital, an orphanage established in 1739 by Captain Coram, a friend of Hogarth, as a pioneering public exhibition space for British art. The Royal Academy, founded in 1768, with its first President Joshua Reynolds, defined itself against Hogarth's populism and sought to provide an alternative to the perceived lack of high seriousness in the work exhibited in Vauxhall and the Foundling Hospital. The association of painting with pleasure and public philanthropy was treated with contempt by

Reynolds, who argued in his *Discourses* for an art of Italianate grandeur. Vauxhall Gardens continued to function into the nineteenth century but its period of glory was the middle decades of the eighteenth century.

FURTHER READING

Allen, B. and T. J. Edelstein, *Vauxhall Gardens*, New Haven 1983.
Bindman, D., 'Roubiliac's Statue of Handel and the Keeping of Order in Vauxhall Gardens in the Early Eighteenth Century', *The Sculpture Journal*, vol.1, 1997, pp.22–31.
Solkin, D., *Painting for Money*, New Haven and London 1993.

The Conversation Piece

MARTIN POSTLE

The conversation piece was a form of small-scale informal group portrait that first became popular among British artists during the early decades of the eighteenth century. Its rise has been associated inevitably with the advent in the art market of middle-class patrons who wished to exhibit their social aspirations, material possessions and 'family' values: hence the prominence of private parks and houses, polite domestic rituals and the ubiquitous presence of children, often engaged in recreational activities. And yet the conversation piece was by no means restricted to the middle classes, finding favour also with established aristocratic families and the monarchy. Nor was it always informal, since it often sought to visualize newly evolved rituals and etiquette that regulated the public reception of domestic virtues. In other words, in the hands of many of its more routine practitioners, the conversation piece could appear as mannered and hierarchical as the full-scale dynastic portraiture of previous generations.

The antecedents of the British conversation piece are to be found in the work of seventeenth-century Dutch and Flemish artists like Gerard ter Borch (1617–81) and Gonzales Coques (1614–84), but it was imported to Britain in the 1720s and 1730s principally by French immigrant painters, notably Marcellus Laroon and Philip Mercier. Of native British artists who adopted the genre, the Scots artist, Gawen Hamilton (1698–1737), was among the most adept, as in his *Du Cane and Boehm Family Group* 1734–5 (Tate, London), a detailed depiction of the union through marriage of two wealthy Huguenot dynasties. It was William Hogarth, however, who may be said to have 'anglicized' the conversation piece, and transformed it into an innovative and at times subversive genre.

A Performance of 'The Indian Emperor or the Conquest of Mexico' 1732–5 (fig.112) is arguably the most accomplished of all British conversation pieces. Here Hogarth combined domestic portraiture and drama, in a depiction of the children of John Conduitt, Master of the Mint, performing a play by John Dryden before members of the royal family, taking care to focus equal attention upon the actions of the protagonists in the drama and the varied reactions of the select audience. Conduitt, in whose house the event is staged (and whose portrait, alongside that of his wife, hangs on the wall), was not, despite his professional position, representative merely of the 'rising middle class'. An

112 WILLIAM HOGARTH
A Performance of 'The Indian Emperor or the Conquest of Mexico' 1732–5
Oil on canvas 80 × 146.7 (31½ × 57¾)
Private Collection

eminent natural philosopher and Fellow of the Royal Society, he was firmly established among the country's intellectual and social elite, a fact confirmed by the presiding presence upon the mantelpiece of a sculpted bust of Isaac Newton, a friend who was his wife's uncle.

The trajectory taken by the conversation piece in the wake of Hogarth's achievements during the 1730s is somewhat contradictory. While Thomas Gainsborough explored its possibilities during the 1740s in portraits such as the brilliantly quirky *Mr and Mrs Andrews* (National Gallery, London), he soon abandoned it in favour of large-scale portraiture. Nor did Reynolds ever resort to it, except briefly in caricatures. Instead, the conversation piece became increasingly the bread and butter of regional artists such as Preston-based painter Arthur Devis or of

painters like Nathaniel Dance, who used the format successfully in Italy to cater for group portraits of Grand Tourists.

While it was, by mid-century, in danger of becoming passé, the proliferation of the conversation piece in the later 1700s was due principally to the German-born Johann Zoffany, who used it as the basis of his career as a theatrical painter (notably in his numerous portraits-in-character of David Garrick), as well as the cornerstone of his successful bid for royal patronage. From the mid-1760s, through his intimate royal portraits set in private apartments and gardens, Zoffany provided George III and Queen Charlotte with images that celebrated the domestic pretensions of their court – albeit with the requisite material trappings. In other royal commissions, notably the *The Royal*

113 JOHANN ZOFFANY
The Tribuna of the Uffizi c.1772–8
Oil on canvas 123.5 × 155 (48⅝ × 61)
Royal Collection

Academicians (fig.128, p.200) and *The Tribuna of the Uffizi* (fig.113), Zoffany also demonstrated the potential of the conversation piece to exploit rituals associated with sites of public spectacle. Set in the gallery of the Grand Duke of Tuscany in Florence, Zoffany's *Tribuna* – which imaginatively drew together works from different locations – provided a uniquely personal, and modern, view of the social and aesthetic interaction of collectors and connoisseurs, who are themselves the principal focus of interest – rather than the Old Master paintings or revered icons of classical sculpture around which they cluster. Yet, while Zoffany endowed the conversation piece with technical sophistication, and psychological penetration, those artists who followed in his wake were for the most part unable to match his achievement.

FURTHER READING

Praz, M. *Conversation Pieces: A Survey of the Informal Group Portrait in Europe and America*, London 1971.
Retford, K. *The Art of Domestic Life: Family Portraiture in Eighteenth-Century England*, New Haven and London 2006.
Sitwell, S. *Conversation Pieces: A Survey of English Domestic Portraits and their Painters*, London and New York 1969.

The Private Sculptural Monument

MALCOLM BAKER

After the sixteenth-century Protestant Reformation, family chapels in parish churches continued to house monuments erected to commemorate members of the local gentry and landowning aristocracy. Most remain *in situ* and together constitute a major category of British art produced between 1550 and 1850. In the setting of the family chapel such monuments, especially when they were placed alongside earlier tombs commemorating previous generations, served to register lineage and the continuity of a family name. Far more costly than paintings, these monuments to private individuals and families provided sculptors with lucrative commissions from the early sixteenth century onwards. Only in the nineteenth century, with the widespread commissioning of public monuments, did the private monument become more marginal. Whether elaborate or modest, the monument was made up of several main components. One was the architectural form, which in earlier and more ambitious examples consisted of a freestanding tomb chest, following a medieval tradition (the remains of the deceased were almost always interred elsewhere). By the seventeenth century, however, space within family chapels was increasingly limited, so that the wall monument became the preferred format. More modest monuments or tablets had no figurative imagery, but others included portrait busts of the deceased, allegorical figures of the virtues or mourning figures of children, holding emblems of mortality such as an hour glass. As important for patrons and viewers were the family's coat of arms, and the epitaph recording lines of descent and the deceased's public achievements.

The production of figurative monuments during the seventeenth century was largely in the hands of 'mason-sculptors' such as William Stanton (1639–1705). While workshops flourished in provincial centres such as Bristol and Norwich, the most important were in London, at Southwark or Camberwell south of the Thames where they could operate freely without the restrictions of the Mason's Company that regulated work within the City. Green of Camberwell employed large numbers and sent monuments of standard design throughout the country by water. Major talents like Nicholas Stone (1583–1647), with a training in the Netherlands, were executing figurative sculpture of sophistication and ambition. The emergence of the monument

114 LOUIS-FRANÇOIS ROUBILIAC
Monument to General William Hargrave 1757
Marble, approx. height 300 (120)
Westminster Abbey, London

as a mode of sculpture valued for its aesthetic qualities came only in the early eighteenth century, however, with the arrival of sculptors such as Michael Rysbrack and Louis-François Roubiliac. Alongside other Flemish-trained sculptors, including Laurent Delvaux (1695–1778) and Peter Scheemakers (1691–1781), Rysbrack was employed by patrons wanting ambitious monuments in which figurative sculpture played a prominent role. Working in collaboration with architects such as James Gibbs and William Kent (as in the monument to Isaac Newton in Westminster Abbey), Rysbrack soon established a flourishing practice, producing both relatively modest wall monuments for churches throughout the country and complex multi-figured tombs, which reclaimed the use of the reclining figure of the deceased flanked by allegories, a form long used for papal monuments. At the same time Rysbrack and his contemporaries were meeting a growing demand for independent portrait busts, some of them produced as duplicates of those on monuments. While some of the most impressive of Rysbrack's monuments – that to the Foley family at Great Witley in Worcestershire (fig.115), for example – were for churches associ-

ated with aristocratic country houses, others were for Westminster Abbey. Despite the role that the Abbey played as a national pantheon, most monuments erected there commemorated private individuals, to the surprise of foreign visitors like Voltaire. The smaller monuments set within the thirteenth-century wall arcades in the Abbey, including that of a sarcophagus surmounted by a portrait bust, provided a pattern for sculptors like Peter Scheemakers and Henry Cheere (1703–81) for monuments produced in London and sent throughout the country. For such smaller works Cheere's workshop used the same elements in different combinations, and used coloured marbles and floral decoration to distinguish his productions from the austere white marble monuments of Scheemakers, The marketing of such private monuments thus shared practices with other luxury trades.

During the 1750s the static format of Rysbrack's monuments, with their individual figures placed within an architectural structure, was challenged by Roubiliac's monument type, in which figures interact in dramatic narrative compositions (fig.114). Admired for their invention, his monuments were aesthetically

115 MICHAEL RYSBRACK
Monument to Thomas, 1st Baron Foley,
and his Family 1735–8
Marble, approx. height 650 (258)
Great Witley Church, Worcestershire

ambitious, and the way in which they were
viewed – evident in the language describing
them in guidebooks to Westminster Abbey –
signalled a shift in the status of both sculptor
and sculpture. By 1800 large-scale monuments
in Westminster Abbey and St Paul's Cathedral
were increasingly publicly funded, but private
monuments continued to be commissioned for
parish churches from sculptors such as Joseph
Nollekens (1737–1823) and John Flaxman.
Roubiliac's dramatic narratives were now,
however, replaced by Neoclassical figure compo-
sitions, often with a prominent urn in the form
of the ubiquitous Neoclassical vase. The imagery
of such monuments was frequently overtly
Christian, and in examples from the early
nineteenth century by Francis Chantrey and
Richard Westmacott affectionate family groups
become a favourite subject. Private monuments
continued to be produced during the second
half of the century but by 1870 they often
imitated medieval examples, in accord with the
principles of the Gothic revival. Examples from
all these periods might sometimes be found
in the same family chapel, commemorating
successive generations of the same family in
a continuous sequence from the fourteenth
to the nineteenth centuries.

FURTHER READING

Baker, M. *Figured in Marble*, London 2000.
Bindman, D. and M. Baker, *Roubiliac and the*
 Eighteenth-Century Monument, New Haven and
 London 1995.
Whinney, M. *Sculpture in Britain, 1530–1830*,
 New Haven and London, 2nd ed., 1988.

Joseph Wright 'of Derby' and Industry

ELIZABETH E. BARKER

Between 1771 and 1773 Joseph Wright (1734–97) exhibited a series of paintings – three showing blacksmiths' shops and two showing iron forges – that rank among the earliest and most accomplished depictions of industrial subjects in British art. Significantly, these images engage with the Industrial Revolution not only in their subject matter but also in their surfaces, in the distinctive manner of manipulating paint that Wright developed while preparing these seminal works.

In *A Blacksmith's Shop* 1771 (fig.116) three men shape a horseshoe, their faces flushed by the hot iron bar that illuminates the space – apparently a former chapel, which retains an angel carved in the spandrel of an arch. One boy observes the work in progress with curiosity; another turns and covers his face. An old man sits on a rough-hewn stool, leaning against an upturned hammer, and gazes at the floor. Outside, a boy lifts a saddle from a horse as two men examine its hoof by candlelight. Wright's rendition of a conventional genre subject elevates it to the status of history painting. The romantic setting and dramatic illumination cast an air of mystery over the commonplace event (the Georgian equivalent of emergency car repair), recalling nocturnal depictions of the Nativity. The three artisans – surely more hands than strictly necessary to shape a horseshoe – display a range of compelling figures, thereby evoking the *paragone*, or 'comparison', the age-old debate over the relative superiority of painting versus sculpture. These strong bodies articulate British labour – the motor for an unprecedented industrial expansion then creating rapid economic growth – in heroic, patriotic terms. Yet if the broad themes seem clear, narrower readings prove more elusive. What prompts the lucubration? Why are children present at so late an hour? Has the youngest boy been startled by the noise or heat? Or burned by a spark?

The polysemic narrative probably reveals a deliberate strategy. By inviting a range of readings, Wright stood to captivate more viewers – and to put off fewer of them. Following the perceived failures of *The Orrery* 1766 (Derby Museum and Art Gallery) and *Air Pump* 1768 (National Gallery, London), whose unprecedented depictions of contemporary science education had been difficult to sell – and had not prompted an invitation to join the Royal Academy at its founding (1768) – Wright must

116 JOSEPH WRIGHT OF DERBY
A Blacksmith's Shop 1771
Oil on Canvas 128.3 × 104.1 (50½ × 41)
Yale Center for British Art, New Haven
Paul Mellon Collection

117 JOSEPH WRIGHT OF DERBY
An Iron Forge 1772
Oil on canvas 121.3 × 132 (47¾ × 52)
Tate. Purchased with assistance from the
National Heritage Memorial Fund, The Art Fund
and the Friends of the Tate Gallery 1992

have felt the need to change tack. The resulting
blacksmiths' shops and iron forges proved a
resounding success. All sold within months
of completion (one while still on the easel) to
distinguished collectors: two connoisseurs,
two aristocrats and the Empress of Russia.
Mezzotints after three were published within
months of the related exhibitions; reproduc-
tions as glass paintings and mechanical
paintings followed.

In *An Iron Forge* 1772 (fig.117) Wright intro-
duced variations on the theme: a water-powered
tilt hammer replaces the hand-held tools of the
earlier scenes, and only a single artisan labours,
positioning the glowing ingot on the anvil.
Another man, perhaps the forge's owner (whose
striped waistcoat attests to the prosperity
brought by this technological advance) stands
with folded arms, looking approvingly towards
the woman and girls beside him. The seated
thinker reappears with a small girl leaning
against his knee. The children seem to meet
the viewer's eyes, as if inviting a response. And
on the walls behind them, dashes, dabs and
squiggles of paint, applied with bushes, knives
and sponges, define the scabrous bricks. The
effect – more marvellous than naturalistic –
finds no comparison in the work of any other
late-eighteenth-century British painter.

Wright referred to this effect as 'finishing'.
For him, the term was not simply synonymous
with completion: clients were offered the option
of finishing, but could also purchase a painting
without it, at a correspondingly lower price.
Wright seems to have defined the word much
as the fabric industry did, in reference to the
skilled, lengthy transformation of initially
manipulated raw materials into coloured,
textured cloth – a refined product ready for
the marketplace. Presumably familiar with the
term from Derby, the site of England's first silk
mill, Wright would also have encountered it
in Liverpool, an important port for the cotton
trade where Wright worked for large portions
of the period 1768 to 1771.

Modern economists might describe Wright's
finishing as a value-added service. They might
also recognize its function as a branding
mechanism, a readily identifiable characteristic
that distinguished Wright's paintings within
an increasingly competitive late-eighteenth-
century marketplace for art. Seen in this light,
Wright's paintings of industry appear to cele-
brate not only the accomplishments of modern
British industry, but also proclaim the artistic
achievements that Wright alone had wrought.

FURTHER READING

Barker, E.E., Alex Kidson, et al., *Wright of Derby in
Liverpool*, exh. cat., Walker Art Gallery, Liverpool,
and Yale Center for British Art, New Haven, 2007.
Egerton, J. et al., *Wright of Derby*, exh. cat., The Tate
Gallery, London, 1990.
Solkin, D. 'Joseph Wright and the Sublime Art of Labor,'
Representations 83 (summer 2003), pp. 167–94.
Nicolson, B. *Joseph Wright of Derby, Painter of Light*,
2 vols., London and New York, 1968.

The Pre-Raphaelite Brotherhood and the Painting of Contemporary Life

ELIZABETH PRETTEJOHN

The name chosen in 1848 by seven young artists, 'Pre-Raphaelite Brotherhood' (or 'P.R.B.'), suggests a preoccupation with the art of the past, and early controversies over their work centred on its perceived archaism. When the critic John Ruskin came to the group's defence, in a letter of 1851 to *The Times*, he refuted such charges:

> They intend to return to early days in this one point only – that, as far as in them lies, they will draw either what they see, or what they suppose might have been the actual facts of the scene they desire to represent, irrespective of any conventional rules of picture-making; and they have chosen their unfortunate though not inaccurate name because all artists did this before Raphael's time, and after Raphael's time did *not* this, but sought to paint fair pictures, rather than represent stern facts. (Cook and Wedderburn, XII, p.322.)

Thus Ruskin places the P.R.B. on the virtuous side of a moral antithesis between the worthy representation of 'stern facts' and the meretricious blandishments of 'fair pictures'. At the same time he deconstructs the previous antithesis between modernity and archaism; his phrasing does not distinguish between the representation of the present – 'what they see' – and the past – 'what they suppose might have been the actual facts of the scene they desire to represent'. This implies that a certain contemporaneity is built in to Pre-Raphaelite realism: whether the subject is set in past or present times, it has the immediacy of observed fact and at the same time the moral value of scrupulous honesty.

But at the date of Ruskin's letter the Pre-Raphaelites were still concentrating their more ambitious efforts on subjects from the past; they had not yet found ways to transfer their project to contemporary life, which was at this time strongly associated with the humble tradition of Dutch genre painting, mediated through the work of such artists as David Wilkie in the earlier nineteenth century. *Answering the Emigrant's Letter* 1850 (fig.118), by the P.R.B. James Collinson (1825–81), deals with an urgent contemporary issue, emigration to the British colonies; but it is not innovative in pictorial conception and remains close to earlier conventions for genre painting. In an article published the same year in the short-lived Pre-Raphaelite magazine, *The Germ*, the sculptor and Pre-Raphaelite associate John Lucas Tupper (?1824–79) pointed to the difficulties involved in creating an original pictorial mode for subjects from contemporary life: 'It is the luck of all things of the past to come down to us with some poetry about them; while from those of diurnal experience we must extract this poetry ourselves.' Yet Tupper believed that the motive for artistic creation must come from the life around us; the artist should not take the easier route of depending on the poetic associations of subjects from the past: 'If, as every poet, every painter, every sculptor will acknowledge, his best and most original ideas are derived from his own times: if his great lessonings to piety, truth, charity, love, honor, honesty, gallantry, generosity, courage, are derived from the same source; why transfer them to distant periods, and make them *not things of to-day?*' (*The Germ*, March 1850.) Tupper might have been admonishing his Pre-Raphaelite friends; in their earlier pictures there is no lack of engagement with contemporary issues such as class difference or sexual

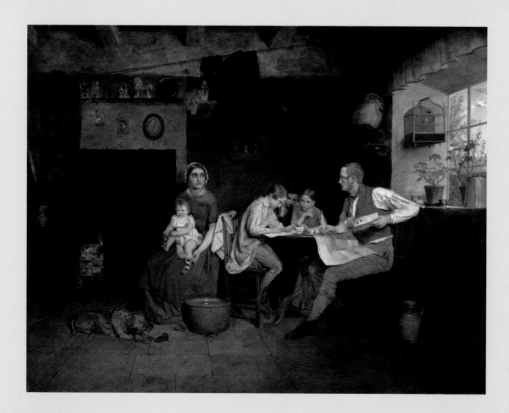

118 JAMES COLLINSON
Answering the Emigrant's Letter 1850
Oil on canvas 101 × 108 (39¾ × 42½)
Manchester City Art Galleries

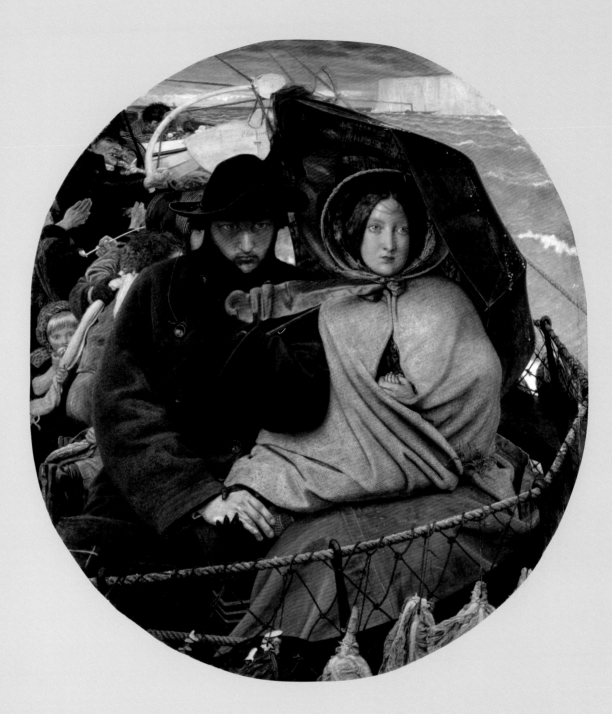

119 FORD MADOX BROWN
The Last of England 1852–5
Oil on panel
82.5 × 75 (32 × 29)
Birmingham Museums and
Art Gallery. Purchased 1891

morality, but these concerns are ordinarily transferred to distant periods.

In 1852 Ford Madox Brown (1821–93) – not a P.R.B., but the closest associate of the group – designed three remarkable pictures that took up the challenge of painting 'things of to-day'; in *An English Autumn Afternoon* 1852–5 (Birmingham Museums & Art Gallery) he represented the rapidly changing environment of suburban London, and in *Work* 1852–65 (Manchester City Art Galleries) he presented modern labour in all its varieties. *The Last of England* 1852–5 (fig.119) relates, like Collinson's painting, to contemporary debates on emigration, but it also derives a startlingly original

pictorial idea from the modern subject. Brown uses the circular format to dramatize the small world of the emigrant couple, anxiously huddled under the paltry shelter of a rain-streaked umbrella; with one hand the woman clutches the tiny hand of her baby, hidden under her drab cloak, while the other, black-gloved, clutches the bare hand of her husband, pinched and reddened with cold. Strident details such as the shrill pink of the woman's flying hat-ribbons, crinkling in the harsh wind, and the cabbages lashed to the rigging are painted as 'stern facts'. This is not a 'fair picture'; nonetheless, it finds a distinctive 'poetry' in the 'diurnal experience' of emigration, at its height when

the painting was conceived. In the next few years the Pre-Raphaelite painting of contemporary life flourished in works that bring the social concerns, as well as the visual appearance, of the 1850s vividly before us.

FURTHER READING

Barringer, T. *Men at Work: Art and Labour in Victorian Britain*, New Haven and London 2005.
Cook, E.T. and A.Wedderburn, *The Works of John Ruskin: Library Edition*, 39 vols., 1903–12.
Prettejohn, E. *The Art of the Pre-Raphaelites*, London 2000.

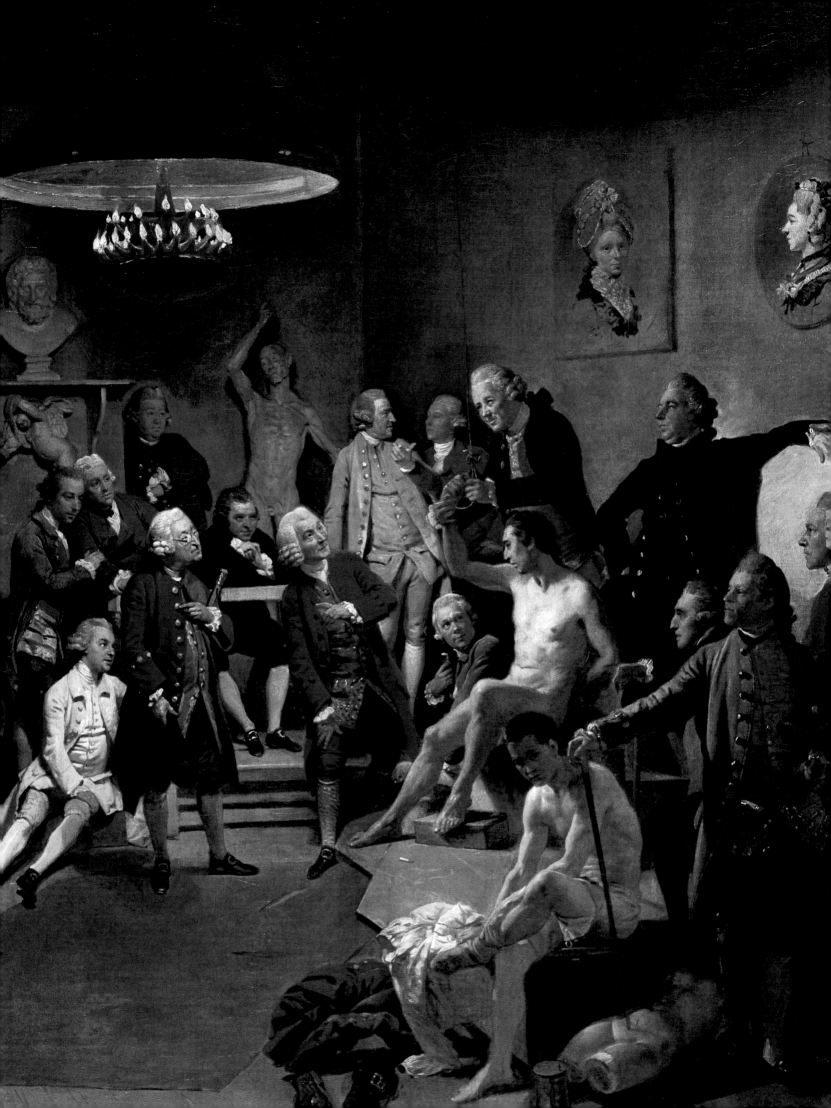

6 The British Artist c.1570–c.1870

MARTIN MYRONE

'The Rise of the Artist'

From the vantage point of 1870 the writer Francis Davenant was able swiftly to summarize the history and character of the British artist, insofar as he considered that these could be of interest to the target readers of his vocational guide, *What Shall my Son Be? Hints to Parents on the Choice of a Profession or Trade*.[1] The visual arts were here considered alongside the church, law, medicine, the armed services, architecture, science, business and finance as a viable career choice for the sons of middle-class families. But Davenant notes that compared to most of the others, the history of the occupation of artist in Britain is brief, dating only to the reign of George III, adding that the artist's character as a kind of professional is peculiar in the extreme:

> With few exceptions it has been the practice of English people to act upon the sentiments enunciated by their half-barbarous monarch, George, when he announced, for the benefit of whomever it might concern, that he 'hated boets and bainters'. They had an idea that painting was an effeminate art, pursued only by effeminate persons; and that while it did well enough for Frenchmen, Italians, and the like, it was wholly unsuited to the manly English character.
>
> There was no English school of art; what pretended to be English, was but a mongrel adaptation of German or Dutch, and the few great artists who lived and were famous before the reign of George the Third, were like beacons to show how many more there might have been had attention been paid to art.

Even in the present day, reported Davenant, these prejudices lingered:

> though art has become 'respectable' in itself, and although the rewards it brings have dissociated itself from poverty and lowliness as necessary companions, there is still a lurking idea that artists themselves are not quite *comme il faut* persons, that they are more or less 'naughty'.

The artist's material fate was, though, still precarious: 'As a means of merely making money, an artist's profession is about the last one to choose.' And while the professional training available at London's Royal Academy was important, it by no means wholly qualified the artist: 'After studying at the Academy, the student should still consider himself, what in effect he really is, a tyro in the profession.' Even when an individual might be considered professionally established, by some measure, he might not draw his primary income from being an artist. Very many were occupied providing illustrations for magazines, teaching, or in some other business. This brought a strange advantage: 'They go back to what they call their legitimate work with a greater zest for having to do other work less congenial to them, and their eyes and hands are not injuriously affected by the change of subject for study.'

Davenant effectively describes the genesis of the modern artists' role. In his time and ours the individual who professes himself or herself an artist may not, perversely, derive their primary income from the independent practice of art, but from employment in commercial design or in education (a situation given its own professional form in the creation of a whole class of art teachers by Henry Cole at the Government Schools of Design in the mid-nineteenth century). But equally perversely, this apparent failure may actually encourage a sense of self-belief. In the domain of the artist, it seems, the distinction between success and failure does not follow the usual logic, nor is the character of achievement self-evident, involving, as it does, an unpredictable combination of formal qualifications and affiliations, material rewards, and issues of perception (of the self and by peers).[2]

Davenant was writing at a point in history when the visual artist was a more prominent feature of British cultural life than ever before. As one critic wryly put it in 1871, Britons were living in the 'Golden Age of Art', though 'not so much from the excellence of the Art-works produced, as from the unprecedented prices which modern artists obtain for their productions'.[3] In the 1850s and 1860s a combination of rapidly accelerating middle-class prosperity, access to a mass market for art via exhibitions

and print reproductions, and the possibility of reliable financial rewards from magazine illustration had conspired to create opportunities for material security and even wealth. Most famously, William Powell Frith (1819-1909) had exhibited a series of enormously popular set-piece representations of contemporary life. His *Derby Day* (fig.120) had earned him £3,750 in total – from a combination of the original commission, selling the rights to engrave the painting, and the permission to exhibit it after the initial showing at the annual Royal Academy show in 1858. Famously, police officers had been called in to protect the picture from the crowds there.

Frith's success was not isolated, nor was it entirely new. The exhibition of John Martin's *Belshazzar's Feast* (private collection) at the British Institution in 1821 had drawn huge crowds, necessitating the introduction of a barrier to guard the picture from the pressing body of the public. David Wilkie had scored a series of famous successes; the response to a painting he showed at the Royal Academy exhibition of 1822, *Chelsea Pensioners Receiving the London Gazette Extraordinary of Thursday June 22d, 1815, Announcing the Battle of Waterloo!!!* (Apsley House, London) had required the intervention of the police and a safety rope at the Royal Academy for the first time. Such events were the most dramatic testament to the way that visual art had become a public spectacle, even to the extent, as some commentators feared, that its highest principles and values were being compromised.

The first specially organized mixed shows of contemporary art had been those put on in London by the Society of Artists from as recently as 1760, by the two artists' societies that emerged from a split in this group from 1761, and those set up by the more powerful Royal Academy from 1769 (see also Ogée, pp.152–73).[4] Elsewhere, there had been exhibitions in Glasgow in 1761, and in Dublin, where a Society of Artists was set up in 1765 and continued to exhibit through to 1780 (and again after 1800). Liverpool had its own attempts to set up a kind of academy, with shows including the work of such prominent figures as Joshua Reynolds and Henry Fuseli put on there in 1774, 1784 and 1787. In London a multitude of commercial gallery ventures and one-person exhibitions achieved varying levels of success. The galleries of narrative paintings organized in London in the 1790s by the publishers and entrepreneurs John Boydell, Thomas Macklin and Robert Bowyer had relatively short lives but considerable

cultural impact, bringing together the most acclaimed artists of the day in the production of ambitious representations of scenes from literary favourites. One-man shows ranged from the disastrous, with the unfortunate presentation by George Carter (1737-94) of his subject paintings in 1785, to the pioneering, such as John Singleton Copley's display of his single canvases of *The Death of Major Peirson, 6 January 1781* 1783 and *The Collapse of the Earl of Chatham in the House of Lords, 7 July 1778* 1779-80 (both Tate, London) and Thomas Gainsborough's annual displays at his home in Pall Mall, timed to coincide with and thus rival the Academy shows.

Exhibiting societies proliferated in the early nineteenth century, as artists, entrepreneurs and connoisseurs jostled to establish their authority over a burgeoning cultural marketplace. A short-lived body named (tellingly, given the rapid development of nationalist ideals in the arts at the time) the British School held exhibitions in 1802-4. An engraver's group was founded in 1802, and the Society of Painters in Water Colours was set up in 1804, while a rival group dedicated to promoting the interests of the practitioners of that medium existed in 1808-12, and a more enduring New Society of Painters in Water Colours was established in 1831. The British Institution was created in 1805 by a group of connoisseurs and collectors, intending to promote contemporary history painting and knowledge of the Old Masters. Outside London exhibitions were being organized across Britain, by the Norwich Society of Artists from 1803, in Edinburgh and Bath in 1808, in Leeds in 1809, in Liverpool by a society formed of local connoisseurs and collectors from 1810, in Manchester from 1823, by the Royal Scottish Society of Arts and the Scottish Academy in Edinburgh in 1827, and by a West of Scotland Academy in Glasgow in 1841. Besides this vast array of exhibition spaces, there was the proliferation of printed reproductions, in steel-engraving, wood-engraving, lithography and subsequently photomechanical methods. Illustrated magazines and specialized art periodicals, including the *Art Journal* founded in 1849, made reproductions of artworks part of the staple of news and current affairs available to the literate public. The Art Unions, notably London's (founded in 1837) offered prints and the chance to win original artworks by major British painters in return for relatively modest annual membership fees.

This proliferation of exhibition spaces and display opportunities meant that an ever-widening social constituency

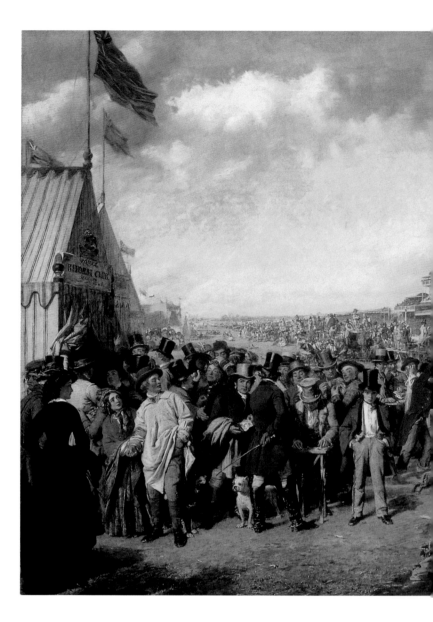

120 WILLIAM POWELL FRITH
The Derby Day 1856–8
Oil on canvas 101.6 × 223.5 (40 × 88)
Tate. Bequeathed by Jacob Bell 1859

could claim a stake in British culture, not through acts of direct patronage, so much as by buying tickets for shows, reading the newspapers and magazines, taking part, in however small a way, in the social rituals that surrounded the presentation of art. Correspondingly, the artists' groups and exhibition organizations provided a focus for the occupational life of painters and sculptors, creating titles and status, public exposure and a sense of identity. These latter developments have often been seen as defined by a process of 'professionalization', parallel to the development of professional life as a whole from the late seventeenth to the nineteenth century, wherein specialized occupational groups establish their power within society and their independence from direct state control.

But the term 'professionalization' may not be wholly adequate as a means of accounting for the development of the British artist. As present-day social scientists have stressed, and as Davenant indicates in the comments given above, the 'profession' of artist as it has emerged in modern times defies the conventional definition almost point-by-point.[5] Recent accounts of professionalization have stressed that there may be no single measure of professionalism, but a complex variety of elements that combine and take priority in different ways, at different times and in different circumstances, as distinct groups try, competitively, to assert a monopoly over specific sectors of the market and to establish the mechanisms for translating their skills and knowledge into capital. But even this might be to ascribe too great a degree of economic rationality and order to the processes by which artistic identity is established. Considered as a reasoned effort towards establishing personal interests, the material suffering and self-defeating or even self-destructive behaviour that appears as a recurring feature of artists' lives in the modern era might only be explained in terms of failure or misfortune, rather than, as the evidence should suggest, a structural feature of the artistic occupation itself. Although some artists certainly did claim a professional identity of the most conventional sort and though the efforts of the various artists' groupings of the eighteenth and nineteenth centuries may have emulated activities in other occupational areas, the profession of artist remained precarious and ill-defined not simply because these efforts failed, but rather because the artist was by definition characterized by a degree of irregularity and uncertainty, what sociologists might call *anomie*, or 'normlessness'.[6]

In this chapter I want to provide in outline an account

of the historical genesis of the 'normlessness' of artistic identity in Britain, from the late sixteenth century through to the Victorian era. This should establish the terms on which we can apprehend the economic reality and class-bound character of the British artist, and the archetypal 'modern' status of this figure. The suggestion is that what has been described as the 'professionalization' of the artist might be, to a degree, euphemistic: the British artist was fostered within, and exemplified, the particular formations of bourgeois culture as these took shape in the context of the first great capitalist economy.

Gentlemen and Artists

In the broadest and most crudely reductive terms, we can characterize the population of art producers in the sixteenth and earlier seventeenth centuries as occupying at

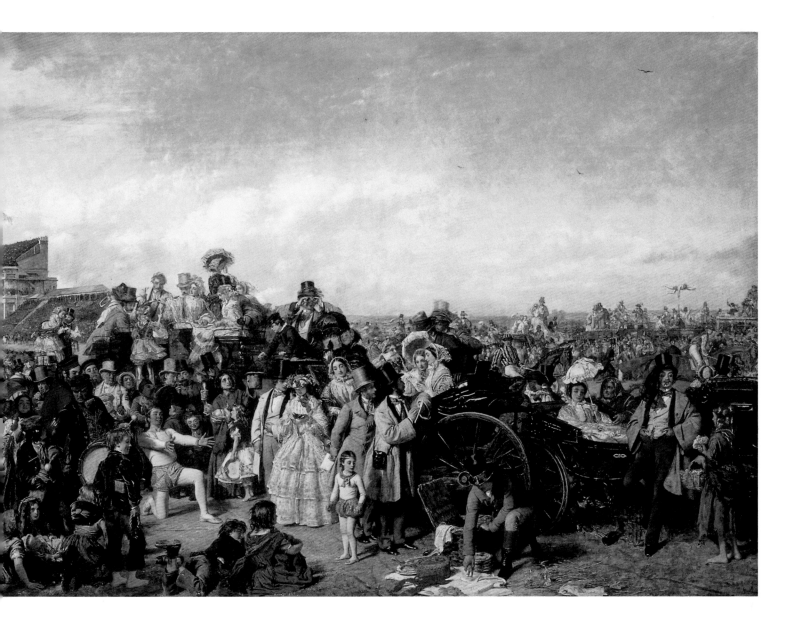

least three adjacent, interconnected and sometimes over-lapping realms, which fostered variant, and not necessarily complementary, ideas about artistic identity. Firstly, there was the domain of the court where, from the middle of the sixteenth century and particularly during the reign of Charles I (1625–49), major foreign talents found employment and prestige (see Alexander, p.78). Here the idea, derived from Italian humanist thought, of the artist's intrinsic, and even sacred, social dignity had a hold, albeit in circumstances of the most precious (and, history tells us, precarious) nature. Alongside this, and least clearly apprehended by art history, there is the world of the artisan or the generalist painter, whose identity and status shifted in the period under consideration here in ways that are only beginning to be properly explored. Finally, there was the world of what was defined in the early seventeenth century as the 'virtuoso', the person of genteel birth (although not, necessarily, of great wealth) who practised

the visual arts without compromising their status, although such a 'mechanic' (that is, manual and money-making) activity threatened to be socially demeaning for a class whose rank was predicated on their freedom from material want and practical interests.

The world of the court artist is the most readily defined and described of these realms, for there is a documented succession of painters who were employed at the English and Scottish courts in the late sixteenth and early seventeenth centuries.[7] The official court painters to Elizabeth I were George Gower (1540–96), who was charged with managing the dissemination of her portraits, and the miniaturist Nicholas Hilliard; a number of foreign artists are also recorded as working at court, mainly of Netherlandish extraction and based in England only for periods. Reflecting the political strife of the 1580s and 1590s, Scotland had a much smaller and more precarious court culture, and with the accession of James I to the

throne of England as well as that of Scotland in 1603, a short-lived one. The Flemish painter Arnold Bronckorst (fl.1565/6–83) appears to have been virtually trapped into service as court painter in Edinburgh, having gone to Scotland as an agent for Hilliard. He was succeeded by another Netherlandish artist, Adrian Vanson (fl.1561–1602), who was admitted as a 'burgess' of Edinburgh on the understanding that 'he tak and Instruct prenteisses', which suggests, significantly, that there was an understanding that imported talent could be used as the foundation of a local school. From the 1590s Netherlandish painters brought to Britain a new, more fluent form of oil painting, now on canvas rather than panel and thus of a grandeur, grace and scale that was previously unknown. At the court of James I in England Marcus Gheeraerts the Younger and John de Critz (c.1551/2–1642) were much employed. These were succeeded by a new wave of talent from the Netherlands at the end of the 1610s, including Paul van Somer (c.1576–1622) and Daniel Mytens (c.1590–1647), who was appointed 'picture-drawer' to Charles I on his accession in 1625. The court of Charles I provided, of course, the most propitious circumstances for artists of international standing, including the painter of biblical and allegorical scenes, Orazio Gentileschi, from 1626 until his death in 1639, Peter Paul Rubens in 1629–30 and Anthony Van Dyck in 1632–40. Van Dyck's drawn portrait of Gentileschi (fig.121) was, significantly, meant as one of a series of likenesses of courtiers, diplomats and scholars, which were subsequently engraved; the artist belonged in their company and could, by turns, serve himself as a courtier, diplomat and adviser.

Naturally, these visiting artists maintained studios, with assistants and pupils, and indeed members of their families; Gentileschi was accompanied by his sons and was joined for a period by his painter daughter Artemisia (1593–1652/3). But this clearly did not amount to a stable and reliable means of art training; the evidence is that any artist seeking to emulate them had to look outside the British Isles for their professional education. Cornelius Johnson (1593–1661) was the son of a Flemish painter and, though he was born in England, appears to have been sent to the Continent for his training. The same is true of Adam de Colone (fl.1622–8), who was almost certainly the son of Adrian Vanson but similarly went abroad. Further into the seventeenth century there are certainly important exceptions, notably William Dobson, who served what was effectively the court in exile

in Oxford in the early years of the civil wars, having studied in England under Francis Cleyn (1582–1658).

The courts of Scotland and England employed a limited number of artists over the late sixteenth and early seventeenth centuries, including only a handful of native-born painters. Yet Mary Edmond's documentary work has shown the extent of the community of artists in London at this time, with hundreds of painters congregating on the fringes of the City and, with a pronounced westward drift in the early seventeenth century, around Covent Garden (the heart of the metropolitan art community for the coming century).[8] These were sustained not, or not only, by the decorations and portrait commissions of the court but by the patronage of civic bodies and private individuals. At least in principle, their activities were meant to be regulated by the Painter-Stainers' company, the guild for painters active in the fifteenth century and given its charter by Elizabeth in 1581. The scope of the guild was set by the most literally material definition of 'painter', as someone who works with paint, whether to create ornamentation,

122 ANON.
Portrait of Thomas ap Ieuan ap
David of Arddynwent c.1600
Oil on panel
67.5 × 54.3 (26½ × 21⅝)
National Museum of Wales, Cardiff

plainly decorate or represent images. As such, the boundaries of its governance were constantly under question, as the activities covered by this guild overlapped, or were seen to overlap, with the work of plasterers (who might paint in imitation of marble) and specialized herald-painters. The guild representing this last group challenged the authority of the Painter-Stainers repeatedly and in 1685 offered a thoroughly demeaning definition of their rivals' world: 'The term steinors', they claimed, applied only to 'a race of mechanical artificers so very low that, like other day labourers, their hire and daily wages were settled by Act of Parliament.'[9] However, as Susan Foister has pointed out, in the sixteenth and early seventeenth century at least, the company also included painters of easel pictures.[10] The court painter Gower was a Painter-Stainer as well as a painter in oil. He managed the decorative works required by the court, but also produced a significant self-portrait (private collection), which suggests a degree of self-consciousness about his status as an artist.

The old guild was not able to control the production of art in an increasingly diffuse and vigorous cultural marketplace, nor was it easily able to accommodate new ideas about the status of the artist derived from Continental humanist thought and given institutional expression in the idea of an 'academy'. Importantly, a petition to use a part of the guild's hall for 'drawing to the life' was rejected: 'There should be no meeting of the company or appertaining to the Guildhall whereby to keep an Academy in a part thereof for drawing to the life.'[11] The rarefied ideals associated with the art academy, which stressed intellectual achievement over manual expertise and the classical tradition of figurative art over market demands, were hard to reconcile with the practical emphases of the guild system. In a variety of ways, this academic conception of the artist as someone who pursues original 'design', and who is defined by their invention rather than their pure technical skill, was to become dominant in the coming decades.[12]

Yet we may suspect that the artisan artist was a more vital, and more enduring, figure than has generally been allowed. Certainly, the case in Scotland seems to be that the worlds of vernacular decorative painting and easel art were not clearly separated at this early date. Taken as the first notable native-born painter of easel paintings (as opposed to decorative or architectural works), George Jamesone (1589/90–1644) was the son of a master mason (the masons' guild in Scotland included painters as well

as stonemasons and sculptors), trained under a decorative painter and maintained close links with the artisan painters, working himself in providing decorations and making historical portraits. As Peter Lord has detailed, in the relative geographical isolation of Wales herald-painters of the most traditional sort could turn their hand to the creation of oil paintings.[13] Contemporaneous with the productions of Van Dyck or Mytens at court, such works exhibited an enduring aesthetic little influenced by Continental ideals (fig.122). Victor Morgan has speculated that, among the immigrant and naturalized Dutch community of Norwich in the late sixteenth and early seventeenth centuries, the urban merchant class patronized a specifically Dutch, and backward-looking, school of artists, who involved themselves with decorative work and civic portraiture.[14] On the other hand, a number of artists prominent in the quite transformed art-world of later eighteenth-century London maintained links with the Painter-Stainers. Even Reynolds, President of the Royal Academy, attended a guild dinner at one point. The practical and ritual functions of the company at this late date have not yet been fully assessed and may be greater than has traditionally been assumed.

The privileged court artist and the artisan painter offer extremes of artistic identity worked out, in part, in antagonistic opposition to one another. On the one hand, there is the notion of the uniquely gifted, creative individual valued for his extreme invention and social grace; on the other,

123 NICHOLAS HILLIARD
Self-Portrait 1577
Watercolour on vellum, laid on card
diameter 5.1 (2)
Victoria and Albert Museum, London

the craftsman who worked to order, for a wage, and whose skills could be expected to be biologically predictable (a major route into any guild was by virtue of being a son of an existing member). But the opposition between these parties was by no means as clear as this stark account would suggest. Moreover, there was a further and important model of artistic identity that reconciled social gentility and artistic expertise, to a degree, that of the gentleman-artist or, to use the term that gained currency in the mid-seventeenth century, the 'virtuoso'.

The genesis of this figure can be discovered in the writings and art of Nicholas Hilliard. His painted self-portrait is unequivocally the image of a gentleman, evident from his finery, refinement and the arch certainty of his glance (fig.123). 'None should meddle with limning but gentleman alone', he wrote in his *Treatise Concerning the Arte of Limning*, written around 1598 or 1599, which has been described as both 'The first true artist's handbook in England' and 'the first portrait of an artist – by an artist – written in English'.[15] Drawing on Italian Renaissance notions of courtly behaviour and intellectual value, Hilliard defined the artist as possessing innate social quality on the basis of his passion and creativity. The literal cleanliness of 'limning' (watercolour painting, including, but not necessarily limited to, miniatures) and its private, intimate character became singularly important in this context (see Sloan, pp.214–15). Dirty, time-consuming and laborious,

oil painting could not easily be reconciled to genteel identity as it was conceived at this early date. So, perversely, the British artist who deserved recognition and social status was, by definition, not a dedicated professional and did not work in media that had a meaningful public life. When Henry Peacham, the gentleman's tutor who articulated the first extended body of art theory in English, addressed oil painting, he made explicit the double standard that was at work: 'Painting in Oyle is done I confesse with greater iudgement, and is generally of more esteeme than working in water colours; but then it is more Mechanique and will robbe you of over much time from your more excellent studies, it being sometime a fortnight or a moneth ere you can finish an ordinary peece.'[16]

Hilliard had been perhaps the first to imagine that the British artist could pursue art passionately, as a vocation, and thereby define a genteel identity in a realm aside from the arena of public affairs that had defined the court artist. It can, though, be hard to draw a line between amateurs and professionals at this early date. There were artists of genteel birth who obtained extended professional training in workshops at home and abroad, sold their works and published prints for profit, who we might still class as 'amateur'.[17] The rhetoric of gentility and disinterest that surrounded art dealing and practice in the realm of the elite could obscure the economic realities that were involved.

The contradictions inherent in this structuring of the relations between gentility, class and specialist practice are made apparent in the early history of a particular print-making method that owes its existence to the rarefied realm of elite culture: mezzotint. The perfection of this technique was conventionally attributed to Prince Rupert (1619–82), the third son of Frederick of Bohemia and nephew of Charles I. Strictly speaking, he only refined the method, collaborating with Wallerent Vaillant (1623–77) as an assistant, having been shown it by a German soldier who had invented it, Ludwig von Siegen (1609–?80), while he was in exile in the Netherlands in 1654. Rupert himself demonstrated the technique to members of the Royal Society in 1661 and created a mezzotint print for John Evelyn's book on the history of printmaking, *Sculptura*, in 1662. Although Evelyn mentioned the method, he deliberately avoided describing it in any detail, fearing that it would 'be prostituted'. Workable knowledge about the technique was restricted to the elite circles around these men, and deliberately kept from the eyes and ears of professional

124 ROBERT ROBINSON
*Banquet Piece with Covered Bowl,
Lobster and Game* 17th century
Mezzotint 22.9 × 19.1 (9 × 7.5)
Yale Center for British Art, New Haven
Paul Mellon Collection

printmakers. Information about the technique did slip out, apparently only through conspiracy and blackmail, and by these routes the method was communicated to artists working on the Continent. Perversely, it was only with the arrival of large waves of immigrant artists from France and the Netherlands in the 1670s that the technique became commercially established in England.

As the civil service and the great professions (doctors, lawyers and clergymen) emerged as a powerful sector of society in the late seventeenth century and as the wealthiest Whig landowners extended agrarian enterprise – as, in other words, a capitalist economy emerged in its early maturity – the idea of the British artist developed in ways that reconciled notions of social dignity and materialism. This was the case even though there was no great court or church to sustain this possibility and even though there were no great princes whom artists could serve, or a state-sponsored academy that could consecrate them, or a heritage of great studios that could nurture their talents. Instead, the artist could now be imagined as serving himself and contributing economically and culturally to the progress of the nation, conceived as a sovereign people with (in principle, and only overlooking the real barriers of class and gender) universal membership. The national interest provided a new rationale – we might say alibi – for the self-promotion of that special class of creative entrepreneurs known as artists.

A New World of Opportunity?

Yearning for a lost golden age of courtly patronage, the Tory writer William Aglionby lamented in 1685 that 'of all the Civilized Nations of Europe, we are the only one that wants Curiosity for Artists' and that Britons had 'a Notion of Painters little nobler than Joyners or Carpenters'.[18] But things were definitely changing, if not in ways Aglionby and his ilk would have approved of. The developing market economy meant, among other things, that the generalist artisan painter who worked for a wage had to give way to specialists who produced highly differentiated products on commission or speculatively, and that the possibility of sustaining a career outside the metropolis declined in favour of specialized forms of training in urban centres, primarily in Edinburgh or London. Here there were

portrait painters, serving a swelling body of middle-class patrons; landscape painters, marine artists and painters of still lifes, who painted on commission or provided products for the stock of 'shops'; draughtsmen who made designs for book illustrations; engravers and print publishers; and the busy workshops of sculptors and statuaries making architectural decorations, monuments and memorials, portrait busts and classical figures for gardens. A distinct and lively native art economy was emerging at this point. It has been reckoned that by the 1690s perhaps half the pictures that passed through London's sales were produced by artists based in London.[19] The expanding market for prints, especially mezzotints, established Peter Lely and Godfrey Kneller as the purveyors of images that could have a life far beyond the closed circuits of court. At the same time mezzotint made pictorial art available to a large middle rank of society, in the form of still lifes, decorative prints and bawdy prints, such as those produced, notably, by the City-based artisan painter Robert Robinson (1651–1706) (fig.124).[20]

It was in the context of this burgeoning market that the mezzotint engraver John Smith (1652–1743) achieved particular acclaim. He can be identified as the first British printmaker to achieve an international reputation: 'As his fame was universally known to all ingenious persons of his time in England, so his work was of no less esteem abroad in France, Holland, Flanders, Germany & Italy.'[21] Smith appears to have been among the first printmakers to set

125 GODFREY KNELLER
John Smith the Engraver 1696
Oil on canvas 75.8 × 63 (29⅞ × 24¾)
Tate. Presented by William Smith 1856

prominent artists, notably the court portraitist John Closterman and the wood carver Grinling Gibbons (1648–1721), as well as genteel antiquarians, connoisseurs and collectors. The Society had little formal purpose beyond conviviality, but this was in itself significant. The idea of the virtuoso served an important role in raising artistic status during the period, defining the terms on which men of money and property and practising artists could meet socially as ostensible equals in a changing society where the personal qualities of 'politeness' and 'refinement' conferred status, rather than the old markers of land-ownership or aristocratic title.[22] More tangibly, the group was instrumental in promoting the publication of John Dryden's translation (1695) of Charles Dufresnoy's *De Arte Graphica* ('The Art of Painting'), a poetic treatise on academic art principles that remained a standard source for the next century. They were also involved in agitation for a royally sanctioned academy for art in 1698, although this came to nothing. Nonetheless, their activities are telling in revealing how the regulation and institutionaliza-tion of art was emerging, by this date, as a key means of laying claim to social status and cultural authority among a newly constituted class of artists, collectors and art dealers unified under the rubric of the virtuosi. In the socially heterogeneous world of eighteenth-century polite culture, the visual arts served as an important common ground where men of different ranks could meet and have their sense of social importance confirmed.

The first sustained academy dedicated to the cultivation of practising artists was that held in Great Queen Street, set up in 1711 and directed first by Godfrey Kneller and then by James Thornhill.[23] Here young artists and established professionals could have access to life-drawing classes on a regular basis. A rival and ultimately more enduring academy was set up in St Martin's Lane by the French draughtsman Louis Chéron and John Vanderbank; this was subsequently re-established by William Hogarth after Vanderbank's death and became a central focus for London's art community, promoting a naturalistic treat-ment of the human body and a robust sense of a national cultural tradition (themes apparent in Hogarth's famous self-portrait, fig.126). Rather than teaching institutions in any formal, hierarchical sense, the London academies of the earlier eighteenth century were spaces of collective study where a community of practising artists and their students and assistants could gather voluntarily to develop

himself up as a publisher, thus allowing him control the means of production and profit on a long-term basis from his labours. Smith drew particular advantage from his partnership with Kneller, enjoying a virtual monopoly over the production of prints of his work during the painter's lifetime. This material success was matched by a distinc-tive self-awareness of the printmaker's status as an artist. Smith's unusual practice of collecting and ordering his own productions in mezzotint into volumes was an assertion of artistic identity – constituting an *œuvre* with him as the author, even though he was reproducing the images of others. Kneller's portrait of Smith (fig.125), which Smith eventually turned into a characteristically accomplished mezzotint (1716), is a forthright image of professional pride and creative independence.

The earlier eighteenth century saw the organization of an 'art world' that was populated by such independently minded urban professionals, and existed above and beyond the realm of the artist's studio or workshop, and aside from either the court or the guilds. According to tradition, Van Dyck had gathered artists in the winter and entertained them on St Luke's Day (18 October). The court painter to Charles II, Peter Lely, maintained the tradition in the later seventeenth century and apparently supervised drawings from the living model in around 1673. Significantly, the earliest regular artistic club, the Society of the Virtuosi of St Luke, claimed the social gatherings around Van Dyck and Lely as direct precedents. The Virtuosi, who met regularly in various London taverns after 1689, included several

126 WILLIAM HOGARTH
The Painter and his Pug 1745
Oil on canvas 90 × 69.9 (35⅜ × 27½)
Tate. Purchased 1824

their skills and to socialize (see also Ogée, pp.152–73). These drawing schools were part of a growing metropolitan art community that encompassed painters, sculptors, designers and architects and advanced considerably in its scale and ambition towards mid-century. Though not to be identified with any of the actual spaces of study, Joseph Wright of Derby's image of *An Academy by Lamplight* (fig.127), evokes the ethos behind these informal academies. Here, delicately featured young men in historically suggestive costumes (recalling the seventeenth century) dispose themselves elegantly around the iconic objects of their attention, meeting as equals in a cloistered but democratic environment.

The dominance of French imports over the market in luxury goods became the subject of increasing concern in the 1750s and 1760s, and was assumed by contemporary commentators to stem to a large degree from the poor quality of British design. The demand for improved models for artisans and industry was met in part by commercial activities, with the flourishing of ornamental prints and pattern books issued by enterprising booksellers and publishers. But there were also direct interventions by the state and by public-minded groups who could claim to be furthering the interests of the nation in its powerful new formulations (see Bindman, pp.18–45). The first instance of this formalization of art training was, perhaps pointedly, in the colonial context of Dublin, where a drawing school was set up by the Dublin Society with money from the British government. In this context the academy appeared as an attempt to consolidate the cultural power of an Anglo-Irish political elite sponsored by the central British state. In Edinburgh the Board of Trustees for Fisheries, Manufacturers and Improvements in Scotland set up a drawing school in the mid-1750s that was intended to train designers for manufacture and thus serve the local economy, but that also taught art skills. Here a self-consciously enlightened middle class was laying claim to authority over the city's commercial and civic life – an effort culminating in the literal construction of a 'New Town' from 1767. In London the Society for the Encouragement of Arts, Manufactures and Commerce (or Society of Arts) was established in 1754 by the drawing master William Shipley and an alliance of aristocratic and wealthy middle-class supporters with the express purpose of promoting a wide range of cultural, technical and mercantile activities, primarily though the annual distribution of premiums

according to set classes of competition. For a relatively brief period the promotion of the fine arts was accommodated to that larger project, and the Society ran a series of art competitions. From the outset the Society offered premiums for drawings by children, with the emphasis on work connected with industrial design. But even in these early years some figurative studies were also awarded prizes. From 1759 awards were given for drawn studies and models done after the life in the St Martin's Lane academy or at the Duke of Richmond's gallery of casts, which had been opened for the use of students. From 1760 to around 1770 yet larger prizes were bestowed for bas-reliefs in various media and large-scale paintings of historical subjects and marines. Shipley and his colleagues may have thought that their promotional activities would influence industrial design, but they may have been more successful simply in firing the imaginations of a generation of potential artists. Among the beneficiaries of these prize schemes were such notable figures as the painters Richard Cosway (1742–1821) and John Hamilton Mortimer (1740–79), and the pioneering classical sculptors John Bacon the Elder and Thomas Banks.

Yet serious doubts emerged about the influence these competitions were having on artists. In 1766 the architect John Gwynn had complained of the Society of Arts, which 'so far as it regards the polite arts, may be very justly compared to a green house, in which every plant thrives and flourishes, but upon being transplanted into the open air becomes instantly chilled, and is destroyed by the severity of the climate'.[24] There were, after all, only a few prizes, and there were no guarantees that works created for competition would ever be sold. The competition pieces were 'orphan' productions, created not to the specification of any individual patron or for any given venue or location, or even for the open market, but for the purely artificial arena of the competitions. The grand history paintings remained mostly unsold and neglected; the competitions in sculpture led to the production of curiously hybrid pieces – relief sculptures on classical themes that were created in the durable outdoor materials of Portland stone or Purbeck marble but had no certain destination other than to be shown indoors for a short period, and to be judged by men who had no practical investment in these objects or their producers.

The British artist appears, in the context of the Society's competitions, as a producer of relatively autonomous commodities, floated in an economy of opinions and critical

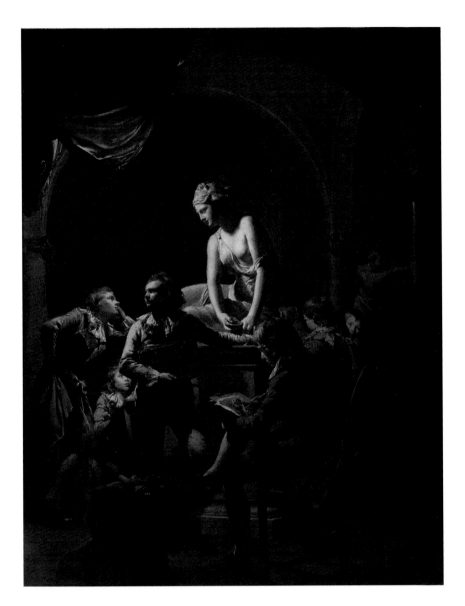

127 JOSEPH WRIGHT OF DERBY
An Academy by Lamplight c.1768–9
Oil on canvas 127 × 101 (50 × 39¾)
Yale Center for British Art, New Haven
Paul Mellon Collection

judgements with a vague notion that this served the national interest, but without certain rewards for the painters and sculptors involved. Consequently, the Society's competitions might be said to serve the interests of art consumers rather better than the producers, despite the immediate financial rewards that the competitions might provide for a lucky few of the latter. William Hogarth, who was a member of the Society of Arts from 1755 to 1757, certainly grew disgruntled with the organization and drifted away from it (along with many other artists initially involved in the institution). He damned it as a talking-shop, where 'people of leisure tired with public amusements found themselves in good company and amused with the formal speeches of such who still had more pleasure in showing their talents for oratory'.[25] By this point major schisms were opening up within the London art community, with divisive efforts to establish a more formal and hierarchical art academy gaining momentum. Meanwhile, the problem of making art training relevant to the practical needs of industry and decorative design remained unsolved and would become only more pressing during the nineteenth century, until it became the guiding theme of the highly political writings of John Ruskin and William Morris.

The Academy in the World of Art

It has been proposed that the period 1660 to 1730 witnessed a brief equilibrium in the realm of art, when the supply of artists was equal to a rising urban and middle-class market for their productions.[26] By the 1760s this balance between supply and demand was definitely over. The new opportunities for artistic publicity, the potential for self-education inherent in the flourishing supply of pattern-books and instruction manuals, and the direct intervention of bodies committed to 'encouragement' helped to short-circuit the long-term, personal networks of artistic training

that were emerging in the early eighteenth century in London, Dublin and Edinburgh. To be an artist now, it no longer seemed necessary to be genteel by birth, or connected to the court, or fostered by the guild system, or even trained up in a studio or workshop. Over-supply appeared to be becoming the structural norm of the art world in London, an inevitable consequence of the mystical or enchanted status of 'art' as a special category of human experience. Hogarth noted: 'There is some[thing] so bewitching in these arts that in spite of poverty there will always be too many Poets and Painters.'[27]

Artists had multiplied in numbers, but without a matching increase in the opportunities for work, or a secure institutional framework or sense of career structures. The foundation of the Royal Academy in 1768–9 appeared to be some sort of a solution to these problems. For the first time there was a centralized art institution that could claim representative national status and had drawing schools, an annual exhibition and formal structures of approbation and consecration, as well as, importantly, teaching collections and a library in which its students could become educated in the classical tradition. Johann Zoffany's well-known painting of the members gathered in the life school represents a powerful corporate identity, in which the social standing of the sitters is by no means compromised by the visible presence of the equipage of study and work (fig.128). This picture helps articulate a newly discrete identity for the artist, one consecrated by the bureaucratic machinations of a royally sponsored institution and focused on the idealistic representation of the human form.

The establishment of the Academy can be interpreted as a concerted effort to establish an emphatically professional idea of the British artist, that could be contrasted both to the amateur practitioner and the passive connoisseur (both the

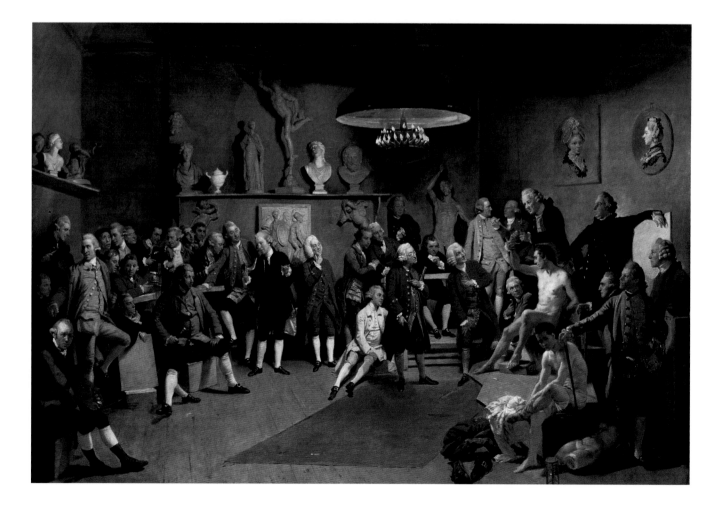

descendants of the virtuosi) and to the traditions of artisan art practice. According to the Academy, oil painting was the paradigmatic art, and other media were considered inferior or even debarred. The Academy's exhibiting policy excluded the display of 'Baubles', which meant, in this context, works in non-standard media (paper-cutting, hair pictures) regardless of the very high degree of skill involved. Watercolours and drawings were considered a lower form of artistic expression and were associated with mechanical aids, which threatened to reduce the art to a mere 'craft'.[28] Artists who worked in these materials became increasingly disgruntled about the way their works were displayed at the annual exhibitions, and their status within the institution. Most controversial was the exclusion of reproductive engravers from the membership of the Academy, the source of strong complaints from print-makers for decades. In an earlier generation reproductive printmakers like John Smith were able proudly to proclaim their achievements; under the auspices of the Academy such men were to be considered 'mere' craftsmen, lacking, it was now claimed, the essential quality of the creative artist – originality.

In this context high art was being defined even more emphatically than before as a masculine affair. While there were no explicit regulations concerning the sex of the membership or student body, women were excluded from both in practice. The very rhetoric of artistic 'genius' fostered by the Academy, with its emphasis on intellectual abstraction, conceptual difficulty and heroic effort, was saturated with gendered values. The mechanism of 'emulation' by which young artists were said to absorb the lessons of their masters through dutifully copying their works, before being inspired to rival and even surpass them and becoming in turn an example to a new generation, was imagined as constituting an exclusively masculine artistic lineage.[29] It was difficult, even impossible, to imagine a female 'genius' on these terms. Women were more readily conceived of as the passive consumers of art, rather than producers. Artistic excellence among women was generally classed as problematic, compromised or inherently inferior, as an 'accomplishment' rather than an achievement of the sort that could win the artist a place in the canon of great artists.[30] In the nineteenth century the rules around admission to the Royal Academy Schools were eventually challenged by a nascent feminist movement and eventually openly flaunted and ridiculed by Laura Herford,

who was enrolled, ambiguously, as 'L. Herford', in 1860, only to be excluded on the trumped-up claim that the Schools were full. From that date women were admitted to study, though only very irregularly at first and still on the basis that they were not allowed to draw from the living model (for the same reasons of propriety that meant that the female foundation Academicians, Mary Moser and Angelica Kauffman [see Rosenthal, pp.82–3], were represented through portraits rather than in person in Zoffany's picture).

Yet, in very real and immediate terms the Academy militated against workshop practices and against the economic self-realization of even male artists. In the first paragraphs of his first presidential lecture Reynolds proclaimed that the Academy had definitely not been founded 'upon considerations merely mercantile'.[31] While he hinted at the established argument that the fine arts would naturally lead to improvements in manufactures, he did not set out to elaborate on this point in a meaningful way. He was preoccupied, instead, with laying out a high-minded ethos for the students, insisting that art be pursued in the spirit of noble disinterest, labour and creative fortitude. The student who deviates from this slow, arduous route to excellence neglects nature and seeks short-cuts to the 'dazzling excellencies' of showy technique; 'debauched and deceived by this fallacious mastery' he may succeed materially, and be popular and fashionable, but will be forgotten by future ages.[32] Importantly, in contrast to earlier academic professors in Italy and France, Reynolds did not mount his arguments on a strictly defined hierarchy of the genres of art: it was the way that the academic artist painted that lent his art dignity and importance not, necessarily, what he painted. He knew – from his own practice as a portraitist if nothing else – that the market in Britain could not sustain painters of high-minded classical subjects in any numbers. Thus Reynolds opened up a potential loop-hole at the heart of British academic art, which allowed for the possibility of 'lowly' genres like portraiture and landscape assuming the greatest importance, as the representatives of a newly imagined national tradition.

This oddly evasive high rhetoric was matched by the lack of practical support provided for the students. Apart from travel grants, in the form of the Rome Prize, which was given intermittently from 1772, the students of the Academy were not provided with funding nor even pecuniary prizes. The awards in the annual competitions for

129 THOMAS ROWLANDSON
A Bench of Artists 1776
Pen and ink and pencil on paper
27.2 × 54.8 (10¾ × 21⅝)
Tate. Purchased as part of the
Oppé Collection with assistance
from the National Lottery through
the Heritage Lottery Fund 1996

drawing and modelling for students in the Schools were silver and gold medals; the reward for becoming an Academician was a diploma. More importantly, the students were not given the opportunity to develop the full range of practical skills that would serve them in professional practice. Students were not rewarded for producing large or finished works, but only sketches or models. The Schools themselves were notoriously badly run, leading to repeated efforts to reform and upgrade the facilities. A rota of visiting Academicians taught, with highly variable levels of commitment and expertise, in the life-drawing classes, which became the source of much complaint. The physical awkwardness of the students in Thomas Rowlandson's *A Bench of Artists* (fig.129) is meant, of course, for comic effect. But it also reflects the physical oppression associated with the strictly hierarchical ethos of the Schools, where young men could labour for years without progressing from one school to another, leading potentially to cynicism or disenchantment. As early as 1801 the then Keeper of the Schools, the sculptor Joseph Wilton (1722–1803), reportedly 'lamented the prospect of the arts ... for the young artists who had come through his hands for several years past shewed no desire for the art, they came there merely as to a drudge whereby they were to gain money, more by making it a mechanical trade than a fine art'.[33] The contrast with Wright's earlier and idealistic scene of artistic study is striking.

The Academy was credited by its supporters as having created a new beginning for the history of British art, but it also threatened to alienate young artists from existing traditions of art practice. This is most clearly so in the case of sculpture. As Matthew Craske has argued, there was already a high degree of continuity in artistic training in the field during the eighteenth century, based around a network of workshops and the apprenticeship system, and it was only retrospectively that the foundation of the Royal Academy was claimed as the originating moment for a new national school of sculpture.[34] The material influence of the Academy on sculptural practice could, in fact, be considered in quite another light. The students in sculpture at the Academy were not taught any practical skills in the cutting of stone or marble, polishing finished works or carving inscriptions as they would be in traditional workshop settings. Instead, they were offered classes in drawing and some, limited, opportunities to model using only soft materials. Yet such was the potential of the public exhibitions and artistic publicity in general that it was possible for an individual to achieve a high degree of acclaim as a sculptor within the academic system without acquiring the practical attainments that would be required to set up as an independent sculptor. Such was the case with Thomas Procter (1753–94) in the early 1790s. He was widely proclaimed as the most talented sculptor of his generation on the basis of what he had achieved in the drawing schools and the plaster models he had exhibited at the Academy, without any training in a sculptor's workshop or the capacity to realize his highly imaginative classical figures in the finished forms of marbles.[35]

The Academy's classes may have been free, but this of

course meant that the student needed an alternative income. The drawing schools were held in the evenings, on the basis that the students would be otherwise occupied in the day. We might assume that this meant that the students would be occupied in their master's studio (on the French model). Academic study might then supplement practical training in the workshop, instilling high-minded principles that could correct and reform such mechanically learned skills. However, a full-blown 'atelier system' of this sort was notably under-developed in Britain, and the decades after the foundation of the Academy saw it dwindle away even further. Recalling his days as an art student in the 1840s, William Holman Hunt (1827–1910) claimed: 'There was indeed no systematic education then to be obtained amongst the leaders of art, of whom the principal had had a hard struggle to keep their art alive during all the days of poverty which followed the Napoleonic wars.'[36] Hunt's own practical training was obtained almost accidentally, in a piecemeal fashion, at the Academy, at Dulwich Picture Gallery and in the company of like-minded friends. The 'Academic' ideal of the artist incorporated, perversely we might think, older ideals of the amateur or virtuoso, the artist who was driven not by the need or desire to make money and acquire status but by a 'pure' love of art.

Even the fierce supporters of the dignity of the Academy, Samuel and Richard Redgrave, could note in 1866 that many, if not most, British artists were effectively 'self-taught'. The very absence of the studio system in England, and the relative weakness (or lack of formal authority) of the Academy, was cast by them as peculiarly expressive of a national character:

> It is a peculiarity in Art that many men enter the profession entirely self-taught; and these men, both within and without the Academy, are largely indebted to their professional brethren for much generous assistance . . . It is thus alone that true Art should or can progress, every rising genius creating by his originality a new field for himself, not standing in the way of others, but increasing the spread of Art to the common advantage of all its professors.[37]

In its very laxness as a teaching body, the Academy could be said to have ushered in a very particularly British art world, based on free-market principles and the values of individualism (values that lay at the heart of modern bourgeois self-definition). The material suffering and psychological drama associated with the 'romantic' artist of this period has paradoxical roots in the institutionalization of art as an autonomous activity under the aegis of the Royal Academy.

Before the foundation of the Royal Academy the history painter James Barry observed of such institutions in general that parents 'send their children to be painters and statuaries . . . only because it is less expensive than making them perukiers or shoemakers'.[38] A young artist in the 1770s suggests that the same might have become true of the London academy:

> Few or none of the Artists take apprentices or journeymen. I understand it is very easy to gain admittance into the Academy. The form of admission is only this, to make a drawing from the plaister, and show it to a Gentleman who is appointed for that purpose.
>
> The students there have their Instructions *gratis,* but have no allowance or Salary, as in France . . . The number of Painters at present in London, and of young students who are following that Profession, is indeed, inconceivable.[39]

As a number of commentators noted in the 1770s and 1780s, the supply of artists was such that many were travelling abroad, to America and the West Indies, and particularly India, in search of new sources of patronage. The expanding empire offered some, inherently risky, opportunities to a few adventurous artists. But the metropolitan art economy still became engorged. It has been estimated that London's art world consisted in around 1720 of perhaps 200 individuals.[40] In 1818 it was thought that there were 1,000 artists in London.[41] By the time the profession of artist was being counted in the national census, in 1861, there were reckoned to be 4,643 in England and Wales (the figure was over 11,000 by 1881). While the great majority of these were in London, there were over 180 recorded in Manchester, around 150 each in Birmingham and Liverpool, and 50 or more in Bristol, Brighton and Bath.[42] Insofar as the Royal Academy played a part in creating a modern art world, as many historians would assert, it did so by ensuring that the supply of individuals entering into that field of competition was always far in excess of the supply of material support for them. And the Academy helped establish art as a profession only by ensuring that its equivocal status as such was given institutional form.

130 DAVID ALLAN
The Foulis Academy c.1765
Oil on canvas 33 × 40.6 (13 × 16)
Hunterian Art Gallery,
University of Glasgow

But to demonstrate that none of this was inevitable or natural, we need only to glance at the quite different situation within the short-lived art school in Glasgow, which had opened some years earlier, in 1753. This academy was established by the printer Robert Foulis (1707–76) and his brother Andrew (1712–75) (fig.130), and bankrolled by three local merchants, who ensured that it was extremely well equipped and financially independent from the state (the Foulis brothers were, notably, Jacobites).[43] Although the school was advertised as fee-paying, it appears that students actually received a wage – and they were encouraged to take on paid commissions and to sell their work. So although it lasted only until 1775 and produced few artists of great reputation – the genre painter David Allan (1744–96) being the notable exception – the Foulis Academy represented the possibility of a quite different sort of art education than that provided by London's Academy. It is difficult to judge how the course of British art would have been changed, had its example been more widely followed. As it was, the Academy became the dominant art institution, even as the nature and the quality of its teaching came under repeated attack throughout the nineteenth century, with complaints arising among the students, critics and artists, and even from the government (culminating in formal inquiries in 1835–6 and 1863). In its very incoherence and ineffectiveness, the Academy represented the confused values of the ascendant modern, capitalist culture all too completely.

Three Academic Artists: Etty, Constable and Turner

In place of the ad-hoc arrangements of an earlier era, the Royal Academy offered a point of identification for young artists, at least those willing and able to travel to London, and a constant measure of their success. It did not, however, provide any simple assurance of social status, technical training or financial support. So while the Academy made a great formal display of its meritocratic character, the experience of the Academy was influenced tremendously by the social trajectory of those who participated in the body. The social profile of its membership, and its student body, was overwhelmingly middle class, allowing that this was a class that could encompass a wide social sector from relatively humble craftsmen and shopkeepers through to professionals and the lesser gentry. The biographical information that is available to us indicates that the sons and daughters of the working class – the 'general labourers' who toiled in the fields and factories, and made up the majority of the population – were barely represented among these artists.

There are numerous, and largely self-evident, reasons why individuals from the lowest ranks of society did not turn to art, even in this period. A disposition towards art would require, we might assume, physical access to the art world, which was most readily available in the large metropolitan centres where skilled craftsmen and businessmen

and professionals congregated. The apprenticeship rates for artists were relatively, even prohibitively, high, compared to other occupations that offered more secure incomes. More speculatively, we might argue that the inherently risky nature of the artistic career as this took shape in the eighteenth century – the fact that the rewards of success were symbolic (in the form of personal independence and social status) at least as much as economic – is representative of a specifically middle-class outlook. A desire for personal autonomy, of the sort that life as an artist promised to supply in abundance, has been counted as a defining bourgeois characteristic, even as this conflicts with the desire for material success also typical of this social type.[44]

It is no accident that a chapter on 'Art Workers' appears in Samuel Smiles's classic essay on middle-class self-improvement, *Self-Help* (1859). For Smiles the painter William Etty (1786–1849) was the finest example of someone from a modest background who had pulled themselves up through the ranks purely by 'unflagging industry and indomitable perseverance'.[45] Coming from relatively lowly origins in York (though materially aided by an uncle and elder brother who were in business), Etty is cast by Smiles as an obsessive worker. The rarefied world of Academic study provided the artist with the opportunity of exercising 'the divine faculty of work' for its own sake, even if this meant that he 'was looked upon by his fellow-students as a worthy but dull, plodding person'. More critically, we could say that Etty exemplified the possibility that the artist could be a kind of perpetual student, locked into a closed world of study and approbation, to a degree that could cause outright embarrassment. His relentless dedication to the representation of the nude – the traditional exemplar of academic skill – as a subject in its own right and as an all-too-prominent feature of narrative scenes (fig.131), raised eyebrows among his contemporaries (and a certain amount of psychoanalytic speculation subsequently). In 1818 he even entered a painting competition at the Royal Academy. Understandably, fellow students were rather alarmed that someone who had already been a student for twelve years was competing with much younger and less experienced men, and the prize was withdrawn on a technicality. There was clearly a sense of embarrassment all round. Etty's friend and peer John Constable made a number of documented jibes regarding his refusal to give up life study amongst students half his age. Referring to Etty and Henry Sass – a mutual associate who ran the

leading preparatory drawing school – he quipped: 'Sass – the inexorable Sass - & the imperturbable Etty - are never absent. They sett indeed an excellent example (to the models) for regularity – I presume not to hold them up as exemplars in any other respect.'[46]

There is a good-humoured bullying in Constable's comments. But although both were sons of millers (Etty himself drew attention to the fact in his autobiography, adding for good measure that Rembrandt had a similar background),[47] there is a considerable social distance between them that may have influenced their relationship with the Academy. Etty's family appear to have been respectable, but not affluent. Constable's were extremely well off, and sought and achieved high status in their rural community, emulating the gentry class with land ownership and the purchase of a substantial mansion. His early

interest in art emerged as a young person whose class lent him leisure time and a degree of physical freedom to roam the countryside that his social inferiors did not have. He was, in many respects, an amateur, who counted many amateurs among his friends and correspondents, and his initial inspiration as an artist was the gentleman-painter Sir George Beaumont who had connections in the area. But equally pivotal at this early date was the local artisan and painter John Dunthorne (c.1770–1844), with whom Constable walked and painted. Significantly, though, while Dunthorne stayed in East Bergholt, it was only Constable who had the material and social influence to allow him to move to London, where he ultimately defined himself as, in the most emphatic terms, an artist.

Constable's early development seems in large part to be based around the absorption and rejection of the styles available to him in the examples of the amateur and professional artists with whom he associated. On the one hand there was Beaumont, on the other, Ramsay Richard Reinagle, the son of a painter trained at the Royal Academy, whose rapid, facile style Constable adopted then rejected. In the early summer of 1802 he wrote to Dunthorne in an important letter that reveals his 'deep conviction of the truth of Joshua Reynolds's observation that "there is no *easy* way of becoming a good painter"'. Defining himself in relation to academic principles – he held Reynolds in the highest regard – Constable comes up with a kind of formula for his art:

> There is little or nothing in the exhibition worth looking up to – there is room enough for a natural painture. The great vice of the present day is *bravura*, an attempt at something beyond the truth. In endeavouring to do something better than well they do what in reality is good for nothing. *Fashion* always had, & always will have its day – but *Truth* (in all things) only will last and can have just claims to posterity.[48]

Contable's pursuit of 'natural painture' steered a course between the realm of the amateur – a category of artist that was gaining a kind of degrading definition at this point – and the professional, insofar as this had acquired a distinct metropolitan identity over the last generation or two and had, through the Academy exhibitions, a hold over public taste. This manoeuvre was conducted with minimal concern for the market and was forged, at least in part, with a self-conscious regard to Reynolds's idealistic rejection of commercial impulses. The paradox was that it was because he was freed from material and social constraints that he was at liberty to experiment and define himself as a professional in this way.

Contable's pursuit of 'natural painture' defines a particular relationship with art, based around sincerity, truthfulness and privacy in the field of pictorial art – landscape painting – that was seen contemporaneously as the most vulnerable to the corrupting influences of populism and commercial imperatives (fig.132). Constable's imagery of the native English landscape, even his expressive painterly technique, seemed rooted in his direct and intimate, and thus somehow authentic, experience of the countryside, which depended, in reality, upon certain economic and social privileges. But while Constable loved the Academy, the Academy did not necessarily love him back. In reality, this relative material affluence could itself be the object of criticism. He remained until late in life a sort of 'junior' artist, tainted by amateurism, and progress through the ranks of the Academy was slow. When he was finally elected an Academician in 1829 it was suggested in the press that this was only because of his relative affluence.[49]

In their different ways Constable and Etty lived out aspects of the Academic ideal, defining themselves as significant artists in relation to the Academy and its formal structures, largely apart from marketplace realities. It offered Etty the possibility of social ascent, precarious enough to encourage in him a sort of perpetual studentship where he was always competing and seeking to prove himself. For Constable the Academy offered a sense of independent artistic identity that would free him from the taint of amateurism, a possibility tempting enough to make him dogged in his efforts towards promotion within the Academy, despite public criticism and the absence of real material motivations. More dramatic still is the case of J.M.W. Turner (fig.133). Turner was from an unequivocally lower-middle-class background. His father was a barber and wig-maker whose shop was in Maiden Lane, in London's West End, and there appears to have been no formal connection with the art world. Yet even this provided some advantage. Turner's first biographer Walter Thornbury, apparently embarrassed and even physically disgusted at the modesty of his subject's youthful surroundings, nonetheless noted: 'A family like Turner's, that produced a small tradesman, a bank-clerk, and a

132 JOHN CONSTABLE
Flatford Mill ('Scene on a Navigable River') 1816–17
Oil on canvas 101.6 × 127 (40 × 50)
Tate. Bequeathed by
Miss Isabel Constable as the gift
of Maria Louisa, Isabel and Lionel
Bicknell Constable 1888

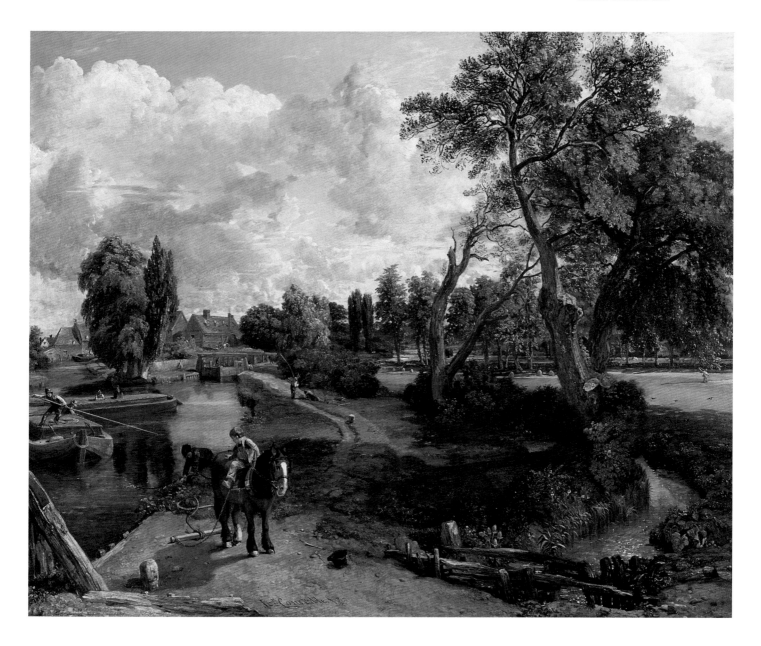

133 J.M.W. TURNER
Self-Portrait c.1799
Oil on canvas
74.3 × 58.4 (29¼ × 23)
Tate. Accepted by the nation as
part of the Turner Bequest 1856

134 J.M.W. TURNER
*Dort, or Dordrecht: The Dort
Packet-Boat from Rotterdam
Becalmed* 1817–18
Oil on canvas
157.5 × 233.7 (62 × 92)
Yale Center for British Art, New Haven
Paul Mellon Collection

Meanwhile, there was the good fortune of physical proximity to the art world:

> The older Turner, like the Florentine barber in [George Eliot's novel] *Romola*, lived in a centre of culture, and though Maiden Lane is not in appearance more beautiful or artistic than some street in Manchester or Birmingham, it is even yet, and was far more decidedly at that time, much closer to the artistic centre of England . . . The barber's shop was near Somerset House, and not very far from the studio of Sir Joshua Reynolds.

According to his Victorian biographies, Turner's transformation from a jobbing colourist of prints and topographical designs was due entirely to his association with the Academy. He was an Associate of the Academy at the age of twenty-four, a full Academician at twenty-seven, Professor of Perspective (1807–37) and a relentless supporter of the Academy's bureaucratic activities and exhibitions, even acting as President in 1845–6. Turner exhibited over 250 works at the Academy during his lifetime, encompassing almost all his major productions. Prompted by failings within and challenges to the Academy from without, Turner assumed the role of 'defender of the art', and of the institution. In 1814 he submitted a work for competition against much younger and less experienced students at the rival British Institution, as Etty was to do at the Academy in 1818, and similarly raising eyebrows among those who thought it unseemly for a grown man of reputation to be entering into competition in this way.

Turner represents the first and greatest triumph for a new system of the arts, in which the Academy provides a refuge and a relatively autonomous sphere where prestige is ostensibly granted as a reward for talent alone. Without 'gentility to maintain', as Hamerton put it, Turner was at liberty to play for the highest stakes. A work such as the *Dort, or Dordrecht* (fig.134) is loaded with ambitious allusions to the authority of past masters; not only is the painting a consummate exercise in the style of the much admired seventeenth-century Dutch painter Albert Cuyp, it represents the location of that artist's birth. In the otherwise very different cases of Turner and Etty we might argue that their adherence to the Academy served to externalize, objectify and give apparently stable form to their achievements.

solicitor, must have as least been of as good yeoman rank as Shakespeare's. It is the middles classes indeed that have produced England's greatest minds.'[50]

The issue was elaborated in Philip Gilbert Hamerton's later biography of Turner (1879). Hamerton detects in the physical and social world of the London tradesman a prompt and influence on the nature of his subject's mind and his professional trajectory:

> He was born exactly in that rank of society where artistic genius had, at that time, the best chance of opening, like a safely-sheltered flower. To perceive the full truth of this, we have nothing to do but imagine him born in any other than the humbler middle class. If his father had been a little lower in the world, the boy would have been fixed down to some kind of humble labour from his childhood, and held down afterwards by want . . . If Turner had been what is called a gentleman, he would have been exposed to influences which are as deadly to artistic genius as an unbreathable gas is to the animal organism.[51]

Yet in neither case do we really witness the sort of complete social mobility that, superficially, the Academy appeared to offer. Modern art biography tends to stress the social lowliness of painters like Turner, emphasizing the influence of 'pure' talent over their fates. Hamerton's biography gives full weight to the influence of the painter's social origins, physical location and, exceptionally, the specific privileges that even someone of his background enjoyed, when seen in a wider social context: even his limited 'schooling must have established a wide difference between him and the lad who has never been taught anything at all, such as the Suffolk ploughboy before the invention of School Boards'. He thus makes explicit the established limits of social opportunity, at least before the establishment of the School Boards and universal elementary education in 1870.

The art education system that emerged in the late eighteenth century was one implicitly dedicated to the benefit of an urban middle class who had physical access to a centralized world of art, even if (like Turner) they lacked financial resources. The shortcomings of the Academy's art teaching were perceived early on, both within the art world and beyond, leading eventually to a wholesale official enquiry to find out how it could more effectively influence Britain's design and manufactures. But it has

been observed, even of the languages used around the reform of art education in the 1830s, that the intention, radical as it was, was not the education of the industrial working classes in the visual arts but the refinement and enhancement of an artisan class, an upper class of the labouring workers already, albeit marginally, of the middle rank of society.[52] The Schools of Design established in the wake of the government's Select Committee report on the Academy in 1835–6 were aimed at the artisan class (as such a class was imagined by the middle-class proponents of the scheme), and while in the event individual Academicians had a role in defining the curriculum of these schools, there was no pretence that what they were teaching was 'art'.

Thus it is that so few artists came from working-class origins, even in the nineteenth century. John Martin came from a lowly background and was trained as an artisan; but although he achieved huge popularity with his spectacular paintings, high-minded critics of the time looked upon him with disdain. James Sharples (1825–93) was a further rare example of someone who was from the industrial working class and gained acclaim – albeit briefly – as an artist. An industrial blacksmith, his only formal training in art was in attending art classes at Bury Mechanics' Institute. He laboured for years at his monumental painting of *The Forge*

(Blackburn City Art Gallery), and many years more on the engraving of it (fig.135), using self-made tools and improvised techniques. Although this work, which he publicized himself, was acclaimed by critics and commentators, his material circumstances were not transformed. Despite being admitted into the canon of self-made artists set up by Samuel Smiles, he was not, as Tim Barringer has discussed, actually admitted as an artist in broader terms: he had what Smiles called the 'good sense' to return to life as a working man.[53] The languages of meritocracy and self-help that reshaped the idea of the artist in the nineteenth century had definite, though masked, limits, as John Ruskin tacitly acknowledged in tempering his initial enthusiasm for educating working men in art: 'My efforts are directed not at making a carpenter an artist, but to making him happier as a carpenter.'[54]

The British Artist and Modernity

Compared with the full-blooded artistic struggles in France in the mid- to late nineteenth century, the domain of culture that emerged contemporaneously in Britain may look tepid, incomplete and ineffectual. The *Fine Art Quarterly*, which, during its existence in the mid-1860s, mounted a sustained and relatively isolated critique of the Academy and public taste, drew attention to the failures of the state at a time when artists were enjoying 'more extensive and better-paid employment for the painter by private patrons than has ever been known in any period of history or any country'.[55] Against the minutely naturalistic painters supposedly favoured by these persons, the *Quarterly* championed 'outsiders' (the painter-etchers and Whistler, pre-eminently) who explored more elusive and unfinished effects. The

THE FORGE.

contest between the popular or 'middlebrow' and the aesthetic or avant-garde, the modern and the traditional, and the aristocracy of culture and the bourgeoisie was beginning to take on what we might consider its characteristic shape – insofar as this is assumed to be modelled on the situation in later nineteenth-century France. Yet faced with the strident politics of the contemporary French artists associated with the Salon des Refusés (1863), particularly Jean-François Millet (1814–75) and Gustave Courbet (1819–77), even the *Quarterly* recoiled. Britain's 'avant-garde' remained – by reputation at least – stunted, timid and relatively inert.

It is not that there had been no artistic rebels in Britain – nor was there any shortage of criticism for the Royal Academy – but these were, basically, isolated phenomena, which did not transform the overall shape of the art world. The most forthright artistic innovativeness could be combined with a deeply conservative political and social outlook, as was the case with Samuel Palmer and Constable, whose deeply reactionary views are documented. Where we tend to think of 'avant-garde' artists as making a collective break with the past, in Britain the progressively minded painters of the nineteenth century seemed more concerned to make a break with the present. Thus there is the outstanding case of William Blake, whose technical and imaginative innovations were set against the prevailing commercialization of art, and the example of Benjamin Robert Haydon, who tried to set up a workshop to train young artists quite independently from the academic system. The 'Ancients' who gathered around Samuel Palmer in Shoreham in Kent in the 1820s and 1830s were united by their admiration of Blake and in seeking in the medieval past alternative techniques and artistic identities. The portrait of John Varley by John Linnell (fig.136) offers a self-consciously archaic image of the artist, characteristic of the medievalizing strain apparent in many of the efforts towards establishing artistic brotherhood as a means of evading or contesting the dominant conditions of artistic production . The 'Clique', which included Frith, Richard Dadd (1817–86) and Augustus Leopold Egg (1816–63), offered an image of youthful rebellion, but the group did not put forward a coherent artistic outlook and was basically aligned to the Royal Academy (see Payne, p.222). The Pre-Raphaelite Brotherhood was the great exception – a group that sought actively to oppose the dominant working methods and art organization of the

day by looking back to the imagined working conditions of the past, where artists would train in studios, and proposing a laborious technique to contest the 'slosh' that was characteristic of productions prepared in haste for the marketplace. The violence with which the works of the core members of the group were received after the existence of the group became known in 1850 conforms to accepted ideas of avant-gardism. *Christ in the House of His Parents* by John Everett Millais (1829–96) (fig.137; see also Payne, pp.222–3), in particular, created the sort of stir normally associated with Paris, being perceived as a wholesale affront to good taste, morals and religion. The P.R.B. was, though, determinedly bourgeois in its personnel, without political bite, and was short-lived. It may have offered an alternative artistic creed for a short moment, but its members were largely absorbed back into the Academy. While there was a well-developed sense of an artistic Bohemia by the middle of the nineteenth century, it appeared largely ineffectual, thoroughly middle-class and ultimately playful.

The historical processes that formed a coherent avant-garde in France, one actively opposed to the authority of the academy as an institution, and academic art as a style and ethos, have been described and analyzed by the influential French sociologist Pierre Bourdieu. He presents a shift from a monopolistic structure, where centralized academies (in this case, the French Académie) consecrated artists and established a hierarchy of values in the world of art, to a situation where the right to establish hierarchy and consecrate artists becomes an interminable contest. Instead of the kind of cultural 'monotheism' enforced by the academies, there is 'a plurality of competing cults with multiple uncertain gods'.[56] This is the 'institutionalisation of *anomie*', which ensures that the definition of the artist' role and the value of art are always open to dispute.

Some recent commentators have tried to stress the rather greater involvement between the state and the Royal Academy than has previously been imagined, drawing attention to the role of Academicians in advising the government, and the professional opportunities provided by officialdom. Yet in Britain there was never the stark opposition between the Academy and 'bohemia' that there was in France. The Royal Academy did not establish a coherent, centralized system of artistic consecration. It did not care for and nurture talent in a proscriptive way, to the extent that this appeared to be a fault among those – the minority of critics – who would want a more completely authoritarian cultural system. That a similar situation did not arise in Britain has been ascribed to a peculiar failure of nerve on the part of the British bourgeoisie. While they were wealthier and more politically potent at an earlier date than elsewhere in Europe, critics and historians focused on the French model have assumed that they were unable to form a coherent culture to match. Instead, the bourgeoisie threw in their lot with the established upper class, and turned to traditionalism, conservatism and conservation

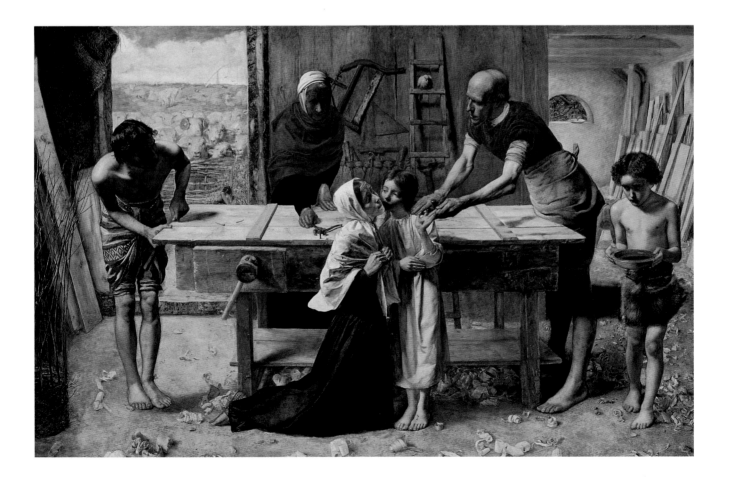

in the matter of culture.[57] The contrary point can be made: that Britain was more completely capitalist at an earlier date and that the cultural struggles apparent in nineteenth-century France were a sign of an incomplete process of *embourgeoisement* there, rather than its triumph. Meanwhile, art historians are questioning the rather one-sided view of 'modernity' traditionally presented in accounts focused on France, drawing attention to the specific modernity of British culture and the complexity of cultural forces and positions involved. In relation to the visual arts, it could, in fact, be argued that the 'institutionalisation of *anomie*' was complete in some form at a much earlier date in Britain.

It was no accident that the dominant idea of a national character for the British artist was most clearly and enduringly defined in the period of the French Revolution, in relation to the commercial ventures of Boydell and Macklin. Here, as Boydell explained, the principles of free enterprise become consolidated as a practical aesthetic: 'Every Artist, partaking of the freedom of his country, and endowed with that originality of thinking, so peculiar to its natives, has chosen his own road, to what he conceived to be excellence, unshackled by the slavish imitation and uniformity that pervade all the foreign schools.'[58] The realm of art in Britain was generally seen as one of free enterprise, outside of state or institutional control, an idea consolidated in the wake of Britain's long wars with Revolutionary and Napoleonic France and as its commercial empire expanded. The 'romantic' freedom and variety seen in the styles and techniques of early nineteenth-century British art were interpreted as testifying to distinctive national liberties. Efforts to reform and formalize the art world were repeatedly resisted, not least by the Academy itself, as intrinsically alien to the temperament of British artists. As the art critic Tom Taylor commented of London's art world in 1863, 'the dominant features are internal anarchy ... and an unexampled and triumphant intrusion into the domain of art of the trading and speculative principle'.[59] The result was a national school that was not really a school, where 'the individual qualities, bent, genius, personality of the painter have such free play'. This was 'art without law, except such as each man makes for himself'. With capitalist principles appearing so thoroughly embedded in the practices of cultural production, such strategies of outright opposition as were exhibited among the French avant-garde were perhaps neither necessary nor desirable. Even by the beginning of the nineteenth century in Britain, a free

wheeling art market, rapid social change and an official art world that stood determinedly aloof meant that the artist was being very effectively prepared as fodder for the disputes over cultural value and leadership that were to characterize bourgeois capitalism in its most complete but also most invidious national formation.

Amateur Artists

KIM SLOAN

Aristotle and other classical authors recommended drawing as a useful and appropriate activity to be taught as one of the liberal arts. Their curriculum was adopted and emulated by Renaissance authors and incorporated into their humanist ideals. Sir Thomas Elyot re-interpreted Baldassare Castiglione's *Il libro del Cortegiano* ('Book of the Courtier'; Venice 1528) for an English audience in 1531, significantly altering the code of behaviour for Italian humanist courtiers to fit the Protestant English ideal of public service. It provided for emulation the concept of the gentleman as a 'governor', useful to English society. English books of manners that followed, including Henry Peacham's *The Compleat Gentleman* (1634), fused the two traditions, encouraging the accomplishments of the courtier alongside the gentleman's pursuit of useful knowledge – making the practice of drawing both courtly *and* useful.

In the sixteenth and early seventeenth centuries both male and female 'princes' sat on the English throne, providing a model of 'governorship', emulated by their courts. Sir Humphrey Gilbert at Queen Elizabeth's court and Sir Balthazar Gerbier at King James's both outlined academies for English gentlemen that would teach them not only the princely skills of navigation and fortification, languages, natural philosophy and mathematics, but also drawing and an appreciation of the arts of painting, sculpting and architecture. Influenced by such ideals and tutored by men such as Elyot and Peacham, Queen Elizabeth I, and later Prince Henry, Elizabeth of Bohemia and her son Prince Rupert (son, daughter and grandson of James I), were all accomplished artists who both gave and received drawings and 'limnings' (paintings in watercolour) from gentlemen *and* women at their courts. There are few documented examples from the sixteenth century – the watercolours of the flora, fauna and people of 'Virginia' by John White, which were presented to an unknown patron at Elizabeth's court, are perhaps the earliest English examples (fig.138). This gentleman-adventurer, who invested his own money and family in Walter Raleigh's attempts to colonize America, was entitled to a coat of arms by birth, as was George Gower, the Queen's painter and an accomplished artist. Nicholas Hilliard and Edward Norgate were professional limners who believed none but gentlemen should meddle in this polite and gentle art (see also Myrone, p.194). Its neatness

and cleanliness made it the perfect activity for gentlemen and they shared the secrets of their art not with other professional artists but with gentlemen such as Richard Haydocke, who in 1598 translated Lomazzo's treatise on painting for other gentlemen, and Sir Nathaniel Bacon, who not only limned and invented his own recipes for pigments but also painted life-size genre scenes (fig.139) and self-portraits in oil.

Drawing and limning remained the accomplishment of courtiers and gentlemen and their wives and daughters during the seventeenth century. King Charles II kept a cabinet of limnings, including portraits, flowers and copies of larger works in oils, presented to him by women such as Elizabeth Pepys and Susanna Evelyn. Eighteenth-century examples by the daughters of the collectors Sir Hans Sloane and Sir Abraham Hume survive. But drawing had not become the preserve of women – it was added to the curriculum of Christ's Hospital on the recommendation of Samuel Pepys and Christopher Wren in the 1590s in order to better prepare boys for life as apprentices or at sea. Shortly

138 JOHN WHITE
A Wife of an Indian Werowance or Chief of Pomeiooc, and her Daughter c.1585
Watercolour and bodycolour over pencil
26.3 × 14.9 (10⅜ × 5⅞)
British Museum, London

139 NATHANIEL BACON
*Cookmaid with Still Life of Vegetables
and Fruit* c.1620-5
Oil on canvas 151 × 246.7 (59½ × 97⅛)
Tate. Purchased with assistance from
The Art Fund 1995

afterwards drawing became standard on the curricula of naval and military colleges at Portsmouth, Greenwich, Woolwich and elsewhere.

Throughout the eighteenth and nineteenth centuries, the 'polite' and 'necessary' accomplishment of drawing was available in the form of extra paid lessons from drawing masters who attended the young gentlemen at Eton, Harrow, Westminster and other public schools as well as the universities of Oxford and Cambridge. Both professional artists supplementing their income and professional drawing masters attended young gentlemen and women or entire families for private lessons during the season at Bath or in their own homes in London and in the country. The social range of people who drew now extended from the charity children of Blue Coat schools, through Dissenting and private academies, public schools, and private individuals from the rising merchant and middle classes, to landed gentry and peers, in addition to courtiers and 'princes'. George III, Queen Charlotte and most of their children could draw and paint in

some form or another with varying degrees of accomplishment; Queen Victoria was deemed a charming enough artist for her sketchbook to be published in 1979, shortly after the success of *The Country Diary of an Edwardian Lady* – a facsimile edition of the 1906 illustrated diary of Edith Holden that sold over three million copies. These last examples are perhaps representative of how art historians had come to view 'amateur artists' in the twentieth century – women filling their time and sketchbooks with pretty but not very skilled watercolours with personal relevance only. However, from the late 1970s interdisciplinary studies began to judge them not for their skill, which was never intended to rival that of professional artists, as that would imply the skill of someone who was paid for their work, but for what they revealed of the social and cultural spheres in which they participated, casting light on issues of public and private, recreation and amusement, creation and imitation, accomplishments and attributes, politeness and taste, and virtue and virtuosity.

FURTHER READING

Bermingham, A. *Learning to Draw: Studies in the Cultural History of a Polite and Useful Art*, New Haven and London 2000.
Clarke, M. *The Tempting Prospect: A Social History of English Watercolours*, London 1981.
Sloan, K. *'A Noble Art': Amateur Artists and Drawing Masters, c.1600–1800*, London 2000.

William Blake

MORTON D. PALEY

William Blake (1757–1827) spent his boyhood in art. At first he drew independently, and then for four years he attended Henry Pars's drawing school. At fourteen he was apprenticed to an engraver for the normal period of seven years. The strong sense of line that his master, James Basire, taught him became for him an aesthetic ideal, one that he later referred to as 'the hard and wiry line of rectitude and certainty'. This emphasis on line was reinforced when Blake entered the Royal Academy Schools in 1779. It was a time when what came to be called Neoclassicism was beginning to gain ascendance, notably in the work of James Barry, then Professor of Painting and much admired by Blake, and in that of his fellow student and friend John Flaxman. The Neoclassical ideal involved rigour of outline, abolition of perspective and the placing of principal figures on the same plane. Many of Blake's earlier pictorial works, such as *Lear and Cordelia in Prison* c.1779 (Tate, London), display such characteristics, as does the relief etching after an earlier design, *Joseph of Arimathea Preaching to the Inhabitants of Britain* 1793–6. However, Blake was not an artist to be bound by his own theories, and over a long career he produced an astonishing variety of works.

Blake's graphic work was often commercial, as that was his main source of income, but his most important printmaking was of an entirely different kind: the 'illuminated books', which, no matter how many parallels we may adduce, are peculiar to himself. He etched and printed these in a mode that he himself invented: relief etching, in which (contrary to intaglio etching), the 'mountains' on the copper plate are printed and the 'valleys' are left blank. By 1789 Blake had produced a masterpiece in this new method: the *Songs of Innocence* – still probably his best-known work – in which he developed his 'composite art', a form in which the text and design on each plate interrelate in complex ways. As Blake continued his illuminated printing into the 1790s, he began to develop his own mythology – political, psychological and cosmogonic in reference – in works like *America*, *Europe* and *The [First] Book of Urizen*. In 1795 he was engaged to illustrate Edward Young's poem 'Night Thoughts' and proved especially successful in fleshing out Young's abstract personifications. Another major series of works is a group of colour-printed drawings or monotypes, among which one of the best known is *Newton* (fig.140), the basis for Eduardo Paolozzi's bronze outside the British Library.

In 1809–10 Blake held his own one-man exhibition in his brother James's hosiery shop. The pictures shown there, along with the *Descriptive Catalogue* Blake wrote to accompany them, give us a very good idea of his artistic aims. Two of the featured paintings, the tempera *Spiritual Form of Pitt and Nelson* (c.1805–9; Tate, London), had 'recondite meaning, where more is meant than meets the eye'. Blake's 'heroes', as he ironically calls them, are shown guiding the monsters of war, Behemoth and Leviathan. Although this symbolism is understood today, it was baffling to his contemporaries, and Blake's exhibition failed to attract the public attention for which he had hoped. One patron who remained faithful during Blake's period of obscurity was a civil servant named Thomas Butts, to whose modest but steady patronage we owe some of Blake's finest drawings of Biblical subjects.

Blake's later years were rich in accomplishment. The unique coloured copy of the 100-plate

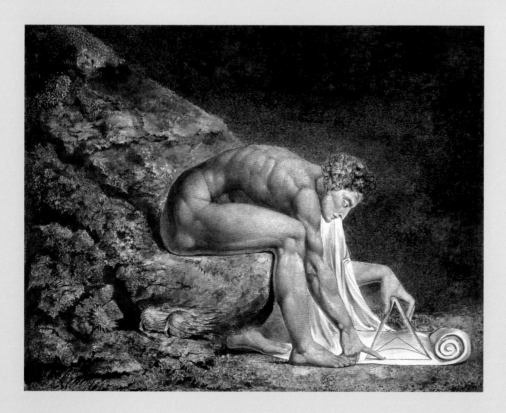

140 WILLIAM BLAKE
Newton 1795, printed c.1805
Colour print finished in ink
and watercolour on paper
46 × 60 (18⅛ × 23⅝)
Tate. Presented by
W. Graham Robertson 1939

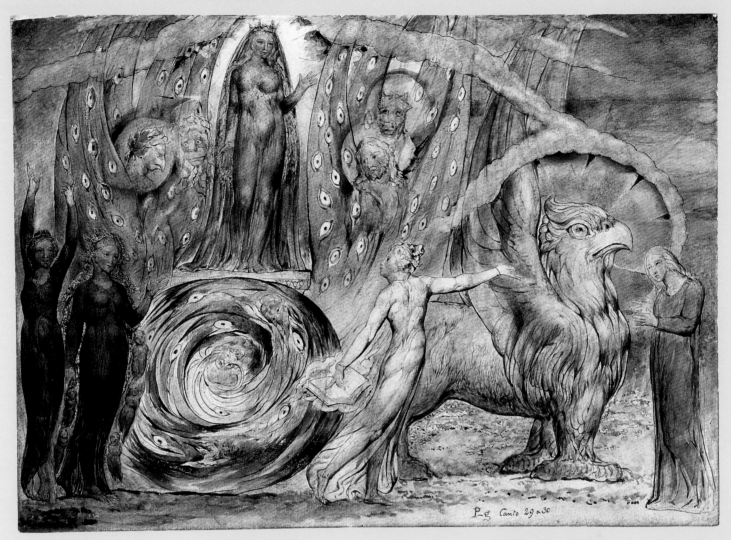

141 WILLIAM BLAKE
Beatrice Addressing Dante from the Car 1824–7
Pen and ink and watercolour on paper
37.2 × 52.7 (14⅝ × 20¾)
Tate. Purchased with the assistance of a special
grant from the National Gallery and donations
from The Art Fund, Lord Duveen and others,
and presented through the The Art Fund 1919

Jerusalem (Yale Center for British Art, New Haven) was completed by 1821. Had Blake not, shortly before this, met and become friends with John Linnell, a younger painter of landscapes and portraits, he might have spent this period making a living from copy engraving. Linnell published Blake's great *Job* engravings and sponsored Blake's 102 watercolour illustrations to Dante's *Divine Comedy*. One magnificent example of the latter is *Beatrice Addressing Dante from the Car* 1824–7 (fig.141), which exhibits Blake's colouring at its most brilliant. Blake was also fortunate at this time in being surrounded by young artists, most notably Samuel Palmer, Edward Calvert (1799–1883), and George Richmond (1809–96), who revered

and for a time imitated the pastoral aspects of his work. His influence continued after his death, first with the Pre-Raphaelites and then with twentieth-century artists like Graham Sutherland (1903–80) and Stanley Spencer (1891–1959). In contemporary British art Blake's presence may be felt in the work of artists as different as Ian McKeever (b.1946) and Douglas Gordon (b.1967). Blake's admirers see him in a variety of roles – political radical, visionary painter, master printmaker and prophetic poet – but one term unlikely to be used for him again is the one Alexander Gilchrist chose for the subtitle of his pioneering *Life of William Blake* (1863) – '*pictor ignotus*' (unknown artist).

FURTHER READING

Butlin, M. *The Paintings and Drawings of William Blake*, 2 vols., New Haven and London 1981.
Essick, R.N. *The Separate Plates of William Blake: A Catalogue*, Princeton NJ 1983.
The William Blake Archive, ed. M. Eaves, R.N. Essick and J. Viscomi: http://www.blakearchive.org/.

Watercolour Painting in the Eighteenth Century

SCOTT WILCOX

Watercolour painting as a distinct form of artistic practice evolved in the second half of the eighteenth century to become celebrated as one of the defining achievements of British art. This process of evolution involved a series of differentiations in the conception of the medium and the artistic functions it could serve: between drawing and painting, between amateur and professional, and between utilitarian and expressive or aesthetic orientations.

The eighteenth-century uses of water-soluble colours for drawing or painting had roots in medieval manuscript illumination, in the painting of portrait miniatures and copies of Old Master oil paintings in miniature, in the colouring of maps and prints, and in a range of utilitarian drawing practices – architectural, antiquarian, topographical and botanical. Manuscript illumination and miniature painting employed opaque watercolours, known as bodycolour or gouache. From the traditions of draughtsmanship came the use of washes of transparent colour. Although the terminology was far from consistent or precise, 'watercolour' frequently signified gouache, whereas the use of coloured washes, often in conjunction with pen and ink outlines, was termed 'stained' or 'tinted' drawing.

The careers of Paul Sandby and John Robert Cozens chart the changing nature and status of later eighteenth- century watercolour painting. In his early training in topographical drawing, Sandby was typical of his generation of water-colourists. He joined the Board of Ordnance in 1747, becoming the chief draughtsman of the Military Survey of Scotland, for which he produced maps and topographical drawings of the Highlands. Based in London from 1753, he established himself as a drawing master, print-maker and painter of topographical landscapes. According to Thomas Gainsborough, he was 'the only Man of Genius' painting '*real Views from Nature in this Country*' (see fig.142).

The inclusion of watercolours in the public exhibitions that became a regular feature of London's artistic life in the 1760s fuelled the creation of watercolour painting as a more publicly oriented art. Very much at the centre of the London art world, Sandby exhibited with the Society of Artists from 1760 and was a founding member of the Royal Academy in 1768. Although he embraced the new public role for watercolours, in his handling of the medium he remained wedded to the older traditions of painting in gouache and of the 'stained' drawing. His later works were frequently dismissed as old-fashioned, but he was acknowledged at his death as 'the father of modern landscape painting in water-colours'.

For John Robert Cozens, as for Sandby, topography was central to his career, but from his father Alexander Cozens he inherited a concern with the more theoretical and expressive aspects of landscape composition. His evocative and poetic approach to landscape signalled a shift away from a more pedestrian conception of topography. Unlike Sandby, the younger Cozens was little involved in the more public arena of exhibitions and artist organizations, relying instead on the patronage of a small group of connoisseurs and collectors. These included Richard Payne Knight, with whom he made his first trip to Italy in 1776–9 and William Beckford, with whom he returned to Italy in 1782–3. Cozens pioneered a more

142 PAUL SANDBY
The Norman Gate and Deputy Governor's House c.1765
Gouache on laid paper
38.4 × 54 (15⅛ × 21¼)
Yale Center for British Art, New Haven
Paul Mellon Collection

143 JOHN ROBERT COZENS
The Lake of Albano and Castle Gandolfo c.1779
Watercolour over graphite on wove paper
43.2 × 61.6 (17 × 24¼)
Yale Center for British Art, New Haven
Paul Mellon Collection

painterly use of transparent watercolour along with contemporaries such as William Pars (1742–82) and John 'Warwick' Smith (1749–1831), combining broad washes of colour with a modelling of form through the build-up of masses of individual brushstrokes (see fig.143). Aspects of both Cozens's technique and his expressive content were adopted by artists of the following generation, particularly Thomas Girtin and J.M.W. Turner.

In the 1790s Girtin and Turner, young artists moving beyond the topographical conventions in which they were trained, expanded the range of the landscape watercolour. Along with Richard Westall (1765–1836), who specialized in figural subjects from history and literature, they brought watercolour painting to a new level of

ambition and technical sophistication. It was, however, the landscapes of Girtin and Turner, rather than the historical subjects of Westall, that provided the most fertile ground for the future development of a national school of watercolourists. The association of landscape with watercolours and the ascendancy of transparent watercolours over gouache were well established by the time of the foundation of the Society of Painters in Water Colours in 1804. The inauguration of this society marked the coming of age of watercolour painting and the opening of a new chapter – the Romantic watercolour, as practised by John Varley (1778–1842), David Cox (1783–1859), Peter De Wint (1784–1849), Richard Parkes Bonington (1802–1828) and, above all, Turner.

FURTHER READING

Hardie, M. *Water-Colour Painting in Britain*, 3 vols., London 1967–8.
Smith, G. *The Emergence of the Professional Watercolourist: Contentions and Alliances in the Artistic Domain, 1760–1824*, Aldershot 2002.
Wilton, A. and A. Lyles, *The Great Age of British Watercolours, 1750–1880*, Royal Academy, London 1993.

Turner's Tours

DAVID BLAYNEY BROWN

Turner was a lifelong traveller, both in Britain and Continental Europe. The nearest parallel in the creative arts is the poet Byron, whose *Childe Harold's Pilgrimage* he read and illustrated. He shared with the poet a Romantic wanderlust that cannot be explained only by the objective needs of his art or by simple curiosity, but suggests a psychological imperative. His tendency to retreat from friends and colleagues or construct alternative identities (like the seafaring 'Admiral Booth'), along with his lack of a stable family life and his domestic squalor, may have driven his restless escapism. This gives his work a conceptual diversity and internationalism that is exceptional in the history of British art and contrasts with his main competitor John Constable, who admired 'stay at home' Dutch painters, never went abroad and preferred familiar locales.

The origins of Turner's travelling lay in the topographical tour. Much of his reputation was made by engravings after his drawings in antiquarian books and guides. This sector of the publishing industry burgeoned as the wars with Revolutionary Europe closed the Continent and concentrated interest on the domestic landscape and heritage. Turner established a routine of touring and collecting data in his sketchbooks (mainly in the Turner Bequest, Tate Britain, London) during the summer and working up the results in London in the winter. These included commissioned images, independent works for the next year's exhibitions and, from 1796, oil paintings. A major tour of the north of England in 1797 yielded a rich fund of subjects from castles, abbeys and cathedrals to the beauties of the Lake District, the favourite destination for admirers of the picturesque. His tours of North Wales (1798, 1799; see fig.144) and Scotland (1801) took him to wild, mountainous terrain that met the fashionable criteria of the sublime. This was also the object of an Alpine tour during the Peace of Amiens in 1802, which stole a march on his colleagues who ventured no further than Paris. He exploited his experience in works ranging from scenic views to complex allegories of landscape and history (fig.145).

In 1802 Turner was accompanied by Newbey Lowson, who kept accounts on behalf of the noblemen, including the Earls of Yarborough and Darlington, who had funded the trip. They intended Turner to study the collections of the Louvre; his interpretation of his brief was characteristically independent. Apart from a tour of the Val d'Aosta with his patron H.A.J. Munro of Novar in 1836, Turner usually travelled alone and

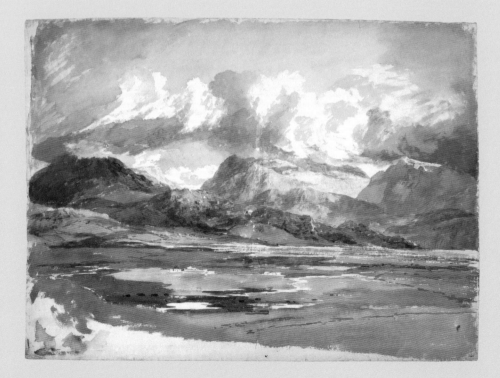

144 J.M.W. TURNER
Traeth Mawr, with Y Cnicht and Moelwyn Mawr 1799
Pencil and watercolour on paper
55.3 × 76.5 (21¾ × 30⅛)
Tate. Accepted by the nation as part of the Turner Bequest 1856

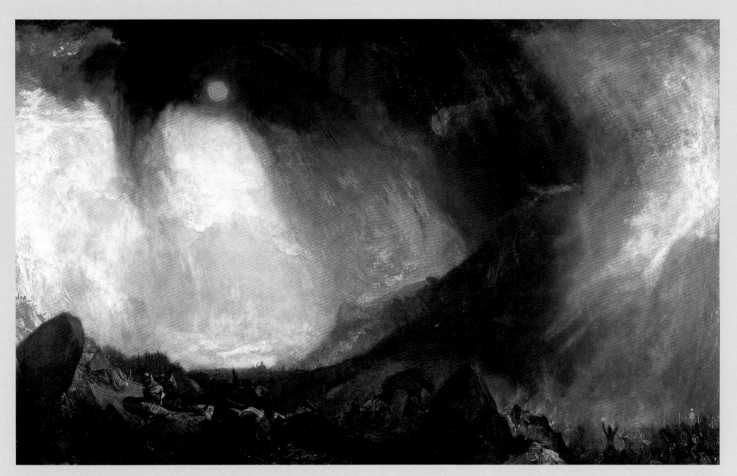

145 J.M.W. TURNER
*Snow Storm: Hannibal and his Army
Crossing the Alps* exh.1812
Oil on canvas 146 × 237.5 (57½ × 93½)
Tate. Accepted by the nation as part of
the Turner Bequest 1856

self-financed; Lowson was doubtless a useful tutor in the practicalities of 'abroad'. Resumption of war confined Turner to England but he visited Waterloo and the Rhineland in 1817, and remained an almost annual visitor to the Continent until his health failed in 1845. In Rome or Naples he trod in the footsteps of former grand tourists but his fascination for Venice was entirely of its time, matching the experience of middle-class travellers who were discovering the city's delights while empathizing with Byron's Romantic view of its decline. Turner was essentially one of them: he read the same books and his Venetian pictures were consequently among his most popular and marketable works. He also played a leading part in introducing the British to rural France and the Swiss lakes. But in much of Germany, in Austria, Denmark or Bohemia he had few contemporary rivals and fewer followers. Although he turned down Lord Elgin's proposal to go to Athens, never visited Constantinople, the Holy Land or Spain like his colleague Wilkie, nor fulfilled a

late wish to see Niagara Falls, the sum total of his travel experience was remarkable.

It bore fruit in series of published engravings that reinvented the art of topography through their rich and allusive content and comprehensive range. At home his surveys of the *Southern Coast* (1814–26), the *Rivers* (1827) and *Ports of England* (1826–8) culminated in the magisterial *Picturesque Views in England and Wales* (1827–38). His Loire and Seine views, published under the title of *Turner's Annual Tours* (1833–5), were intended as part of a wider survey of the great rivers of Europe. Such projects guided many of his itineraries. His role on an advisory committee for London's new National Gallery and Royal Academy probably led him to Munich in 1833 and Berlin in 1835 to see the new museum architecture of Leo von Klenze and Karl Friedrich Schinkel. His motivations for travel were as varied as its pictorial results, in which travel itself and transport, from ships to railways, were celebrated, too.

FURTHER READING

Butlin, M., E. Joll, and L. Herrmann (eds.), *The Oxford Companion to J.M.W. Turner*, Oxford 2001.
Hamilton, J. *Turner's Britain*, exh. cat., Birmingham Museums & Art Gallery 2003.
Wilton, A. *Turner in his Time*, revised ed., London 2006.

Artists' Groups from the Ancients to the Pre-Raphaelite Brotherhood

CHRISTIANA PAYNE

A number of informal artists' groups were set up in the first half of the nineteenth century in Britain, including the Sketching Society in the early 1800s and the Clique in the late 1830s. The most important of these groups were the Ancients and the Pre-Raphaelite Brotherhood. Both were directly influenced by the ideas of William Blake in their belief that art had declined since the High Renaissance and in their desire to seek a purer inspiration in the works of the 'grand old men' such as Albrecht Dürer (1471–1528) and Jan van Eyck (c.1395–1441). They probably also knew of the German Brotherhood of St Luke (later called the Nazarenes), set up in Rome in 1809 by Franz Pforr and Friedrich Overbeck, whose example might have encouraged the Ancients to seek seclusion from the world and the Pre-Raphaelites to style themselves a Brotherhood – a choice of name that provoked an undertone of anti-Catholic prejudice against their early work.

The Ancients gathered around Samuel Palmer, particularly during the time he lived in the village of Shoreham, Kent, in the later 1820s and early 1830s. The group included George Richmond and Edward Calvert, but not John Linnell, Palmer's mentor and later father-in-law, who was never more than an honorary member and resented his exclusion. The Ancients adopted primitive styles and media to convey their vision of a simple pastoral life derived partly from Blake's woodcut illustrations to Virgil. Palmer's *Coming from Evening Church* 1830 (fig.146), painted in his own form of tempera, expressed his faith in the village community, ironically in a year that saw the outbreak nearby of the rural incendiarism of the 'Swing' riots. The Ancients read poetry and devotional literature and were intensely religious, although Calvert was also attracted to paganism and studied erotic antique gems. The group maintained strong friendships in their later years, even when their ways of working diverged: Richmond, for example, became a successful society portrait painter.

The Pre-Raphaelite Brotherhood, founded in the 'year of revolutions', 1848, consisted of seven members: John Everett Millais, William Holman Hunt, Dante Gabriel Rossetti, Thomas Woolner (1825–92), James Collinson, William Michael Rossetti (1829–1919), and Frederick George Stephens (1828–1907). Ford Madox Brown was an important associate, who probably told them about the Nazarenes. The major accounts

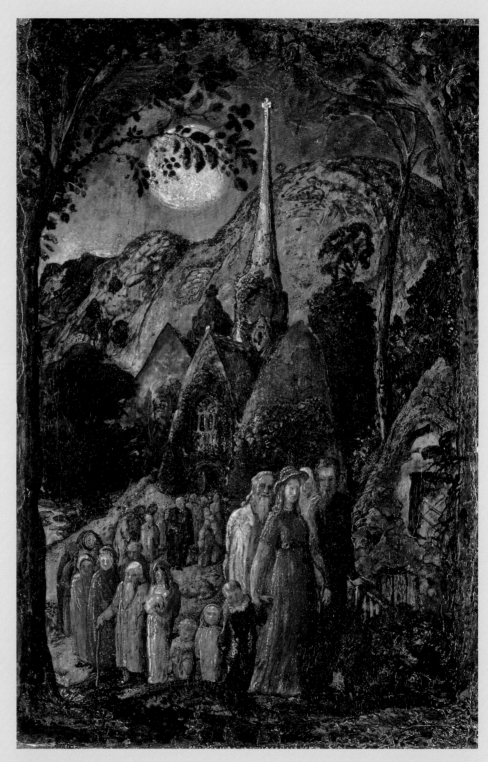

146 SAMUEL PALMER
Coming from Evening Church 1830
Mixed media on gesso on paper
30.2 × 20 (11⅞ × 7⅞)
Tate. Purchased 1922

of their beliefs date from the late nineteenth and early twentieth centuries and are influenced by hindsight, but it seems that they chose their name to convey their determination to revive the truth to nature and sincerity that they found in early Renaissance art. Millais and Hunt had met at the Royal Academy Schools, and were drawn together by their dislike of the teaching methods they encountered there. Their early works, such as Millais's *Christ in the House of his Parents* 1849–50 (see fig.137, p.212), employ meticulous detail and bright colours, avoiding academic conventions such as chiaroscuro and perspective. The group agreed, initially, to place the letters 'P.R.B.' on their paintings but not to divulge their meaning. These tactics provoked a furious critical response when the meaning of the initials was revealed in 1850, exacerbated by the group's choice of religious themes. The critic John Ruskin came to their defence in 1851 and was a strong supporter of the group thereafter. By 1853 the Brotherhood had broken up, but many other artists adopted similar methods and techniques, with a particular emphasis on painting on a white ground, directly from nature and, in the case of landscape, in the open air.

In the 1850s the Pre-Raphaelites took themes from modern life, driven by a social conscience (fig.147), but in the paintings of the later phase of the movement, dominated by William Morris and Edward Burne-Jones, medieval themes became increasingly important. Morris, however, channelled his social conscience into practical work, becoming a socialist and reviving old craft skills in an attempt to reverse the numbing effects on the worker of industrialization and mass production.

In recent years art historians have pointed out that the term 'Pre-Raphaelite' has become a lucrative category for publishers and exhibition organizers, with more and more artists drawn into the 'movement', often constructed in these settings as being dominated by paintings of beautiful women. They have also shown the important role played by many women artists in the movement, starting with Elizabeth Siddal (1834–62), who was briefly married to Dante Gabriel Rossetti. Like the Ancients, the Brotherhood was exclusively male, but their distrust of academic training worked to the advantage of women artists, who were excluded from the study of the nude in this period.

FURTHER READING

Morowitz, L. and W. Vaughan (eds.), *Artistic Brotherhoods in the Nineteenth Century*, Aldershot 2000.
Prettejohn, E. *The Pre-Raphaelites*, London 2000.
Vaughan, W., E.E. Barker and C. Harrison, *Samuel Palmer 1805–1881: Vision and Landscape*, exh. cat.,British Museum, London 2005.

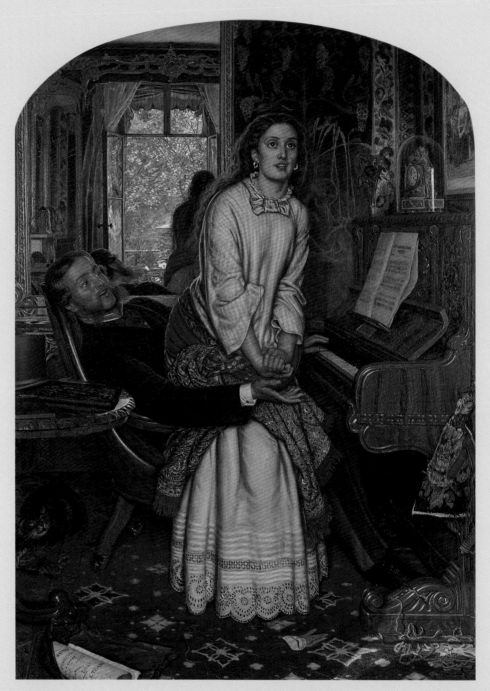

147 WILLIAM HOLMAN HUNT
The Awakening Conscience 1853
Oil on canvas
106 × 85.7 (41¾ × 33¾)
Tate. Presented by Sir Colin and Lady Anderson through the Friends of the Tate Gallery

Popular Prints

TOM GRETTON

'Popular' is a difficult word. It is as slippery as 'art' and is loaded with at least as much social, moral and political freight. If popular means simply 'the opposite of unpopular', then William Woollett's enormously successful engraving after Benjamin West's *Death of General Wolfe* 1776 is a popular print. But when art historians talk about popular *culture* they are normally referring to a huge and relatively undifferentiated mass of pictures that are not art but provide allusion, motif, model or counter-model for artists. When art historians talk about popular *prints*, however, they tend to mean a sub-set of that mass, a difficult-to-delimit set of prints produced before the industrialization of picture-printing in the nineteenth century and made by undocumented producers for nameless poor consumers. These were cheap and usually rather crude, tending to be made on typographical presses from wood-cuts and printed on the same sheets as type-set texts, rather than on the intaglio presses that produced most prints aimed at the prosperous classes. Calling them 'popular prints' invokes the idea of 'the people', a political concept in which notions about authenticity of experience and the transcending of social position mingle with those of subalternity in political relations, backwardness in cultural change and marginalization in the processes of national and transnational cultural formation.

Given the importance of the idea of 'the people' in much political discourse in Britain as elsewhere in the European and Atlantic worlds since the middle of the eighteenth century, it is not surprising that prints called popular should have been invested with special sorts of value. The idea of the popular print has solved the problem of authorship that these undocumented or anonymous prints raise. Artistic value in the modern and post-modern world has been closely tied to identifiable authorship, and 'the people' functions as author of these kinds of anonymous prints, on the basis that prints produced and consumed in culturally excluded milieus were somehow authentic expressions of real experience, aspirations and feelings. For many art lovers high art carries just those values of authenticity and expressiveness, values we assume to have been debased or occluded in capitalist and industrialized production and consumption of cultural goods. If we imagine popular prints as being made outside the vulgarizing machine of capitalist culture industries, then they can embody real values, including the chance of authorial authenticity.

Such a projection of critiques and aspirations upon 'the people' and its culture has been present in Western societies for more than two hundred years, a strong indicator that some truth is being addressed. But it may be more a truth about the downside of capitalist culture industries than about the authentic value of a motley assemblage of cheap printed pictures, made at various times, in varying circumstances and for a variety of bottom-end markets.

The assemblage is certainly very motley. In the seventeenth century British wood-cut craftsmen started to make small blocks to illustrate ballads and chapbooks; many of these blocks were used over and over again, right through to the early nineteenth century, to illustrate or adorn printed papers far removed from their original subjects and purposes. This collective stock of small blocks was added to in the next two centuries, to decorate cheap song-sheets and story-books to sell in pubs and markets. In the same period, from time to time, a religious printmaker or political propagandist would produce a larger and more elaborate picture, harder to adapt from subject to subject but worth the investment for a long or cyclical print run.

In early nineteenth-century London some printers, of whom the most famous are John Pitts (1765–1844) and James Catnach (1792–1841), combined the popular religious picture-and-text trade and the adorned song-sheet trade with another, the illustrated news-sheet trade, which dealt with all manner of fake and real stories, with a focus on crimes and (public) executions. The highly successful London-based caricature industry, an important dimension of high visual culture, soon developed a 'down-market' tail to its business. In the radical political climate of the years around the passing of the 1832 Reform Acts, *The Political Drama*, a series of wood-cut caricatures that combined radical hostility to the political status quo with a brutally simplified graphic style, was published; these prints, by C.J. Grant (fl. c.1830–c.1845; fig.148), succeed in both articulating a 'popular' politics and developing a 'popular' aesthetic that built on the works produced by Catnach and Pitts.

By the end of Grant's career the market for cheap pictures in Britain was utterly transformed by a series of technical and wider cultural changes. The *Penny Magazine*, founded in 1832, used the latest printing technologies to bring a lavishly illustrated weekly paper to hundreds of thousands of homes, providing a regular stream of relatively sophisticated wood-engraved pictures in unprecedented numbers at amazingly low prices. After the 1840s the railways unified the national market for newspapers, and thus for printed pictures, creating a national mass market. The supply of well-trained wood-engravers kept pace with burgeoning demand. In and after the 1870s wood pulp made it possible to cut the prices and multiply the supplies of paper. From that same period photomechanical processes were slashing the cost of making pictures to print, so that by the end of the nineteenth century the historian of visual culture is faced with a highly differentiated market for pictures, including an industrialized mass market for pictures of works of art and an elite market for relatively pricey new printed pictures that mimicked the aesthetic that Catnach, Pitts and Grant had developed out of the wood-cut traditions they had inherited. No wonder that art historians, longing for the simplicities of the good old days, have been content to imagine that once upon a time there were such things as easily definable 'popular prints'.

FURTHER READING

Gretton, T. *Murders and Moralities: English Catchpenny Prints, 1800–60*, London 1980.
Maidment, B.E. *Reading Popular Prints, 1790–1870*, Manchester 1996.
O'Connell, S. *The Popular Print in England*, British Museum, London 1999.

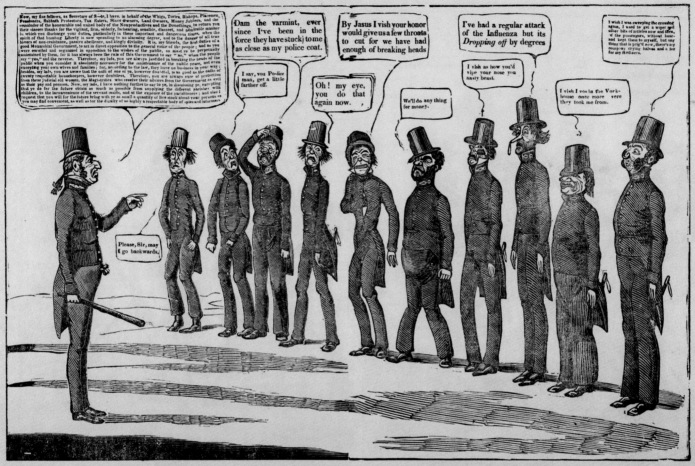

148 C.J. GRANT
Reviewing the Blue Devils,
from *The Political Drama* 1833
Woodcut
Strang Printroom,
University College London

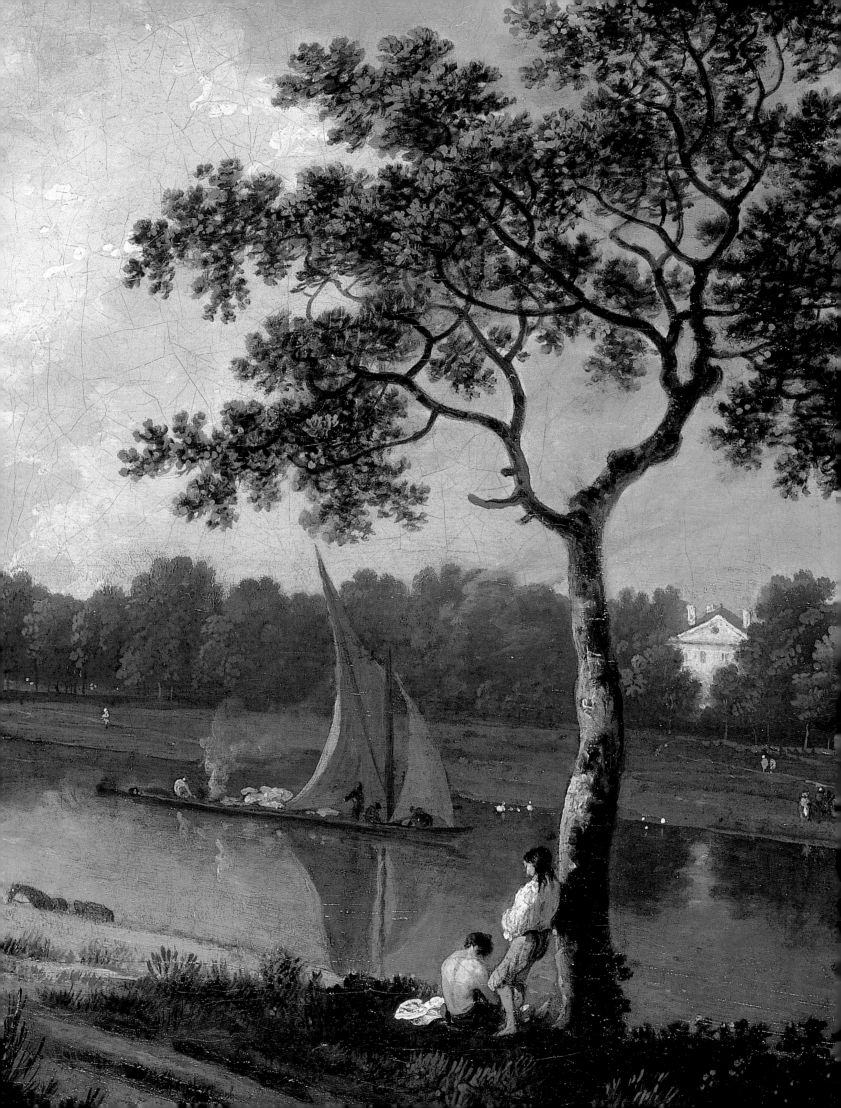

Notes

1 IDEAS AND IMAGES OF BRITAIN
c.1570-c.1870 (pp.20-46)

1 Pevsner 1956 (from the Reith Lectures of 1955). See also W. Vaughan, 'Behind Pevsner: Englishness as an art historical category', in Corbett, Holt and Russell 2002, pp.354-5.
2 See Vaughan's incisive critique, op. cit.
3 T.G. Ash, 'Two flags, one muddle', *The Guardian*, 13 June 2002, p.19.
4 Irwin and Irwin 1975; Macmillan 1990; Cullen 1997 and 2000; Lord 1998 and 2000. On Pevsner see Vaughan in Corbett, Holt and Russell 2002, pp.354-5.
5 *Art History*, vol.16, no.4, Dec. 1993, pp.600-18.
6 Especially Hemingway 1992 and Daniels 1993.
7 *Oxford Art Journal*, vol.13, no.2, 1990, pp.11-23.
8 The collections of essays in the series *Studies in British Art*, published by the Paul Mellon Centre for Studies in British Art, have much material on the issues in question, especially no.4: M. Rosenthal, Payne and Wilcox 1997; and no.5: Corbett, Holt and Russell 2002.
9 Colley 1992a, pp.5-6; Norman Davies, *Guardian* (Saturday Review), 13 Nov. 1999, p.3.
10 MacDougall 1982, pp.7-8.
11 Strong 1987, pp.20-1.
12 Ibid., pp.134-42.
13 Richard Helgerson, 'The Land Speaks: Cartography, Chorography and Subversion in Renaissance England' in Greenblatt 1988, pp.335-40.
14 See D. Bindman, 'How the French became Frogs: English caricature and a national stereotype', *Apollo*, Aug. 2003, p.15.
15 I am indebted here to Thomas Latham, whose Ph.D. thesis was on this topic.
16 R. Strong in Jackson-Stops 1985, no.56.
17 See Millar 1958 and Strong 1980.
18 Donovan 2004, p.111.
19 Strong attributes the scheme to Inigo Jones (Strong 1980, p.15), but Bishop Thornborough, as the author of *The Ioeful and Blessed Reuniting of the two mighty and famous kingdoms, England and Scotland*, Oxford 1604/5, is more likely.
20 Strong 1980, p.18.
21 Ibid., p.28.
22 Orgel and Strong 1973.
23 Sharpe 1990, pp.179-180.
24 Ibid., p.204.
25 Orgel and Strong 1973, II, pp.567-98.
26 Ibid., p.577.
27 Griffiths 1998, no.115.
28 Ibid, p.178.
29 The fullest account of the Greenwich scheme is to be found in Paulson 1991, pp.95f.
30 Webb 1954, p.131.
31 Pressly 1981, p.143-4.
32 Blake 1993a, p.170, pl.27.
33 Piggott 1985, pp.97-8.
34 Blake 1993a, pl.70.
35 Pressly 1981, pp.77-8.
36 Blake 1993b, pp.248-9.
37 See Mancoff 1990 and Poulson 1999.
38 Mancoff 1990, p.155.
39 See B. Taylor, 'Foreigners and Fascists: Patterns of Hostility to Modern Art in Britain before and after the First World War', in Corbett, Holt and Russell 2000, pp.169-98.
40 Smiles 1994, pp.129-30.
41 Marshall 1994, p.48.
42 Stevenson and Thomson 1982, nos.35 and 36.
43 Kidd 1999, pp.79-80.
44 MacDougall 1982, pp.42-3.
45 Webb 1954, pp.98 and 100; Kenworthy-Browne 1985, pp.220-7.
46 MacDougall 1982, p.47.
47 Ibid., p.49.
48 Cited in Kenworthy-Browne 1985, p.222.
49 For Vauxhall see Edelstein 1983.
50 Allen 1987, no.63.
51 Bindman 1981, pp.134-5.
52 See Irwin 1966.
53 Macmillan 1990, pp.121-6.
54 Cullen 1997, ch.2.
55 Pressly 1981, pp.175-6.
56 Smiles 1994, pp.156-7.
57 Ibid., pp.47-51.
58 Butlin 1981, no.655.
59 British Museum, Catalogue of Political and Personal Satires, no.8346.
60 Alexander 1998, no.23.
61 Ibid, no.22.
62 British Museum, Catalogue of Political and Personal Satires, no.9228.
63 J. Thomson, *The Seasons*, London 1730, 'Summer', lines 420-8.
64 See Nicholson 1990, pp.102-3.
65 Butlin and Joll 1984, no.140.
66 Ibid., no.347.
67 Ibid., no.12.
68 Lord 2000, p.72.
69 Lord 1998, pp.60-2.
70 Macmillan 1986, p.75.
71 Cullen 1997, pp.16-18.
72 Ibid., pp.116-18.
73 Sheehy 1980, pp.20-2.
74 See note 1.
75 William Wordsworth, *The Excursion*, 1814, Book VI.
76 Wilton 1979, p.24.
77 Prebble 1988.
78 Sergio Benedetti, *The Milltowns: A Family Reunion*, National Gallery of Ireland, Dublin, no.22.
79 Hugh Cheape, *Tartan*, National Museums of Scotland, 1995, p.40.
80 Cooper 1982, no.12.
81 Ballew Neff 1995, no.9.
82 Prebble 1988, p.112.
83 Macmillan 1986.
84 Ibid., pp.79-80.
85 Rebora et al. 1996, no.31.
86 Ibid., no.46.
87 Mankin Kornhauser 1991, no.5.
88 Ibid., no.29.
89 Mannings 2000, no.417.
90 Cullen 1997, pp.104-15.
91 Lord 2000, pp.124-7.

2 BRITAIN AND EUROPE c.1600-c.1900
(pp.56-77)

1 Walpole 1762-71; for the description of Hogarth as 'author' see vol.3, p.1.
2 Fry 1934, p.23.
3 Perhaps the only other example is that of Russia, which has separate museums for Russian art in Moscow and St Petersburg. This is interesting since Russia, like Britain, has reason to see its visual culture as flourishing on the periphery of a mainstream European tradition.
4 For recent discussions on the founding of the Tate see Taylor 1999, ch.4, pp.100-31, and A. Smith, 'A "state" gallery? The Management of British art during the Early Years of the Tate', in Barlow and Trodd 2000, pp.187-98.
5 Richard Redgrave, for example, claimed that the presence of the Flemish painters Rubens and Van Dyck in Britain 'gave birth to a native school of painters' (Redgrave and Redgrave 1890, p.12.)
6 Waagen 1838
7 Although the British Royal Academy awarded a prize for travel to Rome, there was no institutional support given to winners of the prize when they were in Rome.
8 Alison 1790, p.234.
9 Immediately after the First World War Grosz wanted, according to his friend Harry Kessler, 'to become the "German Hogarth", consciously objective and moral' (Harry Graf Kessler, *Tagebücher 1918-37*, ed. Wolfgang Pfeiffer-Belli, Frankfurt-am-Main 1982, p.114).
10 Nicholls 1785, p.50.
11 Rouquet 1755. A facsimile was published by the Cornmarket Press, London, with an introduction by R.W. Lightbown, in 1970.
12 Postle 1995, p.207.
13 Irwin 1997, pp.129-30.
14 For David's interest in contemporary British art in general see Philippe Bordes, 'Jacques-Louis David's Anglophilia on the eve of the French Revolution' in *Burlington Magazine*, vol.134, no.2073, Aug. 1992, pp.482-90.
15 Farington 1979, p.1882. This remark was made on the occasion of the exhibition of West's *Death on a Pale Horse* at the Paris Salon in 1802. See W. Vaughan, '"David's Brickdust" and the Rise of the British school', in Everest and Yarrington 1993, pp.134-58, especially pp.147-9.
16 The earliest appears to have been the *Essay towards an English School*, appended by Bainbridge Buckeridge to his translation of Roger de Piles's *The Art of Painting* in 1706. See Vaughan 1983, pp.105-11.
17 Walpole, *Anecdotes*, I, 1762, preface, p.v.
18 Britton 1812; see W. Vaughan, '"David's Brickdust" and the Rise of the British School', in Everest and Yarrington 1993, pp.134-58, esp. pp.148-9.
19 See Kriz 1997, especially ch.2 'Of Old Masters, French Glitter and English Nature', pp.33-56.
20 Lippincott 1983, pp.22-4.
21 See for example Memes 1826, pp.208-9. For further discussion of this interpretation of British art see Vaughan 1990, pp.15-16.
22 See Waagen 1838, I, pp.ix-xi.

23 Waagen 1838, II, pp.208-9.
24 See Waagen 1838, II, p.152.
25 *Art Union Monthly Magazine*, vol.1, no.8, Sept. 1839, pp.136.
26 Haydon 1963, IV, p.222.
27 Robert de la Sizeranne, *La Peinture anglaise contemporaine*, Paris 1895, pp.5-6; English translation in Haville Desmarais 1998, p.87.
28 Destrée 1894; Mouray 1895; Sizeranne 1895. See Haville Desmarais 1998, pp.84-7.
29 Haville Desmarais 1998, pp.126-7.
30 See Helmreich 2002, pp.45, 104.
31 'After all the stimulation that England has given to our art and to our design, she is now resting on her laurels ... Tiredness, exhaustion and a senile looking-backwards has followed on the great expenditure of force in recent years' (Richard Muther 'Die Pariser Weltausstellung 1900' in *Studien*, Berlin 1924, pp.549-50).
32 Pevsner 1956. For a discussion of Pevsner's interpretation of British art see W. Vaughan, 'Behind Pevsner: Englishness as an Art Historical Category', in Corbett, Holt and Russell 2002, pp.347-68.

3 BRITAIN AND THE WORLD BEYOND
c.1600-c.1900 (pp.86-115)

1 The second line of the inscription on Gillray's print reads 'the great globe itself and all which it inherits is too small to satisfy such insatiable [appetite].'
2 Joseph Addison, *The Spectator*, no.69 (Saturday 19 May 1711), in Allen 1970, p.210; see also Fowkes Tobin 1999, pp.33-4.
3 As Kathleen Wilson has put it, 'modes of British and English cultural production and consumption were constituted in part by bodies, practices and exchanges of people across the globe' (Wilson 2004, p.8).
4 Vaughan 1994, pp.58-9.
5 Green Fryd 1995, pp.72-85. Johnson had also led the British and Native Americans to victory at the Battles of Lake George and Fort Niagara.
6 Montagna 1981, pp.72-88; Colley 1992a, pp.178-9; Blayney Brown 2001, p.78.
7 T.J. Edelstein, 'The Gardens', in Allen and Edelstein 1983, p.13; C.A. Bayly, P.J. Marshall, and B. Allen in Bayly 1990, p.99-100, cat.107; B. Allen, 'From Plassey to Seringapatam: India and British History Painting c.1760 - c.1800', in Bayly 1990, pp.30-1; Marshall 2000, pp.11-12.
8 Colley 1992a, p.178.
9 Bayly 1990, p.100.
10 K. Sloan, 'Setting the Stage for John White, A Gentleman in Virginia', in Sloan 2007, pp.11-14; C.F. Feest, 'John White's New World', in Sloan 2000, pp.765-77; M. Gaudio, 'Savage Marks: Engraving and Empire in Thomas Harriot's *Briefe and True Report*', in Barringer, Fordham and Quilley 2007, p.272.
11 Hackforth-Jones 1980, p.7.
12 Gerhard 1959, p.207.
13 M.M. Robinson, *Ode for the Queen's Birthday* (1816), quoted in Smith 1985, pp.232-3.

14 Smith 1985, p.228; Riggs 1936, pp.279-86.
15 Vaughan 1994, pp.32-3; Ryan 2001, pp.265-79.
16 McCarthy 1965, pp.105-13.
17 E.K. Helsinger, 'Land and National Representation in Britain', in Rosenthal, Payne and Wilcox 1997, pp.13-35.
18 Hackforth-Jones 1980, p.17; Mikesell 1960, pp.70-2; G. Martin and B.E. Kline, 'British Emigration and New Identities', in Marshall 1996, pp.256-7.
19 Mikesell 1960, p.70; Blainey 1968, pp.118-19.
20 Cerwonka 2004; Blaut 1993; Cohen 1996; Maddox 1993.
21 Smith 1985, pp.254-5; Hackforth-Jones 1980, pp.23-6.
22 Bermingham 2000, pp.164-74.
23 Hodges 1793, p.2.
24 Ibid.
25 Helsinger, in Rosenthal, Payne and Wilcox 1997, p.27.
26 Edward Lear, 'Journals in India', unpublished manuscript, Houghton Library, Harvard University, fMS Eng 797.4, journal entry for Saturday, 13 Dec. 1873, p.4.
27 Balm 2000, p.587.
28 L. Bell, 'To See or Not to See: Conflicting Eyes in the Travel Art of Augustus Earle', in Codell and Macleod 1998, p.119.
29 Bermingham 2000, pp.83-4. It should be noted that by the middle of the nineteenth century lessons in geography were also part and parcel of children's education. See Ray 2006, pp.25-6.
30 Military drawings can be found in the collections of the British Library, National Archives (Kew), National Maritime Museum (London) and the National Library of Australia (Canberra), among many others.
31 Chalmers 2001, pp.113-30.
32 Lipscomb 1999, pp.24-9.
33 Ibid, pp.24-5.
34 Dehejia 1989, I, pp.24-31.
35 P.J. Marshall, '1870-1918: The Empire Under Threat', in Marshall 1996, pp.74-5.
36 Jackson 1998.
37 Special guides for young visitors became popular such as *Visits to the Leverian Museum: Containing an Account of Several of its Principal Curiosities, both of Nature and Art: Intended for the Instruction of Young Persons in the First Principles of Natural History*, London 1805.
38 The mezzotint (62 × 38 cm) was published on 15 April 1773 by S. Hooper, London.
39 All these paintings are discussed in Hackforth-Jones 2007.
40 Reynolds kept the portrait in his possession throughout his life; see Postle 2005, p.27.
41 H. Guest, 'Curiously Marked: Tattooing, Masculinity, and Nationality in Eighteenth-Century British Perspectives of the South Pacific', in Barrell 1992, pp.101-34.
42 Jasanoff 2004, pp.109-35, 113.
43 Eaton 2006, p.238.
44 Allen 1969, I, p.196, quoted in Eaton 2006, p.230.
45 Jasanoff 2004, pp.130-4; Welch 1978, p.24.
46 Jasanoff 2004, pp.122-3.
47 Desmond 1995, pp.290-301.
48 Ibid., pp.260-3; Ponsonby 1996, p.124.

49 A.B. Shtier, 'Women and the Natural World: Expanding Horizons at Home', in Pomeroy 2005, pp.67-76; R. Ray, '"A Dream of Beauty": Inscribing the English Garden in Victorian India', in Pomeroy 2005, pp.51-66.
50 Anderson 1795, p.143; Colley 1992b, p.311.
51 Roebuck 1983, p.240.
52 On chinoiserie see Porter 2001, esp. chs.3 and 4, and Sloboda 2004.
53 Porter 2001, p.160; Sloboda 2004.
54 Sirén 1990, p.75.
55 Myer 1961, pp.203-10.
56 'Momus: or The Laughing Philosopher' in *The Westminster Magazine; or The Pantheon of Taste*, July 1774, p.348, quoted in Harriet Guest, 'Ornament and Use: Mai and Cook in London', in Wilson 2004, p.317.
57 Jasanoff 2004, p.116.
58 Archer 1979, pp.99-102.
59 Leask 2002, p.62.
60 Joseph Banks, 'Papers 1745-1820', 'Things intended for Omai', manuscript list: 22.5 × 18.5 cm, Manuscript Collection MS9/14, http://www.nla.gov.au/exhibitions/omai/pages/text.html; Leask 2002, p.62; Wilson 2004, pp.328-31.
61 Bance 2004, p.20.
62 R. Ray, 'Maharaja Dalip Singh', in Hackforth-Jones 2007, pp.112-13.
63 On the *Omai* pantomime (1785), and the pantomime *The Death of Cook (La Mort du Capitaine Cook*, see Arnould 1789; O'Keeffe 1981; Smith 1985, pp.114-22; Christa Knellwolf, 'Comedy in the Omai Pantomime', in Hetherington 2001, pp.17-21; Wilson 2003, ch.2, esp. pp.63-70; Joppien and Smith 1988.
64 Whitley 1928, II, p.354, quoted in Smith 1985, p.118.
65 Smith 1985, p.116.
66 Whitley 1928, II, p.352, quoted in R. Joppien, 'Philippe Jacques de Loutherbourg's Pantomime "Omai, or, a Trip round the World" and the Artists of Captain Cook's Voyages', in Mitchell 1979, p.111, no.76; see also Joppien 1978, p.6; *Public Advertiser*, 21 Feb. 1781; Smith 1985, p.116. For de Loutherbourg's Eidophusikon and a modern-day recreation see A. Bermingham, 'Sensibility and the Cult of Special Effects', in Bermingham 2006; Altick 1978.
67 Wilson 2003, pp.69-70; Roach 1996.
68 'Pantomimes. Omai', in *The Times*, 28 Dec. 1785, no.315, p.3.
69 A print of the exhibition shows how prominently Hodges's paintings were displayed see Quilley 2004, pp.46-53.
70 K.D. Kriz 'Marketing Mulatesses in the Paintings and Prints of Agostino Brunias', in Nussbaum 2003a, pp.195-210, esp. p.198.
71 Edwards 1805-6, II, p.205.
72 Tobin 1999, pp.149-50; Honychurch 2004, pp.104-28; also http://www.cavehill.uwi.edu/bnccde/svg/conference/papers/honychurch.html, 5, suggested that Brunias inserted his own face into the figure of the voyeur. For a fascinating reading of eighteenth-century English literary and visual culture in relation to human difference and empire see Nussbaum 2003b.

73 Tobin 2005, pp.15-16.
74 A. Rosenthal 2004, pp.562-92; on 'Racial Femininity: "our British Fair"' see also Nussbaum 2003a, pp.135-50, and A. Rosenthal 2006b, pp.97-128.
75 The veracity of aspects of Equiano's accounts has been questioned. See Equiano 2003, pp.ix-xxxii.
76 For a discussion of these paintings see Honour 1976, pt.1, pp.66-74.
77 Wood 2000, p.63.
78 Coleman 1994, pp.341-62; see also Bindman 1994, pp.68-82.
79 Thanks to Sarah Watson Parsons for sharing with me her unpublished paper 'The Arts of Abolition: Race, Representation and British Colonialism, 1768-1807.'
80 The painting is now in the Foreign and Common-wealth Office in London. See also Allen, 'From Plassey to Seringapatam', in Bayly 1990, p.28.
81 A. Porter, 'Empires in the Mind', in Marshall 1996, p.203.
82 J. Marsh, 'Icon of the Age: "Africa", Victoria and The Secret of England's Greatness', in Marsh 2005, pp.57-67.

4 NEW WAYS OF SEEING: LANDSCAPE PAINTING AND VISUAL CULTURE c.1620-c.1870 (pp.122-143)

1 Goodman 1976; Barrell 1972.
2 For example, Andrews 1999. The best review of the recent literature on landscape painting is Michael Rosenthal's introduction in Rosenthal, Payne and Wilcox 1997, pp.1-13.
3 Edward Norgate, Miniatura, or Art of Limning (1648), cited in Hearn 2005, p.13.
4 I owe this suggestion to Charles Ford.
5 Cited in Strong 2004, p.236.
6 See Alpers 1983, pp.33-41.
7 Henry Chauncy, The Historical Antiquities of Hertfordshire, London 1700.
8 Barrell 1983, pp.41-8.
9 H. Fielding, Joseph Andrews, London, 1742, vol.2, p.163. I owe this reference to Jules Lubbock.
10 J. Thomson, preface to 'Spring', in The Seasons, ed. J. Sambrook, Oxford 1972.
11 Everett 1994, p.13. See also Jacob 1976.
12 Hemingway 1992, p.14.
13 Barrell 1972, p.7.
14 For a discussion of this painting see Solkin 1982, pp.56-76.
15 For a fuller discussion of Woollett's print see Clayton 1997, pp.181-206.
16 I would like to thank Jules Lubbock for bringing this to my attention.
17 Horace Walpole to George Montagu, 17 May 1763, in Horace Walpole's Correspondence, X, ed. W.S. Lewis, New Haven 1970, p.73.
18 Quoted in Gaiger, Harrison and Wood, 1999, pp.881-2.
19 R. Southey, Letters from England (1807), quoted in Fenwick 2004, p.22.
20 T. Gainsborough, letter to D. Garrick, 1772, in Gainsborough 2000, p.108.

21 See I. Mackintosh's note for John Hayes, in Gainsborough 2000, p.108.
22 Rosenthal 2000, p.240.
23 J. Austen, Northanger Abbey, ed. Marilyn Butler, London 2003, p.114.
24 Quoted in Pratt 1978, p.76.
25 Quoted in Crouan 1982, p.xv.
26 In private correspondence.
27 For Hearne see Morris 1989.
28 Cited in John H. Farrant, 'Grimm, Samuel Hieronymous', Oxford Dictionary of National Biography, 2004.
29 Memoirs of the Life of William Collins, Esq., R.A., cited in Crouan 1982.
30 Hemingway 1993, p.93.
31 Wilcox 1997, p.10.
32 Venning 2003, p.108.
33 See M. Rosenthal 1983, ch.3. In the following discussion of association theory I have drawn especially on Hemingway 1993, Klonk 1996, chap.1, and Kris 1997.
34 Hemingway 1993, p.70.
35 Points that were commonly made against artists as diverse as Boucher and Loutherbourg. On comparisons of British and French art, see Kris, Genius as Alibi, chap.2; also Vaughan in the present volume.
36 These comments based on Hemingway 1993, and D. Blayney Brown, Hemingway and Lyles 1999, pp.183-204.
37 Leight Hunt, in The Examiner, 29 April, 1827, quoted in Hemingway 1993, p.125.
38 'Experiment and Experience in the Arts', in Gombrich 1982, p.239.
39 Hemingway 1993, pp.191-2.
40 Helsinger 1997, pp.41-59.

5 BRITISH ART AND THE SOCIAL WORLD (pp.154-172)

1 John Wilmot, Earl of Rochester, 'A Satire on Charles II', 1672, lines 20-21.
2 See J. Dryden's Parallel between Poetry and Painting (1695), which includes his partial transla-tion of Bellori's influential 1664 discourse Idea of Beauty.
3 Alexander Pope later satirized as the epitome of bad taste in his seminal 1731 'Epistle to Richard Boyle', lines 145-8.
4 Abraham Cowley's 'To the Royal Society' 1667, lines 85-8.
5 Thomas Sprat, The History of the Royal Society 1667, section XI.
6 Ibid., section XX.
7 D. Defoe, A Tour through the Whole Island of Great-Britain, first published 1726, reprinted Harmondsworth 1971, p.286.
8 Ibid., p.309.
9 Connoisseur, no.11, 11 April 1754.
10 See Godfrey Kneller's famous series of 'Kit-Cat' portraits in the National Portrait Gallery.
11 Spectator, no.409, 19 June 1712.
12 Spectator, no.226, 19 November 1711.
13 G. Vertue, Notebooks (for 1729), 6 vols.,

The Walpole Society, vol.22 (1934), p.46.
14 Solkin 1993, p.87.
15 Champion, 10 June 1740.
16 Hogarth 1955, p.209.
17 Bourdieu 1984.
18 Brewer 1997, p.250.
19 All these examples are quoted in Brewer 1997, pp.274, 250.
20 Joshua Reynolds, 'Discourse IX' (1780) in Robert Wark (ed.), Joshua Reynolds: Discourses on Art, New Haven and London 1997, p.171.
21 Spectator no.29, 3 April 1711.
22 Spectator, no.411, June 21, 1712.
23 Ibid.
24 Quoted in Leslie 1843.

6 THE BRITISH ARTIST c.1570-c.1870 (pp.188-213)

1 F. Davenant, What Shall my Son Be? Hints to Parents on the Choice of a Profession or Trade, London 1870, pp.149-60.
2 These three dimensions of artistic identity are derived from the empirical research model outlined in Hosie, Jeffri and Greenblatt 1985, and Jeffri and Greenblatt 1987, pp.5-14.
3 J. Piggott, 'The Golden Age of Art', Art-Journal, no.33, Dec. 1871, quoted in Olmsted 1985, p.290.
4 For the growth of the London art world see Solkin 2001; Peter Funnell, 'The London Art World and its Institutions', in Fox 1992, pp.155-66. On developments outside the metropolis see Breeze 1985; Fairfull-Smith 2001; D. Forbes, 'Artists, Patrons and the Power of Association: The Emergence of a Bourgeois Artistic Field in Edinburgh, c.1775- c.1840', Ph.D. thesis, University of St Andrews 1996; Fawcett 1974; Darcy 1976; Morris and Roberts 1998.
5 See Menger 1999, pp.541-74, and Menger 2001, pp.241-54.
6 See Bourdieu 1993 and 1996.
7 For the court context see Malcolm Smuts 1987 and Howarth 1997.
8 Edmond 1980, pp.60-242.
9 Quoted in Borg 2005, p.92.
10 See S. Foister, 'Foreigners at Court: Holbein, Van Dyck and the Painter-Stainers Company', in Howarth 1993, pp.32-50.
11 Quoted in Englefield 1923, p.115.
12 See M. Baxandall, 'English Disegno', in Chaney and Mack 1990, pp.203-14.
13 See Lord 2000, pp.35-7.
14 V. Morgan, 'The Dutch and Flemish Presence and the Emergence of an Anglo-Dutch Provincial Artistic Tradition in Norwich, c.1500-1700', in Roding 2003, pp.57-72.
15 Bermingham 2000, pp.21-2.
16 Peacham 1906, pp.129-30.
17 See Bermingham 2000 and Sloan 2000.
18 Aglionby 1685.
19 See Gibson-Wood 2002, pp.491-500.
20 See James A. Ganz, 'A City Artist: Robert Robinson', in Galinou 2004, pp.103-18.
21 Vertue 1930-55, vol.3, p.113. On Smith see

Griffiths 1989.

22 See Solkin 1993, pp.78-105.

23 On English art training in the eighteenth century see I. Bignamini, 'The "Academy of Art" in Britain before the Foundation of the Royal Academy', in Boschloo 1989, pp.434-47; Bignamini and Postle 1991.

24 Gwynn 1766, pp.57-9.

25 Michael Kitson,'Hogarth's "Apology for Painters"', *Walpole Society*, no.41 (1966-8), p.87.

26 See Earle 1989, pp.73-4, and Holmes 1982, pp.20-42.

27 Kitson, 'Hogarth's "Apology for Painters"', p.96.

28 See Smith 2002, for sustained discussion of this point in relation to the practice of watercolour painting.

29 See Myrone 2005, pp.1-46.

30 See A. Rosenthal 2006a for a full-scale case study of a female artist and her reputation in the eighteenth century. See also Bermingham 1993.

31 Reynolds 1975, p.13.

32 Ibid., pp.17-18.

33 Robertson 1897, p.47.

34 Craske 2006, pp.25-45.

35 Myrone 2005, pp.278-83.

36 Holman Hunt 1886, p.474.

37 Redgrave and Redgrave 1866, I, p.74.

38 James Barry to Edmund Burke, c.1765-6, in Barry 1809, I, p.47.

39 George Heriot to Sir James Grant, 14 Sept. 1777, National Archives of Scotland, GD 248/54/5/63.

40 A figure speculated by Lippincott in Lippincott 1983, p.15.

41 Figure quoted from *The Literary Journal* (25 May 1818) in Smith 2002, p.230.

42 See John Seed, '"Commerce and the Liberal Arts": The Political Economy of Art in Manchester, 1775-1860', in Seed and Wolff 1988.

43 See Fairfull-Smith 2001.

44 See Corfield 1995, pp.174-6. See also Simpson 1981 for a thought-provoking analysis of the contemporary scene that draws out the class-bound nature of modern artistic identity.

45 Smiles 2002, p.160.

46 Note from John Constable to C.R. Leslie, in Constable 1965, pp.36-7.

47 *Art-Journal*, vol.1, 1849, p.13.

48 Quoted and discussed in M. Rosenthal 1983, pp.26-7.

49 *Morning Chronicle*, 16 April 1829, quoted in Crosby Ivy 1991, pp.14 and 132.

50 Thornbury 1862, I, p.5.

51 Hamerton 1879, pp.7-8.

52 See T. Gretton, '"Art is Cheaper and Goes Lower in France": The Language of the Parliamentary Select Committee in the Arts and Principles of Design of 1835-1836', in Hemingway and Vaughan 1998, pp.84-100. See also M. Romans, 'Social Class and the Origin of Public Art and Design Education in Britain: In Search of a Target Group', in Romans 2005, pp.55-65.

53 Barringer 2005, pp.133-85.

54 Quoted and discussed in Barringer 2005, p.143.

55 Quoted and discussed in Codell 1990, pp.91-7.

56 Bourdieu 1993, pp.252-3.

57 See Anderson 1992 and Easthope 1999. See also Meiksins Wood 1992.

58 John Boydell to Sir John William Anderson, 4 Feb., 1804, in J. Boydell's 'Preface' (1805) to *Collection of Prints, from Pictures Painted for the Purpose of Illustrating the Dramatic Works of Shakespeare* (1803-5), facsimile reprint with an introduction by A.E. Santaniello, Boydell Shakespeare Gallery, New York and London 1968.

59 Taylor 1863, pp.3-5. See also C. Trodd, 'Representing the Victorian Royal Academy: The Properties of Culture and the Promotion of Art', in Barlow and Trodd 2000, pp.56-68.

Further Reading

This bibliography is not intended as a definitive list of books on the art of this period, but has been compiled from references in the long essays in this volume.

AGLIONBY 1685
W. Aglionby, *Painting Illustrated in Three Dialogues*, London 1685.

ALEXANDER 1998
D. Alexander, *Richard Newton*, Manchester 1998.

ALISON 1790
A. Alison, *Essays on the Nature and Principles of Taste*, Edinburgh 1790.

ALLEN 1969
B.S. Allen, *Tides of English Taste, 1619–1800*, 2 vols., New York 1969.

ALLEN 1970
R.J. Allen (ed.), *Addison and Steele: Selections from* The Tatler *and* The Spectator, New York 1970.

ALLEN 1987
B. Allen, *Francis Hayman*, New Haven and London 1987.

ALLEN AND EDELSTEIN 1983
B. Allen and T.J. Edelstein, *Vauxhall Gardens*, New Haven 1983.

ALPERS 1983
S. Alpers, *The Art of Describing: Dutch Art in the Seventeenth Century*, London 1983.

ALTICK 1978
R.D. Altick, *The Shows of London*, Cambridge, Mass. 1978.

ANDERSON 1795
A. Anderson, *A Narrative of the British Embassy to China*, London 1795.

ANDERSON 1992
P. Anderson, *English Questions*, London 1992.

ANDREWS 1999
M. Andrews, *Landscape and Western Art*, Oxford 1999.

ARCHER 1979
M. Archer, *India and British Portraiture 1770–1825*, London 1979.

ARNOULD 1789
M. Arnould, *The Death of Captain Cook: A Grand Serious-Pantomimic-Ballet in Three Parts*, London 1789.

BALLEW NEFF 1995
E. Ballew Neff, *John Singleton Coply in England*, London 1995.

BALM 2000
R. Balm, 'Expeditionary Art: An Appraisal', *Geographical Review*, vol.90, no.4, Oct. 2000, pp.585–602.

BANCE 2004
P. Bance, *The Dalip Singhs: The Photographic Album of Queen Victoria's Maharajah*, exh. cat., Phoenix Mill, Gloucestershire 2004.

BARLOW AND TRODD 2000
P. Barlow and C. Trodd (eds.), *Governing Cultures: Art Institutions in Victorian London*, Aldershot 2000.

BARRELL 1972
J. Barrell, *The Idea of Landscape and the Sense of Place*, Cambridge 1972.

BARRELL 1983
J. Barrell, *The Dark Side of the Landscape: The Rural Poor in English Painting 1730–1840*, Cambridge 1983.

BARRELL 1992
J. Barrell (ed.), *Painting and the Politics of Culture: New Essays on British Art 1700–1850*, Oxford and New York 1992.

BARRINGER 2005
T. Barringer, *Men at Work: Art and Labour in Victorian Britain*, New Haven and London 2005.

BARRINGER, FORDHAM AND QUILLEY 2007
T. Barringer, D. Fordham and G. Quilley (eds.), *Art and the British Empire*, Manchester 2007.

BARRY 1809
The Works of James Barry, ed. Edward Fryer, 2 vols., London 1809.

BAYLY 1990
C.A. Bayly, *The Raj: India and the British 1600–1947*, exh. cat., National Portrait Gallery, London 1990.

BERMINGHAM 1993
A. Bermingham, 'The Aesthetics of Ignorance: Accomplished Women in the Culture of Connoisseurship', *Oxford Art Journal*, vol.16, no.2 (1993), pp.3–20.

BERMINGHAM 2000
A. Bermingham, *Learning to Draw: Studies in the Cultural History of a Polite and Useful Art*, New Haven 2000.

BERMINGHAM 2006
A. Bermingham, *Sensation and Sensibility: Viewing Gainsborough's 'Cottage Door'*, exh. cat. Huntington Library, San Marino 2006.

BIGNAMINI AND POSTLE 1991
I. Bignamini and M. Postle, *The Artist's Model: Its Role in British Art from Lely to Etty*, exh. cat., University of Nottingham 1991.

BINDMAN 1981
D. Bindman, *Hogarth*, London 1981.

BINDMAN 1994
D. Bindman, '"Am I not a Man and a Brother": British Art and Slavery in the Eighteenth Century', *RES*, no.26, autumn 1994, pp.68–82.

BLAINEY 1968
G. Blainey, *The Tyranny of Distance: How Distance Shaped Australia's History*, New York 1968.

BLAKE 1993a
William Blake, *Jerusalem*, c.1820, Blake Trust/Tate Gallery edition, ed. M. Paley, London 1993.

BLAKE 1993b
William Blake, *Visions of the Daughters of Albion*, 1793, Blake Trust/Tate Gallery edition, *The Early Illuminated Books*, ed. M. Eaves, R.N. Essick, J. Viscomi, London 1993.

BLAUT 1993
J.M. Blaut, *The Colonizer's Model of the World: Geographical Diffusionism and Eurocentric History*, New York 1993.

BLAYNEY BROWN 2001
D. Blayney Brown, *Romanticism*, London 2001.

BLAYNEY BROWN, HEMINGWAY AND LYLES 1999
D. Blayney Brown, A. Hemingway and A. Lyles, *Romantic Landscape*, London 1999.

BORG 2005
A. Borg, *The History of the Worshipful Company of Painters, Otherwise Painter-Stainers*, London 2005.

BOSCHLOO 1989
A.W.A. Bochloo et al., (eds.), *Academies of Art Between Renaissance and Romanticism*, The Hague 1989.

BOURDIEU 1984
P. Bourdieu, *Distinction: A Social Critique of the Judgement of Taste* (1979), trans. R. Nice, London 1984.

BOURDIEU 1993
P. Bourdieu, *The Field of Cultural Production: Essays on Art and Literature*, Cambridge 1993.

BOURDIEU 1996
P. Bourdieu, *The Rules of Art*, trans. Susan Emanuel, Cambridge 1996.

BREEZE 1985
G. Breeze (ed.), *Society of Artists in Ireland: Index of Exhibitions 1765–80*, Dublin 1985.

BREWER 1997
J. Brewer, *The Pleasures of the Imagination: English Culture in the Eighteenth Century*, London 1997.

BRITTON 1812
J. Britton, *The Fine Arts of the English School*, London 1812.

BUTLIN 1981
M. Butlin, *The Paintings and Drawings of William Blake*, New Haven and London 1981.

BUTLIN AND JOLL 1984
Martin Butlin and Evelyn Joll, *The Paintings of J.M.W. Turner*, New Haven and London 1984.

CERWONKA 2004
A. Cerwonka, *Native to the Nation: Disciplining Landscapes and Bodies in Australia*, Minneapolis and London 2004.

CHALMERS 2001
J.G. Chalmers, 'Art Education in a Manly Environment: Educating the Sons of the Establishment in a 19th Century Boys' School', *Studies in Art Education: A Journal of Issues and Research*, vol.42, no.2, Winter 2001, pp.113–30.

CHANEY AND MACK 1990
E. Chaney and P. Mack (eds.), *England and the Continental Renaissance: Essays in Honour of JB Trapp*, Woodbridge 1990.

CLAYTON 1997
T. Clayton, *The English Print 1688–1802*, New Haven and London 1997.

CODELL 1990
J.F. Codell, 'The *Fine Arts Quarterly Review* and Artpolitics in the 1860s', *Victorian Periodicals Review*, vol.23, spring 1990, pp.91–7.

CODELL AND MACLEOD 1998
J.F. Codell and D. S. Macleod, *Orientalism Transposed: The Impact of the Colonies on British Culture*, Aldershot 1998.

COHEN 1996
B.S. Cohen, *Colonialism and its Forms of Knowledge: the British in India*, Princeton 1996.

COLEMAN 1994
D. Coleman, 'Conspicuous Consumption: White Abolitionism and English Women's Protest writing in the 1790s', *English Literary History*, vol.61, 1994, pp.341-62.

COLLEY 1992a
L. Colley, *Britons: Forging a Nation 1707-1837*, New Haven and London, 1992, pp.4-5.

COLLEY 1992b
L. Colley, 'Britishness and Otherness: An Argument', *The Journal of British Studies*: 'Britishness and Europeanness: Who Are the British Anyway?', vol.31, no.4, Oct. 1992, pp.309-29.

CONSTABLE 1965
R.B. Beckett (ed.), *John Constable's Correspondence. III: The Correspondence with CR Leslie*, Suffolk Records Society, vol.8, 1965.

COOPER 1982
H. Cooper, *John Trumbull*, exh. cat., Yale University Art Gallery, New Haven 1982.

CORBETT, HOLT AND RUSSELL 2002
D.P. Corbett, Y. Holt and F. Russell (eds.), *The Geographies of Englishness: Landscape and the National Past, 1880-1940*, New Haven and London 2002.

CORFIELD 1995
P.J. Corfield, *Power and the Professions in Britain, 1700-1850*, London and New York 1995, pp.174-6.

CRASKE 2006
M. Craske, 'Reviving the "School of Phidias": The Invention of a National "School of Sculpture" in Britain (1780-1830)', *Visual Culture in Britain*, vol.7, no.2, 2006, pp.25-45.

CROSBY IVY 1991
J. Crosby Ivy, *Constable and the Critics 1802-1837*, Woodbridge 1991.

CROUAN 1982
K. Crouan (ed.), *John Linnell: A Centenary Exhibition*, Cambridge 1982.

CULLEN 1997
F. Cullen, *Visual Politics: Representation of Ireland, 1750-1930*, Cork 1997.

CULLEN 2000
F. Cullen, *Sources in Irish Art: A Reader*, Cork 2000.

DANIELS 1993
S. Daniels, *Fields of Vision: Landscape Imagery and National Identity in England and the United States*, Cambridge 1993.

DARCY 1976
C.P. Darcy, *The Encouragement of the Fine Arts in Lancashire 1760-1860*, Manchester 1976.

DEHEJIA 1989
V. Dehejia, *Impossible Picturesqueness: Edward Lear's Indian Watercolours, 1873-1875*, New York 1989.

DESMOND 1995
R. Desmond, *Kew: The History of the Royal Botanic Gardens*, London 1995.

DESTRÉE 1894
Olivier-Georges Destrée, *Les Préraphaelites*, Paris 1894.

DONOVAN 2004
F. Donovan, *Rubens and England*, New Haven and London 2004.

EARLE 1989
P. Earle, *The Making of the English Middle Class: Business, Society and Family Life in London, 1660-1730*, Berkeley and Los Angeles 1989.

EASTHOPE 1999
A. Easthope, *Englishness and National Culture*, London 1999.

EATON 2006
Natasha Eaton, 'Nostalgia for the Exotic: Creating an Imperial Art in London, 1750-1793', *Eighteenth-Century Studies*, vol.39, no.2, winter 2006, pp.227-250.

EDELSTEIN 1983
T.J. Edelstein, *Vauxhall Gardens*, New Haven 1983.

EDMOND 1980
M. Edmond, 'Limners and Picturemakers', *Walpole Society*, vol.47, 1980, pp.60-242.

EDWARDS 1805-6
B. Edwards, *The History, Civil and Commercial, of the British Colonies in the West Indies*, 4th ed., 4 vols., 1805-6.

ENGLEFIELD 1923
W.A. Englefield, *The History of the Painter-Stainers Company of London*, London 1923.

EQUIANO 2003
O. Equiano, *The Interesting Narrative and Other Writings*, ed. V. Caretta, New York and London 2003, ix-xxxii.

EVEREST AND YARRINGTON 1993
K. Everest and A. Yarrington (ed.), *Reflections on Revolution*, London and New York 1993.

EVERETT 1994
N. Everett, *The Tory Idea of Landscape*, New Haven and London 1994.

FAIRFULL-SMITH 2001
G. Fairfull-Smith, *The Foulis Press and Foulis Academy: Glasgow's Eighteenth-Century School of Art and Design*, Glasgow 2001.

FARINGTON 1979
The Diary of Joseph Farington, V, ed. K. Garlick and K. Macintyre, New Haven and London 1979.

FAWCETT 1974
T. Fawcett, *The Rise of English Provincial Art: Artists, Patrons, and Institutions Outside London, 1800-1830*, Oxford 1974.

FENWICK 2004
S. Fenwick, *The Enchanted River: 200 Years of the Royal Watercolour Society*, Bristol 2004.

FOX 1992
C. Fox (ed.), *London - World City: 1800-1840*, exh. cat., Villa Hügel, Essen 1992.

FRY 1934
Roger Fry, *Reflections on British Art*, London 1934.

GAIGER, HARRISON AND WOOD 1999
J. Gaiger, C, Harrison and P. Wood (eds.), *Art in Theory 1648-1815*, Oxford 1999.

GAINSBOROUGH 2000
T. Gainsborough, *The Letters of Thomas Gainsborough*, ed. John Hayes, New Haven and London 2000.

GALINOU 2004
M. Galinou (ed.), *City Merchants and the Arts 1670-1720*, London 2004.

GERHARD 1959
D. Gerhard, 'The Frontier in Comparative View', *Comparative Studies in Society and History*, vol.1, no.3, March 1959, p.207.

GIBSON-WOOD 2002
C. Gibson-Wood, 'Picture Consumption in London at the End of the Seventeenth Century', *The Art Bulletin*, vol.84, no.3, 2002, pp.491-500.

GOMBRICH 1982
E. Gombrich, *The Image and the Eye: Further Studies in the Psychology of Pictorial Representation*, Oxford 1982.

GOODMAN 1976
N. Goodman, *Languages of Art: An Approach to a Theory of Symbols*, Indianapolis 1976.

GREEN FRYD 1995
V. Green Fryd, 'Rereading the Indian in Benjamin West's "Death of General Wolfe"', *American Art*, vol.9, no.1, spring 1995, pp.72-85.

GREENBLATT 1988
S. Greenblatt (ed.), *Representing the English Renaissance*, Berkeley 1988.

GRIFFITHS 1989
A. Griffiths, 'Early Mezzotint Publishing in England - I: John Smith, 1652-1743', *Print Quarterly*, vol.6, no.3, 1989, pp.243-57.

GRIFFITHS 1998
A. Griffiths, *The Print in Stuart Britain*, British Museum 1998.

GWYNN 1766
J. Gwynn, *London and Westminster Improved*, London 1766.

HACKFORTH-JONES 1980
J. Hackforth-Jones, *Augustus Earle: Travel Artist Paintings and Drawings in the Rex Nan Kivell Collection National Library of Australia*, London 1980, p.7.

HACKFORTH-JONES 2007
Jos Hackforth-Jones (ed.), *Between Worlds: Voyagers to Britain 1700-1850*, London 2007.

HAMERTON 1879
P.G. Hamerton, *The Life of J.M.W. Turner, RA*, London 1879.

HAVILLE DESMARAIS 1998
J. Haville Desmarais, *Beardsley and the Beardsley Industry*, Aldershot 1998.

HAYDON 1960
B.R. Haydon, *The Diary of Benjamin Robert Haydon*, 5 vols., ed. W.B. Pope, Cambridge, Mass., 1963.

HEARN 2005
K. Hearn, *Nathaniel Bacon: Artist, Gentleman and Gardener*, London 2005.

HELMREICH 2002
A. Helmreich, *The English Garden and National Identity*, Cambridge 2002.

HELSINGER 1997
E. Helsinger, *Rural Scenes and National Representation: Britain, 1815–1850*, Princeton 1997.

HEMINGWAY 1992
A. Hemingway, *Landscape Imagery and Urban Culture in Early Nineteenth Century Britain*, Cambridge 1992.

HEMINGWAY AND VAUGHAN 1998
A. Hemingway and W. Vaughan (eds.), *Art in Bourgeois Society, 1790–1850*, Cambridge 1998.

HETHERINGTON 2001
Michele Hetherington (ed.), *Cook and Omai: The Cult of the South Seas*, Canberra 2001.

HODGES 1793
W. Hodges, *Travels in India, during the Years 1780, 1781, 1782, & 1783*, London 1793.

HOGARTH 1955
W. Hogarth, *The Analysis of Beauty, with the Rejected Passages from the Manuscript Drafts and Autobiographical Notes*, ed. Joseph Burke, Oxford 1955.

HOLMAN HUNT 1886
W. Holman Hunt, 'The Pre-Raphaelite Brotherhood: A Fight for Art. I', *Contemporary Review*, vol.49, 1886, pp.470–88.

HOLMES 1982
G. Holmes, *Augustan England: Professions, State and Society, 1680–1730*, London 1982.

HONOUR 1976
H. Honour, *Image of the Black in Western Art*, IV, New York 1976.

HONYCHURCH 2004
L. Honychurch, 'Chatoyer's Artist: Agostino Brunias and the Depiction of St Vincent', *Journal of the Barbados Museum and Historical Society*, no.50, 2004, pp.104–28.

HOSIE, JEFFRI AND GREENBLATT 1985
J. Hosie, J. Jeffri and R. Greenblatt, 'The Artist Alone: Work-Related, Human, and Social Service Needs – Selected Findings', *Journal of Arts Management and Law*, vol.17, no.3, 1985, pp.5–22.

HOWARTH 1993
D. Howarth (ed.), *Art and Patronage at the Caroline Courts: Essays in Honour of Sir Oliver Millar*, Cambridge 1993.

HOWARTH 1997
D. Howarth, *Images of Rule: Art and Politics in the English Renaissance, 1485–1649*, Basingstoke 1997.

IRWIN 1966
D. Irwin, *English Neoclassical Art*, London 1966.

IRWIN 1997
D. Irwin, *Neoclassicism*, London 1997.

IRWIN AND IRWIN 1975
D. Irwin and F. Irwin, *Scottish Painters: At Home and Abroad, 1700–1900*, London 1975.

JACKSON 1998
C.E. Jackson, *Sarah Stone: Natural Curiosities from the New Worlds*, London 1998.

JACKSON-STOPS 1985
G. Jackson-Stops (ed.), *The Treasure Houses of Britain*, Washington 1985.

JACOB 1976
M. Jacob, *The Newtonians and the English Revolution*, Hassocks 1976.

JASANOFF 2004
M. Jasanoff, 'Collectors of Empire: Objects, Conquests and Imperial Self-fashioning', *Past and Present*, vol.184, no.1, Aug. 2004, pp.109–36.

JASANOFF 2005
M. Jasanoff, *Edge of Empire: Lives, Culture, and Conquest in the East, 1750–1850*, New York 2005.

JEFFRI AND GREENBLATT 1987
J. Jeffri and R. Greenblatt, 'Between Extremities: The Artist Defined', in *Journal of Arts Management and Law*, vol.19, no.1, 1987, pp.5–14.

JOPPIEN 1978
R. Joppien, *Philippe Jacques de Loutherbourg*, London 1978.

JOPPIEN AND SMITH 1988
R. Joppien and B. Smith, *The Art of Captain Cook's Voyages*, 3 vols., London 1988.

KENWORTHY-BROWNE 1985
J. Kenworthy-Browne, 'Rysbrack's Saxon deities', *Apollo*, Sept. 1985, pp.220–7.

KIDD 1999
C. Kidd, *British Identities before Nationalism*, Cambridge 1999.

KLONK 1996
C. Klonk, *Science and the Perception of Nature*, New Haven and London 1996.

KRIZ 1997
K.D. Kriz, *The Idea of the English Landscape Painter: Genius as Alibi in Early Nineteenth Century*, New Haven and London 1997.

LEASK 2002
N. Leask, *Curiosity and the Aesthetics of Travel Writing, 1770–1840*, Oxford 2002.

LESLIE 1843
C.R. Leslie, *Memoirs of the Life of Sir John Constable*, London 1843.

LIPPINCOTT 1983
L. Lippincott, *Selling Art in Georgian London: The Rise of Arthur Pond*, New Haven and London 1983.

LIPSCOMB 1999
A. Lipscomb, 'Around the World in Watercolours', *Royal Geographical Society Magazine*, vol.71, no.3, 1999, pp.24–9.

LORD 1998
P. Lord, *The Visual Culture of Wales: Industrial Society*, Cardiff 1998.

LORD 2000
P. Lord, *The Visual Culture of Wales: Imaging the Nation* Cardiff 2000.

MCCARTHY 1965
F.I. McCarthy, 'The Bard of Thomas Gray, its Composition, and its Use by Painters', *The National Library of Wales Journal*, vol.14, no.1, summer 1965, pp.105–13.

MACDOUGALL 1982
H. MacDougall, *Racial Myth in English History*, Montreal and Hanover 1982.

MACMILLAN 1986
D. Macmillan, *Painting in Scotland: The Golden Age*, Oxford 1986.

MACMILLAN 1990
D. Macmillan, *Scottish Art, 1460–1990*, Edinburgh 1990.

MADDOX 1993
G. Maddox (ed.), *Colonialism and Nationalism in Africa*, 2 vols., New York 1993.

MALCOLM SMUTS 1987
R. Malcolm Smuts, *Court Culture and the Origins of a Royalist Tradition in Early Stuart England*, Philadelphia 1987.

MANCOFF 1990
D. Mancoff, *The Arthurian Revival in Victorian Art*, New York and London 1990.

MANKIN KORNHAUSER 1991
E. Mankin Kornhauser, *Ralph Earl: The Face of the New Republic*, New Haven and London 1991.

MANNINGS 2000
D. Mannings, *Sir Joshua Reynolds*, New Haven and London 2000.

MARSH 2005
J. Marsh (ed.), *Black Victorians: Black People in British Art 1800–1900*, exh. cat., Manchester City Art Gallery 2005.

MARSHALL 1994
C. Marshall, *Irish Art Masterpieces*, New York 1994.

MARSHALL 1996
P.J. Marshall (ed.), *The Cambridge Illustrated History of the British Empire*, Cambridge 1996.

MARSHALL 2000
P.J. Marshall, 'Presidential Address: Britain and the World in the Eighteenth Century: III, Britain and India', *Transactions of the Royal Historical Society*, VI, no.10, 2000, pp.11–12.

MEIKSINS WOOD 1992
E. Meiksins Wood, *The Pristine Culture of Capitalism: A Historical Essay on Old Regimes and Modern States*, London 1992.

MEMES 1826
J.S. Memes, *History of Sculpture, Painting and Architecture*, Edinburgh, 1826.

MENGER 1999
P-M. Menger, 'Artistic Labor Markets and Careers', *Annual Review of Sociology*, vol.25, 1999, pp.541–74.

MENGER 2001
P-M. Menger, 'Artists as Workers: Theoretical and Methodological Challenges', *Poetics*, vol.28, no.4, Feb. 2001, pp.241–54.

MIKESELL 1960
M.W. Mikesell, 'Comparative Studies in Frontier History', *Annals of the Association of American Geographers*, vol.50, no.1, March 1960, pp.70–2.

MILLAR 1958
O. Millar, *Rubens: The Whitehall Ceiling*, Oxford 1958.

MITCHELL 1979
T.C. Mitchell (ed.), *The British Museum Yearbook 3: Captain Cook and the South Pacific*, London 1979.

MONTAGNA 1981
D. Montagna, 'Benjamin West's *The Death of General Wolfe*: A Nationalist Narrative', *American Art Journal* vol.13, no.2, spring 1981.

MORRIS 1989
D. Morris, *Thomas Hearne and his Landscape*, London 1989.

MORRIS AND ROBERTS 1998
E. Morris and E. Roberts, *Liverpool Academy and Other Exhibitions of Contemporary Art in Liverpool 1774–1867: A History and Index of Artists and Works Exhibited*, Liverpool 1998.

MOURAY 1895
Gabriel Mouray, *Passé le détroit*, Paris 1895.

MYER 1961
P.R. Myer, 'Images and Influences of Oriental Art: A Study in European Taste', *Art Journal*, vol.20, no.4, 1961, pp.203–10.

MYRONE 2005
M. Myrone, *Bodybuilding: Reforming Masculinities in British Art 1750–1810*, New Haven and London 2005.

NICHOLLS 1785
J. Nicholls, *Biographical Anecdotes of William Hogarth*, 3rd ed., London 1785.

NICHOLSON 1990
K. Nicholson, *Turner's Classical Landscapes*, Princeton 1990.

NUSSBAUM 2003a
F.A. Nussbaum, *The Global Eighteenth Century*, Baltimore and London 2003.

NUSSBAUM 2003b
F.A. Nussbaum, *The Limits of the Human: Fictions of Anomaly, Race, and Gender in the Long Eighteenth Century*, Cambridge 2003.

O'KEEFFE 1981
John O'Keeffe, *Omai; or, A Trip Round the World*, in *The Plays of John O'Keeffe*, vol.2, ed. Frederick M. Link, New York 1981.

OLMSTED 1985
J. C. Olmsted, *Victorian Painting: Essays and Reviews; Vol.3: 1861–1880*, New York and London 1985.

ORGEL AND STRONG 1973
S. Orgel and R. Strong, *Inigo Jones: The Theatre of the Stuart Court*, 2 vols., London 1973.

PAULSON 1991
R. Paulson, *Hogarth*, I–III, New Brunswick and London 1991.

PEACHAM 1906
H. Peacham, *Peacham's Compleat Gentleman 1634*, ed. G.S. Gordon, Oxford 1906.

PEVSNER 1956
N. Pevsner, *The Englishness of English Art*, London 1956 (based on the Reith Lectures, delivered by Pevsner for the BBC in 1955).

PIGGOTT 1985
S. Piggott, *William Stukeley*, London 1985.

POMEROY 2005
J. Pomeroy (ed.), *Intrepid Women: Victorian Artists Travel*, Ashgate 2005.

PONSONBY 1996
L. Ponsonby, *Marianne North at Kew Gardens*, London 1996.

PORTER 2001
D. Porter, *Ideographia: The Chinese Cipher in Early Modern Europe*, Stanford 2001.

POSTLE 1995
M. Postle, *Sir Joshua Reynolds: The Subject Pictures*, Cambridge 1995.

POSTLE 2005
M. Postle (ed.), *Joshua Reynolds: The Creation of Celebrity*, exh. cat., Tate, London 2005.

POULSON 1999
C. Poulson, *The Quest for the Grail: Arthurian Legend in British Art, 1840–1920*, Manchester 1999.

PRATT 1978
J. Pratt (ed.), *Thoughts of the Evangelical Leaders*, Edinburgh 1978.

PREBBLE 1988
J. Prebble, *The King's Jaunt: George IV in Scotland, 1822*, London 1988.

PRESSLY 1981
W. Pressly, *The Life and Art of James Barry*, New Haven and London 1981.

QUILLEY 2004
G. Quilley, 'William Hodges, Art and Empire,' *History Today*, vol.54, no.7, 2004, pp.46–53.

RAY 2006
R. Ray, 'The Beast in a Box: Playing with Empire in Early 19th-Century Britain', *Visual Resources: An International Journal of Documentation*, vol.22, no.1, March 2006, pp.7–31.

REBORA ET AL. 1996
C. Rebora et al., *John Singleton Copley in America*, exh. cat., Metropolitan Museum of Art, New York 1996.

REDGRAVE AND REDGRAVE 1866
R. Redgrave and S. Redgrave, *A Century of Painters of the English School*, 2 vols., London 1866.

REDGRAVE AND REDGRAVE 1890
R. Redgrave and S. Redgrave, *A Century of Painters of the English School*, 2 vols., 2nd ed., London 1890.

REYNOLDS 1975
J. Reynolds, *Discourses on Art*, ed. Robert R. Wark, New Haven and London 1975.

RIGGS 1936
M. Riggs, 'The Influence of the Pastoral Industry on Australian Exploration', *Economic Geography*, vol.12, no.3, Jan. 1936, pp.279–86.

ROACH 1996
J. Roach, *Cities of the Dead: Circum-Atlantic Performance*, New York 1996.

ROBERTSON 1897
E. Robertson (ed.), *Letters and Papers of Andrew Robertson*, London 1897.

ROEBUCK 1983
P. Roebuck (ed.), *Macartney of Lisanoure, 1737–1806: Essays in Biography*, Belfast 1983.

RODING 2003
J. Roding et al. (eds.), *Dutch and Flemish Artists in Britain 1550–1800*, Leiden 2003.

ROMANS 2005
M. Romans (ed.), *Histories of Art and Design Education: Collected Essays*, Bristol and Portland (Oregon) 2005.

ROSENTHAL, A. 2004
A. Rosenthal, '*Visceral Culture*: Blushing and the Legibility of Whiteness,' *Art History*, vol.27, no.4, Sept. 2004, pp.562–92.

ROSENTHAL, A. 2006a
A. Rosenthal, *Angelica Kauffman: Art and Sensibility*, New Haven and London 2006.

ROSENTHAL, A. 2006b
A. Rosenthal, 'Bad Dreams: Race and The Nightmare of 1781', in Wagner and Ogée 2006, pp.97–128.

ROSENTHAL, M. 1983
M. Rosenthal, *Constable: The Painter and his Landscape*, New Haven and London 1983.

ROSENTHAL, M. 2000
M. Rosenthal, *Thomas Gainsborough: 'A Little Business for the Eye'*, New Haven and London 2000.

ROSENTHAL, M., PAYNE AND WILCOX 1997
M. Rosenthal, C. Payne and S. Wilcox (eds.), *Prospects for the Nation: Recent Essays in British Landscape, 1750–1880*, New Haven and London 1997.

ROUQUET 1755
Jean-André Rouquet, *The Present State of the Arts in England*, London 1755.

RYAN 2001
V.L. Ryan, 'The Physiological Sublime: Burke's Critique of Reason', *Journal of the History of Ideas*, vol.62, no.2, April 2001, pp.265–79.

SEED AND WOLFF 1988
J. Seed and J. Wolff (eds.), *The Culture of Capital: Art, Power and the Nineteenth-Century Middle Class*, Manchester 1988.

SHARPE 1990
K. Sharpe, *Criticism and Compliment: The Politics of Literature in the England of Charles I*, Cambridge 1990.

SHEEHY 1980
Jeanne Sheehy, *The Rediscovery of Ireland's Past: the Celtic Revival*, London 1980.

SIMPSON 1981
C. R. Simpson, *SoHo: The Artist in the City*, Chicago and London 1981.

SIRÉN 1990
Osvald Sirén, *China and Gardens of Europe of the Eighteenth Century*, Washington 1990.

SIZERANNE 1895
Robert de la Sizeranne, *La Peinture anglaise contemporaine*, Paris 1895.

SLOAN 2000
K. Sloan, *"A Noble Art": Amateur Artists and Drawing Masters, c.1600–1800*, exh. cat., British Museum, London 2000.

SLOAN 2007
Kim Sloan et. al., *A New World: England's First View of America*, Chapel Hill 2007.

SLOBODA 2004
S.L. Sloboda, 'Making China: Design, Empire, and Aesthetics in Britain, 1745-1851', Ph.D. thesis, University of Southern California, 2004, UMI (Microform 3145290).

SMILES 1994
S. Smiles, *The Image of Antiquity: Ancient Britain and the Romantic Imagination*, New Haven and London 1994.

SMILES 2002
S. Smiles, *Self-help, With Illustrations of Character, Conduct, and Perseverance*, ed. Peter W. Sinnema, Oxford 2002.

SMITH 1985
B. Smith, *European Views and the South Pacific*, New Haven 1985.

SMITH 2002
G. Smith, *The Emergence of the Professional Watercolourist: Contentions and Alliances in the Artistic Domain, 1760-1824*, Aldershot 2002.

SOLKIN 1982
D. Solkin, *Richard Wilson: The Landscape of Reaction*, London 1982.

SOLKIN 1993
D. Solkin, *Painting for Money: The Visual Arts and the Public Sphere in Eighteenth-Century England*, New Haven and London 1993.

SOLKIN 2001
D. Solkin (ed.), *Art on the Line: The Royal Academy Shows at Somerset House, 1780-1836*, London and New Haven 2001.

STEVENSON AND THOMSON 1982
S. Stevenson and D. Thomson, *John Michael Wright*, exh. cat., Scottish National Portrait Gallery, Edinburgh 1982.

STRONG 1980
R. Strong, *Britannia Triumphans*, London 1980.

STRONG 1987
R. Strong, *Gloriana: The Portraits of Elizabeth I*, London 1987.

STRONG 2004
R. Strong, *The Arts in Britain: A History*, London 2004.

TAYLOR 1863
T. Taylor, 'English Painting in 1862', *The Fine Art Quarterly*, vol.1, 1863, pp.1-26.

TAYLOR 1999
B. Taylor, *Art for the Nation: Exhibitions and the London Public 1747-2001*, Manchester 1999.

THORNBURY 1862
W. Thornbury, *The Life of J.M.W. Turner, R.A.*, 2 vols, London 1862.

TOBIN 1999
B.F. Tobin, *Picturing Imperial Power: Colonial Subjects in Eighteenth-Century British Painting*, Durham 1999.

TOBIN 2005
B.F. Tobin, *Colonizing Nature: The Tropics in British Arts and Letters, 1760-1820*, Philadelphia 2005.

VAUGHAN 1983
W. Vaughan, 'When was the English School?' *Probleme und Methoden der Klassifizierung*, Vienna 1983.

VAUGHAN 1990
W. Vaughan, 'The Englishness of British Art', *The Oxford Art Journal*, vol.13, no.2, 1990, pp.15-16.

VAUGHAN 1994
W. Vaughan, *Romanticism and Art*, London 1994, reprinted 2003.

VENNING 2003
B. Venning, *Turner*, London 2003.

VERTUE 1930-55
G. Vertue, *Notebooks*, 6 vols., 1930-55, in *Walpole Society*, vols.18, 20, 22, 24, 26, 30.

WAAGEN 1838
G.F. Waagen, *Kunstwerke und künstler in England*, 3 vols., Berlin 1837; *Works of Art and Artists in England*, trans. H.E. Lloyd, 3 vols., London 1838.

WAGNER AND OGÉE 2006
P. Wagner and F. Ogée (eds.), *Representation and Performance in the Eighteenth Century*, ed. P. Wagner and F. Ogée, Berlin 2006.

WALPOLE 1762-71
H. Walpole, *Anecdotes of Painting in Englands*, 4 vols., Strawberry Hill 1762-71.

WEBB 1954
M.I. Webb, *Michael Rysbrack, Sculptor*, London 1954.

WELCH 1978
S.C. Welch, *Room for Wonder: Indian Painting During the British Period 1760-1880*, exh. cat., American Federation of Arts, New York 1978.

WHITLEY 1928
W.T. Whitley, *Artists and their Friends in England, 1700-1799*, 2 vols., London 1928.

WILCOX 1997
T. Wilcox, *Francis Towne*, London 1997.

WILSON 2003
K. Wilson, *The Island Race: Englishness, Empire and Gender in the Eighteenth Century*, London and New York, 2003.

WILSON 2004
K. Wilson (ed.), *The New Imperial History: Culture, Identity and Modernity in Britain and the Empire 1660-1840*, Cambridge 2004.

WILTON 1979
A. Wilton, *Constable's 'English Landscape Scenery'*, London 1979.

WOOD 2000
M. Wood, *Blind Memory: Visual Representations of Slavery in England and America*, New York 2000.

Timeline 1600–1899

Social and political events
Cultural events

1600–1699

1600	East India Company founded
1600	William Shakespeare writes *Hamlet*
c.1600	Nicholas Hilliard writes *The Art of Limning*
1601	Earl of Essex's rebellion fails
1603	'Union of Crowns': King James I of Scotland becomes King James VI of England; beginning of Stuart dynasty
1605	Gunpowder Plot
1605	Francis Bacon publishes *Advancement of Learning*
1606	Henry Peacham publishes *The Art of Drawing with a Pen*
1607	William Camden publishes a new illustrated edition of *Britannia*
1610	Ben Jonson's play *The Alchemist* first performed
1611	Authorised ('King James') version of the Bible published
1612	Henry Peacham publishes *Minerva Britannia*
1612	Michael Drayton publishes the first part of *Poly-Olbion*
1616	Death of William Shakespeare
1618–22	Banqueting House at Whitehall built, designed by Inigo Jones
1620	*Mayflower* Puritan ship sails to North America
1623	First Folio of William Shakespeare's plays published, containing 36 plays
1625	Accession of Charles I
1629	Charles I dissolves Parliament
1629	Rubens begins work on paintings for the Banqueting House, Whitehall
1630	Peter Paul Rubens, *St George and the Dragon in a Landscape*
1632	First coffee-house opens in London
1632	Anthony Van Dyck settles in London
1634	Thomas Carew's masque *Coelum Britannicum* performed
1640	'Long Parliament' called
1641	Death of Anthony Van Dyck
1642–9	Civil War and second wave of iconoclasm
1649	Charles I executed, followed by a Republic under Oliver Cromwell
1658	Death of Oliver Cromwell
1658	William Sanderson publishes *Graphice … The Most Excellent Art of Painting*
1658	William Faithorne, *Oliver Cromwell between Two Pillars* (after a drawing by Francis Barlow)

1660	Restoration of monarchy and accession of Charles II
1660	Samuel Pepys begins keeping his diary
1661	Peter Lely becomes Charles II's court painter
1662	Restoration of Church of England
1662	Royal Society receives charter
1662	Licensing Act passed: religious authorities control what material can be published
1662	John Evelyn publishes *Sculptura*
1665	Plague kills up to a fifth of London's population
1666	Great Fire of London, followed by rebuilding and rapid expansion of London
1667	John Milton publishes *Paradise Lost*
1675	John Bunyan writes *Pilgrim's Progress* in Bedford jail
1675–1710	St Paul's Cathedral built, designed by Christopher Wren
1679–81	Emergence of 'Whig' and 'Tory' parties
1680	John Michael Wright portrait of Sir Neil O'Neill of Killeleagh
c.1683	John Michael Wright portrait of Sir Mungo Murray
1685	Accession of Catholic James II
1687	Isaac Newton publishes *Principia Mathematica*
1688	'Glorious Revolution': deposition of James II and accession of William III and Mary II
1689	Bill of Rights passed by Parliament, outlining rights of citizens of the constitutional monarchy
1689	Henry Purcell composes the opera *Dido and Aeneas*
1690	John Locke publishes *An Essay Concerning Human Understanding*
1694	Bank of England founded
1695	Licensing Act of 1662 lapses
1695	John Dryden publishes his translation of Charles Du Fresnoy's *De Arte Graphica* ('The Art of Painting')

1700–1799

1700	Jan Siberechts, *Nottingham from the East*
1701–14	War of Spanish Succession
1702	Accession of Anne, following settlement leading to Hanoverian dynasty

1704	Battle of Blenheim
1707	Union of England and Scotland
1708–12	James Thornhill's paintings at Greenwich
1711	*Spectator* magazine first published
1711	Earl of Shaftesbury publishes *Characteristicks*
1712	Sir Godfrey Kneller's Academy founded in London
1712	Joseph Addison's essays 'The Pleasures of the Imagination' published in the *Spectator*
1714	Accession of George I
1714	Alexander Pope publishes *The Rape of the Lock*
1715	First Jacobite Rebellion defeated
1715	Jonathan Richardson publishes *Essay on the Theory of Painting*
1718	Thornhill's Academy founded in London
1719	Daniel Defoe publishes *Robinson Crusoe*
1720	'South Sea Bubble' financial crash
1720	John Vanderbank's Academy founded in London
1721–42	Premiership of Robert Walpole
1726	Jonathan Swift publishes *Gulliver's Travels*
1726	Francis Hutcheson publishes *Inquiry into the Original of Our Ideas of Beauty and Virtue*
1727	Accession of George II
1728	John Gay's *Beggar's Opera* first performed
1730	James Thomson publishes *The Seasons*
1732–3	William Hogarth, *A Performance of 'The Indian Emperor or the Conquest of Mexico'*
1733	Society of Dilettanti founded to encourage connoisseurship and art-collecting
1733	William Hogarth, *Harlot's Progress*, *Southwark Fair* and *A Midnight Modern Conversation*
1733–5	William Hogarth, *Rake's Progress*
1735	St Martin's Lane Academy founded in London by Hogarth and others
1735	Engraver's ('Hogarth's') Copyright Act
1736	William Hogarth, *Before & After*
1738	Beginnings of Methodism
1738	William Hogarth, *Strode Family* and *Four Times of the Day*
1738	Louis-François Roubiliac, statue of George Frederick Handel for Vauxhall Gardens

1740–8	War of Austrian Succession
1741	Samuel Richardson publishes *Pamela*
1742	William Hogarth, *Miss Mary Edwards*
1742	George Frideric Handel's *Messiah* first performed
1743	Battle of Dettingen
c.1743	William Hogarth, *Marriage A-la-Mode*
1744	Samuel Baker's first auction of books (the firm later becomes Sotheby's)
1744–5	William Hogarth, *The Battle of the Pictures*
1745	Second Jacobite Rebellion; failure results in end of Stuart hopes
1745	William Hogarth, *Self-Portrait with Pug*
1747	Antonio Canaletto, *Westminster Bridge*
1747	William Hogarth, *Industry & Idleness*
1749	Henry Fielding publishes *Tom Jones*
1749	William Hogarth, *The March to Finchley*
1751	William Hogarth, *Gin Lane & Beer Street* and *Four Stages of Cruelty*
1752–3	Joshua Reynolds, portrait of Augustus Keppel
1753	British Museum founded in London
1753	William Hogarth publishes *The Analysis of Beauty*
1754	Society of Arts founded
1755	Samuel Johnson publishes *Dictionary of the English Language*
1755–8	William Hogarth, *Four Prints of an Election*
1756–63	Seven Years' War between England and France
1757	Edmund Burke publishes *Philosophical Enquiry into the Origin of the Sublime and the Beautiful*
1757	Thomas Gray publishes *The Bard*
1757	Sir William Chambers publishes *Designs of Chinese Buildings*
1760	Accession of George III
1760	Richard Wilson exhibits *Destruction of the Children of Niobe*
1760	First Society of Artists exhibition in London
1761–2	Francis Hayman, *Robert Clive and Mir Jafar after the Battle of Plassey, 1757*
1762	James Stuart and Nicholas Revett publish *Antiquities of Athens*
1762	Henry Home Lord Kames publish *Elements of Criticism*
1762	George Stubbs, *The Grosvenor Hunt*
1762–80	Horace Walpole publishes *Anecdotes of Painting*

1764	Death of William Hogarth
1765	East India Company assumes control of Bengal
1766	James Christie's first sale of artworks
1766	George Stubbs, *Anatomy of the Horse*
1766	Joseph Wright, *The Orrery*
1767	Laurence Sterne publishes *Tristram Shandy*
1767	John Singleton Copley, portrait of Nicholas Boylston
1768	Royal Academy founded
1768	Adam brothers begin work on the Adelphi Buildings
1768	Sir James Clerk commissions Alexander Runciman to paint ceiling at Penycuik
1768	First volumes of *Encyclopedia Britannica* published
1768	John Singleton Copley, portrait of Paul Revere
1768	Thomas Gainsborough, portrait of Ignatius Sancho
1768	Joseph Wright, *An Experiment on a Bird in the Air Pump*
1769	James Watt patents steam engine
1770	Captain Cook arrives at Botany Bay
1770	Benjamin West, *The Death of General Wolfe*
c.1770	Agostino Brunias, *French Mulatress and Negro Woman Bathing*
1771	Richard Arkwright's first spinning mill
1771	Richard Wilson, *A View near Wynnstay, the Seat of Sir Watkin Williams-Wynn, Bt* and *Dinas Bran from Llangollen*
1771	Joseph Wright, *Blacksmith's Shop*
1771–2	Johann Zoffany, *The Royal Academicians*
1772	Joseph Wright, *Iron Forge*
1772–8	Johann Zoffany, *The Tribuna of the Uffizi*
1773	Samuel Johnson and James Boswell tour the Scottish Highlands and the Hebrides
1773	Benjamin West, portrait of Joseph Banks
1773	Joshua Reynolds, *Three Ladies Adorning a Term of Hymen*
1775	Richard Brinsley Sheridan's *The Rivals* first performed
1775	Nathaniel Hone, *The Conjuror*
1775–83	American War of Independence
1776	Edward Gibbon publishes *Decline and Fall of the Roman Empire*
1776	Adam Smith publishes *The Wealth of Nations*

1776	James Barry, *The Phoenix or the Resurrection of Freedom*
1776	George Romney, *Joseph Brant (Thayeadanegea the Mohawk Chief)*
1776	William Hodges, *Tahiti Revisited*
1777	John Howard publishes *State of Prisons*
1777	John Webber, portrait of Poedua
1777	Thomas Gainsborough, *The Watering Place*
1778	William Storer patents his *Royal Delineator*, a portable *camera obscura*
1779–80	Construction of Somerset House, designed by William Chambers
1779–81	Samuel Johnson publishes *Lives of the Poets*
1780	Anti-Catholic Gordon Riots in London
1780	John Singleton Copley, portrait of Major Hugh Montgomerie
c.1780	Agostino Brunias, *Market Day, Roseau, Dominica* and *Linen Market, Dominica*
1781	William Pitt the Younger becomes Prime Minister
1781	William Gilpin publishes first volume of *Picturesque Tours*
1781–3	Johann Zoffany, *Charles Townley and his Friends*
1783	Peace treaty with the American Republic in which British Crown withdraws its claim to France
1783	William Pitt the Younger becomes Prime Minister
1784	Ordnance Survey of England established
1784	Death of Samuel Johnson
c.1784–6	Johann Zoffany, *Colonel Mordaunt's Cock Match*
1785	*The Times* newspaper founded
1785–7	Thomas Gainsborough, *Mrs Richard Brinsley Sheridan*
1786	Boydell's Shakespeare Gallery founded in London
1786	James Barry, *Lear and Ophelia*
1787	Johann Zoffany, *The Embassy of Hyder Beg Khan to meet Governor-General Cornwallis with a View of the Granary Erected by Hastings at Patna*
1788	Death of Thomas Gainsborough
1788	George Morland, *Execrable Human Traffic*
1789	Fall of the Bastille in Paris
1789	William Blake, *Songs of Innocence*
1789	John Trumbull, *The Sortie Made by the Garrison of Gibraltar*

1790	Edmund Burke publishes *Reflections on the Revolution in France*
1791	Thomas Paine publishes *Rights of Man*
1791	James Boswell publishes *The Life of Samuel Johnson*
1792	Mary Wollstonecraft publishes *Vindication of the Rights of Women*
1792	Death of Joshua Reynolds
1793–1815	War with France
1793	William Blake, *Visions of the Daughters of Albion*
1793–6	William Blake, *Joseph of Arimathea Preaching to the Inhabitants of Britain*
1794	Uvedale Price publishes *Essay on the Picturesque*
1795	Ecole des Beaux-Arts founded in Paris
1796	Vaccination against smallpox introduced
1796–8	Hugh Douglas Hamilton, portrait of Richard Mansergh St George
1798	Irish Rebellion
1798	William Wordsworth and Samuel Taylor Coleridge publish *Lyrical Ballads*
1798	J.M.W. Turner, *Caernarvon Castle* exhibited

1800–1899

1801	First Census: population of UK 10.4 million (USA 5.3 million)
1801	Ireland brought into the Union, forming the United Kingdom
1802	J.M.W. Turner, *Dolbadarn Castle, North Wales* exhibited
1803–12	Elgin Marbles transferred to British Museum
1804	Horticultural Society founded
1805	Battle of Trafalgar; death of Nelson
1805	British Institution for the Development of the Fine Arts founded
1805	James Gillray, *The Plum-pudding in Danger*
1806	Henry Fuseli, *The Negro's Revenge*
1807	Britain abolishes transatlantic slave trade, but not slavery in the colonies
1811	Regency begins
1811	Luddite disturbances against new machinery
1811	John Nash begins Regent Street, London
1812	Henry Raeburn, portrait of Colonel Alasdair MacDonell of Glengarry

1813–4	David Cox, *Treatise on Landscape Painting and Effect in Water Colours*
1814	George Stephenson builds first steam locomotive
1814	William Wordsworth publishes *The Excursion*
1814	Walter Scott publishes *Waverley*
1814	John Constable, *Boat-Building at Flatford Mill*
1814–5	John Constable, *The Stour Valley and Dedham Village*
1815	Defeat of Napoleon at Battle of Waterloo
1815	Controversial Corn Laws passed
1815	J.M.W. Turner exhibits *Crossing the Brook* at the Royal Academy's annual exhibition
1815	James Ward exhibits *Gordale Scar*
1816	'Bread or Blood' riots in East Anglia
1816	Jane Austen publishes *Emma*
1816	John Martin exhibits *The Bard*
1818	Mary Shelley publishes *Frankenstein*
1818	John Keats publishes *Endymion*
1819	Peterloo massacre of political reform demonstrators in Manchester
1819	First iron steamship launched
1819	J.M.W. Turner's *England: Richmond Hill, on the Prince Regent's Birthday* exhibited
1819	Lord Byron publishes the first two cantos of *Don Juan*
1820	Accession of George IV
1820	Théodore Géricault's *Raft of the Medusa* shown in London
1821	Percy Bysshe Shelley writes *Adonais*
1821	John Martin exhibits *Belshazzar's Feast* at the British Institution
1821	William Blake probably completes unique coloured copy of *Jerusalem*
1822	George IV visits Edinburgh; accompanying ceremonies overseen by Sir Walter Scott
1822	David Wilkie exhibits *Chelsea Pensioners Receiving the London Gazette Extraordinary of Thursday June 22d, 1815, Announcing the Battle of Waterloo!!!*
1824	National Gallery, London founded
1824	John Constable's *Haywain* shown to high acclaim at Paris Salon
1824–7	William Blake creates series of watercolours in illustration of Dante's *Divine Comedy*
1825	Stockton and Darlington railway opens

1825	Trade unions legalised
1825	Penry Williams, *Cyfartha Ironworks*
1826	Augustus Earle, *Waterfall in Australia*
1827	Death of William Blake
1827	John Constable, *Chain Pier, Brighton*
1827–38	J.M.W. Turner publishes *Picturesque Views in England and Wales*
1828	J.T. Smith publishes *Nollekens and his Times*
1829	Catholic Emancipation
1829	Metropolitan Police founded
1830	Accession of William IV
1830	Samuel Palmer, *Coming from Evening Church*
1830–2	John Constable publishes *Various Subjects of Landscape Characteristic of English Scenery*
1830–3	Charles Lyell publishes *Principles of Geology*
1831	'Captain Swing' agricultural riots
1832	Great Reform Bill enlarges franchise
1832	Foundation of the *Penny Magazine*
1832	J.M.W. Turner, *Staffa, Fingal's Cave*
1833	Oxford Movement founded
1833–5	J.M.W. Turner publishes *Turner's Annual Tours*
1834	Slavery abolished in British Empire
1834	Houses of Parliament destroyed by fire
c.1835–6	J.M.W. Turner, *Edinburgh Castle, The March of the Highlanders*
1836	Charles Dickens publishes *Sketches by Boz*, with illustrations by George Cruikshank
1837	Accession of Victoria
1837	Charles Dickens publishes *Oliver Twist*
1837	Death of John Constable
1837	School of Design (later Royal College of Art) founded in London
1838	Public Record Office opens
1838	William Petrie, *The Last Circuit of Pilgrims at Clonmacnoise*
1839	*Art Journal* founded
1839	W.H. Fox Talbot publishes a photographic negative
1840s	'Railway Mania'
1840	J.M.W. Turner, *Slavers Throwing Overboard the Dead and Dying, Typhoon Coming On*
1840–52	Charles Barry and A.W.N. Pugin, Houses of Parliament
1841	*Punch* magazine first published
1842	Alfred Tennyson publishes *Morte d'Arthur*

1843	John Ruskin publishes the first volume of *Modern Painters* as a defence of Turner
1844–6	Famines in Ireland
1845	Friedrich Engels publishes *Condition of the Working Classes in England*
1847	Emily Brontë publishes *Wuthering Heights*
1847	William Makepeace Thackeray publishes *Vanity Fair*
1847	Charlotte Brontë publishes *Jane Eyre*
1848	Revolutions in France and elsewhere in Europe
1848	Karl Marx and Friedrich Engels publish *The Communist Manifesto*
1848	Founding of Pre-Raphaelite Brotherhood
1849–50	John Everett Millais, *Christ in the House of His Parents*
1850	Alfred Tennyson publishes *In Memoriam*
1850	David Wilkie, *Answering the Emigrant's Letter*
1851	Great Exhibition, London
1851	Death of J.M.W. Turner
1852	Victoria and Albert Museum opens
1852–5	Ford Madox Brown, *The Last of England*
1852–65	Ford Madox Brown, *Work*
1853	Photographic Society of London founded
1853	Holman Hunt, *Our English Coasts*
1854	Working Men's College founded in London
1854	Franz Winterhalter, portrait of Maharaja Dalip Singh
1854–6	Crimean War
1855	Gustave Courbet's 'Le Réalisme' pavilion at Universal Exhibition, Paris
1856	National Portrait Gallery opens in London
1857	Indian rebellion
1857–65	Transatlantic cable laid
1858	William Powell Frith exhibits *Derby Day*
1859	Charles Darwin publishes *Origin of Species*
1861	Population of UK 23.1 million (US 32 million)
1861	Death of Prince Albert
1863	First underground railway in London
1863	Edouard Manet's *Déjeuner sur l'herbe* exhibited at Salon des Refusés, Paris
1863	Thomas Jones Barker, 'The Secret of England's Greatness'
1865	Lewis Carroll publishes *Alice's Adventures in Wonderland*
1867	Reform Act passed in Parliament, enfranchising all male householders
1869	Suez Canal opens
1869	Matthew Arnold publishes *Culture and Anarchy*
1870	Elementary Education Act
1871	George Eliot publishes *Middlemarch*
1874	Thomas Hardy publishes *Far from the Madding Crowd*
1874	*First Impressionist Exhibition*, Paris
1876	Queen Victoria becomes Empress of India
1877	Grosvenor Gallery opens in London
1877	Society for the Preservation of Ancient Buildings founded
1878	First electric street lighting in London
1878	Salvation Army founded
1878	Ruskin-Whistler libel trial
1879	First telephone exchange in London
1879	Public granted unlimited access to British Museum
1881	Population of London 3.3 million (Paris 2.2 million and New York 1.2 million)
1882	Society for Psychical Research founded
1882	Marianne North, exhibition of botanical drawings at Kew
1882	Henry Peach Robinson publishes *The Lady of Shallot*
1884	John Singer Sargent, *Madame X*
1885	General Charles Gordon killed at Khartoum
1885	First gasoline powered motorcar
1885	Walter Pater publishes *Marius the Epicurean*
1885	Gilbert and Sullivan's opera *The Mikado* first performed
1886	New English Art Club founded in London
1886	Robert Louis Stevenson publishes *Dr Jekyll and Mr Hyde*
1887	Bloody Sunday socialist demonstration in Trafalgar Square
1888	Arts and Crafts Exhibition Society founded in London
1890	William Booth publishes *In Darkest England and the Way Out*
1891	Oscar Wilde publishes *The Picture of Dorian Gray*
1894	First publication of the literary periodical *Yellow Book*, with Aubrey Beardsley as editor
1894	Rudyard Kipling publishes *The Jungle Book*
1894	Edward Burne-Jones, *Love Among the Ruins*
1895	Marconi invents wireless telegraphy
1895	National Trust founded
1895	H.G. Wells publishes *The Time Machine*
1895	Lumière brothers invent cinematograph
1896	First cinema opens in London
1897	Tate Gallery (originally the National Gallery of British Art) opens
1897	Bram Stoker publishes *Dracula*
1899	Magnetic recording of sound invented
1899	Start of Boer War
1899	Edward Elgar composes *Enigma Variations*

Index

Photographic Credits

Ashmolean Museum, Oxford 123
© Banqueting House, Whitehall, London, UK/ The Bridgeman Art Library 22
© Bildarchiv Monheim GmbH / Alamy 50
© Birmingham Museums & Art Gallery 119, 185
© Private Collection/ The Bridgeman Art Library 47, 145, 146, 151
© Coram Family in the care of the Foundling Museum, London/ The Bridgeman Art Library 165
© British Government Collection 100
© The British Library Board. All Rights Reserved 95
© The British Library Board. All Rights Reserved 112
© The Trustees of the British Museum 110, 159, 192, 210, 214
© Cleveland Museum of Art 108
© Dean and Chapter of Westminster 180
2008 The J. Paul Getty Trust. All rights reserved 93
Guildhall Library Print Collection 176
Gernsheim Collection, Harry Ransom Humanities Research Center. The University of Texas at Austin 149
Photo: Rick Stafford © President and Fellows of Harvard College 44
© Hunterian Museum and Art Gallery, University of Glasgow 204
Indianapolis Museum of Art, USA/ Edward L. Anderson Fine Arts Acquisition Fund/ The Bridgeman Art Library 148
Kimbolton Castle 80
© Lady Lever Art Gallery, National Museums Liverpool 141, 142
©Lincolnshire County Council, Usher Gallery, Lincoln, UK/ The Bridgeman Art Library 96
© Manchester Art Gallery, UK/ The Bridgeman Art Library 184
Photograph © 2008 Museum of Fine Arts Boston 37, 111
Image courtesy of National Gallery of Art, Washington 78, 173
© National Gallery of Canada, Ottawa 151
Photo © National Gallery of Canada 151
Photo © National Gallery of Canada, Ottawa 109
Photograph courtesy of National Gallery of Ireland 46
© National Gallery, London 59, 79
National Gallery of Scotland 42

National Library of Australia 91
© National Maritime Museum London 67, 116, 117
National Museum of Wales 193
© National Portrait Gallery, London 21, 35, 49, 88, 114, 168
© Norwich Castle Museum and Art Gallery/ The Bridgeman Art Library - p.137
© Nottingham City Museums and Galleries (Nottingham Castle)/ The Bridgeman Art Library 126
© NTPL/Rob Matheson 82
Old Royal Naval College, Greenwich 26
© 2008 Philadelphia Museum of Art. All rights reserved 102
Private collection 178
Rousham House, Oxfordshire, UK/ The Bridgeman Art Library 63
Royal Botanic Gardens, Kew, London 99
The Royal Collection © 2008, Her Majesty Queen Elizabeth II 60, 104, 118, 124, 179, 200
Reproduced with the kind permission of the Royal Pavilion and Museums (Brighton and Hove) 83
© Royal Pavilion, Brighton, East Sussex, UK/ The Bridgeman Art Library 101
Courtesy of Sotheby's Picture Library 97
Photo © R.J.L Smith 181
Tate, London 28, 31, 32, 36, 38, 40, 52, 61, 62, 71, 72, 73, 74, 79, 119, 127, 128, 129, 132, 135, 136, 139, 144, 147, 157, 161, 162, 169, 170, 176, 183, 190, 196, 197, 202, 205, 207, 208, 212, 215, 216, 217, 220, 221, 222, 223
UCL Art Collections, University College London 148
© Victoria and Albert Museum, London 51, 133, 177, 194
© Westminster Abbey, London, UK/ The Bridgeman Art Library 113
© Whitworth Art Gallery, The University of Manchester, UK/ The Bridgeman Art Library 100
© Wilberforce House, Hull City Museums and Art Galleries, UK/ The Bridgeman Art Library 112
Yale Center for British Art, Paul Mellon Collection 6, 13, 29, 39, 43, 47, 53, 69, 75, 81, 86, 92, 94, 105, 107, 131, 136, 150, 172, 174, 175, 182, 199, 209, 218, 219

First published in North America by the Yale Center for British Art
P. O. Box 208280
1080 Chapel Street
New Haven, CT 06520-8280
www.yale.edu/ycba

in association with Tate Britain

Distributed in North America by Yale University Press
www.yalebooks.com

ISBN 978-0-300-11671-7
ISBN 978-0-300-14304-1 (three-volume set)

Library of Congress Control Numbers:
2008933777
2008933920 (three-volume set)

General Editor: David Bindman
Designed by LewisHallam
Color reproduction by DL Interactive, London
Printed and bound in China by C&C Offset Printing Co., Ltd.

JACKET
FRONT: J.M.W. Turner, *Slavers Throwing Overboard the Dead
and Dying, Typhoon Coming On* 1840 (detail of fig.64, p.111)
BACK: *(from left to right)*: Francis Hayman, *Robert Clive and Mir Jafar
after the Battle of Plassey, 1757* c.1760 (detail of fig.46, p.88);
George Stubbs, *The Grosvenor Hunt* 1762 (detail of fig.90, p.146);
Thomas Gainsborough, *Ignatius Sancho* 1768 (detail of fig.62, p.109);
Joseph Wright of Derby, *An Academy by Lamplight* c.1768–9 (detail of
fig.127, p.199); Anthony Van Dyck, *Orazio Gentileschi* 1632–9 (fig.121, p.192)

FRONTISPIECE: William Blake, *And this the form of mighty Hand*,
Plate 70 from *Jerusalem* 1804–c.1820 (fig.5, p.29)

pp.4–5: John Constable, *A Cottage at East Bergholt: The Gamekeeper's
 Cottage* c.1833 (detail of fig.86, p.141)
 p.18: George Stubbs, *Reapers* 1785 (detail of fig.9, p.36)
 p.54: John Constable, *The Haywain* 1821 (detail of fig.25, p.59)
 p.84: Thomas Jones Barker, *'The Secret of England's Greatness'*
 *(Queen Victoria Presenting a Bible in the Audience
 Chamber at Windsor)* (detail of fig.68, p.114)
 p.120: Peter Paul Rubens, *Landscape with St George and
 the Dragon* 1630 (detail of fig.74, p.124)
 p.152: Arthur Devis, *The James Family* 1751 (detail of fig.99, p.161)
 p.186: Johann Zoffany, *The Royal Academicians* 1771–2
 (detail of fig.128, p.200)
 p.226: Richard Wilson, *The Thames near Marble Hill, Twickenham*
 c.1762 (detail of fig.78, p.129)

Measurements of artworks are given in centimetres,
height before width, followed by inches in brackets.